The Muses' Concord

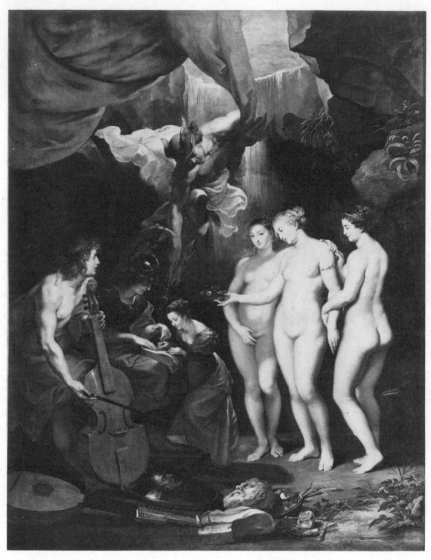

Peter Paul Rubens, *The Education of Marie de' Medici* (1622–23). Paris, Louvre; photo Giraudon.

The *Muses' Concord*

Literature, Music, and the Visual Arts

in the Baroque Age

H. JAMES JENSEN

INDIANA UNIVERSITY PRESS

BLOOMINGTON LONDON

Published in Canada by Fitzhenry & Whiteside Limited, Don Mills, Ontario
Manufactured in the United States of America

Library of Congress Cataloging in Publication Data

Jensen, H. James.
The muses' concord.
Includes bibliographical references and index.
1. Arts, Baroque. I. Title.
NX451.5.B3J46 1976 700'.9'032 76–11940.
ISBN 0–253–33945–6 1 2 3 4 5 81 80 79 78 77

TO SUSAN

Contents

PLATES

PREFACE

Several years ago, I read a paper to a graduate seminar explaining why I thought John Dryden's "A Song for St. Cecilia's Day, 1687" an ambitious failure. I later told my ideas and arguments to my old friend and teacher Samuel Monk, and after much discussion I decided to look again at the poem. This second look made me realize that things were more complicated than they appeared. The poem seemed to spring from a wealth of complex seventeenth-century thoughts and poetic practices. I started reading. In obscure but fascinating works, I encountered all sorts of ideas about the nature of seventeenth-century psychology, artistic creation, education, moral values, social mores, scientific discoveries, and issues of taste. Although the impetus for my studies came from the desire to learn about one poem, the results applied to all Baroque art. I gradually realized that the ideas I was finding allowed me to enjoy seventeenth- and eighteenth-century art much more than I ever had before, so I decided to write a book. Because of the nature of the material, this book is not a tightly organized argument in support of a clearly defined thesis. It is, rather, an explanation or a series of explanations of ideas and procedures aimed at enhancing our perception and appreciation of the glories, universality, and effectiveness of art of the Baroque era.

My approach is intensively and selectively historical. By that I mean I concentrate on carefully chosen historical beliefs and controversies about artistic methods, artistic results, and the ideas in and behind art and its creation during a period of time we may conveniently call the Baroque era. To elucidate the ideas considered and to show their application, I use mainly sixteenth-, seventeenth-, and eighteenth-century theoretical writings and works of art. By such historical means, I hope to enable others to see the universal qualities that lie behind the different manners, conventions, and approaches of the Baroque era in terms of that time. It is through the study and comprehension of historical particularities that we can move to universal generalities, that we can perceive the human condition, that we can learn to appreciate an art built on modes of taste and belief different from our own. As John Dryden says, "Mankind is ever the same, and nothing lost out of nature, though everything is altered" (Preface to *Fables* [1700]).

I use the term *Baroque era* as an historical convenience; this term encompasses a period extending roughly from the early seventeenth through the early eighteenth century. Although I am concerned mainly with late seventeenth-century England, I move freely from one country to another and forward into the eighteenth, as well as back to the beginnning of the seventeenth, century. The *Baroque era* used as an historical concept allows me to do this. Since I use theories and examples of art from France and Italy, as well as from England, I did not want to be bound by an historical conception as narrow as the *English Restoration Period*. Latitude is necessary because many of the ideas I discuss were current throughout both the seventeenth and eighteenth centuries (as well as earlier or later in some cases), although with alterations and dissensions, and are international in scope or influence. To confine myself too strictly to dates or places would cripple my discussions of the development of ideas and of their manifestations in works of art. Despite national and cultural differences, Addison's writings, Vivaldi's music, Rubens's paintings, Shaftesbury's aesthetics, and Coeffeteau's psychology all help elucidate seventeenth-century ideas, where they came from and what they lead toward. Even writers as diverse in time as Sir Joshua Reynolds (1723–92) and Marsilio Ficino (1433–99) express ideas clearly manifest in the Baroque era, and sometimes a seventeenth-century French theoretician or a cinquecento Italian painter will be more important to our understanding of an English Restoration poem than an English contemporary. The freedom to move backward and forward in time also is necessary because ideas generally accepted by an age are often less extensively talked about in that time. New, as yet unaccepted, ideas are discussed more often but actually are more important to subsequent generations than to the age that produces them. Historical knowledge helps us judge which ideas are most relevant to a work of art.

It has been said that the seventeenth century began the modern age. The new perceptions of the construction of the universe and the remarkable changes in attitude toward the human condition were shocking to people of that time, and such changes influenced, as they still do, all considerations of human endeavor. Many assumptions alive in the twentieth century were debated in the seventeenth. The differences between the materialist Thomas Hobbes and the idealistic Cambridge Neoplatonists, for example, are still with us. Hobbes's pessimistic view is that human beings are essentially animals, ruled by the worst and most savage passions, limited to an earthbound, materialistic existence, needing the protection of an all-encompassing state, and requiring a prescriptive form of education. The Neoplatonists think that human beings are innately good and virtuous but are warped by inadequate or improper education. They

maintain that people would function best in a society that would allow innate virtue to grow to its natural bounds, a society wherein people would be able to perceive and to communicate with divine truth and absolute reality. Such conflicts in thinking have ever since been debated; they influence, among other things, conceptions of education, of artistic genius, and of the place in society of art and its creators, all of which in turn not only have influenced the kinds of art produced but also have found their expression in art. A clearer understanding of what others before us tried to do and say can help us better to perceive ourselves, our own time, and our own art.

There are differences between the Baroque era and our own which if not realized will distort our evaluation of Baroque art. Theories of mind and perception, for example, are quite different from our own, although we use their technical terms in everyday, twentieth-century conversation. Baroque poets, painters, and composers thought that each kind of art reached a person through the same route: first through the senses; then to the common sense, memory, and imagination; and finally to the understanding and the will, the only differences between the arts being the exterior sense each touches and moves. However, common sense, imagination, and understanding are not at all what we conceive them to be today, and this is a very important point, especially since the pragmatic and complex psychological conclusions of Baroque artists underlie all the arts and permeate all their theoretical writings. Moreover, theorists, painters, musicians, and poets of that time express, modify, and evaluate all their differing critical theories, aesthetic aims, political purposes, social predilections, and philosophical or theological beliefs through consciously employed rhetorical techniques and devices based on these psychological conclusions. So also, a consideration of rhetoric, rhetoric as they knew it, is essential to an understanding of Baroque aesthetics and art, for their rhetoric, among other things, is concerned with the process of making or creating art and with the ways to induce specific effects in viewers, spectators, and audiences. Since only the means of expression is special to each kind of art, the ideas of creativity or making, as well as results or effects, are common to all art, and all art of the period can be compared on common rhetorical bases.

There are two other topics I would like to mention. One is the structural interpretation of cultural periods used by those who discuss the divisions of Baroque, Mannerist, Renaissance, and Rococo. The *Baroque Era* as comparable to the *Age of Romanticism* is an important and useful label for an historical period. But usually when a work of art is defined as Mannerist or Baroque, it means that it fits into a particular aesthetic movement

defined from a modern point of view as the spirit of the age. Conceptions
such as *Baroque* and *Mannerist* as they are presently defined are difficult
to use in interpretations of specific works, however, even when the mean-
ing of a particular work lies in its general effect. Such a consideration often
overlooks the historical problem of what a creator actually says or means
in his works. There also are attempts to define aesthetic movements such
as Baroque and Mannerist as precisely as possible by explaining them in
terms of artistic, intellectual, and scientific movements that determine
modes of perception during a certain period of time. Although ideas and
kinds of expression keep evolving or changing one into another, there are
periods of intellectual and artistic history that seem to be marked off by
particular artistic styles, and I think that this kind of approach may prove
to be fruitful. My purpose in this book, however, is to explain specific
works of art and the historical ideas that help them come alive for us.
Therefore, I do not discuss what constitutes *Baroque*, as opposed to *Man-
nerist* or *Rococo*, art, although perhaps my discussions of ideas behind art
will help determine more precisely the boundaries of these aesthetic
movements.

The second topic I would like to mention is the difference between
comparing art forms and paralleling them. One compares the arts, or says
that one art form is like another, on the basis of the complex aesthetic
assumptions common to all works of art. Paralleling the arts, that is, equat-
ing one art form with another, results from the human tendency to equate
metaphors. For example, if there is a metaphorical ship of state, the head
of that state becomes like the captain of a ship. As long as there is a real-
ization that the head of state is *like* the captain of a ship, distinctions may
be made between the different kinds of duties expected of each. However,
if the roles are equated, if the head of state *is* a captain of a ship, it is easy
to draw spurious conclusions. The blurring of distinctions between the
metaphorical tenor and vehicle has led to problems in the practice and
theory of art and literature. Colors in painting, for example, often have
been used to describe figures of speech, and vice versa, but colors and fig-
ures of speech are neither equivalent nor parallel. Any parallel or equiva-
lency is based on metaphor. Horace in the *Ars poetica* distinguishes be-
tween painting and poetry (painting and poetry are merely like each
other), but many who took his phrase *ut pictura poesis* (as a painting, so
also a poem) out of context did not. Although some seventeenth-century
writers say so, a figure or trope is not a color, nor is a musical revert a
poetic apostrophe. The concept *ut pictura poesis* does not work if carried
to the means of art. And neither does the concept *ut musica poesis*. Plato
correctly says in *The Laws*, Book II, "To speak metaphorically of a melody

or figure having a 'good color' . . . is not allowable." To parallel the arts is to overlook the fact that the different arts, in their means, have different disciplines, traditions, and logic. Although the process of invention in the different arts may be parallel, just as the emotions or ideas communicated are parallel, the means of expression are not. The arts can more accurately be compared, rather than paralleled, on the bases of invention, arrangement, and means, and since one artistic discipline may use or allude to another in its means, carefully chosen comparisons of specific works of different kinds can make art more sensually exciting and intellectually rewarding. The end of such an endeavor is increased pleasure and understanding.

The *Musical Quarterly*, *Eighteenth Century Studies*, and *Studies in English Literature* have allocated use of portions of articles originally published with them. Indiana University gave me extra funds for two summers and one semester during which I did research and wrote. I would also like to express a special thanks to Samuel H. Monk and Ernest Tuveson for reading and commenting on early versions of the manuscript; Samuel I. Stone, who helped with some of the difficulties of translation; the graduate students, colleagues, and other friends who have suffered my discourses over the years; and my family.

Theories of Knowledge and Perception

The study of the mind and its processes, with historical theories of knowledge and perception as central considerations, is necessary for any understanding of Baroque art. In the Baroque era, writers express varying points of view stemming from various ways of regarding or charting the human soul or mind (for the terms *soul* and *mind* were almost always synonymous). The faculty theory of the mind was deeply entrenched in the culture. This theory, based on the faculty psychology developed by the ancient Greeks, had been refined and expounded for more than two thousand years. Without an historical knowledge of the mythology of the mind and its attendant terminology, we cannot tell how artists and theorists of the Baroque age described their thoughts, either explicitly or implicitly, nor can we understand rhetorical theory, aesthetic and critical movements, social influences, natural tastes, the importance of the new scientific discoveries, and the Baroque parallels and comparisons between the arts. Once the ideas and terminology are understood, the use of the faculty psychology becomes noticeable where before it was not, because most of the terms are still present in modern speech, albeit with changed meanings.

Knowledge of both the theory and the use of popular and erudite ideas behind art is a means to comprehend what painters,

writers, and composers tried to do and express. Since they com-
municate their ideas and feelings to us through works of art, we
are the losers if we neglect responding to their art as much as
possible in their own terms. Painters often depicted personifica-
tions of parts of the mind, or appealed to them, and depended on
their viewers to use the accepted terminology to analyze character
through gesture, color, and posture. Poets often use the terminol-
ogy for character analysis and depiction to describe the mind or
its parts, and they try to achieve certain effects in the minds of
readers and audiences through description, figures of speech, and
diction. And musicians appeal to one part of the mind or another
through melody, key, tempo, rhythmic patterns, and harmony,
besides often writing songs about the parts of the mind. Each
artist does in each medium what others in other media also try to
accomplish. All artists use the terminology and concepts as well
to describe their own minds, their thinking processes, and their
emotional states.

The most important issues in the relationship between mind
and art in the Baroque era concern the ways in which the mind
can impose rational form on the seeming chaos of the worlds of
nature and imagination. To most, there was only *seeming* chaos
in nature because they believed in the existence in nature of an
ultimate, rational, although undiscernible order, resolved within
the principle of *discordia concors*, that the seeming disorder of the
existent world is a part of a larger ordered scheme that is divine
reality. Some thought science was beginning to discover and real-
ize order through observation of natural phenomena, but others,
more Neoplatonically inclined, believed that nature is the product
of the ordering intelligence of "The One," the perfection which
can be perceived only through imagination or vision, religious or
artistic (or both). As they had always done, poets, painters, and
musicians, whether they were Neoplatonists or Neo-Epicurean
materialists, tried to order both nature and imagination through
artistic form; this ordering was a function of the rational faculties
of the mind, or the conscious reason. Whereas science in theory
deals directly with facts and logic, art of necessity expresses and
appeals to faculties that are both rational and irrational, although
instruction of the reasonable, or first, soul, is in the sixteenth and

seventeenth centuries, usually thought of as the most important purpose of art. Instruction, however, can take place in various ways. Some thought that even if a work of art does not instruct overtly through morals, maxims, or demonstrations of poetic justice, it should be harmoniously well proportioned, reflecting in its own order and harmony the harmony God created in the universe. In this way, a work of art, the microcosmic reflection of the macrocosm, expresses and appeals to the most rational part of the mind, as well as to the highest emotions, and in its total effect induces in the whole soul and body that balance, harmony, and proportion the soul ideally should possess in itself, should impose on and share with the body, and should take pleasure in perceiving and receiving.

The thought and feeling that either the human mind or a work of art is a microcosmic reflection of the macrocosm, God's total creation, and the belief and trust in the reasonable soul—the highest part of the soul, the part mankind shares with angels— were more widespread at the beginning of the Baroque era than at the end. The advances of the new science persuaded many to think of mankind more objectively, more in terms of man as animal, denying or at least distrusting the highest soul and denying the connection of man to angels (or even denying altogether the idea of angels). Such negativistic ideas, although terrifying to some and disturbing to others, influenced artists of all kinds. A reduction in the belief in man's potentialities is pessimistic, and the scope of mankind's artistic potentialities in general and in specific works of art contracted accordingly, both literally and theoretically. Nevertheless, the vocabulary and the general theories of knowledge remained fairly constant. Shakespeare, for example, probably could not have written *The Tempest* (1611), with its faith in the Neoplatonic theories of harmony of the soul, in the last part of the century. The play, however, was liked and understood in the English Restoration (1660), as it was at the beginning of the seventeenth century. There are differences, however: the profound morality in equating Prospero with the highest faculties, an intellectual appeal, was not so important to Restoration audiences as titillation or amusement (an appeal to the second soul). The adaptation of Shakespeare's *Tempest* by John

Dryden and Sir William Davenant (1667), as well as that by
Thomas Shadwell (1674), add scenes to Shakespeare's play that
are merely diverting to the emotions or passions.

Dryden and Davenant's addition of a man who has never
seen a woman may have something to do with the history of the
noble savage or with theories of education based on the idea of
the mind at birth as a *tabula rasa,* but it detracts from the har-
mony and dignity of Shakespeare's unity, including Shakespeare's
balanced use of the grotesque, the farcical yet terrifying aspects of
Trinculo, Stephano, and Caliban. As Willard Farnham argues,
"In the hands of Dryden and Davenant Caliban loses dignity and
gains vulgarity."[1] The dignity Caliban has emanates, in Farn-
ham's words, from "strange nobilities of spirit." Such "nobilities
of spirit" come from Caliban's implicit unity with the cosmos: the
connections of the vegetable and animal faculties with divinity.
That is, nobility of soul comes from a belief or feeling that in the
essential divinity and unity of all created things all things tend
toward a mystical oneness. In Dryden and Davenant's concep-
tion, there is less feeling for a unified cosmos, for earthly creatures
do not partake of divinity. As Farnham says, Caliban is changed
from "a monstrous underling capable of strange nobilities of spirit
into a monstrous underling pure and simple" (p. 159). In Shake-
speare's play, at the end, Caliban shows some potential for devel-
oping the highest parts of his soul. In Dryden and Davenant he
does not because of their lack of belief in the highest soul. Dryden
and Davenant's other additions to Shakespeare's *Tempest* are also
almost totally overt appeals to the lower faculties, the baser parts
of the soul. In the case of Hippolito, they amuse and titillate the
viewers, arousing in them emotions of superiority over the comi-
cally naive character on the stage. In Hippolito's case, Dryden
and Davenant also use as their model Hobbes's conception of a
natural man, someone who primarily seeks pleasure and power,
who has no higher soul to share with the angels, who cannot com-
prehend the abstraction of death when he is dying. In *The Tem-
pest,* where Restoration theories of mind and of artistic purpose
can be compared with earlier ideas, there are in Dryden and
Davenant's and Shadwell's changes ramifications of the complex
and profound mixture of ideas in the Baroque age.

The psychological terms used to describe and explain the faculties of the soul or mind were so pervasive in the Baroque era that they were a part of everyday learned conversation. They were as much a part of an accepted mythology of man and his mind as our own Freudian mythology and are sometimes equally confusing, for although the vocabulary for both psychologies is supposedly precise, it is used imprecisely in everyday speech, with changing meanings for single terms. Yet the mythology used by a seventeenth-century creator (or audience, for that matter) to explain how the mind works is effective. Its ready-made reality corresponds to psychological and physiological phenomena which we can see they observed in themselves. It therefore was and still is pragmatic, also like twentieth-century Freudian psychology. That is, it emanates from experience, from observed human behavior and feelings; it professes no knowledge of the internal mechanism of thinking and reacting. In its own sphere, the faculty psychology is practical, serviceable, and highly complex. Louis Martz, for example, voices astonishment at the penetration of the seventeenth-century masters of self-analysis.[2] One of the problems is that their terms are not that unfamiliar to us and often are used as a part of our own language, but with changed meanings. We still lose our "temper"; we are supposed to use our "imaginations" to figure things out; and either we memorize something or we learn it "by heart."

I

The mind (or soul) is usually divided into three parts (sometimes called separate souls): the reasonable (the highest), the sensible or concupiscible (the second), and the vegetable (the lowest). The various faculties (among them the understanding, the imagination, and the memory) are lodged in the three parts of the soul, and they receive, judge, and determine emotions, expression, and actions. Their location depends on their functions. The map or mythology of the soul has much to do with art because it not only explains how artists thought their own and other people's minds worked but also helps us evaluate the status of an art or a work of art: the higher the faculties art expresses and appeals to, the higher and more important is the art or the work

of art itself. The vocabulary of the faculty psychology is everywhere, and it is difficult to understand critical theory, theories of rhetoric, or even popular taste unless we know the changing emphases placed on the different parts of the soul or mind.

F. N. Coeffeteau's *Table of Humane Passions With Their Causes and Effects* (1615) is a very clear, short exposition of the faculty psychology of the soul and in general agrees with all other theories.[3] According to Coeffeteau, the lowest part of the soul, and the least applicable to art, is that called "vegetable":

> Its powers are principally those which nourish, which contribute to the growing and increase, and which serve to generation: and those have other powers for instruments to their actions, as the power to draw, the power to retaine, the power to expell the excrements, the power to digest the nourishment. . . . [Preface]

The main power of the vegetable soul is that of "the natural appetite," which "draws the nourishment" and expels that which the natural appetite abhors. This part of the soul is too low to have senses or knowledge, and mankind shares its functions with both animals and plants. The seeming knowledge of the natural appetite is innate, given by "that sovereign intelligence" which is God or nature, thus presupposing an ordering force which transcends existent nature.

The second part of the soul, the part shared with animals (but not plants) is called sensitive or concupiscible. It is higher than the vegetable part because it has more sophisticated powers: "the faculty to know, the faculty to desire, and the moving powers" (the faculty of action, controlled or directed either by desire or by knowledge). To refine further, Coeffeteau says:

> The knowing powers are of two sorts, that is to say the exterior and interior. The exterior are the five senses of nature, as seeing, hearing, smelling, tasting, and touching, the which as messengers carry to the interior powers indued with knowledge, whatsoever we can comprehend and desire. [Preface]

The senses, however, are limited by the objects each perceives. Thus, "the eyes are only employed to judge of the difference of

colours, as betwixt white and black, and never seek to meddle
with that which concerns the sound, smelling, and other qualities
which have nothing in common with colours" (Preface). The
exterior senses send their signals to be judged by the "common
sense," the first interior power, which decides what is harmful or
healthful. The common sense, then, operates judgmentally on a
very low level, more in terms of cleverness, survival, and every-
day, spur-of-the-moment decisions. Since the common sense has
no memory, and no judgment other than that of self-preservation,
it sends

> all it has gathered, compared, and distinguished, to another
> [interior] power meerely knowing, which is called the imagi-
> native [the imagination or fancy]; as that wherein are graven
> the forms of things which are offered unto it by the common
> sense, so the end of the knowledge may remain after they are
> vanished away. [Preface]

Attached to the imaginative power is a faculty that preserves ideas
and the forms of things, the memory, the storehouse out of which
the imagination may draw, when needed, the forms of things re-
membered to present to the common sense. The common sense
then compares that which immediately confronts it with what it
has confronted before; thereby it determines whether that which
has been perceived is dangerous, pleasurable, uncomfortable, and
so on.[4]

The imagination produces images or ideas or conceptions; it
brings together disparate ideas; and it is often the word-producing
faculty. The status of the imagination varies from theory to the-
ory, and definitions, discussions, and arguments about the imagi-
nation cause most of the seventeenth-century controversies con-
cerning the arts. Coeffeteau viewed its status as low, subservient
even to the common sense, and people of a rationalistic persuasion
agreed. If the imaginative power is in ascendance (if it uncon-
trollably starts envisioning horrid shapes or wonderful scenes on
its own volition), overruling the common sense, a person under
its power would be clearly mad, given to morbid fears, hallucina-
tions, and unrealizable, utopian dreams. There would be no con-
trol by the common sense for self-preservation. Therefore, as Rob-

ert Burton in *The Anatomy of Melancholy* (1621) says, lovers are mad (p. 96). Burton lists as diseases of the imagination "phrenzy," madness, melancholy, dotage, hydrophobia (rabies), lycanthropy (werewolves), and St. Vitus's dance (p. 120); he thought these maladies were caused by "motions" of the imagination, and we know from elsewhere that motions are equated with emotions and passions. Envy, for example, is a "motion." Burton says, "The imagination is the common carrier of passions" (p. 221). In other theories, the imagination is sometimes located in the upper soul and is almost equal to the understanding, a variation used by the Neoplatonic thinkers, who give great importance to an artist's imaginative vision. In such Neoplatonic theories, the imagination envisions people not as they are but as they ought to be. The outcome of such differing theories is that imagination can raise human beings to glorious heights or can degrade them utterly. In the seventeenth and eighteenth centuries, disagreement over the status of imagination caused disputes over the relative excellence of Raphael or Michelangelo, the excellence of Shakespeare, the relative greatness of Homer or Virgil, and the struggle between French and English views of art.

Besides the eight knowing faculties (the five exterior senses plus the common sense, imagination, and memory) there are in the second soul two "appetitive," or desiring, powers wherein "the desires are formed": "The concupiscible or desiring power, and the irascible or angry powers" (Preface). Both are necessary for survival. For example, a lion (appropriately, an animal) that desires to eat another animal will starve if it lacks the irascible power to overcome obstacles in the way of fulfilling its desire for food (Preface). In a more abstract description, someone who wants to pursue an apparent good or avoid an apparent evil reacts this way (the good or evil is only apparent because the second soul cannot distinguish abstractions, only concrete, immediate desires):

> Whenas any difficulty ariseth and opposeth itself to the desire of the concupiscible, [the irascible] comes presently to succour it; and enflaming the blood, excites choler, hope, courage, or some other like passion . . . to make him surmount the difficulties which cross the contentment of the soul. [Preface]

Alone, such motions can lead to theft, murder, or rape, or by chance to heroic actions of one kind or another, because there is no rational force to guide them. A person ruled by this part of the soul is bestial at best, criminal at worst.

The second part of the soul houses all the passions or emotions (fear, admiration, anger, pity, terror, love, horror, lust, and astonishment), that is, the motions or passions that artistic devices try to express and move. When we are emotionally moved, we feel motions inside us, in this part of the second soul. A work of art that appeals to the second soul, therefore, addresses itself to the baser appetites, emotions, or feelings, as they can be conjured up by the imagination. In our terms, pornography does this (as it appeals completely to unintellectual appetites), and so do more respectable art forms that appeal primarily to more acceptable emotions (such as the sentimental paintings of Norman Rockwell). Those who are not relativists still consider art of this kind lower than other kinds because they believe mankind superior to animals absolutely, not merely different from them. It was as true in the seventeenth century as it is today that materialists who deny any soul higher than the sensitive assign little importance to the value of a single human being or to a single work of art as a supe rior intellectual and imaginative effort of a single human being (although they often profess a great concern for mankind as a whole). Those who think man capable of at least visualizing beauty of a higher kind think otherwise and are more concerned with the abilities and worth of individual artists (or human beings, in general) in terms of innate qualities of spirit, not merely in terms of acquired wealth or power, physical prowess, or ideological position.

The last part of the sensitive soul is "the faculty [of] moving from one place to another." This faculty is not centrally located but "is dispersed and resides in the sinnewes, muscles and ligaments, and . . . is dispensed over all the members of the creature" (Preface). The power of physical movement may be controlled by the appetite for its purposes, and the irascible and moving powers are linked in their functions. They do not usually come into play when we experience works of art, unless we are moved by that art to slash pictures, to assault actors, or to perform some other

kind of irrational action (which we may designate after the fact as good or bad), the kind often stimulated by propagandistic devices, unintellectual devices used in a work of art to incite people to action. Dryden's play *Amboyna or the Cruelties of the Dutch to the English* (1673) has such a purpose; it was intended to raise English nationalistic emotions and to incite the English to seek revenge against the Dutch.

The highest soul, the most noble, is the part known as the reasonable soul, that part which is peculiar to mankind (of all creatures on earth). It has two "principall powers": the understanding and the will. The understanding is that power which receives the forms sent to it by the imagination, universalizing them according to abstract principles. Coeffeteau says,

> The office of our understanding, particularly of that which we call possible, is to receive, and in receiving to know, and in knowing to offer unto the will those kinds of formes, which are sent unto it from the imagination. It is true, that being a more noble power than the sensitive, it cannot receive those images and formes, so material, gross, and sensible, as they are of themselves in their particular being, for that they are not proportionable to the purity and excellence of her condition. By reason whereof the philosophers have placed in our soules another power wonderfully noble, whose office it is to purge and to clothe as it were [in] a new lustre, all the images or formes which are found in the imagination or fantasie [fancy]; and by the meanes of this light, to cause those formes which were materiall, sensible, and singular, to become so purified from these earthly conditions as they seem universal. [Preface]

The understanding generalizes and abstracts a specific action or happenstance, comparing it to abstract truth or analyzing it in itself. Some of its functions, therefore, are distinguishing good from evil, right from wrong. For example, the second soul may passionately desire someone else's property, but the understanding will indicate that it is both wrong to desire that property and wrong to take it because on principle (an abstraction) the property belongs to someone else. Louis Martz in *The Poetry of Meditation* (1954) expresses the idea clearly: "As long as the understanding remains unbiassed by the passions, it will easily

distinguish between truth and falsehood, between real evil masquerading as good, and real good under the false appearance of evil" (p. 120). Antoine Arnauld says the same thing in *L'Art de pensée* (1662). But there is disagreement in the Baroque era on even the existence of such a part of the soul. Thomas Hobbes in *Leviathan* (1651) denies not only the existence of innate qualities of the highest part of the soul but also the existence of the part itself, arguing that people act only for their own interests (appetites and pleasures). He thinks that man is an animal, superior to other animals only in that he can improve the faculties he shares with them. Hobbes says,

> For besides sense and thoughts and the train of thought, the mind of man has no other motion: though by the help of speech and method the same faculties may be improved to such a height as to distinguish men from all other living creatures.[5]

Hobbes's ideas are always in the minority in the seventeenth century, yet the materialistic views he represents gained respect toward the end of the century and always lurk somewhere in the background of any metaphysical statement in the period, whether in art or in philosophy. Hobbes sees man as an object, as a machine to be observed or manipulated. This view fits in generally with the development of science. Obviously, this attitude is a commonplace in the twentieth century, for example in the assumptions of behavioristic psychology. Hobbes, in denying the association of the human mind or soul with divine beings or qualities, and in equating human beings with animals, expresses one of the most important ideas developed in and following the period, one which has much to do historically with the status and function of art.

The last faculty of the soul is the will. When it is controlled by the understanding, will is called the intellectual appetite. However, if the understanding is bypassed, that is, if the passions prove too strong for the understanding, the will causes the body to act according to the desires of the appetite. As long as the reasonable soul commands the appetite (or passions), all is well, but if for some reason,

by bad education, or by customes, or by the organs being un-
sound, or for that his will has bad inclinations; so as reason
cannot enjoy her power, and subject the sensual appetite unto
her; but contrariwise he abandons himself in prey unto this
disordered appetite, and suffers himself to be transported by
his furious motions [passions]. So as suddenly when as fan-
tasie [fancy or imagination] offers to the appetite, the formes
which she receives from the senses, under the show of good or
evil; he without stay to have them judged by the discourse of
understanding, and chosen by the will, commands of himself
the moving power, and makes it act according to his pleasure.
And herein consists the disorder which the passions cause in
the life of man, which divert him many times from the laws
of reason. [Preface]

The passions, when aroused, distemper the body, causing it to
lose its harmony or temper—hence our phrase "losing one's tem-
per." Whenever the understanding is deficient in any area of a
person's mind (or in his whole being) and passion grows at that
weak point, that person's behavior is controlled by emotions, pas-
sions, or humours. Passions and humours are therefore dishar-
monious aberrations which have eluded the control of the un-
derstanding or reasonable soul, causing a lack of harmony and
enforcing irrational behavior. In the seventeenth century, hu-
mours and passions were regarded as physical deformities. When
a passion was raised, it was believed to alter a person physiologi-
cally (an idea we are now rather redundantly proving true).[6]
Coeffeteau says, "That which is called passion, say they, is no
other thing, but a motion of the sensitive appetite, caused by the
apprehension or imagination of good or evill, the which is fol-
lowed with a change or alteration in the body, contrary to the laws
of Nature" (p. 2). Lomazzo (1584) discourses on the same idea
in Book II of his *Tracte Containing the Artes of Curious Paint-
inge, Carvinge, and Building*, in a chapter entitled "How the
bodie is altered by imitation." To Lomazzo, imitation (art) raised
passions which in turn alter the body.[7]

 Historically, people thought those who were subject to pas-
sions degraded or mad. They thought man naturally wants to be
closer to God and the angels, and the more reasonable he is, the

closer he is to that higher state of existence. Man's natural soul or disposition is in balance or temper, and passion upsets that balance (Coeffeteau, pp. 12–26). If a humour or passion takes over a person or character completely, he becomes completely distracted, or mad. The madness (which can vary in degreee, the less serious being merely irrationality) may be temporary, depending on whether the reasonable soul can or cannot reassert its primacy after it has once succumbed to a passion or humour. To Robert Burton, passions are the cause for all the bad things in the world that are ascribable to mankind. To him, even original sin emanates from the passions. Shakespeare's character Macbeth (1605) is a case in point. As he succumbs to his passions, he becomes more and more bestial and more and more unbalanced, or mad. Passions also cause imbalance and disaster in Milton's Satan and Samson, Dryden's Maximin, Racine's Phèdre, and others. The same kind of passions are illustrated in paintings and expressed by music. The humours and passions induce disharmony, and the musical analogy is important. In Shakespeare's *King Lear* (1605), Cordelia tries to cure King Lear, to bring his soul back into harmony, by playing music (IV, vii), since the right kind of music was thought capable of bringing the passions back into harmony through its own harmony (Burton, pp. 478–79). The power of music to cure the passions is expressed frequently throughout the whole century.[8]

Because of their discordancy the humours became the basis for comedy. The discord within the play is resolved into harmony, or a seeming harmony, at the end. Ben Jonson's comedies of humour display characters moved by aberrant humours, as do those of his Restoration disciple Thomas Shadwell. In the English Restoration, however, the word *humour* becomes diluted, less precise, at times analogous to a quirk or amusing habit or trait. But the same general idea about its being an aberration or deformity holds true, except that the emphasis is often more external than internal; less importance is placed on the substantive inner physical deformity as it becomes more acceptable to view mankind as more animal than angel. Melantha's humour or aberration for French fashions and language in John Dryden's *Marriage à la Mode* (1673), for example, is superficial and foolish, not so all-permeat-

ing and destructive as Sir Epicure Mammon's lust for gold in
Jonson's *The Alchemist* (1610) or even the assorted humours
displayed by the characters in his *Silent Woman* (1609). How-
ever, it still shows her lack of judgment. The same kind of com-
parison holds true for Jonson and Shadwell. As affective theories
of art, in which the importance of art lay in the way it appealed
to the affections or passions, gained headway, the importance of
humours as serious deformities lessened. Comedy became more
of an amusement and less instructive.

The idea that the understanding, or reason, should control the
passions of the second soul was universally accepted. Coeffeteau's
reference to distemperate passions and his earlier reference to
blood both concern the humours or fluids. A humour (connected
with the second soul) may become uncontrollable when the high-
est soul has a weakness. One humour, or alteration in the soul,
might become dominant, and a person would be out of temper.
The highest soul keeps a person in temper, in an harmonious
condition and therefore content, by intellectually controlling the
humours and passions. Art, which appeals to the passions and
desires, arouses them, "enflaming the blood" and so forth, through
artistic imitation or artifice. Such exercise of the passions is felt
by Plato to strengthen them and is thus bad. This idea is still
strong in the seventeenth century. Control of the passions, accord-
ing to Plato and Galen, comes through exercise of control.[9] To
Burton, reason can make us living saints; whereas "lust, anger,
ambition, pride" make us into beasts (p. 119). Like Galen, he
believes that imagination can be strengthened by exercise (p.
469). A superior person, for example, Shakespeare's Prospero, in
exercising control over his passions is balanced; an inferior person
such as John Ford's Giovanni in *'Tis Pity She's a Whore* (1633)
is more subject to the whims and storms of his baser emotions and
passions. If control by the reasonable soul separates mankind from
lower forms of life, a work of art that powerfully raises passions
or emotions alters its audience or spectators physically, changing
them perhaps for the worse.[10]

Art that was thought to appeal primarily to the emotions, up-
setting the soul's harmony, was usually not considered art of the

highest kind. An epic such as Virgil's *Aeneid*, as it portrays the manners of the rather stoical Aeneas, was therefore thought to be a higher art form than a tragedy such as Sophocles' *Oedipus Rex*, which deals primarily with the passions. A rationally harmonious painting such as Raphael's *School of Athens* was thought of as more admirable than Titian's passionate *Bacchus and Ariadne*.[11] Such a concept not only influences the audience but also the creator. Certain kinds of art became more noble: if an artist in any medium wanted to show off his excellence in the best way, he would appeal to the highest part of the soul. Thus, Jonson wrote *Sejanus* (1603); Dryden always dreamed of writing an epic; and Milton as the culminating work of his career as a poet wrote *Paradise Lost* (1667), *Paradise Regained* (1671), and *Samson Agonistes* (1671). All these works appeal primarily to the understanding and are only reinforced by appeals to the imagination and passions. In *Paradise Lost*, Satan, for example, depends on appeals to the second soul; God and his angels appeal to the reason.

II

The idea of the soul as tripartite is at least as old as the writings of Pythagoras, Plato, and Aristotle and is certainly pervasive in Western Europe from the Renaissance through the eighteenth century.[12] Although Coeffeteau's theory of the soul is not expressed in exactly the same way by all writers, the general outline is much the same. Plato's image in *The Phaedrus* of the soul as a charioteer and his horses and his analysis of the three parts of the soul in *The Republic*, Book IV, are very much in accordance with Coeffeteau's view and with what was generally believed by thinkers in the Baroque period. All the following writers were familiar to the seventeenth century: Galen postulates three kinds of souls, saying that he agrees with Plato. He points out that wine excites the irascible soul, causing it to overcome the rational,[13] a commonplace definition of drunkenness.[14] Boethius postulates the same three souls in the same way.[15] Montaigne mentions the three actions of the soul, the imaginative, the appetitive, and the consenting.[16] He says that it is the understanding (not the imagina-

other pieces [and by implication in other kinds of art as well], both judgment and fancy are required, but the fancy must be more eminent" (ibid.).

Artistic endeavors as emanations primarily from the imagination (or fancy) are to Hobbes, and others like him, products of an inferior activity. Imagination (which is linked to memory) does not deal with sensory perception or facts, and its remembrance of experience fades over time. To Hobbes, imagination, therefore, "is nothing but decaying sense" (p. 27), and works of art entertain or titillate the passions, rather than instruct or teach the highest parts of the mind. To Hobbes, a work of art's utility or function is to tease the senses or prevent boredom; art has for its great end an inferior purpose, delight. In other words, art appeals primarily to the passions or appetite and should not concern itself principally with instructing the understanding.[22] All art is therefore rated below the more useful sciences, especially music, the instructive powers of which are supposed to appeal to the innate capacities of the understanding as it perceives the absolute harmony of the universe in the harmony of music. Contrary to Hobbes, Thomas Mace, a musician representative of older Neoplatonic theories of art, says that man's true understanding is innate, that understanding of music is not attained by art or education but by an "inward ear and sense."[23] Hobbes would have laughed at such words.

Much of the significance of seventeenth-century thought lies in the changes of attitude toward the human soul that occurred during that time, changes reflected in artistic productions. There is no exact point at which ideas like Hobbes's suddenly took over, but the cultural drift was toward man as animal, away from the ascendance of the reasonable soul as a soul mankind shared with angels. The main impetus for this drift of ideas was the new science and the attendant Neo-Epicureanism, which saw man in connection with his natural environment rather than in connection with divine forces and ideas; that is, man as a complicated machine rather than an image of God. Neoplatonism opposes such views. Art constructed according to Neoplatonic proportions and balances supposedly appeals through form to the highest faculties of the reasonable soul.

Neoplatonic refers generally to the ideas expressed by Plotinus in his *Enneads* and by the writings and thoughts that emanate from them, through St. Augustine, Boethius, the Florentine Platonists, and the seventeenth-century English Neoplatonists. Briefly, the term *Neoplatonist* describes someone who believes in the oneness of the universe and all it contains; that existent things are merely poor imitations of divine or absolute realities; that divine reality consists of perfect harmony, proportion, goodness, virtue, and so forth; that divine reality can be envisioned by the artist through his imagination as a part of his highest soul; and that in art the artist as a creator attempts to communicate divine reality to the recipients of his art. Unlike Plato, who banishes most art and artists from his Republic because they exercise the passions, a Neoplatonist thinks of an artist as a creator, an analogue of God who brings peace, harmony, and understanding to the soul through elevated art. Art becomes one of the noblest of human activities. The expansiveness and transcendental heights of such a belief presuppose a partial divinity of the human soul, in direct opposition to materialistic or physically bounded views of human nature. Materialistic views are irrational, dependent on the senses as the primary sources of knowledge. A Neoplatonic view appeals to, and depends on, the understanding, in its most elevated sense.

As the century goes on, appeals to the understanding become more overt and less a function of form. If an appeal to the understanding is a function of form, it is expressed through balance and regularity, an imitation of the symmetry and beauty of the universe (which in itself is an imitation of God's harmony and infinite goodness). Such art helps by example to bring the soul into a state of harmony and goodness. If an appeal to the understanding is overt, it appears as a moral, and usually depends for its effect on manipulation of the emotions. Art of all kinds more and more was made to manipulate the passions and appetites of the second soul. The Abbé Jean-Baptiste Du Bos, in *Réflexions critiques sur la poésie et le peinture* (1719), for instance, points out that the most important function of art is to dispel *ennui*, an idea duly noted by David Hume in *Of Tragedy* (1757). Such a point of view is not found literally in the seventeenth century, although the Chevalier de Méré and Saint-Évremond (as influenced by

the Neo-Epicurean Pierre Gassendi), as well as Hobbes and others, are seventeenth-century forerunners of such a view. And works of art produced for people who regard art in such a way tend to become trivial; the *raison d'être* of art thus viewed is its entertainment value. In the seventeenth century, art lost prestige as the ever-increasing study and explanation of natural phenomena gained importance, for the human being became in itself a natural phenomenon to be studied and explained, a superior animal rather than a divine essence. The reverberations of such a profound change in thinking spread further in the eighteenth century and are still universally felt.

At the end of the seventeenth century, the writings of two well-known English philosophers, John Locke and the third earl of Shaftesbury (Anthony Ashley Cooper), shed light on ideas and attitudes current in the preceding years. John Locke, in many respects Hobbes's philosophical descendant, denies innate ideas, so judgment and wit (or imagination) come from experience; and products of wit, as in Hobbes, are inferior. He says:

> Wit lying most in the assemblage of ideas, and putting those together with quickness and variety, wherein can be found any resemblance or congruity, thereby to make up pleasant pictures and agreeable visions in the fancy; judgment, on the contrary, lies quite on the other side, in separating carefully, one from another, ideas wherein can be found the least difference, thereby to avoid being misled by similitude, and by affinity to one thing for another. This is a way of proceeding quite contrary to metaphor and allusion; wherein for the most part lies that entertainment and pleasantry of wit, which strikes so lively on the fancy, and therefore is so acceptable to all people, because its beauty appears at first sight, and there is required no labour of thought to examine what truth or reason there is in it. The mind, without looking any further, rests satisfied with the agreeableness of the picture and the gaeity of the fancy. And it is a kind of affront to go about to examine it, by the severe rules of truth and good reason; whereby it appears that it consists in something that is not perfectly conformable to them.[24]

If we see Locke and Hobbes as part of their own age, we recognize that their various analyses of knowledge and understanding

are important in that they denigrate artistic pursuits, making them less serious endeavors than other kinds of activities such as the pursuit of science (which deals with facts).

Locke's pupil Shaftesbury, in *Characteristicks* (1711), argues against Hobbes and Locke. He opposes the Hobbesian view that man is naturally passionate and self-serving and reinstates the importance of art for instruction of the highest soul, using examples from art throughout his work. Shaftesbury's aesthetic antecedents are Plato, the Cambridge Neoplatonists, and Plotinus, with whose views he tries to assimilate the ideas of seventeenth-century scientists.[25] Believing in innate ideas, and that a work of art is an image of God's creation, Shaftesbury says,

> That [the supreme power] which fashions even minds themselves, contains in itself all the beauties fashioned by those minds [human creators], and is consequently the principal source and fountain of all beauty. . . . Therefore whatever beauty appears in our second order of forms [works of art], or whatever is derived or produced from thence, all this is eminently, principally, and originally in this last [highest and absolute] order of supreme and sovereign beauty. . . . Thus architecture, music, and all which is of human invention, resolves itself into this last order.[26]

Since the mind of a human artist, to Shaftesbury, is analogous to the mind of God, or a prime mover, its highest faculties are the ordering faculties (the judgment or understanding), plus the imagination as it invents, envisions, or images what will be created. The imagination is important because only through it can we envision absolute beauty. Although absolute beauty (or the universe itself) is imagined, or conceived or perceived, through the imagination, Shaftesbury distrusts the imagination alone; he feels that both the understanding and the imagination are needed in the creation and perception of artistic works. There are hints throughout Shaftesbury, as there are in Plato, that art that is so enticing to the imagination and passions requires in its lovers a strong judgment to overcome its blandishments.[27] The same is true for the creator: his judgment has to be strong or it will be overpowered by the strength of his imaginative vision. Imagination can be an elevated faculty, but because it is also connected

to the lower emotions it must be controlled. Shaftesbury says that although the affections (or passions) are the moving forces within us, fancy and appetite have nothing to do with good sense (II, pp. 112–24). The images artists should form, although emanating from the passions to the imagination (albeit of an elevated nature), should be of a "rational kind." In great art, therefore, imagination and judgment are united on the highest plane, and art besides merely giving pleasure has a moral and social utility:

> Let poets, or the men of harmony [musicians] deny, if they can, this force of nature [the passions], or withstand this moral magic [truth of art]. They for their part, carry a double portion of this charm about them. For in the first place, the very passion which inspires them is itself the love of numbers, decency, and proportion [a passion for rules and order, a higher form of passion combined with understanding; a low passion, for example, is anger. Shaftesbury says that the lower passions are "employed another way."] and this too, not in a narrow sense, or after a selfish way (for who of them composes for himself?), but in a friendly and social view, for the pleasure and good of others, even down to posterity and future ages. [I, p. 90]

Shaftesbury imagines a soul which is in balance and harmony on a very high level of sensibility and rationality, and he sees art as appealing to the whole soul at once, rather than as a series of rhetorical devices which appeal first to the senses and then perhaps to the judgment. Generally speaking, his conception of the soul is similar to, and grows out of, notions that existed in the seventeenth century.

The seventeenth-century struggle between the view of man as a passionate, sometimes clever animal versus the view of man as a reasoning image of God produced a split between skeptical pessimism and belief in man's perfectibility. Jeremy Collier's skepticism about human reason, in his *Essays Upon Several Moral Subjects* (1697), expresses ideas that would not be generally found at the beginning of the seventeenth century. His first chapter, "Upon the Weakness of Human Reason," concludes by saying that we should believe our senses, an idea in general agreement

with Hobbes and suspect to Plato, St. Augustine, and Neoplatonists of all periods. It is ironic that Jeremy Collier, the same moralistic divine who objects so strongly to the immorality of the English Restoration stage, says that we should believe our senses. He is misled by a split view of man and the universe. Collier obviously fails to understand that his trust in the senses not only denies the purpose of his divine calling but also denies ultimately that he is justified in establishing standards of morality.[28]

The split grew larger in the eighteenth century. The more skeptical of the early eighteenth-century writers, who thought men, their minds, and their potentialities more limited, produced art that is correspondingly more limited in scope and more pessimistic, such as Pope's *Dunciad* (first published in 1728) and Swift's *Gulliver's Travels* (1726).[29] Shaftesbury's optimistic view emphasizes more the importance of goodness of the imagination and individual genius. We are still the beneficiaries and victims of both views.

Instruction and Delight in Art

The preeminence usually ascribed to the reasonable faculties of understanding and judgment indicates allegiance to conscious thought and fear of what we call the unconscious; however, a certain amount of skepticism about mankind's rational powers leads to conflicting views. The seventeenth-century controversy as to whether man should believe himself an image of God capable of approaching perfection or believe himself a limited animal leads directly to ideas about the function of art. If man were an image of God and were innately good, he still had to be instructed, taught to improve his understanding of eternal truths. Abstractions such as eternal truth are difficult to communicate through logical discourse, but the imagination as an elevated faculty envisions and communicates, for example, divine beauty through artistic forms such as ideal proportions. Art that achieves such a purpose is art of the highest kind, and it is connected to the highest parts of the soul. If man were merely a sensational animal, the purpose of art would be to gratify appetites for amusement, or to propagandize, or to propagate approved morals or virtues through conventional appeals to the passions or emotions. In art of this lower kind, the imagination is used to stimulate the lower passions, and the judgment is limited to distinguishing right and wrong in temporal terms or in terms of relativistic standards set by society.

Divergent views about judgment and imagination are behind the seventeenth-century preoccupation with "instruction" and "delight," the purposes of art. Writers mention these concepts so often that we are led to think their thoughts on the subject superficial. Sometimes they are. But there are different kinds of instruction and delight, and the debate over them helped determine Baroque taste and artistic form. The Hobbesian sensationalists or Neo-Epicureans are at one extreme; the Christian Neoplatonists, at the other. Individual choices, which usually combine the two extremes, are determined by the ways each artist or theorist saw the human condition in terms of the mind or soul and can vary considerably. A single person could be drawn first to instruction and then to delight, with his views changing throughout his life.

Rubens's painting *Hercules between Vice and Virtue*—representing one of the most popular and important motifs of the period, the motif of Hercules' choice—helps define more clearly the dilemma of instruction versus delight. Which part of Hercules' soul will rule, his appetites or his reason? Will he prefer the immediate, sensual pleasures of vice to the more arduously achieved, long-run, intellectual pleasures of virtue? The decision is ordinarily understood to be virtue over vice, but different painters present the subject in different ways. As Jean Hagstrum says in *The Sister Arts* (1958), Annibale Carracci makes Hercules incline toward virtue, while Rubens makes him incline toward vice.[1] If, like Hobbes, you believe only in the senses, that there is no higher soul, no abstract good or bad, only immediate pleasures, then the choice of vice becomes a choice for pleasure or sensation; thus this choice becomes the rational option. Since the high pleasures of virtue are illusory, immediate pleasure becomes the end of art.

Because of the increasing reliance on the senses to perceive truth, the increasing distrust of the imagination and of individual human endeavor, the boundaries of human perception shrank. The limits of belief moved toward a reality defined by facts and things, toward materialism, and away from belief in transcendent verities, away from the Neoplatonic ideas of vision, truth, and beauty. Instruction became more practical; delight became more sensual.

I

Although the fancy or imagination conceived great visions of goodness, great art, and great plans, it is always distrusted because it stimulates the basest appetites and passions and creates wild fantasies. Without judgment, the chaotic, imaginative powers are undirected. Over and over we learn that uncontrolled fancy is madness, that great powers of mind are close to insanity. Dryden, in well-known lines, says:

> Great wits are sure to madness near ally'd,
> And thin partitions do their bounds divide.[2]

There are many horrible examples of characters whose irrational faculties gain ascendance over their reason, and the idea is not confined to the last part of the seventeenth century. The jealous Othello has an overactive imagination (1604). So have the pride-struck Satan in Paradise Lost (1667); the roistering Israelites in Poussin's Adoration of the Golden Calf (ca. 1633); the drunken Alexander the Great in Dryden's "Alexander's Feast" (1697); the ranting Emperor Maximin in Dryden's Tyrannic Love (1669); the lust-torn Phèdre in Racine's play of the same name (1677). And so have the unstable Duke of Buckingham, Charles II's favorite, and the seventeenth-century religious fanatics whose brains were thought to be cracked by the heat of their overly exercised fancies.[3] The degree to which an artist fears, uses, or trusts the irrational faculties (the imagination or fancy) determines the extent to which he emphasizes the role of judgment or understanding (rationality), the parts of the mind that impose form on art. Although a great wit has to have a powerful imagination (and Milton compliments Shakespeare by calling him "fancy's child"), a person whose imagination or passions are stronger than his judgment is mad, or a madman, and the length of ascendancy of the imagination or passions determines whether a person has a temporary aberration or is permanently insane. Both artists and audiences were thought of in this way. The ideas of furor poeticus, or the poetic afflatus, of Plato's view of the poet as madman (and subsequent variations thereof) were regarded with mixed emotions.[4]

Shakespeare's Caliban and Ariel are instructive personifica-

tions of higher and lower parts of the second, the sensible soul. Caliban, with his libidinal urges, is the embodiment of the lower appetites.[5] Ariel is the personification of "airy" fancy. Marsilio Ficino, the Florentine Neoplatonist, says (in translation) that sound and song "strike the aerial part of the hearer," that delicate part of the imagination that receives music. Thomas Lodge makes the connection among Ariel, aerial music, and the higher parts of the soul even clearer:

> Musicall concent (by reason of the aeriall nature thereof) being put in motion, moveth the body, and by purified aire, inciteth the aeriall part of the soule, and the motion of the body. . . . By the very motion of the subtill aire, it pierceth vehemently, and by contemplation sucketh sweetly.[6]

Shakespeare's Ariel, the dispenser of music, is of the nature of air, a spirit of the middle air. His song, "Where the bee sucks, there suck I" (V, i) is of the nature of music in the sense that Lodge expresses: music "pierceth vehemently" and "sucketh sweetly." The image of music is imaginative and Neoplatonic in its origins. The Renaissance parallel between music and lyric poetry, both of which were often thought by believers to be conducted through air by the spirits of the middle air, is total; recall not only that lyric poetry was sung but also that Renaissance poetry was largely oral.[7] The ideas carry through the seventeenth century, at least as a convenient mythology. Henry Purcell has a charming song that gives the proper conception of the spirits of the middle air, "Ye gentle spirits of the air."[8] Purcell connects the spirits of the air to the imagination, but they are higher than the lower passions. As Purcell's song progresses, the spirits are asked to sing, to lull love (passion) to sleep. The keys, which to Purcell have appropriate meanings, change according to the progress of the song, as passion is overcome. The song starts out in the passionate key of d with love present, modulates to a, to C, and finally to F at the end, when the music indicates that harmony of the soul, or hope of freedom from passion, has been achieved.

The arousal of the passions always has been thought to be fraught with danger, for even a true kind of enthusiasm is not totally controllable, and if the judgment is quiescent, it is difficult

to distinguish between true and false enthusiasms. Ariel, for example, is an amoral spirit who does good things when controlled by Prospero's judgment. The danger even in Ariel's music in *The Tempest* is embodied in the strange shapes that appear in Act III, scene iii, which have to do with the potential, uncontrolled dangers of the imagination and passions when they are excited by music. John Marston, the Elizabethan playwright and satirist, takes a different but not opposing tack, associating music more with lust than with any other passion.[9] Writers of the later seventeenth century usually talk about music and the passions together. René Descartes, in his *Compendium musicae* (Utrecht, 1650), says that each tone in the scale expresses and elicits a different emotion. Jeremy Collier (1697) goes further:

> [Music] raises, and falls, and counterchanges the passions at an unaccountable rate. It charms and transports, ruffles and becalms, and governs with an almost arbitrary authority. [He goes on to say that no reason is absolute proof against it, witness Odysseus and the sirens.][10]

Henry Purcell calls music "nature's voice" and says that the passions (nature in this case), such as love, bind the fancy (Ariel-like fancy) and captivate the whole soul: "Love charms the sense and captivates the mind." When we hear, we grieve or hate or rejoice (*Orpheus Britannicus*, I, p. 158).

The belief in the superiority of judgment or understanding affected the status of different kinds of art. The distrust of the passions goes along with a general distrust of music unless it is somehow subservient to words, which are supposedly more rational. Music overstimulates the passions; words supposedly are more intellectual and easier to control with judgment. This distrust is particularly true for practical, affective music. The Neoplatonic idea is that music (*musica speculativa*) instructs through its form, its mathematical proportions. And music has traditionally been associated with mathematics; both were included in the quadrivium, which consisted of arithmetic, astronomy, geometry, and music. Abstract, ideal mathematical proportions became embodied in sound by means of musical proportions. Such music by definition would be beautiful. But the older, Neoplatonic view

of music, which carries through much of the seventeenth century, holds music less trustworthy than words. Marsilio Ficino, for example, thinks the word (or poetry) superior to music because it is an imitation of the mind of God (or what God thought); whereas music is an imitation of the harmony of the universe, which comes from God's mind at one remove. Poetry is thus prior and superior because it is closer to absolute reality, the mind of God. In its highest manifestations, poetry comes from, and appeals to, the human analogue of God's mind, the understanding, the reasonable part of the soul. Gretchen Finney elaborates on these ideas, which explain why in operas such as Monteverdi's *Orfeo* (1607) the music sets off the text (pp. 131, 133) and why Lully is so respectful of his librettos. The currency of such ideas in the seventeenth century is reinforced by their presence in the eighteenth. The practicing musicians and composers Thomas Clayton, Nicolino Haym, and Charles Dieupart, in a letter to *The Spectator* (No. 258, 26 December 1711), say that music is valuable only as it heightens the purpose of poetry, that music without words or a message of some kind is like nonsense verse:

> It must always have some sentiment or passion to express, or else violins, voices, or any of the other organs of sound, afford an entertainment very little above the rattles of children.

Joseph Addison himself says that words make music reasonable and instructive.[11] The idea that words are superior to sound shows how an idea hangs on after its time. By Addison's era, musical theory is largely affective in nature, that is, music instructs through appeals to the emotions, not so much through mathematically conceived form. The idea that music instructs through mathematical proportions while it delights through harmony had for some time been dying out, but conventions connected with it were through association themselves influencing the passions.[12]

Music is not the only art that raised suspicious passions. Robert Burton in *The Anatomy of Melancholy* (1621) points out that although fancy or imagination helps poets and painters envision transcendent ideas, their work must be governed also by reason.[13] To Burton, human beings who lack reason are merely animals ruled by concupiscence (pp. 140–41). Imagination, the common

cause of passions (p. 224), causes madness (p. 847) and is unfortunately strengthened by the continued exercise of the emotions (p. 469). Art that appeals to, or raises, the imagination is therefore dangerous, for whoever wants to cure madness "must first rectify [the] passions and perturbations of the mind" (p. 467). He describes love, for example, as "a lesion of the fancy" (p. 659). Burton says repression of the emotions is temperance, the "bridle of gold, and he that can use it aright is liker a God than a man: for as it will transform a beast to a man again, so it will make a man a God" (p. 401). In normal or superior people, the imagination, therefore, has to be inferior to the more rational powers in both quality and strength. In *The Tempest*, both the high and the low kinds of passion and imagination are controlled by Prospero, whose power signifies the judgment or understanding of the whole, reasonable soul. The psychological allegory is clear: if Prospero loses his control (his judgment), he literally will lose his power over the ethereal Ariel and be overcome by the sensual Caliban (his baser passions). In the seventeenth century, some theorists and artists may have believed that the rational and irrational faculties should be in balance; but the rational ones always have to be firm to counteract the potentially formless vacuities of the irrational.

The recognition of imagination as a powerful force or faculty caused it to play an important role in all theories of artistic creation, purpose, and reception. Imagination is important to instructive Neoplatonic visions of divine beauty, as well as to art that merely stimulates passions. When Thomas Hobbes says art is the product of a "decaying sense" (imagination), he is not saying that imagination is unimportant to art but that art is less important than either science or history because the imagination is less instructive and less important than the judgment. To Hobbes, the imagination creates, communicates, and receives delight. Dryden, in his Preface to *The Rival Ladies*, says this about fancy:

> This worthless present was designed you long before it was a play; when it was only a confused mass of thoughts, tumbling over one another in the dark; when the fancy was yet in its first work, moving the sleeping images of things toward the light, there to be distinguished, and then either chosen or rejected by the judgment.[14]

The fancy, here, is roughly equivalent to our conception of the unconscious. Dryden's version of fancy is like Hobbes's version because it is not a creating faculty: fancy relies wholly on the memory. The vagaries of the imagination also are thought to work sometimes in terms of chance, and they also produce divine inspiration, which carries a creator to his greatest, unexplainable heights, to the sublime—to Bouhours's *je ne sais quoi*, to Horace's *curiosa felicitas*, to Tasso's *non so che*, or to Pope's "grace beyond the reach of art." This sublime creativity achieves effects far beyond mere beauty, a quality usually reached by a great, sober talent possessing much judgment.[15] Although there were Neoplatonists who thought imagination at least as important as judgment in envisioning beauty, the seventeenth century tended to elevate reason over the imagination. Given the structure of the soul, with the reasonable soul in the highest place, the kind of art that pleased the reason most was thought to be the best art. As John Davies says, "Poetry . . . [requires] not only great happiness of thought, but also a noble restraint of the judgment, over and above some fury or enthusiasm, which may strike life into all the rest."[16]

II

Despite the general distrust of the imagination and the passions, and the kind of art that appealed to them, all Baroque artists and theorists include delight (and persuasion) as an important function of art. The range of opinions about instruction and delight runs from Thomas Hobbes's extreme view of delight as the only end to various kinds and extremes of the opposite view. John Dryden, by far the most influential seventeenth-century English critic, vacillates in his opinion about the relationship of instruction to delight, and his reasoning and debate about these two ends of art are indicative of variable attitudes toward art's moral utility. He first says (possibly under the influence of Hobbes) that delight is primary but later, toward the end of his career, he comes finally to the conclusion that though delight comes first, instruction is the great end, thus affirming the primary role of the reasonable soul in the production and appreciation of art.[17] Dryden's final view of delight as the first but subsidiary end of art is the normally accepted view throughout the seventeenth century.

Thomas Hobbes thinks that delight is the main end of art (see *Critical Essays of the Seventeenth Century*, ed. Joel Spingarn [Bloomington: 1963]):

> For all men love to behold, though not to practise Vertue. So that at last the work of an Heroique Poet [the highest kind of poet] is no more but to furnish an ingenuous Reader (when his leisure abounds) with the diversion of an honest and delightful Story, whether true or feigned. [In Spingarn, II, p. 68]

Hobbes, of course, does not believe in a rational or reasonable soul, and if his views are to be accepted, God and man's elevation toward God are a snare and a delusion. Art cannot instruct in the sense that speculative music is instructive (that it is an imitation of God's order in the universe). Hobbes believes wholly in local stimuli, that external motions touch the senses, stimulating motions within the recipient. Stimuli are also induced locally by art, and thus art to him is totally the product of rhetorical, artistic devices (figures, tropes, colors, sounds) used to arouse specific pleasures and motions in us. Art need have no social utility whatsoever; its *raison d'être* is delight. If people are controlled by local stimuli, they enjoy art only when it pleasurably arouses their appetites or appeals to their tastes, and judgments about art become relativistic, a reflection of individual taste rather than absolute verities or standards. There is no good or bad art in the abstract, there is only art that we either like or dislike. To Hobbes, history or science deals directly with truth or facts. Art does not; it deals with remembered facts dressed up by the fancy. Since a work of art can instruct us only inaccurately about truth (which to Hobbes is phenomenological fact), all higher literary themes are illusory. There is a paradox, however. Hobbes thinks imagination an inferior faculty; yet his belief that man acts only for pleasure and from appetite testifies in itself to the power of the imagination. For it is imagination which enflames the passions. Art is thus an important tool in shaping behavior and belief.

We can see a Hobbesian influence in many Restoration comedies in which the characters act solely according to their appetites. The various villains and heroes—Horner in William Wych-

erley's *Country Wife* (1675), Vernish in Wycherley's *Plain Dealer* (1676), and Dorimant in Sir George Etherege's *Sir Fopling Flutter* (1676)—are not particularly distinguishable from one another in terms of morality or elevation of character, although they are distinguishable in ability and success associated with materially realized cleverness and power. There is little or no regard for abstract moral virtue or for the moral improvement of the audience because there is no such thing as innate virtue (or very little of it). The boundaries of reality are the exigencies and desires of the passions and appetites.

Restoration comedy, as it presents supposed facts about the world, is what we would call realistic entertainment. It fits into a Hobbesian scheme of art by presenting amusing facts and situations as remembered, distorted and exaggerated, so that the imagination that envisaged the situation and that gave impetus to the writing and production of the play is at one remove from the society it mirrors, fitting Hobbes's definition of imagination (since it is derived from memory) as "decaying sense" and reinforcing his view that art exists primarily to give pleasure. But Restoration comedy also instructs. With little emphasis on plot, it teaches its audiences the ways and manners of an elegantly savage world. It tries to show that people act only in their own interests for power, appetite, and pleasure. It represents a world without transcendent values, a world so lacking in idealism that it could not be acceptable for long to any but a small proportion of the population. Restoration audiences in general tended to prefer art that is morally instructive and improving. We would expect, therefore, a reaction to characters and beliefs of such an unsentimental nature, and this is what happened. Shadwell's popular play *Don John, or The Libertine* (1676) forcefully shows the punishment merited and received by a wicked person who does not recognize the reasonable soul, whose every action is to satisfy his carnal appetites, and whose rational faculties are used to figure out the means of satisfying those appetites. The heroes and heroines of sentimental comedy in the early eighteenth century are much more moral (although less entertaining) than those of Restoration comedy.[18] Restoration comedy, for all its licentiousness, was not a widely popular entertainment. London in the Restoration most of the

time barely supported two playhouses in which such plays were performed; much of the time, only one. Although it was important and influential, Hobbes's view of the purpose of art as entertainment is not ordinary.

Although Hobbes's views toward art and life are extreme for his time, all the arts at all levels of morality at least partially aim at delighting the senses, from Milton's *Paradise Lost* (1672) to Rochester's *Valentinian* (1685), and interest in the ways in which the passions could be raised grew as the affections were regarded with more respect. The evidence for this changing interest is everywhere, in all Baroque art, both in England and on the Continent. There is a great deal of difference between Michelangelo's grand perceptions of the human body as a manifestation of God's beauty and Bronzino's sensual *Allegory of Passion* or Bernini's fanciful *Apollo and Daphne*, between the largely speculative music of Josquin Des Prez and the emotionally charged works of Monteverdi. It is this change, the increasing emphasis on human passions, that commentators often note as one of the differences between Renaissance and Baroque art.

Changes in attitude toward the passions over a shorter period of time are more difficult to pin down because of the mixture of beliefs artists—sometimes even the same artist—held. Bernini is an example. Robert Petersson calls the Cornaro chapel "one of Bernini's most theatrical works; and one of his most elaborately illusionistic."[19] He also points out that in Baroque art all the arts are fused to achieve "a single dramatic impact" (p. 47) and that Bernini is a literary artist (p. 50). What he says is true, and the effects he talks about are achieved by rational, artistic techniques that without distortion we call rhetorical. Bernini also has a Neoplatonic side to his art. Petersson says that Bernini's "realism" is "the Christian cosmos of all that can be known, sensed, and intuited" (p. 48), that he imitated the idea in the mind, that models only got in the way (p. 48),[20] and that he thought he breathed life into a statue the way God breathed life into substance (p. 50) —the Neoplatonic belief that the artist is an analogue of God the creator. Petersson ends by saying that Baroque art (Bernini's statue of St. Teresa he calls "perhaps" the "supreme example" of all Baroque sculpture [p. 51]) has "planned spontaneity" (p. 120).

The mixture of Platonic and rationally rhetorical strains of thought that Petersson indicates are in Bernini is also evident in meditative poetry and painting. Anthony Blunt points out the connection of meditative exercises to painting,[21] and as pointed out in Chapter III meditative poetry is rhetorical. Yet Louis Martz correctly says that in meditative poetry the Neoplatonic fusion of beauty and intellect from God is inspiration.[22] There is a mixture of views, but in its increasing emphasis on the passions and the rhetorical devices that present or direct the passions seventeenth-century art became more affective and less Neoplatonically oriented in both conception and effect. It tried increasingly to arouse emotion and passion in its recipients rather than to induce harmony in their bodies and souls. Interest in the passions gradually superseded the transcendent idea that harmonious grace, beauty, and virtue comprise an ideal state of the human soul. Instruction became an overt product of affective devices rather than an elevating effect of artistic form. Delight became more sensual, linked to passion rather than to divine truth. The different meanings attached either to instruction or to delight can cause difficulty for us in understanding what a seventeenth-century writer means.

III

The disapproval of art as entertainment as expressed by Plato in *The Republic*, Book X, was known to every educated person and was extremely influential in the Baroque era. To Plato, if an art does not have a moral purpose and benefit, it should be cast out of the Commonwealth, and he criticizes most severely literary works of art. Much was written to justify the arts in the light of Plato's indictment. Art created for diversion is, therefore, the least defensible kind of art since it concerns the passions rather than the understanding. Art should have a serious purpose. It should be useful if it is to be regarded as respectable. Anthony Blunt recounts the evolution of painting into an honored occupation:[23] an artist had to become an educated person, associating his painting with rhetoric, mathematics, and moral instruction. Paintings could then be conceived and received by the highest part of the reasonable soul, the understanding. The Plotinian or Neoplatonic idea that absolute beauty could be envisioned only by the imagi-

nation and induced into the soul by artistic form gave way to prag-
matic or moral usefulness as the important function of art. In
Shakespeare, for example, there often is no poetic justice because
his vision goes beyond the bounds of mere existence. Justice need
not occur on earth. In the French code of dramatic rules, which
so strongly influenced the Baroque era, poetic justice is important.
It presupposes a moral order on earth, a rational order that can be
anticipated in nature. The movement toward emphasis on poetic
justice confines the moral imagination and bases art on a rational
judgment that is more limited than a Neoplatonic fusion of judg-
ment and imagination. According to French rules criticism, a
transgression or an admirable action has to be duly weighed, then
punished or rewarded in worldly terms. Art that follows such a
rule is not as profoundly real as the excessive suffering of a King
Lear. Rational instruction is clearly the product of the judgment,
and an overactive imagination detracts from overt utility, break-
ing down the controlled perception and understanding of a de-
fined, limited order. There is much difference between a tran-
scendent vision of reality conceived in the soul by means of a
single powerful human imagination and the externally imposed
dogma of critical rules within which the artist must confine him-
self. The primary difference between the two views is evident in
the imaginative scope of the works made.

In the seventeenth century, satirical painting and literary sat-
ire, pastoral music, painting, and poetry express moral purposes
and are justified by the instruction they give. This didactic func-
tion is even more true of the higher genres, history painting, epic,
and tragedy.[24] Le Bossu, for example, says that the first step in
writing an epic is to formulate a moral: "La première chose part
ou l'on dois commencer pour faire une Fable, est de choisir l'in-
struction et le point de morale qui lui doit servir de fond, selon
que le dessein et la fin qui l'on se propose."[25] Dryden records Le
Bossu's influence, saying that Homer's moral in *The Iliad* is "of
preventing discord amongst confederate princes, which was his
principal intention. For the moral (as Bossu observes) is the first
business of the poet, as being the groundwork of his instruc-
tion."[26] Evelyn's translation of Fréart de Chambray (1665) states,
"Paynting, founded upon the real principles of geometrie, makes

at once a double demonstration of what she represents [truth of harmony and proportion, and the moral also]; but it will indeed require different eyes to contemplate and enjoy her beauty entirely: For the eye of the understanding, is the first and principal judge of what she undertakes."[27] Rubens says his figures are allegorical, that he paints to express intellectual meaning (letter no. 93), and (in letter no. 242) describes the allegory in his painting *The Horrors of War*.[28] Thomas Mace, in the old style, says that music "powerfully" captivates all our "unruly faculties and affections (for the time), and disposing us to solidity, gravity, and a good temper; making us capable [to receive and understand] of heavenly and divine influences."[29] Marin Mersenne, whose thought is more modern, devotes all of the First General Preface to the Reader in his monumental *L'Harmonie universelle* (1636) to justifying music's utility.[30]

Since it was thought that art that appeals to baser parts of the human soul (the appetite, the lower passions, and the imagination, which stimulates them) is not instructive and therefore indefensible, throughout the seventeenth century there is allegory in painting (and paintings of noble heroes); Platonic, mystical explanations of music; and moral themes and poetic justice in poetry of every kind. If one art, say, music, were thought to be more morally elevated than another, theorists of other arts, such as of poetry and painting, borrowed conceptions about that art to explain and elevate their own. The harmony of music is therefore identified with the harmony of poetic metrics. Mersenne, for example, in Part II of *L'Harmonie universelle*, tries to work out an explanation of the musical modes in terms of meter, and he discusses rhythms of verse in Pindar, Horace, and Anacreon.[31] George Puttenham devotes Book II of his *Arte of English Poesie* (1589) to harmonic proportion in rhyme, meter, and stanza forms. And the noble heroes, religious figures, and mythological characters that grace paintings are found also in poetry.

Some English critics in the Baroque age, influenced by extreme rationalism, followed French lines of thought about regularity and useful instruction. Thomas Rymer is a conspicuous example. In the Preface of the Translator (1694), in his translation of Rapin's *Reflections on Aristotle's Treatise of Poesie*, Rymer

says, "Fancy with them [the Arabs] is predominant, is wild, vast and unbridled, o're which their judgment has little command or authority: hence their conceptions are monstrous, and have nothing of exactness, nothing of resemblance or proportion" (p. A4).[32] Rymer says of Edmund Spenser, "He wanted a true idea [like Le Bossu's moral]. . . . All is fanciful and chimerical, without any uniformity, without any foundation in truth" (Preface, p. 9). He likes Spenser's wit. The Italians, he thinks, "debauch[ed]" Spenser's judgment. He translates Rapin, "The principle end of poesie is to profit," among other ways "by refreshing the mind, to render it more capable of the ordinary functions, and by asswaging the troubles of the soul with its harmony" (p. 12). That harmony is not the Neoplatonic microcosmic imitation of the macrocosm but a balanced view of the world, the way the world should be (not the way the universe is). Rymer dislikes the imaginative developments of Ariosto, Tasso, and Spenser. He wants them instead to exhibit the order that should exist in the world.

Another work that shows the increasing tendency in England to enshrine rational instruction is Joseph Addison's *Cato* (written ca. 1703), a rather unexciting, but moral and instructive, tragedy admired by cognoscenti in France and England for its appeal to the rational mind. Voltaire, who expresses belief in the pleasurable regularity produced by the unities, says,

> The tragedy of *Cato*, which does such a great honor to M. Addison, your successor in the ministry [Henry St. John, Lord Bolingbroke]; this tragedy, I say, the only one your nation has produced which is well written from beginning to end—you yourself have said it—owes its great reputation to no other element than its beautiful lines, its vigorous and true thoughts, expressed in harmonious verse.[33]

Addison's *Cato* is not widely admired for its imaginative vision.

Unlike Hobbes, both Rymer and Voltaire maintain that art should instruct its viewers in morality, through regularity, decorum, and poetic justice. As such their view agrees with the rational view of art expressed by Plato but takes a potentially transcendent idea like poetic justice and limits it to earthly confines. That kind of idealization of life, combined with the accepted usefulness of

Aristotelian rules to make drama verisimilar or illusionistic, leads to a common source both for French rules criticism and for Hobbesian views of art. That source is the desire for a collective rationality, for the use of external, commonly accepted rules. It is combined with a distrust of the rationality of a single person, presupposing a distrust of individual genius. (Hobbes, of course, says human beings are more equal in intelligence than they are even in physical strength.) The purpose of rules and regularity—Rymer's and Voltaire's concerns—is to make drama as rational as possible so that a rational person can recognize its truth and admire in it those ideas commonly accepted or propagated by society. For the rules supersede individual genius. The judgment works on a low level. *Cato* is a play many thought they should respect and admire. It instructs through overt morality expressed rhetorically, appealing through the passions to the judgment, but not to the total understanding in the manner of *King Lear* or *Antony and Cleopatra*.

The whole idea of moral instruction helped justify rules-oriented criticism about dramatic poesy and painting, wherein the manners, the three unities, *les bienséances*, decorum, poetic justice, and the other rules all are supposed to give the illusion of reality to a morally elevated, larger-than-life presentation of virtue. Art of this moral kind was widespread in the Baroque era, although the fashion and purpose of the morality varied according to perceptions of reality peculiar to individual painters, and changing attitudes over a period of time, and differing national attitudes. The change in French painting over time is evident, and was extremely influential, in England. Simon Vouet, for example, the first painter for Louis XIII, painted large numbers of abstract allegories about truth, justice, and other such abstractions. Nicholas Poussin painted fewer; Charles Le Brun, fewer still. The bulk of Le Brun's paintings, as first painter to Louis XIV, glorify Louis himself, both for state propaganda purposes and for Louis's own ego. Thus we see Louis XIV in a painting of the crucifixion and in other paintings in which he resembles Alexander the Great or some other hero, not to induce harmony into our souls, or even into society, but to glorify Louis XIV. The propagandizing is not carried out through a vision of beauty or even through an appeal

to the highest soul, but through appeals to the emotions. We are to be overcome emotionally by Louis XIV's *gloire*. We are to feel his presence. The instruction in regard to Louis XIV is political and personal yet still rational in intent. We are made to understand and to admire, through emotional persuasion, worldly power and greatness rather than the goodness and vastness of God's cosmos seen through the artistic product as artifact, as microcosm, although conventional allusions to the cosmos are used to achieve emotional effects.

Louis XIV's use of art for political purposes, as well as his own pleasure, is an example of art with all its elevated, Neoplatonic connotations employed rhetorically for political ends;[34] this practice indicated the tendency to follow the kind of materialism espoused by Hobbes. Le Brun's use of an accepted mode of allegorical or rhetorical expression, based on his expectations of how spectators will react to artistic conventions, indicates a fundamental distrust of mankind's rational capacities, a distrust inherent in the external probabilities (truths) imposed by instructively oriented rules criticism. The distrust of individual imagination and judgment coincided in France with the idea that a secular centralized power can provide the corrective, an idea similar to Hobbes's. The history of French art follows such a view. Robert Isherwood can say that Charles Le Brun more than anyone else turned visual allegory and mythology into "a principal weapon of Louis's artistic arsenal" and that Le Brun's paintings are perfect complements to the physical settings of Lully's operas (p. 168). Incidentally, painting and opera in their planned effects, in the passions and beliefs they try to raise and instill in their spectators, are the same. As Isherwood says, "Paintings and opera were almost interchangeable media" (p. 169). When one of Lully's operatic heroes prepares to go to war, his operatic scenes are comparable to the sequence of actions in Le Brun's allegorical *Esquisses pour la voute de la galérie des glaces à Versailles* (1681–84).

The moral, or instructive, content of music is a somewhat special case because music, by its nature, cannot be as overtly instructive as the other arts. Being a part of mathematics, music is more abstract than they, and its suitability for allegorical instruc-

tion lies first in its connection to poetry and song. In song music is subservient to what the words say and tries to imitate their sense either literally or abstractly. If literally, then music is "practical." Thomas Morley, in *A Plaine and Easie Introduction to Practicall Musicke* (1597), says, "Practical [music] is that which teacheth all that may be known in songs, eyther for the understanding of other men's or making of one's own."[35] The instruction contained in practical music is rhetorical in that it teaches through persuasion, through appeals to the emotions. For example, Jacques Gohory says that "Orland di Lassis [Orlando di Lasso], the most skillful musician of this time," expresses all the passions. Gohory says Orlando is the first to set the syllables of words on the notes and is like Virgil and Cicero (and Apelles) in his persuasiveness.[36] Rhetorical, persuasive, practical music consciously contrived to affect the listener is the kind of music that became most important.

Another kind of music instructs abstractly through form. It is music based on the significance of harmony and intervals, for example; it has a kind of mystical instruction or meaning that transcends passions and earthly existence. This is "speculative" music. After stating that we thank God that "he gave us a reasonable soul" so that we can search for "more than earthly things" (Introduction), Thomas Morley says that speculative music "is that kind of music which by mathematical helps, seeketh out the causes, properties, and natures of sounds by themselves, and compared with others proceeding no further, but content with only contemplation of the art. . . ."[37] The instruction offered by speculative music is more abstract, inducing harmony in the soul of listeners through the harmony of the music itself. Sir Thomas Browne says, "For there is musicke wherever there is harmony, order, or proportion; and thus far we may maintain the musick of the spheres; for those well ordered motions and regular paces, though they give no sound to the ear, yet to the understanding they strike a note most full of harmony." As late as 1698 as great a thinker as Christian Huygens says that the harmony of music is the same as geometry in giving pleasure to the understanding.[38] Music thus was thought to lend itself to the expression of Neoplatonic ideas of beauty and harmony throughout the Baroque

age. And artistic theories of the period that rely on relationships depicted in musical terms (proportion, harmony) are still largely Neoplatonic in nature whether they apply to poetry, painting, architecture, or sculpture and whether the idea of musical harmony itself is a rhetorical device.

Proportion in painting serves the same purpose as harmony in music. The influential Lomazzo says (1584) that the proportions have the same purpose in all the arts, as they deal with men.[39] In painting, "when we behold a well-proportioned thing we call it beautiful. . . . [Beauty is] communicated to the eye, and so conveyed to the understanding. . . . Effects of piety, reverence, and religion are stirred up in men's minds, by means of their suitable comliness of apt proportion" (p. 25). After telling us that beauty comes from proportion, he says, "As in all natural things [in art, too], neither goodness can stand without beauty, nor beauty without goodness" (p. 81). As we have already seen, goodness is an idea understood only by the highest faculties of the soul. Beauty, therefore, appeals to those same faculties. And Marin Mersenne says that music assists in the contemplation of the divine mysteries, in the practice of virtue, and in achieving harmony in our lives (I, p. 1).[40] Thomas Tallis's "Mass for Four Voices" (ca. 1570), for example, is supposed to do just that. A common, half skeptical Restoration attitude toward Neoplatonic ideas concerning harmony, intellect, and the soul as found in art is nicely summed up by the Restoration writer Ferrand Spence in his Preface to Saint-Évremond's *Miscellanea* (1686). He says,

> The Thomists will have the fruition of the divinity to consist solely in an act of the understanding, which they call vision: But the Scotists in an act of the will, which is love: And the Thomists seem to have the better of the argument, because seeing the operation in which our perfectest happiness is founded, must be the perfectest operation, and seeing that of the intellectual [the understanding] is more perfect than the sensitive part [the second soul], it is apparent, that the operation of this fruition must lye in the intellectual part only. But though I question not but that both in th'upshot may be brought to an accomodation, according to the maximes of the new philosophy which holds all sensations not to be realities

either in the senses or the objects of them, but to subsist solely
in the perception. I say, I do not care, whether the pleasure
springs from either part, provided I have the pleasure [both
Spence and Saint-Évremond are Neo-Epicureans]: Tho, per-
haps, all that results from harmony, arises from the concern,
[art] bears to our souls, which some have opined to be
harmony.[41]

Spence gives us the point of view of a Neo-Epicurean lover of the
arts, even speculating in the last sentence that the highest plea-
sures might come from the relationship between art and the har-
monic quality of the cosmos, the perception of which art commu-
nicates to our understanding.

It may be puzzling that the kind of instruction offered, when
proportionate and decorous, also gives elevated pleasures to the
reasonable soul. Harmony, for example, gives delight to the soul.
So does beauty (which is harmonious). Truth is delightful. Neo-
platonic ideas operate in the realm of delight, but delight of a
high kind. The higher pleasures may be expressed in terms other
than Neoplatonic, and Aristotle, in the *Nichomachean Ethics*,
helps define them:

It is accordingly clear that we cannot call pleasures those
which are admittedly base; they are pleasures only to corrupt
people. But of the pleasures which are regarded as decent,
what sort of which particular pleasure are we to claim as be-
ing truly proper to man? Surely, this is shown by the activities
in which he engages, since it is these that the pleasures ac-
company. Those pleasures, therefore, which complete the
activities of a perfect or complete and supremely happy man,
regardless of whether those activities are one or several, can
be called in the true sense the pleasures proper to man.[42]

Aristotle, in this rather circular statement, is talking about the
highest pleasures in an existent, terrestial sense, not the real, ab-
solute pleasure of the understanding that emanates from Platonic
thought. Yet because of the confusing mixture of Aristotelian,
Platonic, and Neoplatonic thought that existed in the Baroque
age, Aristotle's statement can be applied in different ways. A good
person can be made happy on earth through the highest earthly

pleasures—as long as these pleasures are morally good—as well as through his nearness to the harmony and perfection of the universe that embody absolute happiness and pleasure. Both views say that good art, as an instructive product of the artist's judgment or understanding, is morally justifiable and socially useful, giving pleasure to the understanding and answering literally Plato's objections to art in Book X of his *Republic*.

One could examine at great length in Baroque treatises on all the arts the role of the understanding, which receives and gives instruction, the faculty that elevates art. Lawrence Lipking sums up the discussion on this subject:

> The development of English writing about the arts [actually, in European treatises in general] was determined largely by theories designed to counter these indictments: poetry is immoral; the skills involved in painting are manual; music is an idle (or sacrilegious) amusement. As a result, critics throughout the seventeenth and eighteenth centuries are likely to argue that poetry is supremely and primarily moral, that painting is the result of intellectual contemplation, and that music is important (or holy) work. Whatever the rights and wrongs of these arguments, critical debate was founded on them. Only when painting had acquired a place of its own, its own appropriate respectability, could the successors of Junius relax their pretensions and begin to speak as equals to equals, as men to men.[43]

Given the whole effect of art, that which appeals to the reasonable soul (instruction or delight) is superior to that which merely gives delight to the sensible soul, that is, merely arouses passions and appetites.

What a creator intends, his content, or what he says (or does not say) affects the status of his art: whether his art is used to improve individual morality, whether his art is useful to his society or to mankind in general, and whether the amusement his art provides is its first or second purpose. Different ways of defining the soul and of viewing its relationship to art produce different kinds of art. Poetic justice in French drama is a device that tells us something about the view of the world expressed. Shakespeare's *King Lear* offers no French conception of poetic justice, yet we

feel Shakespeare's conception of the cosmos is much more magnificent and comprehensive, and so did seventeenth- and eighteenth-century Englishmen. The same differences in conception occur between Poussin and Michelangelo, between Virgil and Homer. A work of art like Racine's *Phèdre* makes us marvel at its decorous regularity and preciseness, and we can see how each part plays on our conception of worldly wisdom. Given the circumstances, the kind of people in *Phèdre* can exist, and Racine's purposes are clear. But a work like Michelangelo's *Moses* transcends our limited world; the personification of power, energy, and wisdom that Michelangelo, with his extraordinary imagination, could only envision and, with his extraordinary artistic skill, can communicate to us only partially is a visual equivalent to the kind of thinking at work in Shakespeare's greatest tragedies. Our understanding of Racine's purposes comes from the parts, from the rhetorical parts as they combine to form a whole. Our feeling for *King Lear* or *Moses* comes from the tremendous effect of the whole work on our whole being; yet these artistic wholes also are made of rhetorically conceived parts. The difference comes from the dominance of the imaginative vision or idea that makes *Moses* and *King Lear* both greater than the sums of their parts. John Evelyn defends Michelangelo's *Moses* against the adverse criticism of Roland Fréart de Chambray ("To the Reader," *An Idea of the Perfection of Painting* [London, 1668]). Evelyn admits that Michelangelo is deficient in decorum, which is essentially a consideration of parts, but justifies his opinion of Michelangelo by using the term *magnificence*, which has to do with the effect of a work in its totality. Fréart attacks the indecorous parts of *The Last Judgment*, for instance, and after a list of examples, he says (in Evelyn's translation):

> And after all this, what are we to expect of tollerable in this famous piece? There being so many strange and extravagant things, totally repugnant to the verity of the Gospels. [P. 74]

The results of such reliance on judgmental matters, such as decorum of parts, are based on a distrust of the force of imagination, the products of which are those "many strange and extravagant things." The more imagination is distrusted, the more distrust

there is of individual human beings and the less regard we have for the kind of art produced by a Shakespeare or a Michelangelo. Individual and national tastes are formed by such ideas. Michelangelo and Shakespeare were important to the English of the Baroque age as neither was to the French of the same period.

Rhetorically, art can be pitched toward any part or faculty of the soul, and once we see how the parts of the soul were regarded, the kinds of behavior and capacities attributed to each part, and how a painter, poet, or a musician of the period understands, expresses, and portrays man's mind and how it functions, we can also see and understand how each artist, using devices of his art, tries to influence or instruct the understandings, opinions, and emotions of his audiences or spectators through delight: through form, content, and characterization. We can thereby understand a great deal more about art and its aims and realize why, sociologically and analytically, certain purposes of art and critical attitudes toward art came to be and why the arts were considered an important endeavor. In the seventeenth century the movement away from art as theoretically elevated to art used in specifically purposeful ways, whether to combat *ennui*, to teach moral lessons, or to reinforce political, religious, and social beliefs, is crucial.

THREE

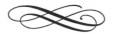

Rhetorical Theory
and Practice

Rhetoric, in practice as well as in theory, underlies all the arts from the Renaissance through the eighteenth century[1] and is closely related to Baroque theories of knowledge, taste, criticism, persuasion, expression, and creation. A study of rhetoric and the ways it manipulates or channels or describes the thinking process was a part of everyone's formal and informal education in the Baroque age. Like the faculty psychology, rhetoric was so much a part of people's intellectual baggage that our understanding of rhetorical intention and effect is fundamental to any consideration of Baroque art. This understanding is not essential to considerations of nineteenth- or twentieth-century art, in which the organic metaphor is used to describe artistic creation and in which a different kind of psychology is applicable, one oriented more toward art as the expression of the unconscious. In the seventeenth century, there was no organic metaphor such as we know it, drawn from science and applied to the arts. In fact, in the seventeenth century, plants were thought to grow like crystals. If anything, the seventeenth-century theory of vegetable growth supports a rhetorical conception of art, a work of art as something made in steps.[2] One result of this theory is that Baroque art is more conscious in intention than we tend to realize. It does not easily lend itself to psychoanalytic approaches.

arts. Even the use of proportion and harmony for effect may be considered a part of rhetoric. Because each art aimed for persuasion or for similar effects, all were deemed similar by people of the Baroque era.[5]

I

Artists and theorists of the sixteenth through the eighteenth centuries, unlike most of us, thought that the rhetorical process of artistic making or creating consists of five parts or steps. The three main parts are *inventio, dispositio,* and *elocutio; actio* (gesture) and *memoria* (memory) are the fourth and fifth steps. These parts or steps come primarily from Quintilian and Cicero, themselves organizers, not inventors, of the art of rhetoric.[6] The first step, *inventio,* is the invention (or discovery) of a main idea (and even the moral) and its attendant images and ideas. *Inventio* is the step most applicable to all the arts. Invention uses the power of the imagination to draw forth forms of things from the memory. Thus, Dryden, in his most famous "spaniel" passage, says (1667):

> The faculty of imagination in the writer, . . . like a nimble spaniel, beats over and ranges through the field of memory, till it springs the quarry it hunted after; or without metaphor, which searches over all the memory for the species or ideas of those things which it designs to represent.[7]

The forms of things, as the imagination retrieves them from the memory (experience), come from three kinds of place: other works (imitation of the great works that are nearest nature); nature itself; and the vision of what the creator thinks of as nonexistent absolutes, or as perfection. This last idea for all practical purposes originates with Plotinus; it elevates the creator as a communicator of divine truth and beauty. In the rhetorical process of creation, mimesis or imitation of nature can fall in any of the three areas invention (or imagination) draws on.

First, invention comes from other works or conventions postulated by other works. Thus, Monteverdi in *Orfeo* draws on the classical myth; Shakespeare hardly ever makes up his own stories; Virgil in his *Aeneid* relies heavily on Homer; there are many

paintings of the crucifixion, of the last judgment, and of Adam and Eve's expulsion from the Garden of Eden; there are myriad musical dialogues between shepherds and shepherdesses; Aphrodite emerges and reemerges from the sea; and authors like Plutarch provide subjects for all kinds of creators. Discovery or invention extends to minute details, and rhetorical devices or conventions are used to give specific effects of all kinds. In music, "dying falls," wherein the sequence of notes also falls, represent ill turns of fortune; in poetry, an apostrophe heightens the emotion of the listener, usually through direct address as in stanza IV of Dryden's "To the Pious Memory of . . . Mrs. Anne Killigrew" (1685). In paintings and in sculpture, the motion of the hair shows emotion or personality traits: Lomazzo points out how the motion of the hair signifies, for example, a station of life or a passion.[8] And certain kinds of meter in music represent anger: Marin Mersenne describes how choler may be represented through accent at the end of measures. Dryden and Henry Purcell use this device in *King Arthur* (I, ii): "Come if you dare, our trumpets sound" (1691); and in the hissing anger of "What flat'ring noise is this" in *Indian Queen* (music ca. 1691, first performed as a play 1665).

Invention of the first kind draws its aims and objects from a pool of subject matter and imagery available to the age (used as an orator employs *topoi*) and is learned from formal and informal education.[9] Classical learning is important to invention, as is biblical lore, to name only two examples. The many paintings of the triumph of Bacchus, the laments in music (such as that of Dido), and the plays about a great hero or heroine torn between love and duty all are taken from specific topics. The topic may be the same although the work has a different subject. For example, a play may be about Alexander the Great, Almanzor, Louis XIV (disguised under another name), or the king of England, but, except for peculiarities of the subject and the playwright's adaptation of it, the heroes' characteristics are remarkably similar, being gathered from earlier artistic works on the same topic. Dryden explains clearly, in "Of Heroic Plays: An Essay" (1672; in Watson, I, pp. 156–66), how he works. After pointing out that Spenser's "Bower of Bliss" is taken from Tasso's "enchanted wood" (I, p. 161), he says:

> I must therefore avow, in the first place, from whence I took
> the character [of Almanzor in *The Conquest of Grenada*]. The
> first image I had of him was from the Achilles of Homer, the
> next from Tasso's Rinaldo (who was a copy of the former),
> and the third from the Artaban of Monsieur Calprenède (who
> has imitated both). [In Watson, I, p. 163]

Dryden's other heroes are not dissimilar. Robert Isherwood notes
commonplaces in French art under Louis XIV:

> How often Louis in the operas [and dances] crushed Dis-
> cord, received the laurel crown from Glory, and basked in the
> accolades of the Graces, Talents, . . . and Muses, as he does
> in Le Brun's "Le roi gouverne par lui-même."[10]

Since learned material plays so important a role in the Baroque
era, we need an historical background to fill in gaps between our
own education and that of the creators of that age.

Second, invention can come from nature, actual or probable,
which means that objects or actions that we observe in everyday
life are imitated. If actual nature is imitated, learned, artificial
devices and conventions are not so important. A character is not
a type so much as an imitation of an actual person. Thus, the
speeches of Thomas Shadwell's characters, following Ben Jon-
son's, often are imitations of London cant, speech rhythms, and
turns of thought, as in *The Squire of Alsatia* (1688). In painting,
the same thing is true of Continental artists who give us "recog-
nizable, unidealized views of their own country," painters like
Adrien van der Velde.[11] In music, this kind of invention imitates
rushing winds (storms), as in Antonio Vivaldi's "Summer," in
his *Le Quattro Stagioni*,[12] and as in Purcell's *Dido and Aeneas*
(1689) when Dido and Aeneas take shelter from the storm. If
probable nature is imitated, we are back in the realm of rhetorical
topics, and conventions and character types become more prom-
inent. A soldier should be bluff, honest, and hearty; a scholar
should be meek and pedantic; a lover, pale, wan, and miserable.
National stereotypes often are used: an Italian is intelligent and
dishonest; a German is gluttonous; a Frenchman is foppish. In-
vention can imitate other art, which also can be considered as
nature, and the better that art, the more likely it is to be consid-

ered as such. Ancient Greek and Roman art, for example, is considered in the Baroque period closest to nature because it is the best art and therefore is most worthy of being imitated in both kind and spirit. Alexander Pope imitates Virgil's pastoral poems; Abraham Cowley, Pindar's odes. John Dryden's praise of Shakespeare's works as nature itself is the highest praise he could give any author (and he gives it only to Shakespeare).

Since nature can be rhetorically idealized, presented as it is, or presented as worse than it is, depending on the effect the artist wants to produce, invention also begets the rhetorical use of genres, all of which exist as ready-made vehicles for certain kinds of ideas or attitudes. The qualifications of subject matter for a high genre like tragedy are rigid, but anything is fair game for satire, a low genre. The highest genres improve on nature for an effect, producing what the French call *la belle nature*. Dryden says (1695):

> The imitation of nature is therefore constituted as the general, and indeed the only, rule of pleasing. . . . Since a true knowledge of nature gives us pleasure, a lively imitation of it, either in poetry or painting, must of necessity produce a much greater. For both of these arts, as I said before, are not only imitations of nature, but of the best nature, of that which is wrought up to a nobler pitch. They present us with images more perfect than the life of any individual. [In Watson, II, pp. 193, 194]

Dryden says about the imitation of lower subjects:

> There are other parts of nature which are meaner, and yet are the subjects both of painters and of poets. For, to proceed in the parallel, as comedy is a representation of human life in inferior persons, and low subjects . . . [it is] a kind of picture which belongs to nature but of the lowest form. . . . There is yet a lower sort of poetry and painting, which is out of nature; for a farce is that in poetry which grotesque is in a picture.[13]

Aristotle in his *Poetics*, Chapter II, points out that different musical instruments, genres, and verse forms imitate nature as

better, the same as, or worse than it is. This idea is an historical commonplace. In the Italian Renaissance, for example, Trissino in his *Poetica* (1529) maintains that the arts are unified in terms of how they imitate people. Thus, in painting, he says that Leonardo depicts people as better than they are, Mantegna worse, and Titian as they are. In dance, Giojosi, Lioncelli, and Rosine treat them as better, Padoane and Spingardo as worse. In music, fifes, flutes, organs, and "sounds and songs which call to battle and similar songs imitate the better"; other music imitates the worse. And in poetry, he says, Homer, Petrarch, Dante, and writers of tragedy treat people as better, while Theocritus, Burchiello, and Berni treat them as worse.[14]

How a creator sees nature also indicates to which part of the soul he wants to appeal. Thus, different genres as they imitate different kinds of activities are supposed to affect either the highest understanding or the lowest passions. The historical presence of this idea is quite strong. Dante, in his *De vulgari eloquentia* (1306–1309), classifies the genres according to the parts of the soul they appeal to: vegetable soul—defense and war poetry; sensible soul—delight and love poetry; rational soul—honor and virtue.[15] Such feelings about genres were extant in the Baroque age. The higher the part of the soul appealed to, the higher the genre and the more elevated the art. The epic appeals to the highest part of the soul and is considered the highest genre. Then comes tragedy, then the great ode. Satire, with its raising of disharmonious passions, is lower and so are love lyrics. The same categories of imitation continue to hold true for eighteenth-century art. Handel and Mozart use musical disharmony to show the disharmonies passion causes in the soul, for example, in Handel's "Bacchus ever fair and young" in *Alexander's Feast* (1736), wherein he indicates pain ("Sweet is pleasure after pain"), and in the beginning of Mozart's "Dissonant" Quartet (1785), which is resolved by the harmonious last movement. Mozart's movement from dissonance to harmony is a kind of rising action from a passionate or ignorant discord to an intellectual or spiritual understanding in tune with idealized nature and with the highest parts of the soul.[16] The difference in levels of imitation is readily apparent in Mozart's *Magic Flute* (1791), in which the tinkly,

charming tunes sung by Papageno (representative of the lower parts of the soul) contrast with the solemn, more elevated tones of Sarastro's arias. Hogarth's satirical paintings obviously show man as worse than he is; heroic paintings show him as better. Similar examples could be cited in literature. We are here interested in imitation of actual or probable nature as a part of invention; the subject of mimesis in general has been covered thoroughly elsewhere.[17]

The third kind of invention resides more with the imagination in its highest form. That is, the artist conceives of a vision identical with, or close to, a Platonic absolute. The closeness to perfection depends on the state of the creator's soul. Once a creator has seen or created his idea or image or vision in his mind, his task as an artist is to communicate this vision, of necessity rhetorically, to his audiences or spectators. This kind of imitation of nature is close to the concept of *la belle nature*, nature improved, but it is not the same because *la belle nature* refers to the improvement of "nature-as-found-in-the-world," while the imaginative vision is supposed to be a glimpse of a nonexistent, absolute reality. The status of the artist as a purveyor of truth is affected a great deal by differing attitudes toward this third kind of imitation or invention. Plato denigrated the artist by saying that art imitates reality at the third remove.[18] Plotinus elevated the artist or creator as an analogue to God by saying that art imitates absolute reality itself, the most original and highest form of invention or artistic creation. Plotinus says of Phidias (ca. A.D. 265):

> Thus Phidias wrought the Zeus upon no mode among things of sense but by apprehending what form Zeus must take if he chose to become manifest to sight.[19]

As for poetry, he says that the world (the cosmos) is a true poem that the poet imitates. Poetry, on the contrary, is the universe in small, and so are dance, painting, and music (Ennead III, ii, 6 and elsewhere in Ennead II, ii). As for music, more specifically, the invention also produces a work that is an imitation of the harmony of the cosmos (the same thing is true for architecture and sculpture). The musician is repelled by "the unharmonious and unrhythmic. . . . He will have to be shown that what ravished

him [through the way tone, rhythm, and sound affected the senses] was no other than the harmony of the intellectual world and the beauty in that sphere, not some shape of beauty but the all-beauty," or beauty in and of itself and not merely something beautiful (Ennead I, iii, 1). This beauty is fundamentally mathematical or geometric and thus is a nonexistent or abstract reality.

II

The second step, the step that follows invention in the rhetorical process, is *dispositio*, the disposition or arrangement of the images, ideas, or arguments into the best, most effective sequence, commensurate with the central idea and the required effect. At this point in the making of a work of art, superfluous material is pruned away; the sequence of events in a plot is set, the positioning of figures on a canvas is determined, or the sequence of movements of a musical composition is arranged. Disposition thus means "design" or drawing to painters, arrangement to musicians, disposition and arrangement to poets. This step is clearly in the province of the judgment or understanding; whereas *inventio*, the first step, is a product of imagination as well as understanding. The judgment arranges or disposes according to the proper effect or meaning the artist wants to achieve. In public speaking, you put your best argument first, your second-best last, and your weakest in the middle. In painting, the most important figure is placed where the viewer will notice it first, and in a musical piece with a theme and variations the theme comes first. If an artist desires to express harmony, he makes a balanced arrangement; if he wants to show perturbation or discord, he creates an imbalance. These are simplified examples, but their ramifications are important to creation and analysis.

Dispositio as a product of the judgment has also to do with revision, rearranging, correcting a design, "retrenching" or pruning, and the selection of the appropriate images or discoveries called up by the imagination. All this arranging is rational and appeals to the reasonable part of the mind. It is the harmonious arrangement of parts that reflects God's cosmic harmony. In other words, that harmonious order which is cosmically a product of

God's highest powers is communicated in all the arts by the artist's own understanding and impresses itself on the highest part of the receptor's mind or soul, teaching him what celestial harmony is and giving him the highest kind of pleasure, a pleasure divorced from discordant passion.

George Puttenham's *Arte of English Poesie* (1589) can be a starting point for explaining Baroque ideas. In dividing up his whole discourse into the three rhetorical parts, he considers *dispositio* as synonymous with proportion. In "Of Proportion" (Book II), he correlates poetic stanza form, meter, and accent with musical chords, parts, and modes, as well as with proportions in painting. Puttenham mentions rhythmus, that musicality of verse that Dryden also talks about.[20] It is the creation of harmony as the function of the judgment in *dispositio* that makes the judgment so important to the creation of cosmic truth. In the later years of the seventeenth century, the judgment becomes less concerned with the higher harmonies of internal order and more concerned with order imposed externally, although its first function is still current. The rules of art, cherished especially by the French, are a product of the judgment, and so is clarity. Common sense to the English, *bon sens* to the French, become products of rationality and of the judgment, the faculty that orders all things well and discriminates between those things that appear to be alike. Verisimilitude, decorum, probability, and the unities all come from the judgment and are recognized as so derived. The change in the conception of judgment, as discussed in Chapter II, is primarily caused by the shift in the perception of man's place in the universe. Cosmic harmony is not so important to those who are interested in man as an intelligent, earthbound animal. Order in society and in individual lives is important because serene existence, as much as it is possible, depends on it.

The use of *dispositio* in manipulating harmony or disharmony for effect can become complex. For example, the plot of a comedy, with its happy ending, resolves itself in harmony, as does a piece of music. Comedy as it treats people as they are or as worse than they are is an imitation of actions in the world. Yet the hope of harmonious endings can be otherworldly. The idea of the unifi-

cation of the microcosm as an imitation of the macrocosm, whether
in marriage or in society in general, may have its origin other than
in Neoplatonic philosophy, but it was often felt that happy end-
ings are allegories of the harmony of the universe or at least of
ideal, serene existence. Dante, of course, ends his *Commedia* with
the highest harmony. Robert Burton, in his *Anatomy of Melan-
choly* (1621), says hopefully, "The world shall end like a comedy,
and we shall meet at last in Heaven, and live in bliss together" (p.
963). He shortly thereafter ends his great work with words from
the Neoplatonist St. Augustine. Actual comedies and paintings
were often more oriented toward the world, and many of Shake-
speare's comedies, for example, end lacking complete harmony:
As You Like It, *Twelfth Night*, and *Measure for Measure*. *The
Tempest* is not set in the actual world, but the characters will re-
turn to it at the end of the play, without total harmonic resolution.
The Dutch paintings showing convivial drinking and singing do
not really depict the highest kinds of people, nor do they appeal
to the noblest parts of the soul. The Restoration is full of plays
with odd endings such as William Wycherley's *Country Wife*
(1675), which seems to end on a rather fragile, tenuous footing.
Yet, Nahum Tate revised *King Lear* with a happy ending, and
even today some audiences like the good feeling they get from a
happy, harmonious ending to a comedy. The convention of the
happy ending can be manipulated rhetorically by an artist for his
own ends, with striking effects.

III

The third step, *elocutio*, is the one most closely associated with
the kind of art used, although it was thought to be the least ele-
vated in the process of composition. Roger Des Piles says, "The
material part of painting is nothing else but the execution of the
spiritual part." The hand is to painting what the word is to poesy,
and "both are servants of the mind" (*Principles*, p. 276). In music
elocutio has to do with tones and musical figures, as in a dying
fall. In poetry it has to do with words, tropes, figures, and style. In
painting it concerns colors and shades. *Elocutio* is, as Dryden says,
the last in the sequence of composition and least in importance,[21]
and that is why he says, in "The Life of Plutarch" (1683),

So in Plutarch, whose business was not to please the ear but to charm and instruct the mind, we may easily forgive the cadences of words and the roughness of expression.[22]

Elocutio as the part of rhetoric that is most applicable to a specific medium of expression is the first part of a work that strikes the senses, and although it was considered the most superficial part of art because it concerns devices that affect the senses and lowest passions through colors, words, turns of phrase, and musical tones and figures, it is a necessary step and therefore important. Roger Des Piles says,

> If we consider a painter by his invention, we rank him among the poets; if by perspective . . . he is not distinguishable from the mathematician; and if by the proportions and measure of bodies, we confound him with the sculptor and geometer. So, though the perfect idea of the painter [*inventio*] depends on design [*dispositio*] and coloring [*elocutio*] jointly, yet he must form a special idea of his art only by coloring. [*Principles*, p. 190]

The problems peculiar to *elocutio* and the senses are discussed in Chapters IV and V.

Elocutio is also the area in which fallacious parallels between the arts are made; this problem arises because these parallels are based on the emotional effects produced by the techniques of the art rather than on the more important teaching and harmony impressed on the highest parts of the soul by invention and disposition or on the composite effects of all three steps. The sixteenth-century Ramistic separation of invention and arrangement from rhetoric, leaving only elocution and delivery,[23] is not convincing to seventeenth century thinkers, especially in comparing the arts, because of the low status of elocution. As Jean-Louis Guéz de Balzac says, in arguing against the Ramistic conception of rhetoric:

> It is true I attribute much to elocution, and know that high things stand in need of the help of words, and that after these have been rightly conceived, they are happily to be expressed. It only angers me, that out of the poorest part of rhetoric received among the ancients, they [Ramists] will needs extract

all ours. And that to please mean spirits, it is fitting (as they think) our works should resemble those sacrifices, whereout they take the heart, and where, of all the head, nothing is left save only the tongue.[24]

IV

There are two more parts to the rhetorical process, *actio* and *memoria*, but they are separate only in oratory. In art these parts, especially *memoria*, usually are incorporated into the first three steps. *Memoria*, or memory, encompasses the remembrance of ideas, arguments, and images (and even the literal memorizing of a speech). For our purposes, it is a part of invention as it certainly fits in that section according to its position in the scheme of the faculty psychology. *Actio*, gesture or action, encompasses postures in painting, gestures by actors, and visual images alluded to by poets and musicians. Poussin refers to *actio* in his "Observations on Painting," published by Bellori in *Vite de' pittori* (1672):

> There are two instruments which affect the souls of the lis-
> teners: action and diction. The first, in itself, is of such value
> and so efficacious that Demosthenes gave it predominance
> over the arts of rhetoric. Cicero calls it the language of the
> body, and Quintilian attributes such strength to it that he
> considers concepts, proofs, and expressions as useless without
> it. And without it, lines and colors are likewise useless.[25]

Poussin not only refers to Quintilian on *actio*, or gesture, in his own right, he refers specifically to Quintilian's reference to Demosthenes. In other words, he is well acquainted with Quintilian's writings.[26] Poussin's figures are drawn with a close knowledge of rhetorical conventions, and although his gestures largely correspond to natural emotions they are used conventionally, just as Quintilian distinguishes between artistic and common gestures (XI, iii, sects. 102, 121). All of Poussin's finger pointings, body positions, eyebrows, eyes, arms, hands, and shoulders mean or express something relatively specific.[27]

An interesting painting to analyze in terms of *actio* is Poussin's *The Judgment of Solomon* (1649; see Plate 9), in which Solomon has just decreed that the disputed child shall be divided equally

in two pieces between its claimants. The public character of the event corresponds to Poussin's use of public gestures, and all the characters reveal their thoughts and emotions through gestures that are explained by Quintilian. Quintilian says, for instance, that raised eyebrows indicate refusal, dropped eyebrows indicate consent (XI, iii, sect. 79). Thus, each character except the impassive Solomon indicates either acceptance or rejection of the grisly decision. The false mother's brows are lowered as are the brows of the rather odious man next to Solomon's left hand. The other figures show various degrees of rejection and horror, even the child on the right. The soldier, for instance, indicates his reluctance to perform his duty. The only variation to this most simple of rhetorical indicators is the woman in the group on the right whose lowered brows indicate more extreme grief and whose writhing body indicates pain at the decision.

The hand gestures are equally significant. Quintilian says that the hands speak by themselves, that they express all passion in an international language (XI, iii, sects. 85–87). He says the eyes always are turned the same way as the gesture except where there is abhorrence. And we can see the most abhorrence, as far as the spectators are concerned, in the woman with the child, at the far right, and in the soldier at the far left. We also know, therefore, which of Solomon's hands is most important to regard. At the moment of decision Solomon's right hand indicates his dramatic, seeming insistence of purpose. Quintilian says that when three fingers are doubled under the thumb, the index finger is "used in denunciation and in indication, . . . while if it be slightly dropped after the hand has been raised toward the shoulder, it signifies affirmation, and if pointed as it were face downwards toward the ground, it expresses insistence" (XI, iii, sect. 94). If the fingers were held by the thumb more firmly, Solomon would be more emotional. As it is, his hand is descending since he has already pronounced his decision. His right hand, with its more gentle gesture, gives promise of the humane and wise judgment yet to come. His thumb and index finger indicate the point he is making. Quintilian has something to say about the gesture in which the last three fingers are folded: "It is much employed by the Greeks both for the left hand and the right, in rounding off their enthymemes,

detail by detail. A gentle movement of the hand expresses promise or assent" (XI, iii, sect. 102).

Hand gestures also are important for characterization of the two main women in the painting. The real mother pleads her case eloquently, indicating her wish for the child to live even if he has to live with the other woman. Her left hand decorously indicates her desire to stop the execution, while her right is extended in an orator's gesture. Quintilian says that in an especially rich and impressive style "the arm will be thrown out in a stately sidelong sweep, and the words will, as it were, expand in unison with the gesture." He goes on to say that in continuous or flowing passages a becoming gesture is "slightly to extend the arm with shoulders well thrown back and the fingers opening as the hand moves forward" (XI, iii, sect. 84). This is an exact description of the gestures of the real mother. The other woman crouches emotionally, her neck indecorously outstretched (Quintilian disapproves; XI, iii, sect. 82). Her insistence that Solomon's grisly decision be carried out is indicated by her pointing finger. To Poussin's stoic tendencies, in keeping with his admiration of classical austerity, the good woman displays the qualities that Quintilian says typify the person of "dignity and virtue" (XI, iii, sect. 184), qualities the bad woman lacks.

Gestures indicate character as mute accompaniment to an imagined voice or thoughts. Quintilian (and Cicero, too) says gesture should be subservient to voice (XI, iii, sect. 14), but he elsewhere says gesture also should be adapted to thought, not to the actual words (XI, iii, sect. 89). Lomazzo agrees (II, p. 4). It is as if a painter had to imagine voices and thoughts before he drew his figures. Des Piles says the artist should look in a mirror to learn proper gestures; he indicates that gestures come originally from observed nature but he also quotes Quintilian explaining the ways in which passions are expressed through particular gestures used as conventions.[28] In his five-volume *Entretiens sur les vies et sur les ouvrages des plus excellens peintres anciens et modernes* (1666), André Félibien also describes the way in which the passions are to be depicted through gesture. The language of rhetorical gestures, besides the significance of color, helps us understand painting and raises emotions in us. *Actio* as it is expressive is

mostly a part of eloquence. Insofar as it relates to the design, as when one kind of expression balances another, it is a part of *dispositio.*

All the parts of the rhetorical process form a unified whole. André Félibien in his *Des Principes de l'architecture, de la sculpture, de la peinture, et des autres arts qui en dépendent* (published 1670), for example, expresses in a number of places the unity he sees in Poussin's work. Poussin uses the passions in harmony as a musician uses sounds (p. 25), and his colors also are used harmoniously (p. 85). Later he says that the beauty in Poussin's works lies in the unity of their parts (p. 129). Félibien says also that beauty comes from a proportion of parts (I, p. 36). The fundamental unity can emanate from either *inventio* or *dispositio* or from both, but it will fail unless *elocutio* (coloring) and *actio* (gesture) also fulfill the artist's intent.

The unification of the rhetorical creative process we have just described is depicted by the well-educated diplomat and painter Peter Paul Rubens in his *Education of Marie de' Medici* (Frontispiece). The painting allegorically expresses the rhetorical divisions. Marie is being instructed in writing, and Athena, representing the faculty of judgment (concerned primarily with organization, arrangement, and the elimination of superfluous material), is overseeing the teaching and is correcting Marie. Hermes (the god of oratory and elocution) draws a curtain from the front of the springs on Mount Parnassus (representing inspiration and invention), showing us that through elocution we express our ideas (or images or conceptions), and his hand helps to guide Marie's pen. Apollo, the god of poetry, music, sculpture, and painting, represents these arts, all of which are created in the same way, by the same rhetorical process. The Three Graces, the three nude figures, personify beauty that is beyond the contrivance of art but that is also associated with the symmetry and harmony that appeal to the understanding (and are defined as beauty). Their sweetness, gentleness, and softness all are qualities attributed to grace and beauty also. The effect of the craggy waterfalls is less harmonious and yet more exalted than that of the regularized beauty of the Three Graces. And the portrait at the bottom left represents the grotesque and ugly, or perhaps the un-

comfortable passion of terror. The painting is an allegory of the rhetorical unification of all the arts in the process of creation and in artistic effect; the work centers on the person of Marie de' Medici, who is learning about it, as we are.

The rhetorical devices Rubens uses in the painting itself correspond to the process we have described. The idea for the painting, the invention, Rubens received from his own learning. The harmonious arrangement of figures is the product of design and of the judgment. The small size of Marie de' Medici herself draws attention to her and to the mythological existence and great powers and importance of the gods and personified abstractions that surround her. The gestures (*actio*) of the characters are appropriate to their roles, from the harmonious, graceful gestures of the Three Graces and the more agitated movement of Hermes to the circumscribed gestures and posture of Athena. The colors, as well as the gestures, are conventional indications of the characters and their roles. Athena is decorously dressed in sedate blue and gold, indicating vigilance. Marie herself is dressed in a rose-colored gown, indicating her joy, or delight, at the instruction. The red of Apollo's drapery and of the curtain Hermes draws indicates the connection of music and eloquence to the passions that they arouse, red being indicative of the more violent passions. There are numerous other devices in the painting that are a part of both design and elocution, but they need not be explored here.[29] The painting not only is about the rhetorical process but also is constructed according to it for the pleasure and instruction of viewers. Because of the predominance of the allegory, the painting appeals in a unified way to our reason or understanding, in other words, to our highest soul (the reasonable). The whole purpose of education, since this painting is the *Education of Marie de' Medici*, is to improve our understanding, the faculty that should rule all other parts of the soul. But the painting's vividness and its rhetorical devices impress our senses first. As Rubens himself says, "Those things which fall under the senses are the most deeply impressed upon the mind."[30]

The process of creation in steps one and two (*inventio* and *dispositio*) are the same in all the arts, and in these areas the arts can be paralleled. The third step, *elocutio*, involves the medium

of expression, and although the arts cannot be paralleled even here they can be compared because their various devices are intended to produce similar effects. For example, the modes of expression in a play, in a painting, and in a musical piece may all raise the same emotion, or at least the same kind of emotion, in their audiences or spectators. The important point here is how artists worked or rather how they thought they worked. From their many comments about it, artists themselves seem to have believed in the accuracy of their own analyses of the sequence of composition. Also, the kind of artistic making that results from the rhetorical process is oriented toward a conscious, intellectually conceived kind of art that can best be analyzed on its own terms as a consciously received kind of art. In other words, if we can ascertain artistic intentions through the conventions used to convey these intentions, we can understand what someone from another age is saying, not only to his own time but to us as well.

Rhetorical Theory and the Arts

Ideas and purposes are communicated in art by rhetorical means, and all the arts touch different senses to achieve comparable effects. In other words, we can feel the same after reading a poem, listening to a piece of music, watching and listening to a play, and looking at a painting. The means of rhetorical art, which induces an emotional state, whether in oratory, poetry, music, or painting, are used to persuade or to capture audiences or viewers by appealing to, or delighting, the senses and thence the passions. The passions, or feelings, excited by rhetorical devices are supposed to overcome the understanding to varying degrees; this result depends on whether the artistic work in question has either an instructive or a pleasurable purpose. The moral or intellectual instruction often may be the important end of a work of art, but it comes after appeals to the senses and passions. Although logic has to be part of rhetoric for expression to make sense, people are less easily instructed or persuaded by the rigor of logic than by emotional means. In other words, audiences must be made ready, softened up as it were, so instruction can take place. The passions to which the means of art first appeal are therefore of great importance, as are the devices that do the appealing and manipulating, and from the Renaissance through the eighteenth century treatises on the soul and on the arts, because of their rhetorical

orientation, all evince great interest in the passions: what they are, which ones to strive for, and how to raise them.[1]

A work of art as an artificially contrived object comes to us via our senses, moving through common sense and the memory and the imagination, all a part of the second, sensible, concupiscible soul, the seat of the passions. At this point, either the effects of the work of art may go on to the reasonable (highest) soul, there to be judged and evaluated according to abstract, elevated principles by the understanding and to show its instruction, or the work may excite the passions to such an extent that the reasonable soul is overcome and bypassed, and we act or are impressed according to appetite and passion (not reason). We may do so willingly, succumbing to the blandishments of pleasure and luxury, just as Hercules at the crossroads supposedly did not. Yet in our appreciation of art, we are drawn to the moral or instruction only by the way the artist first captivates our senses through color, sound, words, design, and invention. Thus, the different kinds of art are interchangeable vehicles, interchangeable in the sense that any one of them can project a creator's intention through the same kind of passion, and although the art of expressing images varies with each medium, its place and function in the artistic process remain the same. Anthony Blunt is not being fantastical when he says that if *The Death of Germanicus* is Poussin's first epic, *The Triumph of Flora* is his first lyric.[2] The identification with rhetoric is fundamental to each art and to comparisons. The growing reliance on affective theories strengthens the relation of art to rhetoric because of the way in which rhetorical devices attempt to elicit specific effects.[3]

The rhetorical devices and conventions used in the Baroque era are so much a part of art that they became homeopathic. That is, a passion represented in a work of art, through certain stylized means, is supposed to produce the same passion in an observer. The French physicist Claude Perrault, for example, points out that all the arts play on our passions by different means (which we would call different media).[4] All try to achieve the same effects, that is, to raise the same passions, and theorists in all the arts use similar terminology or at least try to show how their devices are either the same or similar to the standard, traditional,

rhetorical devices found in all the books on rhetoric, for even figures of speech are important in terms of their effects. The passions are high (elevating to the soul, or elevated) or low (appealing to the lowest passions) depending on the purpose of the artist. Since all people have more or less the same passions, a work of art can persuade or sway all who recognize the conventions.[5] Our recognition of the rhetorical approach and of the conventions used by it enhances our understanding and appreciation of seventeenth-century art. The pervasiveness and importance to the Baroque age of the rhetorical way of approaching art led Zachary Pearce to observe in 1714 that rhetoric's future was greater than the past it had enjoyed among the ancients.[6]

i

There was general acknowledgment that art should appeal to the passions of the second soul, as well as to the judgment of the highest, that it should not concentrate solely on abstractions such as harmony, which appeal to the understanding through a rarefied form of delight. George Puttenham in 1598 says that poetry "invegleth the judgment of man, and carieth his opinion this way and that, withersoever the heart by impression of the ear shalbe most affectionatly [by means of the passions] bent and directed."[7] He says the same thing is true for music, that Orpheus mollified "hard and stony hearts by his sweete and eloquent perswasion."[8] Later writers agree. John Blow in the Preface to *Amphion Anglicus* (London, 1700) thinks music softens people and prepares their minds for wisdom and virtue. He says that music is supposed to

> teach and cultivate humanity; to teach civilized nations; to adorn courts; to inspirit armies; to inspire temples and churches; to sweeten and reform the fierce and barbarous passions; to excite the brave and magnanimous; and above all to inflame the pious and the devout. [Dedication]

Blow's first two purposes of art are instructive, "to teach." The other purposes are "to adorn," "to inspirit," "to inspire," "to sweeten," "to excite," and "to inflame." The arousal of passion receives more weight than instruction alone. Most of his purposes

are to persuade by arousing the proper, higher passions, and all of his purposes fall under the headings of *docere, conciliare,* and *movere*—the three purposes of rhetorical oratory given by Cicero and repeated by St. Augustine.[9] Le Bossu also says that poetry is persuasion,[10] and even Rapin, with due caution, says that delight, although not the main end of poetry, comes first:

> [Poesy] labours [tries rhetorically] to move the passions, all those motions are delightful, because nothing is more sweet to the soul than agitation, it pleases itself in changing the objects, to satisfy the immensity of its desires. 'Tis true delight is the end poetry aims at, but not the principal end.[11]

Others who write about poetry and prose, poetry and music, music and painting, painting and poetry (and architecture and sculpture as well) use rhetorical terminology and refer constantly to rhetorical similarities among the arts. Henry Peacham, in talking about music, says (1622):

> Yea, in my opinion, no rhetorick more persuadeth [than music], or hath greater power over the mind [soul]: nay hath not musicke her figures, the same which [sic] rhetorique? What is a revert but her apostrophe? her reports, but sweet anaphoras? her counterchange of points, antimetaboles? her passionate airs but prosopopeias? with infinite others of the same nature.[12]

The art of rhetoric is, of course, the art of persuading, and the figures Peacham mentions come from books of rhetoric.[13] Peacham is so specific that his close comparisons of figures of speech with musical devices would be fallacious except that the figures and devices of rhetoric, whether in music or in speech, through their powers over the mind are designed to produce certain effects or raise particular passions in an audience. Thomas Mace in *Musick's Monument* (1676) is even more explicit:

> And as in languages, various humours, conceits, and passions (of all sorts) may be exprest; so likewise in music, may any humours, conceit, or passion (never so various) be exprest; and so significantly, as any rhetorical words or expressions are

able to do; only (if I may not be thought too extravagant in my expressions) if any difference be; it is, in that musick speaks transcendentally, and communicates its notions so intelligibly to the internal, intellectual, and incomprehensible faculties of the soul; so far beyond all language of words. . . . I have been more sensibly, fervently, and zealously captivated, and drawn into divine raptures and contemplations, by those unexpressible rhetorical, uncontroulable perswasions, and instructions of musick's divine language, than ever yet I have been, by the best verbal rhetorick.[14]

Notice that raptures (coming from the sensible soul) precede contemplations (which come from the understanding, in the reasonable soul), just as a work of art appeals to passions before it gets to the understanding. Notice also that music persuades (and persuasion is the essence of rhetoric). Mace goes on to say that music has "allusions and references," that "Pavins, Allmaines, and . . . ayres [are] . . . so many pathetical stories, rhetorical and sublime discourses; subtil, and intricate argumentations; so suitable, and agreeing to the inward, secret, and intellectual faculties of the soul and mind."[15]

Lomazzo (in 1584–85) expresses the same kind of thought (as does Coeffeteau in his *Table of Humane Passions* [1615]), saying that "painting speaks all languages" and describing the operation of the creative mind of a viewer, listener, or reader. His discussion in Book III of the meanings of different colors (like Puttenham's consideration of tropes) is the same as Marin Mersenne's discussion in *L'Harmonie universelle* (1636) of the musical meanings of instruments, keys, and modes. Lomazzo says, "Neither doth it [color] only express the outward formes of things; but also discovereth certain inward passions; painting, as it were laying before our eyes, the affections of the mind, with their effects."[16] Mersenne in talking about music goes even further:

Music is an imitation or a representation just as poetry, tragedy, or painting is, as I have said elsewhere, for it does with sounds or the articulated voice what the poet does with verse, the actor with gestures, and painting with light, shadow, and colors.

[La musique est un imitation ou representation aussi bien que
la poésie, la tragédie, ou la peinture, comme i'ay dit ailleurs,
car elle fait avec les sons, ou la voix articulée ce que le poète
fait avec les vers, le comédien avec les gestes, et le peinture
avec la lumière, l'ombre et les coleurs.][17]

Poetry (oratory) can produce emotions different from those
of its imagery and its tropes and figures, just as Lomazzo says that
the color red signifies fierceness (p. 112) and Camus de Mézières
(1780) says that the Tuscan order of architecture produces a feel-
ing of force and solidity.[18] The figure of hyperbaton, Longinus
says, produces vehement passions,[19] just as Rameau says that "har-
mony may excite different passions in us depending on the chords
that are used"[20] and Mersenne says that the different intervals
produce different passions: "From joy to sadness, anger, hatred,
and other emotions that serve to cause the listener to follow the
intent of the orator." [Joye, à la tristess, à la cholère, à la haine,
et aux autres affections qui servent pour porter l'auditeur à suivre
l'intention de l'orateur] (I, p. 7). We are clearly in the realm of
rhetoric when Mersenne compares the art of the composer with
the art of the orator.[21]

The rhetorical way of raising passions can be further illus-
trated by conventional devices. Lomazzo points out that "valiant
and stoute men" have "locks that are rough, wreathed"; groups of
colors such as "black, earthie, light, lead-like, and obscure colors
. . . breed in the eye of the beholder tardity, musing, melancholy";
"green, sapphire, reddish, and gold and silver mixed as yellow"
elicit pleasurable sweetness; and rose, light green, and bright yel-
low elicit joy, mirth, and delight. There are other groups of colors
but these should serve as examples.[22] Thomas Mace in *Musick's
Monument* (1676) compares music to rhetoric (p. 118), noting
that "fugues are humours and conceits" (p. 120). He uses rhe-
torical terminology throughout his work, giving the nature of the
"kinds" of music in passionate terms, according to their measures.
Thus, galliards are grave and sober; "corantoes," brisk and cheer-
ful (p. 129). When Mace becomes more philosophical, he ex-
plains the passions in musical terms, saying that love and hatred
and pleasure and pain, for example, all are expressed in agree-
ments of intervals. The second and seventh, he says, are horridly

hateful and displeasing. In going on to higher matters, he says that the Holy Trinity is expressed in unisons, thirds, and fifths and that the octave unites like unity itself, the harmony of the cosmos, the oneness and wholeness of God's conception (p. 265). Then he goes on to analyze each chord. To Mace, music is a natural language (p. 37).[23]

Musical modes are thought to unite the arts and become in themselves rhetorically conceived genres, analyzed as to the different effects each expresses and elicits.[24] Plato, in Book III of *The Republic*, rejects the mixolydian and hyperlydian modes because they are used for dirges and laments. The Ionian and Lydian modes are rejected as languid. Only the Dorian and Phrygian modes are kept because they express bravery, courage, and steadfastness.[25] Aristotle says that "rhythm and melody supply imitations of anger and gentleness, and also of courage and temperence" through the modes: "The myxolydian is sad and grave, the Dorian is of a moderate and settled temper, while the Phrygian inspires enthusiasm."[26] Plutarch follows Plato.[27] Marin Mersenne, in *L'Harmonie universelle* (1636), says that music speaks through the modes so that an audience can understand the discourse (p. 39). He devises a musical alphabet (p. 40) and later compares modes to genres of literature and painting because they all imitate human nature, meaning the passions (p. 93). Mersenne even diagrams the modes for us (p. 97).

In music, the expression of the passions may be complex because the modes are complex. Mersenne says that in dealing with the passions a musician must consider "the time, the place, the characters, and the subject on which the stress should be placed so that he points out the syllable on which the voice must dwell and which it must build up and reinforce" [le temps, le lieu, les personnes, et le sujet pour lesquels l'accent, se doit faire afin qu'il marque sur la syllable, sur laquelle la voix doit appuyer, et qu'elle doit haisser et renforcer] (p. 371); he later gives examples. The same ideas carry into the eighteenth century. Jean-Philippe Rameau in his *Traité de l'harmonie* (1722) says essentially the same thing about chords and keys. He claims that the ancients made a mistake by ascribing modes to melodies when the melodies were based on chords. Melodies have to do with taste; chords are an

imitation of truth, of nature (p. 157), because of the proportions that obtain in them. The meanings attached to specific chords became associated with specific passions although the chords themselves through proportion were thought to embody abstract truths. Thus, Rameau actually uses convention to explain the meanings of keys and modes, but a convention so well established that it was the same as truth for his well-conditioned listeners. In the major, the classification runs this way: octaves of do, re, la, songs of mirth and rejoicing; fa or sib, tempests, furies, and so on; sol or mi, tender and gay songs; re, la, or mi, "grandeur and magnificence." In the minor, re, sol, si, and mi are for sweetness and tenderness; do or fa, tenderness and "plaints"; fa or sib, mournful songs. Rameau says that the other keys are not in general use (p. 164).

These conventions were developed in the seventeenth century. A major key became gay or optimistic, a minor sad (p. 163), and by Rameau's time the associations were well established. To Rameau, all the twenty-four keys, or *tons*, are supposed to reflect generally a passion. Minor keys are not necessarily sad in the Renaissance, and in the Restoration the less intellectually advanced sections of the populace do not think or feel so. Purcell, for example, uses minor keys in several songs of rejoicing that he wrote for London merchants. Bertrand Bronson explains how intellect and emotion combine in the meaning of keys:[28]

> The prevailing tonality of the work [Handel's setting (1736) of Dryden's (1687) "Song for St. Cecilia's Day"] is D major [see "Re majeur" in Rameau's analysis], and the spirit of it, over all is one of confidence, power and trust. The choice of key is of course by no means haphazard. This particular tonality is selected, not because Handel has thought of some music themes that promise to lie comfortably in the key of D major, but because the dominant mood of Dryden's ode "means" D major. The tonality could have preceded the formula of a single phrase of the music in Handel's imagination. Why D major has this significance is not easy to tell, but it is not by Handelian fiat that it does so. Handel is following a tradition. . . . It is less a matter of feeling than received doctrine. It has nothing to do with private impressions or sensibilities. . . . This is objective, in that it is determined by the intellect rather than

the sense. It belongs to the idea of the key rather than to the sense impression—inevitably so in an era when pitches were inconstant, and when mean temperament had yet to be established. But by Handel's day the intellectual significance of the keys was sufficiently fixed to enable an emotional meaning to associate itself with the idea. [Pp. 99–100]

The musical modes by tradition, by convention, thus become like the different genres, which are in themselves modes. Camus de Mézières (as late as 1780) can therefore compare the orders of architecture to the modes, and even to the keys, of music (since each key also has a specific emotional effect) because of the different effects each order is supposed to produce. He says that the Ionic order by implication is sweet and tender (as Roland Fréart de Chambray also says in *Parallèle de l'architecture antique avec la moderne* [Paris, 1650], p. 36).[29] Mézières speaks for the Ionic order in the following passage:

> In fact, the first torus, the scotia, and the second torus seem to produce for the eye what the notes sol, si, and re do for the ear. The beadings are like voice passages and glides.
>
> [En effet le première tore, la scotie, et la second tore semblant produire à l'oeil ce que les tons de sol, si, se, font à l'oreille. Le filets sont comme les passages et ports de voix.] [P. 32]

Fréart's *Parallèle* as translated by John Evelyn (1680) avoids the musical analogy at one point, comparing the Doric order, the first order, to Hercules with his "rough-hewn and massie club" (pp. 8, 12). Fréart later says that the Ionians,

> considering therefore that the figures of a man's body, on which the Doric order had been formed, was of a shape too robust and massy to fit holy places and become the representation of celestial things [heavenly harmony], they would needs compose an order after their own mode, and chose a model of a more elegant proportion, wherein they had more regard to the beauty than to the solidity of the work.[30]

The Ionic order is thus second. The third order, the Corinthian, represents palm branches and is still more ornate.[31] The three

orders of architecture are therefore associated with the ideas con-
nected to the three parts of the soul. The emotions applying to
the regard with which each is held apply also to each kind of col-
umn. The sweetness and beauty of the understanding are repre-
sented in the Ionic order, the passion and force of the sensible soul
in the Doric, and the inscrutable power of vegetable nature in the
Corinthian. Each order thus is similar to various forms in the
other arts that appeal to the same part of the soul.

There is another kind of allusion to the musical modes as used
rhetorically to influence the state of receptors' souls. George Put-
tenham, in Book II of *The Arte of English Poesie* (1589), treats
proportion in stanza forms and meter, comparing these different
forms and their measures to the various modes, to rhythmus or
measure, and to the concord of rhyme. The effect of poetry's form
is brought about by its proportion, its similarity to music. Putten-
ham says that "poetical proportion . . . holdeth to the musical,"
that "poesie is a skill to speake and write harmonically" (p. 79).
When Puttenham writes about the modes and how they influence
the audience, arousing passions in the soul, he notes also how the
same kind of proportion is conveyed through the eye, saying, "your
ocular proportion doeth declare the nature of the audible" (p.
98). And thus he uses diagrams of stanza forms to communicate
his ideas. What we have here, of course, is an explanation of the
similarities among the arts that derive from their rhetorical nature
and a realization of how similar effects are raised through different
media. Puttenham is saying that poetry communicates ideas and
passions not only verbally but also nonverbally, as music does, and
ocularly (on the page), as does painting.

The kind of explanation Puttenham gives for the effects of
poetry and the terms he uses, such as sound, rhythmus, signifi-
cance, and musical nomenclature, are behind Baroque English
prosodical ideas and terminology.[32] Clearly, the heroic couplet be-
came so popular in the seventeenth and eighteenth centuries be-
cause of its inducement of harmony in the soul, because of its
balance and all the possibilities of different kinds of balance and
harmony. The triplet in heroic verse thus literally becomes a dis-
sonance, which then leads back to the more stable ending found
in the couplet proper. The same is true of seventeenth- and eigh-

teenth-century uses of synalaepha and ideas of "smoothness" and "sweetness." The imitations of Cowleyan pindarics and the Italian *canzone* were done with the musical modes in mind, the rise and fall of the verse rhetorically expressing and inducing passion in the souls of receptors according to authorial intention. The ideas had been current over a long period of time. As Puttenham says,

> For the ear is properly but a conveyance for the minde, to apprehend the sence by the sound. And our speech is made melodious or harmonicall, not only by strayned tunes, as those of Musicke, but also by choice of smooth words: and thus, or thus, marchalling them in their comeliest construction and order. . . . The ministry and use of words doe breed no little alteration in man. For to say truely, what els is man but his minde? . . . He therefore that hath vanquished the minde of man, hath made the greatest and most glorious conquest. But the mind is not assailable unlesse it be by sensible approches [through the senses], whereof the audible is of the greatest force for instruction or discipline: the visible, for apprehension of exterior knowledge. [P. 207]

Nicholas Poussin often says the same thing about painting that Fréart says about architecture and Puttenham about poetry; that is, he compares painting to the other arts because of the effects produced in the viewer, discussing parallels among painting, poetry, and music in terms of effects produced by the modes and by other rhetorical techniques. He talks in painters' terms about the Phrygian mode, which at least from Plato on is associated with a specific effect that music produces.[33]

> Its sharper aspect . . . vehement, furious, very severe, and which astounds people.
> I hope to paint a subject in this Phrygian mode before another year passes.
>
> [Son aspect plus aigu . . . véhement, furieux, très sevère, et qui rend les personnes étonnées.
> J'espère devant qu'il soit un an, dépeindre un sujet avec ce mode phrygien.][34]

He talks also of imitating poetry (1647):

> The good poets used great care and marvellous artifice to fit
> the words to the verses [of music] and to dispose the feet in
> accordance with the usage of speech, as Virgil did throughout
> his poem, where he fits the sound of the verse itself to all his
> three manners of speaking [high, middle, low: the three rhe-
> torical levels of style] with such skill that he really seems to
> place the things of which he speaks before your eyes by means
> of the sound of the words . . . so that when one hears or pro-
> nounces them, they produce a feeling. . . . Therefore, if I had
> made you a picture in which such a style was adhered to [a
> grim subject with grim sounds], you would imagine I did not
> like you.[35]

At other times, Poussin talks about two instruments that af-
fect the souls of listeners (and viewers): action and diction. Some-
times, the two are treated separately, and sometimes together as
parts of elocution. We have seen how Poussin uses what Demos-
thenes, Cicero, and Quintilian say about action or gesture (*actio*)
in terms of rhetorical delivery and how he believes that without
the use of action in the posture of his characters, lines and colors
(words or diction) are useless.[36] He speaks also, as do others, of
parallel genres in the arts, each genre being defined by a view of
reality that treats nature as better than, the same as, or worse than
it actually is. This rhetorical idea is used to define genres such as
the ones already mentioned, plus others like panegyric and satire.
Each is supposed to produce a specific or a general effect on an
audience or to determine an audience's attitude toward reality in
a certain way (say, sneering, mocking, or admiring) and does so
by playing on certain emotions. Views of reality or ways of per-
ceiving nature produce certain emotions in themselves, thus be-
coming natural genres or kinds of literature, arousing passions in
the same way that musical modes arouse passions. A generical
view of art is rhetorical in that an artist picks a genre or kind to
manipulate his audience or to arouse in them certain attitudes or
feelings about reality. And he is helped by the emotional predis-
position his audience has toward specific genres.

The extent to which Poussin thought of painting as rhetorical

is easy to underestimate. Anthony Blunt in his lectures on Poussin points out that Poussin wanted spectators to "read" his paintings through the attitudes of objects and by their facial expressions. In his letter to Chantelou concerning his painting of the Israelites gathering manna (Plate 10), Poussin says:

> Moreover, if you remember the first letter I wrote you mentioning the movements of the figures that I promised to include, and if you consider the picture as a whole, I think you will easily recognize which are the ones that are languishing, which admire those showing pity, performing acts of charity, of great necessity, of desire, sustaining themselves with consolation, and so on, for the first seven figures on the left will tell you everything that is written here and all the rest is cut from the same cloth; read the story and the picture so that you may know if each thing is appropriate to the subject.

> [Au rest, si vous vous souviendrés de la première lettre que je vous ecris, touchons les mouvements des figures que je vous prometois di faire, et que tout ensemble vous considériés le tableau, je crois que facillement vous recognoistrés quelles sont celles qui languisent, qui admire celles qui on pitié, qui font action de charité, de grande nécessité, de désire, de se repestre de cōsolation, et autres, car les sept première figure à main gauche vous diront tout ce' qui est ecy escrit et tout le reste est de la mesme estoffe: lisés l'istoire et le tableau, afin de cognoistre si chasque chose est appropriée au sujet.][37]

As Blunt says,

> This idea of reading the picture is fundamental in Poussin's conception of painting. In Poussin's 'The Israelites Gathering Manna' (1637/38–39), we are to read the characters' gestures. All add to the effects the painting is supposed to elicit in its viewers. The same thing is seen in all his other paintings, such as the highly rhetorical 'Time Saving Truth from Envy and Discord' (1641), or the oratorical gestures in 'The Seven Sacraments: Baptism' (1642).[38]

The same ideas hold true, more or less, for other artists of the period. All gestures correspond to modes; they carry out the makers' intentions in creating states of mind in spectators, consonant with

what an artist is trying to say and do. This idea seems obvious, except that the gestures can be defined metaphorically as a kind of language, each used elsewhere in art and oratory.

II

An artist's purpose in making a work of art can be high or low, and he appeals to the kinds of passions suited to his aim. He may or may not be successful. If a low appeal to the senses succeeds, the artwork is exciting or titillating; if it does not succeed, the work is low and disgusting. Dryden, in his reply to Jeremy Collier's attack, admits to having produced art that appeals to the baser appetites of the second soul: "I have pleaded guilty to all thoughts and expressions of mind which can be truly argued of obscenity, profaneness, or immorality, and retract them" (in Watson, II, p. 293).[39] A high purpose produces some extremely interesting and effective works of art. Some of these works reflect the reforming zeal of the Counter-Reformation, when much seventeenth-century religious art becomes less contemplative and more propagandistic than earlier art and thus more consciously rhetorical, more strongly appealing to the emotions, and more committed to overcoming the understanding. Monteverdi's *Vespro della Beata Virgine* is of this nature, as are Bernini's *Mistica dottora* in the Cornaro chapel,[40] Caravaggio's *Conversion of St. Paul* (1601–1602), St. Ignatius Loyola's *Spiritual Exercises*, and all the painful images of martyrs, their wounds and their sufferings. The heightening demanded by emotional art depends on violent action and tropes and figures in poetry; violent action, color, and *trompe l'oeil* in painting; and splendid noises and effects (for instance, echoes, instrumentation, and size of ensembles) in music.

The highest art often is thought of as the kind that appeals to the emotions so strongly that it captivates one's whole being, bathing the soul in pleasure and ecstasy. Montaigne says in his *Essays* (as translated by Charles Cotton [London, 1685]):

> There is indeed a certain low and moderate sort of poetry that man may well enough judge by certain rules of art; but the true, supreme, and divine poesie is equally above all rules and reason. . . . This is a sort of poesie that does not exercise, but ravishes and overwhelms our judgment. [I, p. 325]

It sounds as if Montaigne is thinking of the sublime (a concept synonymous with elevation), which he probably is not since concepts of the sublime did not take hold until the last part of the seventeenth century.[41] But once we enter the realm of raising the passions in the soul, we are talking about rhetoric proper, whether we are talking about Montaigne's passage or the sublime. According to Boileau's *Traité du sublime* (1674), and Longinus's *Peri Hupsous* (or *On the Sublime*), too, the raising of passions by sublime, or any other kind of, passages or imitations of actions is essentially rhetorical in nature. In translation Boileau says, "I have made a few reasonable observations thereupon, which perhaps may prove advantageous to many of our rhetoricians" (p. 3). The concept of aesthetic sublimity is only touched upon in the seventeenth century, and although Boileau also says that "[the sublime] does not so much perswade, as transport us to a certain admiration and astonishment, which is a clear different thing from bare pleasing or perswading" (pp. 4–5), the raising of elevated passions belongs under the aegis of classical rhetoric, as Boileau elsewhere implies, and as writers of the period say.[42] The importance of rhetorical devices to the raising of the passions becomes even more marked if we consider the influence of Ramistic rhetoric, which places style and elocution alone under the heading of rhetoric, an idea that was influential in the English Renaissance after 1580 and lingered on, despite opposition, into the seventeenth century.[43]

A rhetorical device that produces astonishment stuns or makes one speechless. All works that raise violent emotions do more or less than exhibit the regular, harmonious proportions that are beautiful. As the senses move to something other than beauty, Dryden says, "The sight looks with pain on craggy rocks and barren mountains, and continues not intent on any object which is wanting in shades and greens to entertain it."[44] Lomazzo says that greens (and shades) produce pleasurable sweetness and the attendant passion of delight,[45] a rather mild passion associated with the smaller, more regular, and gentle effects of harmony, symmetry, and beauty. To Dryden, "intentness" is contemplation, an attribute of the understanding, and the judgment cannot work under the effect of asymmetrical, harsher, extraordinary images

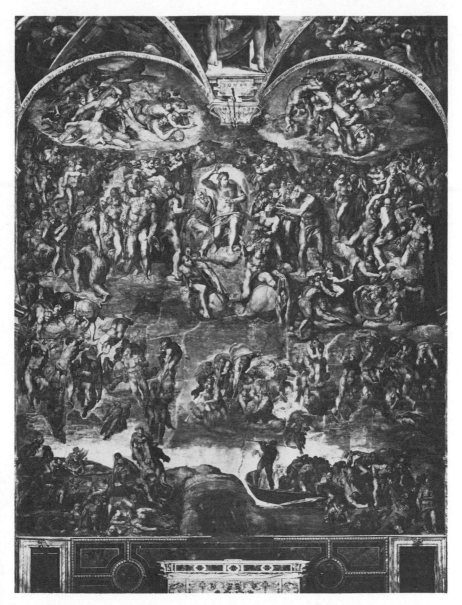

Michelangelo, *Last Judgment* (1541). Vatican, Sistine chapel; photo Alinari Scala.

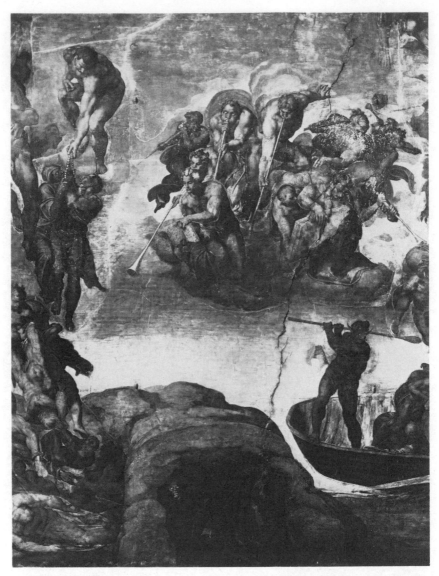

Michelangelo, "Detail of Trumpeters" from *Last Judgment* (1541). Vatican, Sistine chapel; photo Alinari Scala.

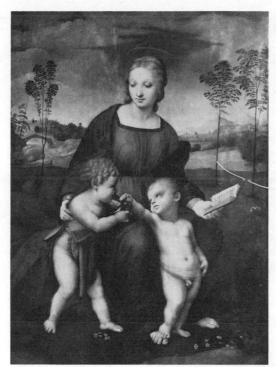

Raphael, *Madonna of the Gold-finch* (ca. 1507). Florence, Uffizi; photo Alinari Scala.

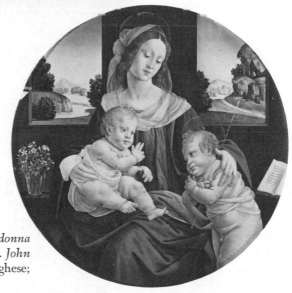

Lorenzo di Credi, *Madonna and Child with Young St. John* (1612–13). Rome, Borghese; photo Alinari Scala.

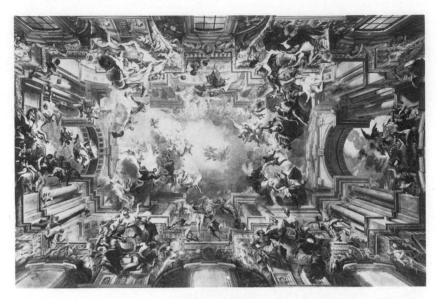

Andrea Pozzo, *Apotheosis of Ignatius Loyola* (1685). Rome, Sant' Ignazio; photo Anderson–Alinari from Art Reference Bureau.

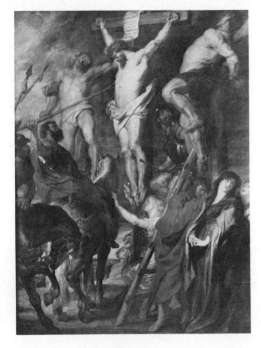

Peter Paul Rubens, *Le Coup de lance* or *Christ between the Two Thieves* (ca. 1620); courtesy Koninklijk Museum, Antwerp.

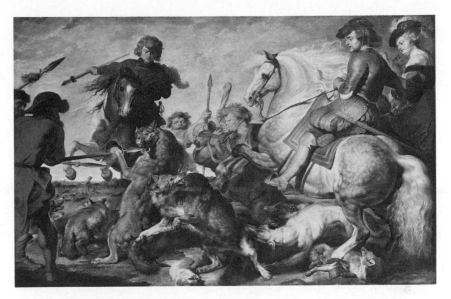

Peter Paul Rubens, *The Wolf and Fox Hunt* (ca. 1615); courtesy Metropolitan Museum, New York.

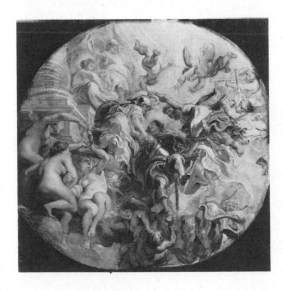

Peter Paul Rubens, *Apotheosis of the Duke of Buckingham* (1625–28); reproduced by courtesy of the Trustees, The National Gallery, London.

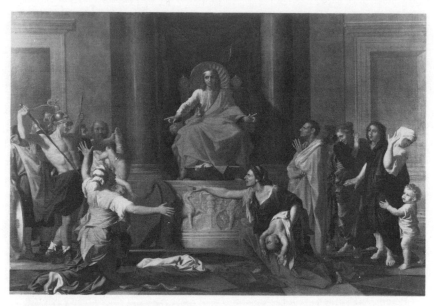

Nicholas Poussin, *The Judgment of Solomon* (1649). Paris, Louvre; photo Giraudon.

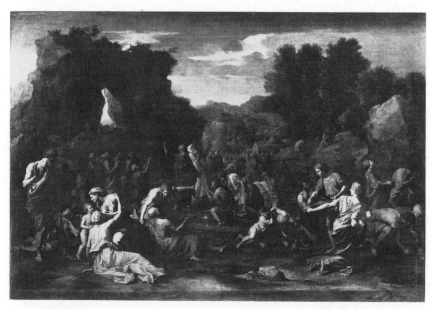

Nicholas Poussin, *The Israelites Gathering Manna* (1638–39). Paris, Louvre; photo Giraudon.

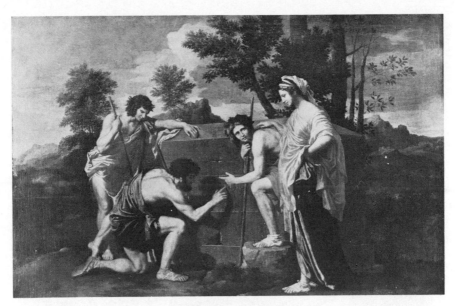

Nicholas Poussin, *The Arcadian Shepherds* (ca. 1655). Paris, Louvre; photo Giraudon.

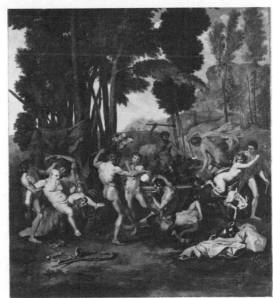

Copy after Nicholas Poussin, *The Triumph of Silenus* (original 1635–36); reproduced by courtesy of the Trustees, The National Gallery, London.

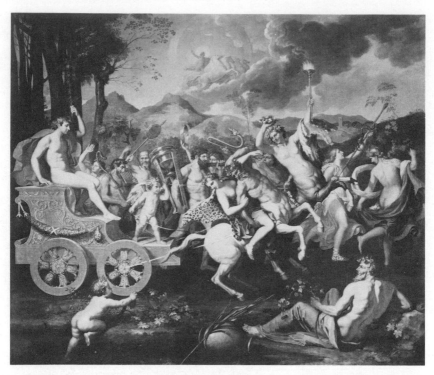

Copy after Nicholas Poussin, *The Triumph of Bacchus* (original 1635–36); courtesy Nelson Gallery–Atkins Museum, Kansas City, Missouri (Nelson Fund).

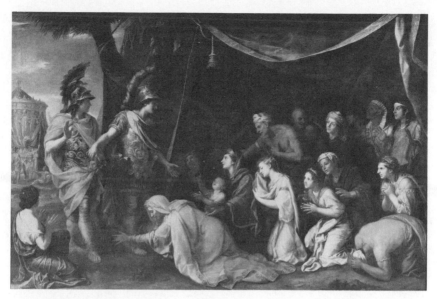

Charles Le Brun, *The Queens of Persia at the Feet of Alexander* (ca. 1660). Versailles; photo Musées Nationaux.

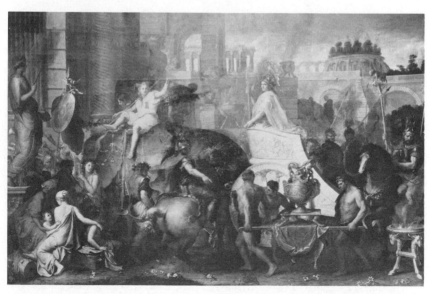

Charles Le Brun, *The Triumph of Alexander in Babylon* (ca. 1664). Paris, Louvre; photo Musées Nationaux.

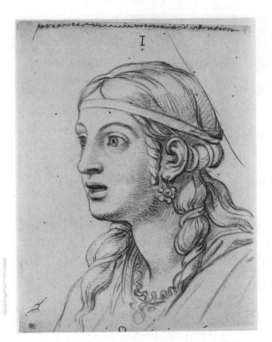

Charles Le Brun, "Woman Expressing Admiration with Astonishment" (1698). Paris, Louvre, cabinet des dessins; photo Musées Nationaux.

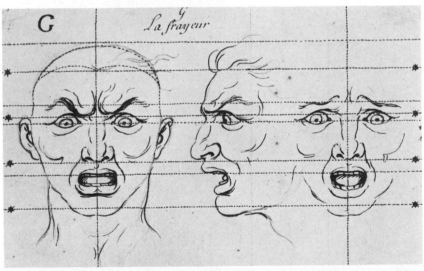

Charles Le Brun, "Terror" (1696). Paris, Louvre, cabinet des dessins; photo Musées Nationaux.

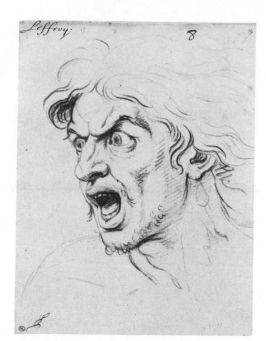

Charles Le Brun, "Head Show-
ing Expression: Terror"
(1698). Paris, Louvre, cabinet
des dessins; photo Musées
Nationaux.

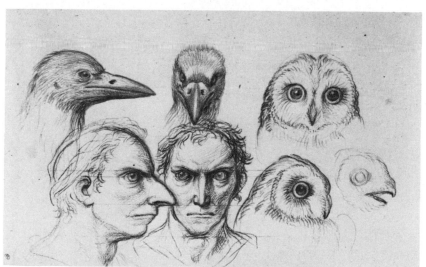

Charles Le Brun, "Heads of Crow-men with heads of crows and owls"
(1668). Paris, Louvre, cabinet des dessins; photo Musées Nationaux.

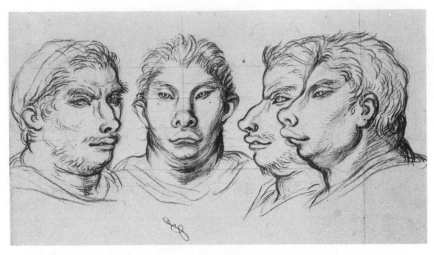

Charles Le Brun, "Two Heads of Wild Boar-men. Two heads of Pig-men" (1668). Paris, Louvre, cabinet des dessins; photo Musées Nationaux.

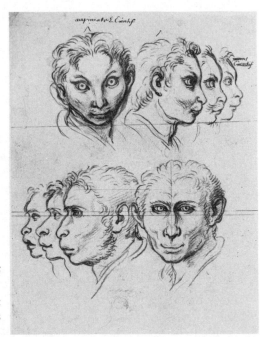

Charles Le Brun, "Heads of Cat-men and Monkey-men" (1668). Paris, Louvre, cabinet des dessins; photo Musées Nationaux.

or objects, more violent than those that are beautiful. What is beautiful is perfect or nearly perfect, and although perfection of the soul implies absence of passion, the contemplation of perfection, near perfection, or the idea of perfection is supposed to produce in the soul an elevating, mild, delightful feeling or passion. This idea of perfection is called *beauty*. Dryden conceives of beauty as the result of a rhetorical process culminating in an artistic object that is harmonious and balanced, raising in our minds "perfect and ideal images and thoughts," satisfying our understandings or judgments by "harmony and order," and pleasing "our senses with appropriate sounds, colours, etc."[46] It is easy to see why the correct works of Raphael, Lully, Virgil, Boileau, and Racine are so highly regarded in the Baroque era, especially when we consider that the harmony and balance they express and represent are regarded as including harmony and balance in the highest part of the souls of their audiences and spectators. Their work is both socially useful and beautiful, producing mostly emotions of satisfaction, calmness, and sweetness rather than astonishment or some other strong feeling.

The higher, stronger passions often are connected with the elevating effect of a work of art as a whole. The passions expressed by a work of art produce in the souls of audiences and spectators those same passions. They are conducive to the highest pleasures, which are described by words such as *admiration, astonishment,* and *sublimity*. A work of art overcomes the judgment through its imaginative power expressed rhetorically, elevating the soul to great heights. Thus, the power of art is great enough to elevate the soul to a pleasurable state almost in tune with universal harmony. Coeffeteau says in his *Table of Humane Passions* that "pleasures quench the judgment" (p. 264). He says also that admiration is a pleasure and "it is a great content to behold things which give us a subject for admiration: for the wonder which they stir up in our soules, inflames us, and makes us desire to know them, and the cause of our admiration. . . . With extreme pleasure . . . [we] mount up to the highest degree of our nature, and to elevate it to her perfection: wherefore this admiration causeth joy" (p. 282). In the same way, the admiration aroused in us by the total effect of Dryden's "Alexander's Feast," for example, al-

though a passion, is of an elevated nature, not like the baser passions of lust and envy, which the poem raises in passing.

Admiration and astonishment, as they are raised by means of rhetorical devices that appeal strongly to the senses, are very powerfully felt. As Charles Le Brun says, among the passions astonishment and admiration are of great strength, and Dryden says that admiration is "a pleasure [a passion in itself] not to be expressed by words."[47] The definition of *admiration* changes during the seventeenth century, becoming weaker as some of its earlier connotations are taken over by *sublimity* and *astonishment*. Dryden says admiration is strong, but Le Brun says it "is the first and mildest of the passions and the one which causes the least disturbance to the heart." The "excess of admiration causes astonishment, and astonishment can come upon us before we even know whether this object suits us or not."[48] Astonishment is connected to lightning and thunder, and when it occurs, the understanding or reason is struck into nonfunctioning quiescence. It is a term connected to the sublime, and Boileau notes this in innumerable places in his *Traité du sublime* (1674). Although in the seventeenth century *admiration* and *astonishment* often are used together, *astonishment* begins to take over connotations earlier attributed to *admiration*. By 1766, Gotthold Lessing can say that "admiration is only a cold sentiment whose barren wonderment excludes not only every warmer passion but every other clear conception as well."[49]

The most powerful and energetic works of art induce the stronger passions of astonishment and admiration. Dryden, in his justifications of heroic drama, calls figures that try to achieve the stronger passions "bold figures" and equates them with the heightening of strong colors in painting.[50] If the heightening works, the audience is transported, the reasonable soul is overcome; if the heightening does not work, the result is tumidity and laughter, as Dr. Johnson points out in his *Life of Dryden*, saying of four passages from three of Dryden's heroic plays, "the two first may be allowed to be great, the two later only tumid."[51] Many late seventeenth-century writers think it possible to place too much emphasis on the passions. The passion involved in *King Lear*, for example, led to Nahum Tate's adaptation, with its happy ending.

Thomas Rymer, the English rules critic, the voice of reason, hated *Othello*; Roland Fréart de Chambray and other French writers thought Michelangelo vulgar; the French moderns thought Homer unsuited to the more refined tastes of seventeenth-century France; and Englishmen of genteel taste preferred the fine sentiments and sedate sounds of Italian love songs to the more rollicking, often bawdy ditties of their native land. Since action usually produces reaction, it is not surprising to find that English audiences of the Baroque era also liked the rhetorical excitement of sometimes outrageous dramatic statements and actions that have little to do with reason; the most obvious example of this sort of art is English Restoration heroic drama. When they are most effective, these stronger images or objects excite the passions enough to bypass the understanding.

The idea that both imagination and judgment (delight and instruction) are important to art gave place more and more to the idea that judgment is a manipulative, factual, and rational faculty in a limited sense, that it is needed primarily to tame, to control, and to manipulate the unruly passions. The kind of work that raises the highest passions in the noblest ways sometimes reaches a union of the understanding and the imagination far surpassing the mortal powers of the judgment. Art that achieves this end is primarily allegorical, appealing to the highest parts of the soul through proportion, harmony, and other elevated levels of appreciation, echoing the harmony of God's creation and inducing that harmony in the souls of spectators and audiences. Art of this kind was predominant in the Neoplatonic orientation of the Renaissance. Later in the seventeenth century, and especially in the Restoration, as the understanding of medieval or Renaissance senses of allegory disappeared and as belief in the new science and factual knowledge (knowledge that is perceived through the senses) grew, there was a corresponding growth in art that appeals to the senses. Thus, the purpose of art changed, and the rhetorical manipulation of the passions through *elocutio* became more important than the rhetorical communication of a vision of supernatural truth and beauty, a vision often communicated through arrangement or proportion appealing to the understanding. French rules criticism, an avant-garde seventeenth-century

movement, rhetorical in the way that it favors manipulation of the emotions through verisimilitude and through a system of values external to works of art, grew in importance, although not so quickly in England, where older views lasted longer. The process of what Morse Peckham calls *cultural drift*[52] is in the Baroque age a change from art that primarily presents beauty to art that primarily raises emotions. But art is seldom, if ever, one kind or the other. Renaissance artists themselves were very much aware of rhetorically manipulating the emotions of their spectators or audiences, and late seventeenth-century artists were aware of abstract, Neoplatonic concepts of beauty. The mixture of these extreme attitudes toward art produced some impressive hybrids, works that express the energy and spirit of a vision of perfection combined with strong, effective appeals to the emotions. It is this kind of art that we think of when we describe great examples of Baroque art.

III

All of the conventional figures that produce the passions, as well as those that produce harmony, homeopathically achieve both high and low effects, depending on the maker's purpose. Lomazzo says in Book I, painting expresses "divers affections and passions of the mind" (p. 13), while a comely proportion and expression of these affections and passions produce the emotions connected to beauty (p. 25), which again is "communicated to the eye and so conveyed to the understanding" (ibid.). For example, the "effects of piety, reverence, and religion are stirred up in men's mindes by means of their suitable comliness of apt proportions" (ibid.). In other words, the expression of an emotion arouses that emotion in viewers. In the homeopathic theory of art, love or hatred depicted on the stage or in a painting (or poem or piece of music) is supposed to induce love or hatred in the spectators. The idea spans the Baroque age. John Hughes says,

> Nature herself has assigned, to every motion of the soul, its peculiar cast of countenance, tone of voice, and manner of gesture; and the whole person, all the features of the face and tones of the voice answer, like strings upon musical instru-

ments, to the impressions made on them by the mind. . . .
[Therefore] all tones supply the actor, as colours do the
painter, with an expressive variety.[53]

The homeopathic potentialities of both high and low passions
are illustrated by Charles Le Brun's *Methode pour apprendre à
dessiner les passions* (1695), in which he describes, in words near
to those of Descartes and in pictures, the passions a painter uses
to raise those same passions in the viewers of his art (see Plates
16–18). He employs such depictions of passions himself, excel-
lent examples of which are his series of paintings of Alexander
the Great.[54] Note the similarity between the woman in Plate 16,
who expresses admiration, and the woman on the far right side
of *The Queens of Persia at the Feet of Alexander* (Plate 14), who
is admiring Alexander. We, too, are supposed to feel admiration.
The homeopathic qualities of enthusiasm are mentioned also by
Roger Des Piles, who says they go beyond the more slow-working
effects of the sublime.[55] According to Des Piles:

> Enthusiasm itself is a rapture that carries the soul above the
> sublime, of which it is the source, and has its chief effect in
> the thoughts and the whole together of a work. . . . The sub-
> lime is perceived equally, both in the general, and in the par-
> ticulars, of all the parts. [P. 71]

The painter works himself up into an enthusiastic state several
times in the course of his making. The spectator who perceives
and feels this enthusiasm, and who does not have to consider par-
ticulars, is transported at once. The enthusiasm embodied in the
work "ravishes the mind with such violence, as leaves it no time
to bethink itself" (ibid.).

Music, as Gretchen Finney says, has to be emotional to raise
emotions (p. 131). She shows how affective theories of art were
coming into being in the seventeenth century and says that Mon-
teverdi (1567–1643) thought (in 1638) he was the first to depict
anger in music, in his *Il combattimento di Tancredi e di Clorinda*
(ca. 1610). Handel's splendid musical setting (1736) of John
Dryden's "Alexander's Feast" (1697) shows how well a composer
can induce passions homeopathically. Alexander the Great is en-

ticed into one passion after another by Timotheus, and Handel's
music and Dryden's verse express those same passions through
musical conventions and poetic devices. The scenes are dramatic
and pictorial, sequential yet separated, and they are described in
such a way that a painter could use them as the bases for a series
of paintings on the passions. The details are left out, which is the
prerogative of the medium of poetry and which allows us to see
our own conception of, for example, Alexander's face.[56] Handel's
keys, phrases, tempos, and dynamics, for example, manipulate our
emotions, making us feel in our souls Alexander's emotions. For
instance, in the section starting "Break his bands of sleep asun-
der / With a rattling peal of thunder," we are in the key of D,
with its "grandeur and magnificence" (Rameau, p. 164), employ-
ing trumpets and drums in an astonishing display of virtuosity,
literally waking us up (as well as Alexander) and exciting us, too.
The section is entirely artificial since Timotheus's lyre could not
except by connotation perform such marvels, but the passions the
music arouses in us do not allow us to think of the inconsisten-
cies. They overcome our rational faculties, leaving us astonished
(stunned) by Handel's and Dryden's rhetorical artifices and in a
state of admiration. The poem is a masterpiece by itself and Han-
del's setting is equally grand. When the work is properly per-
formed, its effectiveness comes from the rhetorical skill of its
makers.[57]

Tropes and figures also are described as homeopathic devices.
Puttenham, in The Arte of English Poesie (1598), indicates as
much by labeling figures of speech with appropriate English
names, names that indicate not only the intention with which an
author would use these figures but also the effect they are sup-
posed to have on readers or audiences. "The drie mock" (ironia),
"the bitter taunt" (sarcasmus), "the fleering frumpe" (micteris-
mus), "the privvy nippe" (charientismus), and "the overreacher,
otherwise called the loud lyer" (hyperbole) are just a few.[58] The
translations of Boileau's Traité du sublime indicate the same idea:
Pulteney (1680) says that anaphora and diatiposis combined pro-
duce "disorder and confusion," which "is the best argument of
passion, which is itself nothing but a disorder and confusion of
the soul" (p. 85), "so there is disorder in his method, and a method

in his disorder" (p. 86); the same thing is repeated in the 1687 translation, as well as in the one published in 1712.[59]

The passions have to be used judiciously, however, if art is to be rational; particular caution must be exercised when they are employed homeopathically. There are good and bad passions and affections. Robert Burton in *The Anatomy of Melancholy* (1621) tells us what they are (p. 141).[60] The good affection is joy, which dilates the heart and preserves the body. The bad affections are simple and mixed. The simple are emotions like sorrow and fear. Sorrow, for example, contracts the heart, macerates the soul, causes melancholy and even death. The mixed affections are such passions as anger, revenge, hatred (inveterate anger), zeal (against one who hurts what you have loved), joy at another's bad luck, pride, self-love, and envy. They are mixed because a little of each is necessary for health and stability. They are bad when they overcome the reason and are used for bad purposes, as defined rationally. The violent emotions of Elizabethan drama were thought barbaric by the French because they raise and exercise passions thought debilitating to the soul.

When the artist's purpose is rational, effective homeopathic use of the passions produces on occasion excellent art and persuasive propaganda. The cultural drift in the Baroque era is toward such rational art, in which the rhetorial means of arousing emotion are subservient to rational, calculated ends. As Thomas Tickell says in *The Spectator*: "The finest works of invention and imagination are of very little weight, when put in the balance with what refines and exalts the rational mind" (No. 634, 17 December 1714). It is easy to see how rhetorical art became used for purposes of propaganda (as it still is). Art was, of course, used in that way politically, especially by Louis XIV for his personal glorification and for the glory of France. He was able to do so by centralizing supervision of the arts in his personally controlled academies.[61] The same thing has been said about the Catholic church of the Counter-Reformation. It certainly is true that after the Council of Trent, the arts in Roman Catholic countries became more rhetorically oriented, more propagandistic, more aimed toward raising specific passions to manipulate those who came in contact with art in churches, pageants, and elsewhere.[62] The ef-

fects on art exerted by the two movements of rationality and of manipulation of emotions are incalculable. Rational art leads also to a refined kind of taste. André Félibien, for example, disapproves of astonishment, saying that it is produced by Gothic art, art that lacks the simplicity, order, and substantialness of that of the ancients. All these commendable qualities are present in the best works, works by Raphael, Poussin, Racine, and Lully.[63] With such sentiments in mind, we can understand how Continental as well as many English writers tended to approve of French Alexandrine couplets, English heroic couplets, the measured music of Lully, and the designs of figures literally balanced against each other in paintings such as Raphael's *Crucifixion, Parnassus,* and *The School of Athens.*

Passions, Rhetoric, and Characterization

The ordinarily accepted theories of the soul and its faculties, and attendant attitudes toward different parts of the soul, profoundly affect and explain human activities as well as approaches to thought and behavior. The faculty psychology and its vocabulary explain the way all character is conceived by Baroque artists and analyzed by their audiences or spectators; for example, whether they prefer decorous French art or the more untrammeled, traditional English works of art. Artistic conventions often are used to convey psychological states or character types. Thus, rhetorical effect frequently is a result of characterization, just as rhetorical devices help us understand character.

I

The passions are important to dramatic and poetic character analysis. The terminology is the same from the Renaissance through the eighteenth century. Shakespeare, for example, is full of references to the passions that he couches in the vocabulary of the faculty psychology. In some randomly selected passages from "The Rape of Lucrece," the villain Tarquinius speaks to Lucrece:

> Thy Beauty hath ensnared thee to this night,
> Where Thou with patience must my Will abide, [Will is the
> faculty that causes the body to act, sometimes under the

rule of the understanding, sometimes—as here—under
the rule of the concupiscible soul; in the latter case the
understanding is either bypassed or overwhelmed because
of the force of passion.]
My Will that marks thee for my earth's delight [the
satisfaction of passion, a product of the second,
concupiscible soul],
Which I to conquer sought with all my might;
But as reproof and reason [faculty of knowing right from
wrong] beat it dead,
By thy great beauty was it newly bred.
. . . All this beforehand counsel comprehends,
But Will is deaf and hears no heedful friends [the reasonable
faculties];
Only he hath an eye to gaze on Beauty,
And dotes [a fault peculiar to the fancy, lodged in the
second soul] on what he looks 'gainst law or duty
[abstractions understood by the reasonable soul only].
I have debated even in my soul
What wrong what shame, what sorrow I shall breed;
But nothing can affection's [the passions, part of the second,
concupiscible soul] course control
Or stop the headlong fury of his speed.[1]

Sextus Tarquinius, by having his reason (a faculty peculiar to
man) overcome by the irrational force of his passions (a part of
the concupiscible or sensible soul, which man shares with ani-
mals), has become a lawless animal (laws are a product of rea-
son). The vocabulary of the soul as Shakespeare uses it here is still
a part of our language.[2] Yet from the Renaissance through the
eighteenth century, the vocabulary of the soul does not consist of
disembodied metaphors as it does today. It refers to diagrammable
parts of the soul, making the references much more vivid. And
even when theorists disagree as to parts and functions, they alter
the diagram rather than construct one anew.

Shakespeare's Falstaff is a literary example from the late sev-
enteenth century whose sensible, or second, soul rules his entire
behavior, and his character can be analyzed in this light. Falstaff
is an exciting person, more witty and interesting and less predict-
able than someone like Prince Hal, who is soberly trying to de-

velop his understanding. Falstaff's imagination, common sense, and appetite control both his thoughts and his actions. He is no coward. He acts expediently: he heeds his common sense, his instinct for self-preservation, and his appetites. His fluency in elocution, or words and images, comes from his imagination. Falstaff's puns indicate a magnificent range of fancy (I Henry IV: I, ii, 6–48). And his imagery is strikingly vivid and concrete, rather than abstract (for example, II Henry IV: III, ii, 307–309). Falstaff fancifully argues against judgment, illogically supporting fantasy and drink (I Henry IV: IV, iii, 91–119). His fancy leads him into outbursts of song (II Henry IV: II, iv, 31–33). And in painting he prefers low, uninstructive hunting scenes (II Henry IV: II, i, 137–45). Sometimes King Henry V thinks Prince Hal is like Falstaff, that he lacks the judgment whereby to control his passions (II Henry IV: IV, iv, 54–68). Falstaff has no conscience, no developed abstract sense of right and wrong, because the understanding of right and wrong is lodged in the reasonable soul. He has no conception of honor because he is incapable of realizing what honor could possibly be (I Henry IV: V, i, 127–39). Shakespeare's characterization of Falstaff is consistent throughout. Falstaff says he has "judgment and understanding," but at the same time he insists (and probably believes) that he is a young man (II Henry IV: I, ii, 157–83); he unphilosophically and irrationally cannot bear talk of his own death and old age (II Henry IV: II, iv, 217–18). He does not generalize about mankind, concentrating his mind on one person, one situation, or one object at a time.

Charming though he is, Falstaff is really a glorified animal, his essence that of the second soul, and King Henry V must allegorically reject that part of his soul if he is to become an efficient king. Shakespeare (although he may also employ the character for various other dramatic purposes) embodies, through Falstaff's dialogue and action, an abstraction of the second soul, in make-believe flesh, blood, and clothes, creating for our pleasure and edification what seems to be a very real person. And we should judge Falstaff as an idealized version of an inferior sort of human being. Falstaff's appearance, his bulk and red nose, makes him appetite personified. To the later seventeenth century, he is a

kind of Silenus, a charming drunkard who is an instructor of youth as well (in this case Prince Hal). Socrates the teacher is also represented by painters as part Silenian, and Poussin's *Triumph of Silenus*(1635–36) and van Dyck's *Le Silène ivre* (1617) give approximations of Falstaff's image: the old, drunken, roistering fat man with a face and function we associate with Socrates (Plate 12). Note also in Poussin's painting the activities and figures associated with the second soul. Dryden himself, after describing Falstaff's qualities, immediately discusses Socrates, associating the two characters. Such a conception sets Falstaff's character and appearance clearly in our minds.[3]

The faculty psychology in the Baroque age does more than help explain or depict characters; it permeates the whole development of drama as a medium that both instructs and amuses by means of passions. The rise and fall of passions often are equivalent to plot, and characterization replaces plot as the most important element in a play. Thomas Otway's excellent and popular *Venice Preserved* (1682), a play relying almost entirely on historical theories of the soul for its conception, meaning, and effect, is not an imitation of an action in the Aristotelian sense but is rather an imitation of a series of motions.[4] *Motion* in the seventeenth century is equivalent not only to the motion of action but also to emotion. If we explain the organization of *Venice Preserved* as understood and used by playwrights of the period, and the organization of the play as it relates to the passions, we see that *Venice Preserved* is a display of passions (or characterization), rather than a plot of action, dependent on the passions aroused in the soul of Jaffeir, the protagonist. Each reversal or turn of passion, which in this play is synonymous with a turn of plot, is caused by people's playing on Jaffeir's emotions, and those varying passions fit the parts of the play as these parts are defined by Sir William Davenant (and repeated by Thomas Rymer).[5]

According to Davenant, "The first act is the general preparative [that renders] the chiefest characters of persons, and end[s] with something that looks like an obscure promise of design" (in Spingarn, II, p. 17). In Act I, Jaffeir is torn by desires of revenge and ambition, which are overcome by his love for Belvidera (Otway, pp. 120–21), and love is usually called the highest passion

since it leads to a harmony of the soul with God (F. N. Coeffe-teau, *Table of Humane Passions With Their Causes and Effects*, trans. Edward Grimeston [London, 1621], pp. 78–174). At the end of Act I, Jaffeir thinks he is resolved, at peace with himself. The promise of the design is the struggle we shall witness taking place in Jaffeir's soul.

Davenant says, "The second [act] begins with an introduce-ment of new persons, so finishes all the characters, and ends with some little performance of that design which was promised at the parting of the first Act" (in Spingarn, II, pp. 17–18). And in-deed, in Act II of *Venice Preserved* we meet all the minor char-acters, each of whom is out of temper, each afflicted by at least one overriding passion: lust for gold or revenge or ambition. We learn that the corruption that pervades Otway's Venetian community comes from the lack of control by the reasonable parts of the char-acters' souls. At the end of the act, the conflict in Jaffeir continues; Belvidera is forcibly torn from his side. He will not be ruled by love but will be subject to revenge and hatred and will carry out the plans to which those evil passions will lead him (Otway, p. 126).

In Act III, Otway again follows Davenant's description: "The third [act] makes a visible correspondance in the under-walks, or lesser intrigues, of persons, and ends with an ample turn of the main design and expectation of a new" (in Spingarn, II, p. 18). The decadent senator Lord Antonio (Otway's caricature of the first earl of Shaftesbury) indicates his animalistic soul by his im-personation of animals, and Jaffeir discovers the conspirator Re-nault's intemperate, animallike lust for Belvidera. Otway's char-acter Renault reveals the curse of concupiscence, saying, "What a slave is man! / To let his itching flesh thus get the better of him" (Otway, p. 131). At the end of the act, we are left waiting for the meeting between Jaffeir and Belvidera. We see an "ample turn of the main design" because of Jaffeir's passion. With Jaffeir alien-ated from them, the conspirators may be betrayed or they may succeed; the result depends on which way Jaffeir's passions move him. This state of affairs leads to the expectation of a new turn.

In Act IV, scene i, conquered by Belvidera and love, Jaffeir decides to betray the conspirators; love temporarily overcomes

hatred, revenge, and friendship. But in the reversal in scene ii, Jaffeir's passion of friendship for Pierre overwhelms the love Belvidera inspires, and in hatred he tries to stab her. Jaffeir speaks of his "divided soul that wars within" (Otway, p. 139). At the end of the act, Belvidera reconquers him, as Jaffeir says, "by all the power that's given thee o'er my soul" (Otway, p. 140). We see again that Jaffeir's turns of passion fit Davenant's description: "The fourth [act] . . . gives a notorious turn to all the underwalks and a counterturn to the main design which changed in the third [act]" (in Spingarn, II, p. 18).

The final act, Act V, Davenant says, unties the knots of the play. In the last act, we see that Jaffeir's passion for duty and friendship, as they are allied with hatred and revenge, cannot be reconciled to harmonious love. Thus, Belvidera's understanding fails to control her passions when Jaffeir leaves her to go to Pierre. Her soul can no longer cope with its internal dissension, and she gives up all control over her fancy. In short, she goes completely mad. In a passage reminiscent of the scene of Lear's madness (III, ii), Belvidera expresses the passions raging in her soul:

> How I could bleed, how burn, how drown, the waves
> Huzzing and booming round my sinking head,
> Till I descended to the peaceful bottom!
> Oh, there's all quiet; here, all rage and fury:
> The air's too thin, and pierces my weak brain.
> I long for thick substantial sleep. Hell, hell,
> Burst from the center, rage and roar aloud
> If thou art half so hot, so mad as I am.

After she goes mad, Belvidera's fancy (now unchecked by the judgment) imagines scenes that have no connection with the existent world; they are only for what she has always longed:

> Murmuring streams, soft shades, and springing flowers,
> Lutes, laurels, seas of milk, and ships of amber. [V, 355–62]

Jaffeir then goes to Pierre, who dies on the scaffold. Jaffeir commits suicide, the passion that manifested itself in friendship winning out over his love for Belvidera. In the last scene, the mad

Belvidera dies, the ghosts of Pierre and Jaffeir hovering overhead. The spectacle is hardly verisimilar, appealing almost entirely to the audience's emotions. And Otway expects the spectators' understandings to be overcome by the power of the passionate spectacle.

The faculty psychology provides the rationale and the method for plot and characterization, as well as for homeopathically manipulating audiences and spectators. Furthermore, it induces visual expectations into the minds of audiences or readers, for gestures in acting are conventional. Generally speaking, the reasonable part of the soul is most important. Where poetic justice is used, characters ruled by passion—for example, Racine's Phèdre—come to bad ends, while characters whose understanding and judgment dominate their souls are wise, good, and fortunate. Even where poetic justice is dispensed with, the audience is manipulated by the playwright according to his conception of their collective souls. This is what happens in *Venice Preserved*. There is no poetic justice, and the outcome of the play is logical. We see Jaffeir and Belvidera as horrible examples of souls distraught, of the trouble that comes when the parts of the soul war against each other, with no resolution occurring in this life. It is no wonder the play was popular with audiences who no doubt generally agreed with the philosophy of the soul on which the play rests.

II

The various parts of the soul and how they are affected by music are intimately connected to characterization, whether by reaction, performance, or composition. Purcell's song "Musick's the cordial of a troubled mind" is excellent testimony to the belief in music's power to calm the passions. It is "the softest remedy that grief can find." It "calms the rufling passions of the mind" (Henry Purcell, *Orpheus Britannicus* [London, 1721], I, pp. 117–22). Almeria, in William Congreve's *The Mourning Bride* (1697), is another late seventeenth-century character who is out of temper, whose reasonable soul is unable to control her passions. The most expeditious way Congreve can show this defect is through Almeria's reactions to music, for "Music has charms to sooth a savage breast" when it is of the right kind.[6] When Congreve's play opens, the harmony of music (as an imitation of the harmony of the uni-

verse) is supposed to bring Almeria's soul into harmony with itself
and with the universe, but it does not. She is too distracted, too
out of balance or temper. She says:

> Music has charms to sooth a savage breast,
> To soften rocks, or bend a knotted oak.
> I've read that things inanimate have mov'd,
> And, as with living souls, have been inform'd,
> By magick numbers [speculative music, based on Neoplatonic
> proportion and mathematics] and persuasive sound
> [practical music appealing to the passions and based on
> rhetoric].
> What then am I? Am I more senseless grown
> Than trees or flint? O force of constant woe!
> 'Tis not in harmony to calm my griefs. [I, i, 1–11]

Music is supposed to be able to calm disharmonious passions
or to arouse them. Either it keeps the soul in temper through its
calming effects, its own harmony, or it assaults the seat of har-
mony and understanding in the soul, raising disharmonious pas-
sions, which are supposed to be controlled by the judgment. These
disharmonious passions are the "motions" of the soul; they are set
in action by external motions taking such forms as sound, smell,
and literal movement. One way to describe this process is to say
that external motions (sounds, smells, movements) touch the
senses, actuating motions within us. Thus, when we say that a
work of art moves us, we are saying that we are literally moved,
our passions are aroused. When we describe the consequence of
motion in this way, we are talking about local motion, the stimu-
lation of a specific sense or senses. The imagination can, of course,
stimulate the senses, and thus the conscious use of synaesthesia
permeates art of the period—paintings to stimulate smell and
touch and music to stimulate sight, for example. In the sixteenth
and early seventeenth centuries, the tendency is to do this alle-
gorically; later, it is done more directly.[7]

A character's judgment, not his imagination, is essential to
decorum of behavior and speech, a concept very important to so-
phisticated men and women of the Baroque age, and we get clues
about a person's judgment or lack of it through his attitudes toward

music and its performance. Music, as well as the other media, is rhetorical, the direct affection of the senses being the purpose of "practical" music. Music arouses passions, producing an imbalance in the soul, but since through harmony music supposedly also heals the sick or emotionally disturbed, the effect of harmony is not always local. The spirit of a piece of music, the harmony, enters the soul, calming the passions and inducing harmony totally. In conjunction with the imagination and the passions (in the second soul), music may raise forces in the soul contrary to the rule of harmony, judgment, and understanding. Or it can help calm those same passions. A person with a strong understanding need not fear music. In fact, a well-balanced person always likes music, and something is terribly wrong with a person who does not like music at all. This idea is present before and during the Baroque age on the Continent as well as in England. Henry Peacham, for instance, quotes what he calls an old Italian proverb: "Whom God loves not, that man loves not music."[8] Thomas Mace says that music is "that thing which [the] worst of men most . . . refuse."[9] We need only cite Malvolio in *Twelfth Night* (1600; II, iii, 80–85), Shylock in *The Merchant of Venice* (1597; I, v, 1–3; II, vi; V, i, 83–88), Gripe in Shadwell's *The Woman Captain* (1680; see Act II), and Lump in Shadwell's *I he 'I rue Widow* (1679; see Act III). All of these music haters are desiccated, humorless (in both the modern and the old meaning) misers or social climbers. Quite simply, they lack the humanity, the elevation of the reasonable soul, that responds to a harmony that is the earthly reflection of divine harmony; this quality differentiates the more admirable forms of human life from the lower.

Although music can move us strongly, and although we may succumb to its charms temporarily, the reasonable soul in a balanced person should assert itself immediately after the music stops. A rational person from polite society never is carried away by music. As La Bruyère says, "A man of sense [*bon sens*] has in him the seeds of all truth and opinions; nothing is new to him. He admires little, it being his provence chiefly to approve."[10] If the reason does not reassert itself when the music ceases, the understanding must be deficient. Something is the matter with a character who responds too strongly or emotionally to music after

it has stopped. If someone says, "Play again that song I love so well," either he has to be cured of a weakness or he will come to a bad end. Thus, we know something is wrong with Duke Orsino's soul in *Twelfth Night* (1600) when he says, "If music be the food of love, play on, / Give me excess of it, that, surfeiting, / The appetite may sicken, and so die. / That strain again" (I, i, 1–4; see also II, iv, 1–4). The same is true of Alceste in Molière's *Le Misanthrope* (1666) when he repeats his nice but silly song (the scene with Oronte in Act I). It is also true of Sir Humphrey Scattergood in Shadwell's *The Woman Captain* (1680) when he calls for "the song I love so well" and then goes down into his garden to hear it again.[11] And the fumes of alcohol, combined with Timotheus's music, have overcome Alexander's understanding and judgment in Dryden's "Alexander's Feast" (1697), leading him to lust, violence, and other emotions and the actions that they inspire.

A well-bred, dignified person of the Baroque period rarely performs music, unless something is the matter with him. For an example of something wrong with the reason of an individual who sings, see Dryden's *Marriage à la Mode* (1673; I, i); Doralice opens the play singing "Why should a foolish marriage vow." Shadwell, too, thus uses singing in *The Lancashire Witches* (1681), in *Bury Fair* (1689), in *Don John, or The Libertine* (1675), and in the *Amorous Bigotte* (1690). There is an idea that the convention against singing in public may be primarily English. Edward Dent points out that the Elizabethans think someone who breaks into song mad, clownish, or supernatural. He explains further that the English believe that singers are only the medium for music. The Italian idea, he says, is that music expresses the personality of the singer.[12] There is something to the idea of differing national ideas and customs toward behavior. In Book II Lomazzo discusses national differences in showing emotion (p. 52) and in various kinds of dances (p. 53). But there are other traditional opinions about public performances that without question transcend national boundaries. The playing of wind instruments is especially frowned on (they are considered the most passionate instruments and therefore they appeal to the lowest parts of the soul). Lomazzo records the story of Minerva's (she

represents the highest parts of the soul) throwing away her in-
strument when she saw herself in the mirror (ibid.). Alcibiades
did the same. Castiglione refers to the same stories (p. 104), en-
joining people to avoid playing wind instruments. This disap-
proval extends beyond the Baroque age. The eighteenth-century
English gentleman Lord Chesterfield goes even further, telling
his son that *all* music is for listening only:[13]

> If you love music, hear it; go to operas, concerts, and pay fid-
> dlers to play for you; but I insist upon your neither piping nor
> fiddling yourself. It puts a gentleman in a very bad light;
> brings him into a great deal of bad company; and takes up a
> great deal of time, which might be much better employed.
> Few things would mortify me more, than to see you bearing
> a part in a concert, with a fiddle under your chin, or a pipe
> in your mouth.

The change in attitudes toward performing lies in attitudes
toward music. If music composes the soul, inducing into it the
same heavenly harmony it expresses, it is good and important. If
music serves mainly to affect the passions, it is not a decorous ac-
tivity for anyone with at least pretensions to good breeding.

In the early seventeenth century, practical music is thought
to heighten and intensify words, thus fusing poetry and music,
intellect and passion.[14] Poetry ordinarily is related to intellect;
practical music, to passion. In the music of Lanier and Lawes, the
words come first. There are no repeats, and Lanier's music, for
example, would be meaningless out of context.[15] By the time of
Henry Purcell and John Blow, the music is more important than
it is in earlier works. There are repeats, and the music can be
heard by itself.[16] The reason for the secondary role of music in the
first part of the century is the Neoplatonic idea expressed by Ficino
that the word is from and for the mind; whereas music, although
often a reflection of the harmony in the universe, finds its ana-
logue in that harmony rather than in the mind of God, which is
the origin of that harmony. Since the higher music is a reflection
of God's harmony and is able to project that harmony, serenity,
and health into a soul filled with disharmony (disharmony even
to the point of insanity), it is in one sense a medical device, while

the lower kind of music is merely an arouser of passion.[17] Music
(or dancing) as a curative can be dangerous or not, depending on
the origin of the disease. It may restore harmony to the soul by
calming the passions. However, if a disease comes from music,
music will make it worse: a tune, for example, may keep repeating
itself in a person's mind, increasing the aberrant passion.[18]

There are problems about how music expresses, or is able to
express, specific things like a passion or an idea. We have men-
tioned before how practical music or *musica humana* imitates the
thoughts expressed. In a phrase such as "his throne on high,"
"high" will be sung on a note higher than the preceding.[19] The
matter of rhythms' and keys' expressing or representing specific
passions is more complex. Isherwood says that French composers
of the early seventeenth century do not "correlate or imitate par-
ticular passions with particular musical rhythms," but use them
only "to provide a sense of motion and sound vaguely appropriate
to the emotional content of the text" (p. 71). This practice seems
to be generally followed. Keys are more interesting. Isherwood
says that in Lully's *Amadis tragédie*, C is optimistic; f is a "dark
key"; and F expresses faint optimism. There are several other key
changes before the finale in C, when the lovers are reconciled
(p. 234). Despite his use of keys to express passion, Lully knew
the French thought that music (or indeed any art) that overly
exercises the lower emotions (as opposed to ambition or glory,
for instance) is not good. He was a rational composer who wrote
music for a group of people who thought themselves rational.
Because of Lully's rationality, Edward Dent says that in his
operas, he does not use music enough for characterization (p.
157), but Dent does not seem fully aware of the meanings of
keys. He does say, however, that the C trumpet is martial and
that Lully uses major keys (actually, Lully merely prefers them)
because the French did not like "the savage emotionalism of the
Italians" (p. 204), an emotionalism expressed in minor keys.[20] In
French drama and painting, the same attitude toward rationalism
holds true. Poetic justice is a dramatic rule for that reason. In
painting, Simon Vouet's *Allegorie des beaux arts* (1626–27) is an
example. He shows that rationality should rule art even though
the passions are present. Minerva presides over the arts, while the

passions in the form of an undesirably presented satyr lurk in the bushes.

The meaning of keys is often rather elusive in the Baroque age because there was no exact, standard pitch and because a key does not always mean the same thing. Still, keys do mean something, and a composer had to have a reason for choosing one key in preference to another. Certain keys were used for particular instruments, especially for a valveless brass instrument. The emotions connected to this instrument, therefore, help determine what the keys it played in are supposed to express. The trumpet is a good example, and almost all of the trumpet parts in Purcell's *Orpheus Britannicus* are in C. Purcell (1658–94) uses C mainly for panegyrical odes (twenty of them) and war songs and triumphs (twelve). In Purcell's "A Song for St. Cecilia's Day, 1692" (*Orpheus Britannicus*, II, pp. 157–66), each instrument displays its sounds in a different key. Flutes were considered passionate or erotic, violins or like instruments were considered rational. Emanuel Winternitz examines the musical meanings of the *lira da braccio* in his *Musical Instruments and Their Symbolism in Western Art* (1967), analyzing Raphael's *Parnassus* in terms of musical instruments. He comments also on the erotic nature of flutes. Purcell uses flutes in love songs played in the appropriate minor keys emphasizing the lower passions (in the *Orpheus Britannicus*). He does so in "Hark the songsters of the grove" (I, p. 76), in "In vain the amorous flute and soft guitar" (I, p. 203), and in "Is my cavalier return'd" (p. 68), to name only three examples.[21]

The meanings of keys and the attendant problems can be seen without much elaboration in the songs of Henry Purcell and John Blow. Blow is a good composer but less up-to-date than Purcell, who of course was a first-rate musician and composer.[22] Blow's use of key indicates less preciseness of meaning than Purcell's, corroborating Isherwood's idea that key meanings become more definite as the century goes on (p. 71); yet Blow's music corresponds generally with the classification of loose meanings set up by Jean-Philippe Rameau in his *Traité de l'harmonie* (1722).[23] Rameau's idea is that keys and chords are identical with the modes, which in themselves are supposed to express particular passions.[24]

Purcell uses specific keys, more or less, with certain emotions. His songs about passionate love and its torments are in the keys of c, d, and g. He saves e for the most extreme cases of death, cold, doubt, and so on; a is not so extreme but is used generally for the same subjects. In a single song he changes keys to indicate which emotion is being expressed. For example, in "Bess of Bedlam" (*Orpheus Britannicus*, I, pp. 101–103) a madwoman wanders from passion to passion as her delusions—and the keys—change. This device is used by Purcell, too, in " 'Tis nature's voice" (I, pp. 158–165), a song about the passions themselves. There are a few exceptions to this scheme of Purcell's but there are reasons for them. Purcell wrote a panegyric to English wool in d and an ode to the merchant fleet in g. Apparently, the London merchants were more old-fashioned and still liked their panegyrical odes in minor keys.

The nuance of a particular passion presented itself to a composer of the time as fitting a certain key. Thus, there are no strict classifications. The pangs of love are less serious and less moving at one time than another, fitting one key rather than another. We can judge what a key means only from more general effects since a feeling for some keys is and was to a certain extent a personal matter. Thus, Blow's and Purcell's ideas as to what each key represents agree in general but sometimes differ in particulars. (Purcell, however, is more consistent in his assignations of significance to keys.)

III
Expression of the passions in painting is done through more or less codified or understood signals, rhetorical devices that take the form mainly of facial appearance but also of gestures, colors, draperies, hair, and scenes. Here, the English were almost totally dependent on French and Italian practice and theory. Roger Des Piles in his *Principles* (1709), in defining the difference between expression and passion, explains what passions are and how they are expressed.[25] To Des Piles, expression is a general term,

> signifying the representation of an object, according to its character and nature, and according to the turn which the

> painter has a mind to give it. [Passion] is an emotion of the
> body [the second soul], attended with certain strokes or lines
> in the face, denoting an agitation of the soul. . . . All passion
> is expression, but all expression is not passion. [P. 101]

Since Des Piles's statement that the passions are expressed through
certain strokes or lines was generally accepted, it is easy to see how
emotions became codified. Charles Le Brun's *Traité des passions*
(Paris, 1698), of course, codifies the passions (for examples, see
Plates 16, 17, and 18), and his ideas were highly influential.[26]
Le Brun also experimented with human heads, representing the
animal traits of the second soul as birds, cats, pigs, and so forth
(Plates 19, 20, and 21).[27] Félibien records that traits of the body
and face show character. In Félibien's "Second Conference" (Sat-
urday, 4 June 1667) van Opstal comments that Laocoön's courage
and goodness are seen in his large chest and high shoulders, that
his face and body show *douleur* (pain), horror, fear, and despair
all together, especially *douleur*. Félibien says that colors express
perfectly the passions of the soul (*Entretiens*, III, p. 209).[28] Des
Piles is more specific in describing the passions. There are two
kinds (an idea he gets from Quintilian): pathetic and moral. The
pathetic commands, the moral persuades. The pathetic passions
are violent—hatred, wrath, and envy; the moral are those of ten-
derness and humanity. Then he indicates how features show these
passions. To show scorn, raise the tip of the nose and swell the
nostrils, "drawing the upper lip up to the corners of the mouth."
"The nose," says Des Piles, "is the seat of anger in beasts," not
men. Therefore, it expresses only the emotions of beings repre-
senting the animal soul. Pan, for example, wrinkled up his nose
in anger when the nymphs tied him up and insulted him.[29] Lo-
mazzo is even more specific than Des Piles. In *A Tracte Con-
taining the Artes of Curious Paintinge, Carvinge, and Building*
(trans. Richard Haydocke [London, 1598]), he describes a mili-
tary complexion:

> Swart complexion, mixed with adust redde, having a low
> forehead, great eyes, in color yeallowe like the flame of fire,
> with large eyelids, wide and open nostrils, breathing forth
> vapors in great abundance, a wide mouth, thicke lips, and

redde, white teeth, small eares, a round chinne, forhead and
jaws, a darkish haire, but tending to a fiery redde; stiffe,
wreathed, and curled locks, an exile, shril and violent voice,
etc. delighting altogether in laborious matters, as to beare
arms, exercise his bodie in wrestling. Likes report of ter-
rible and fearful accidents better than smooth and pleasant
carpet-discourses: he is exceedingly sensual, impatient, un-
quiet, stirring, etc. [Book II, p. 14]

The soldier is obviously a type, and his personality has been
formed by a particular humour, namely, choler. His choler upsets
the harmony of his soul, causing him to be afflicted by violent
passions like anger and hatred, besides giving him other qualities:
boldness, arrogance, fierceness, boisterousness, and violence.[30] Lo-
mazzo also describes abstract passions. Mercy (or a merciful per-
son) has a sour, pale, woeful countenance and a weeping, bowing
head; his neck is turning, his hand reaching out, his arms spread-
ing abroad (p. 66). See, for instance, Simon Vouet's *Saint Eu-
stache enlève au ciel* (1635)[31] and Charles Le Brun's *Les reines
de Perse aux pieds d'Alexandre, ou la tente de Darius* (1660–61;
Plate 14).[32] Rusticity in a person is shown by posture. A character
leans with an arm or a leg on what is next to him. His actions are
clownish, slow, irreverent (p. 71). Poussin's shepherds in *The
Arcadian Shepherds* (ca. 1662) are good examples of rustic folk
(Plate 11).[33] Color, to Lomazzo, not only expresses emotions but
adds "a . . . true spirit and life to all such things as are first artifi-
cially drawn" (Book III, p. 97). Mirth is red. Thus, the Virgin
casts her eyes to earth (humility), but her complexion is mixed
with red (Book II, p. 44). All of these gestures, colors, and ex-
pressions serve to raise passions in viewers. They do so homeo-
pathically, according to "what kinde of bodies" are most receptive
to what is expressed (Book II, p. 12). In other words, a passion
expressed most easily arouses someone with a like passion, thus
altering the body by the influence of art (Book II, pp. 10–12).
Raphael, to Lomazzo, is the best painter of motion because he ex-
presses the most balance, the least turbulence, and induces that
balance into the soul of the viewer. Raphael is the favorite painter
of the seventeenth-century French for the reasons Lomazzo gives.

Characterization in painting appeals to the understanding, the
imagination, and the passions as it instructs and gives delight; it

also was thought to express the soul of the creator. The greatest painters unite instruction of the understanding with the highest pleasures. That is, a painter shows the power of his understanding (or lack of it) by expressing through his characters the harmony or lack of harmony in his own soul, instructing his viewers through his own example and inducing the pleasure of harmony into their souls through the total harmony of his work.[34] Raphael and Virgil, with their graceful balance and regularity, were much admired in late seventeenth-century France, Restoration England, and in general in the eighteenth century because their understanding or judgment is so obviously in control of their art. The admiration felt for Raphael's painting is an elevated kind of pleasure. Thus, characterization in Raphael's painting is linked to the kind of pleasure based on the harmony appreciated by the understanding rather than to the titillation experienced by the external senses, which arouses low passions. We can see how instructive pleasure works in artistic characterization by looking at Shaftesbury's analysis of *The Judgment of Hercules*.[35] In his essay "Notion of the Historical Draught or Tablature of the Judgment of Hercules" (1713), he says that in a history painting (the highest genre of painting), "Men, . . . manners, and human passions are represented" (in Holt, II, p. 244). Thus, Hercules becomes an instructive example whose elevated soul leads him to choose the path of virtue (a higher pleasure) over the pleasures of the senses. Shaftesbury thinks that the greatest pleasures are those that lead to, and result from, harmony in the soul, and in a painting the depiction of the more noble passions gives the greatest pleasure. Roland Fréart de Chambray, in *An Idea of the Perfection of Painting* (trans. John Evelyn [London, 1668]), says much the same thing. In characterization, the higher passions give pleasure and instruct by example. He says,

> But as the first three parts are highly necessary for all painters in general [invention, proportion, coloring]; this fourth, which concerns expression and motion of the spirit, excells them all, and is indeed admirable; for it gives not only life to figures, by representing their gestures and passions; but seems likewise to make them vocal and to reason with you. It is from hence, a man is enabl'd to judge of the worth and abilities of a painter. [P. 14]

Fréart's "expression and motion of the spirit," as it is translated by Evelyn, is a complex phrase. *Expression of the spirit* refers to the artist's soul as well as to the soul of the character; *motion of the spirit* means the emotions in the characters' souls. He assumes here that the motion of the spirit is on a high level; otherwise, the artist would not be a good man, and thus a bad artist. Fréart then goes on to say that good characterization means honor, modesty, and good manners. In other words, in good characterization, we are instructed by the ethos of the artist himself, as well as by the example of his characters. Raphael is an excellent artist to consider since in the late seventeenth century he was noted for his expression.[36] We can use Fréart's ideas (ideas common in the late seventeenth century) to analyze Raphael's *The Madonna of the Goldfinch* (Plate 3). In the symmetry of the painting, we can see the piety and good nature of the major figure (illustrated through her grace and through her noble, relaxed, and humane gentility) as well as the peaceful good nature of the children (Christ and John the Baptist), all reflecting the tranquil soul and the piety of the artist. The Virgin becomes a model for good behavior. Lorenzo di Credi (1459–1537) may not be as good a craftsman as Raphael, and in his *Madonna and Child with Young St. John* (Plate 4) it is immediately apparent that he is also less well tempered. The symmetry is there; the Virgin is a model for good, pious behavior; and the drawing of the major figure is excellent. What is missing is a grace of vision, the harmonious blending of elements and actions. The major figure is more awkward, superficial. And it is artificially posed: the tilt of the head, for example, is an affectation showing a fanciful aberration. The motion of the spirit is less impressive; the expression, inferior; the painter is inferior in his own character; the painting is not as good as Raphael's.

Not all painters and critics necessarily agree with the ideas of the rather straitlaced Fréart, who thinks nudes vulgar, for example. Still, their way of looking at paintings is fundamentally the same.[37] Nicholas Poussin, in speaking of his own work, agrees generally with Fréart (1647):

> If the picture of Moses found in the waters of the Nile, which belongs to Monsieur Pointel, has filled you with a feeling of

love, it therefore bears witness to the fact that I did it with more love than your pictures. Don't you see that it is the nature of the subject that is the cause of this effect and of your feelings and that the subjects that I treated for you must be represented in a different manner? This is what the whole artifice of painting consists of. Pardon the liberty I am taking if I say that you have shown yourself to be hasty in the judgment you made of my works. To judge them well is very difficult unless one has closely combined a great amount of theory and practice in this art. Our emotions should not be the sole judge but reason, too.

[Si le tableau de Moïse trouve dans les eaux du Nil, qui possède Monsieur Pointel, vous a donne dans l'amour, est-ce un temoignage pour cela que je l'aie fait avec plus d'amour que les vôtres. Voyez vous pas bien que c'est la nature du sujet qui est cause de cet effet, et votre disposition, et qui les sujets qui je vous traité doivent être representes par une autre manière. C'est en cela que consiste tout l'artifice de la peinture. Pardonnez à ma liberté si je dis que vous vous êtes montré précipiteaux dans le jugement que vous avez fait de mes ouvrages. Le bien juger est très difficile, ci l'on n'a en cet art grande théorie et practique jointes ensemble. Nos appetits n'en doivent pas juger seulement, mais la raison.][38]

The close relationship of characterization to instruction and pleasure is summed up concisely in a passage by Sir Joshua Reynolds, whose thinking reflects the same tradition although he lived a century later. After stating that "you cannot express the passions [the lower passions], all of which produce distortion and deformity, more or less, in the most beautiful faces" (p. 58), he later says,

To him who has no rule of action but the gratification of the senses, plenty is always dangerous; it is therefore necessary to the happiness of individuals, and still more necessary to the security of society, that the mind should be elevated to the idea of general beauty, and the contemplation of general truth; by this pursuit the mind is always carried forward in search of something more excellent than it finds, and obtains its proper superiority over the common senses of life, by learning to feel itself capable of higher aims and nobler enjoyments. In this

gradual exaltation of human nature, every art contributes its
contingent towards the general supply of mental pleasure.
Whatever abstracts the thoughts from sensual gratifications,
whatever teaches us to look for happiness within ourselves,
must advance in some measure the dignity of our nature. . . .
The art which we profess has beauty for its object; this it is
our business to discover and to express; but the beauty of
which we are in quest is general and intellectual; it is an idea
that subsists only in the mind; the sight never beheld it, nor
has the hand expressed it: it is an idea residing in the breast
of the artist, which he is always labouring to impart, and
which he dies at last without imparting; but which he is yet
so far able to communicate, as to raise the thoughts, and ex-
tend the views of the spectator; and which, by a succession of
art, may be so far diffused, that its effects may extend them-
selves imperceptibly into publick benefits, and be among the
means of bestowing on whole nations refinement of taste:
which, if it does not lead directly to purity of manners, ob-
viates at least their greatest depravation, by disentangling the
mind from appetite, and conducting the thoughts through
successive stages of excellence, till that contemplation of uni-
versal rectitude and harmony which began by taste, may, as
it is exalted and refined, conclude in virtue.[39]

By "disentangling the mind from appetite," as Reynolds puts it,
the artist will have started a spectator's mind on the path toward
virtue. He does so through the presentation of characters that in
themselves aspire to the highest levels of human excellence and
that reflect the virtues of the artist himself. The artist projects
himself and what he wants to express through his characteriza-
tions. His own state of being, therefore, should be such that the
understanding rules the thoughtless passions and appetites and
the shifting, unprincipled opinions of the second soul. All art
should appeal to the understanding. The flawed characters con-
ceived by artists in terms of the faculty psychology, characters
torn between one passion and another or between passions and
virtues, became important object lessons for people who analyzed
their own souls and behavior in the same way.

SIX

Rules Criticism and Aesthetics

The most important critical, intellectual, and social move-
ments of the seventeenth century caused great changes in the
perception and the status of the arts. These changes influenced
what kind of arts were encouraged and regulated, the audiences
to whom artists spoke, what artists were trying to say, and what
kinds of art were most stimulating to the artists themselves.

There are two general lines of thought expressed in this pe-
riod: one distrusts individual human faculties and so denigrates
the role of individual genius; the other thinks of the human mind
as a microcosm of God's mind, thus flattering man's faith in the
importance of individual visions, insights, and power, especially
as they are expressed and felt through art. The first line of thought
expresses skepticism about individual human abilities; its propo-
nents believe in an external system of rules, probabilities, and
conventions to provide a way for the ordering of individual artistic
productions. The second line of thought is more traditional and
expresses more optimism about human capabilities; its proponents
believe that individual powers rather than rules are most impor-
tant in visualizing and in imparting ideas of beauty and perfec-
tion. Adherents to this line of thought show more faith in what
we call individual genius and place less emphasis on the judg-
ment. The imagination visualizes, and the judgment regulates the

imparting of what is visualized. By the English Restoration, this view is less *à la mode*, more provincial, more English than Continental, but extremely important in providing an alternate, and subsequently a major, line of aesthetic and critical thought in Western European culture. In the Restoration, however, Continental rules criticism and ideas of judgmental control over both art and behavior exerted a powerful influence over English minds, although the English never accepted this view entirely (or certainly not to such a degree as the French). The change that took place in England corresponds to the cultural drift toward correctness, toward rules in behavior and in the arts, toward the new science and new theories of knowledge.

I

Rules criticism means that works of art should be constructed according to preconceived notions of correctness: in theater, the dramatic unities of time, place, and action and the *liaisons des scènes* (the absence of scene breaks, the stage in a single act never is empty); mathematical proportions of bodies and of perspective in painting as derived from other works of art; in poesy and in painting, the manners, whereby decorum of persons is kept, in delineation and placement, appropriate to social station, sex, profession, and so forth; the restraint of violence or untoward behavior in all the arts; the use of poetic justice, with its fitting rewards and punishments; the conventions of key and mode used to arouse passions in practical music. Regularity and proportion of the rules result in beauty of a rational kind, an instructional sort of beauty that helps calm the passions and also leads to the social utility effected by the example of characters' proper behavior, according to their stations in life. The rewards and punishments are received by good and bad characters according to their actions and their social stations. The feeling of serenity and stability induced by ordered art was an important part of aesthetics. It was justified in the seventeenth century as the ideal order and peace that reign in a soul in which the judgment or the understanding rightfully controls the aberrant forces of the imagination and the passions. The orderliness, balance, harmony, grace, and evenness that the rules try to induce in audiences are the same qualities that we

detect in balanced works of art such as those by Virgil, Poussin, and Raphael, who impose the order of an ideal world on imagination and nature—in a manner that many thought equivalent to the way understanding in a good person should order the irrational faculties of the soul.

The manifestations of the rules make works of art seem less artificial, nearer to a probable version of truth or reality. A play embodying the unity of time, for example, represents nature more closely than one that covers years because the former corresponds more nearly to the time taken up by a play's performance. Poetic justice—the reward of goodness, the punishment of evil—imposes an ideal order of probable, natural truth found all too seldom in everyday existence. Rules criticism is rational, appealing to the judgment (although the rules themselves are not rationally but dogmatically based), and its rationality was strong support to people who believed that the irrational faculties should be controlled by the rational. By subscribing to the rules, an artist shows an admirable subservience to reason and to nature because the rules, like the new science, are equated with the ordering of nature itself. Alexander Pope says, "Those rules of old discovered, not devised, / Are Nature still, but Nature methodized" ("Essay on Criticism," in *Poems*, ed. John Butt [New Haven. Yale University Press, 1963], p. 146, ll. 88–89).

The paradoxical advantage of rules is that an artist narrowly restricted is freer to concentrate his energies in other directions. Racine, therefore, produced within the rules regular and beautiful masterpieces of psychological subtlety, and second-rate sixteenth-century Italian painters like Zuccaro, who worked within the rules, were able to turn out extraordinarily good work. The disadvantage of the rules is that all too often they legislated artificially a kind of external verisimilitude, what Dryden, with his inadequate knowledge of sculpture, calls the "beauties of a statue, not of a man." The coldly impersonal outward regularity and balance of external appearances does not in itself capture the soul within.[1] Neoplatonic ideals of divine reality as captured by the imagination are not really possible under a rigid rules criticism because the rules presuppose ideal truth to be defined collectively through the rules. Proponents of rules criticism, no matter of what

age or what kind of rules, profoundly distrust the individual imag-
ination, placing limits on human endeavor. There is some justice
in the observation that watching a French play is like watching
someone dance in chains: the wonder is not at how well the per-
son dances but at the beauty of his movements within such con-
fining bounds.[2]

Many people in the Baroque era, just as people of any age,
were tempted to believe in reductionistic, safe, and relatively sim-
ple ways of codifying behavior and truth. The rules, especially
literary rules, provided a short cut that seemed rational, and there
is nothing strange about a general movement toward simplicity
and stability in an age when there occurred the most jarring kinds
of changes in the way man was forced to view his relationship to
the universe. The new science, especially astronomy (but cer-
tainly other areas as well), induced profound spiritual changes
that in their complexity are difficult to understand. Besides, a
belief or faith in scientific fact and probability tends to downgrade
the importance of imaginative speculations or mere imitations of
reality (as opposed to demonstrations or explanations of natural
phenomena). The basis for rules criticism lies partly in its intel-
lectual parallel to the new science. The rules were, as Pope says,
discovered. They supposedly were discovered in ancient writings
as scientific laws were discovered in nature, and they certainly
were believed in by many as if they were equal to those laws and
natural principles discovered by Newton, Galileo, Copernicus,
Kepler, Gilbert, William Harvey, and many others. After all, the
writings of the ancients were regarded as "nature." The literary
and dramatic rules were partly an effort to keep pace with science,
to assure to literature and the other arts a certainty that they nat-
urally do not have, and were partly an attempt to impose a rational
form, an order, on the seeming chaos of human behavior and of
natural events. The unities, poetic justice, *les bienséances*, deco-
rum all existed to make probable representations of the world
more believable. The most startling rule is "poetic justice," which
unlike the other rules is philosophical rather than structural in
nature. As a play imitates existent nature, and the rules try to
achieve verisimilitude, so poetic justice is a concept imposing an
ideal conception of existence on existence itself. It works, of

course, by formula: actions are rewarded or punished according to degrees of goodness or badness. No conception of existence could be further from the imaginative creations of Michelangelo and Shakespeare.

The new science, with its faith in empirical data gathered by the senses, has to believe in at least the possibility of accuracy in its observations. Accordingly, many of those aligned with the new science disparage the role of the imagination and distrust individual speculation.[3] A human being is not so much a mysterious image of God, with vast potential, but more an object or superior animal. A human being with limitations can be studied and observed; experiments can be conducted on such a creature. Nature itself is what can be observed, not the infinity of God's mind. The rational judgment can derive rules from phenomena, but the imagination alone can attempt to envisage infinity. The distrust of individual reason (as reason is opposed to the authority of empirical observation by the senses) leads to a formulation of rules that supersede individual thought. Thus, the rules, especially in France, where the most avant-garde thought was found, were thought by many to be an aid to expressing truth. It is not surprising that we find the usual opinion of the rules voiced in a scientific treatise: Abraham Bosse, in his *Traité des pratiques geometrales et perspectives* (Paris, 1665), insists on the rules and says that some practitioners of the arts even believe that they "trouble and fatigue invention and also create difficulties in imagining beautiful images" [troublent et fatiguent l'imagination, et mesme qu'elles empeschent les belles idées]. He says that the idea that the imagination is superior to the rules is an opinion (or whimsy) founded on bad habits and bad taste (p. 121).[4] The authority of the rules became more important as belief in innate goodness as a check on human aberrations declined and belief in the Hobbesian idea of human beings as innately selfish and bestially motivated advanced. The rules were formulated by the collective efforts of human beings and therefore were thought to transcend the vagaries of a single imagination.

Emile Bréhier thinks that in the seventeenth century "the vital, exuberant spontaneity that men like Bruno [a Neoplatonist] saw in nature gave way to the rigid rules of mechanism."[5] He

points out that the period 1620–50 is decisive for the scientific movement (pp. 16 ff.), the growth and importance of which is immense.[6] Although the crucial years in the history of science are approximately those Bréhier identifies, the changes corresponding to advances in scientific thought had been going on for some time and continue afterward. Otherwise, there would have been neither the intellectual climate nor the mental set or pointing of individuals to achieve breakthroughs or to make discoveries. Changes were taking place in music, for instance, from Neoplatonic, mathematically oriented, theoretical art that is supposed to induce harmony into the soul (and body) to the more practical music—music as affective art that appeals to the senses.[7] The increased trust in the senses led to the relativism of sensational psychology in the early eighteenth century;[8] the acknowledgment of the mystery of natural elements and its concomitant effect on the importance of the arts;[9] the split between scientific thinkers, with their specialized knowledge, and humanists, who deal more with general knowledge; the erosion of belief in orthodox religions;[10] and the belief in centralization of authority not only by means of the rules in the arts but also by a political reorientation.

If human beings are out only for their own gain and are subject to too many aberrations, rules become all-important not only in the arts but also in politics for the restraint of appetites that are antisocial. Sir George Clark points out that although Hobbes is not a totalitarian, the idea of totalitarianism is present in his writings.[11] The rationality of French thought as it corresponds to the rigor of rules, scientific precision, and reliance on the senses led to government supervision. Louis XIV, with his able economic minister Colbert, for example, centralized his academies and thus gained control of the arts, using them to glorify himself, to foster order in the realm, and to show the order that already existed.[12] That control relied on a mixture of beliefs. It appealed to a liking for a Platonic moral order, but through specific appeals to the senses it was really concerned with the manipulation of the social and political order, encouraging this order and glorifying it for rational ends as defined in a social sense.

The interest in the new science was international and pervasive. Fontenelle's *Plurality of Worlds* (1686), for example, was

translated into English shortly after its publication in France, and there was a carry-over from science to disciplines besides the arts, areas such as the classics and history.[13] The results of the interest in the new science were different in different countries; they reflect the extent to which the old Neoplatonic humanism was supplanted. In Restoration England there was no centralization of power either in the arts or in politics, but because the English were catching up to the Continent, in many ways the changes in the arts were more drastic than in France. Kerry Downes correctly points out, for example, that "the ninety-one years of Wren's life saw changes in English architecture comparable to three whole centuries in Italy."[14] Christopher Wren, a devotee of the new science, as a compromise tried to combine the old and the new, what Victor Fuerst calls the rational and the ornate Baroque.[15] But compared to the Italians and the French, the Restoration English came closer to older Neoplatonic ideas about art, and these views, combined with the English growth as a middle-class, commercial power, along with English interest in science, made for a rather schizophrenic attitude toward the arts.[16] The English, therefore, were extremely interested in ideas from the Continent but used them only sometimes, at other times rejecting or partially accepting them. But in general, in Restoration England the growing influence of French ideas caused an increasing belief in rules, the rational ordering power in the arts that appeal to the most reasonable part of the soul. As H. T. Swedenberg, Jr., says, "We can document a general swing to belief in authority as the seventeenth century draws to a close. The rules and reason became companions."[17] The kinds of individual and national adherence to ideas in the period have a great deal to do with our analyses of what artists were doing and saying, particularly through their use of imagery of all kinds, for imagery drawn from art of different places has by necessity been selected not by chance but by conscious choices. Such choices vary from age to age and from artist to artist. But despite individual variations, works of art are subsequently more popular in one period than another. The choices and preferences displayed by cultures and individual artists help us understand their values, tastes, and ideas. It is important to know why a group of people prefers Rubens to Poussin, for example.

II

In the English Restoration partial resistance to Continental taste, correctness, and artistic rules led to a different taste and formula for greatness, in both the appreciation and the composition of art; in other words, the English developed a different aesthetic.[18] The French influence was so powerful that it took a dramatic corpus of English plays that is sometimes regarded as the world's greatest flowering of drama to provide impetus enough for an English aesthetic based on irregular art. The realm of English tragedy and tragicomedy, especially, provided the English with definitions of great art that did not exist in France and that color the perception of all Englishmen, even when they use French critical ideas and vocabulary. In this period the English express a bifurcated vision of art. When Dryden uses Corneille's ideas in his famous "Essay of Dramatic Poesy," his use of those ideas, for example, points to different assumptions and conclusions.[19]

Renaissance English plays, which were thought in the Restoration to appeal almost entirely to the passionate and not the reasonable soul, exhibit a kind of transcendent *élan vital*, which is found in a higher kind of order or unity. That unity is the product of an imaginative breadth of vision, or force, that is analogous to the seeming chaos of the universe, over which God has imposed a transcendent unity, and that appeals in a delightful way to all parts of the soul simultaneously. Restoration writers often prefer an *élan vital* to a controlled form and content that please by a superficial verisimilitude, by an instructive order, and by a manipulation of the emotions, and they justify its value by explaining how it is a product of, and appeals to, the highest parts of the soul. Our understanding of the aesthetics of an enhancing, elevated delight (rather than rules-oriented instruction or rhetorical titillation) plays an important role in our recognizing the strength of the English preference for, and justification of, imaginative force in art. We can reach an understanding of attitudes in the period through the then strong but now faint connotations of such words as *lively* and *motion*, through the role of the passions in art, and through a demonstration of the kind of art thought most excellent in the Restoration. In other words, we see the differences between Neoplatonic and Rationalistic views of art very clearly

in England because the English Renaissance was late in coming and because Neoplatonism was much more of a moving force in thought and art in England than on the Continent.

Modern critics pay a great deal of attention to Baroque concepts and terms that come from rhetoric and rules criticism and rightfully so; yet English aesthetics emanates from sources other than Hobbes, the traditional books on rhetoric, and the French critics. An awareness of the cosmology of the Cambridge Neoplatonists helps shed much light on Dryden, for instance.[20] Dryden's reference to God as "the almighty poet" (in Watson, I, p. 4)[21] coincides with Cudworth's calling God "that skillful dramatist," a comparison evolving from Plotinus's idea of "the evolution of the world" as a "true poem";[22] hence, the double-directed character of Dryden's aesthetic-rhetorical thought comes not only from the difference between French rules and English freedom but also from the kind of difference one sees between Hobbes and Cudworth, between Hobbes's ultimately Epicurean, mechanistic view of nature and Cudworth's more mystical idea that the universe has to be seen in organic terms. Cudworth's *élan vital* is approximately equivalent to Dryden's *liveliness* as a prerequisite for great art, although Dryden also sees effective poesy as the product of rhetoric and the rules (if they are not taken too seriously.) Dryden's calling God the "almighty poet" and his repeated close connections of divinity and poets and poetry certainly do not lessen the relevance of John Smith's statement about the Bible: "Men may teach the grammar and rhetoric, but God teaches the divinity."[23] Considering Dennis's conceptions of religious sublimity, it is not too farfetched to say that Smith's divinity is related to imaginative power, that living force, that *élan vital*, which seventeenth-century audiences, readers, and spectators felt in great works of art.

What is important about the application of Neoplatonism to English literary endeavors is that Neoplatonism is used to analyze and to describe the effects of English writers. English music, which succumbed to Continental influences, always is considered heavily endowed with Neoplatonic mystical meaning. Music always was related to the harmony of the spheres, and the satisfactory feelings people experienced when a piece of music had been performed were explained by the extension of the harmony of the

universe into the receptors' souls. During the Baroque age this attitude about music was true in France and elsewhere, as well as in England.[24] The effect of Neoplatonism in music, as well as the proportions found in the other arts, is inherent in the art itself. The difference between Rationalism and Neoplatonism in invention lies in the recognition of the imaginative power perceived in the creator; the creator's individual imagination makes itself felt strongly when his art is effective. We feel this imaginative power in the greatest art, which in England is literary, not musical. Indeed, this power is an important part of the English literary tradition. The Neoplatonic development in England, as it relates to art, shows a marked resemblance to trends among earlier Italian artists and critics, to the literary criticism of thinkers such as Speroni, Tomitano, and Patrizi,[25] to the artistic writings of Michelangelo and Lomazzo (translated into English in 1598),[26] and to the mystical philosophy of Marsilio Ficino, Pico della Mirandola, and Giordano Bruno.[27] They all testify to the importance of the forces of imagination in the creator and talk about an *anima* or life in art that emanates from his mind and that appeals to the understanding and the imagination on a high level.

The connotations of *lively* and *just* from Dryden's definition of a play as "a just and lively image of human nature"[28] illuminate English seventeenth-century attitudes toward the force of imagination and the powers of judgment in literature. *Justness* (or *appropriateness*) is regulated by the judgment and appeals only to the understanding. *Lively* is associated with imagination. Imagination, although sometimes seen as the faculty that makes up rhetorical figures and tropes, is often the faculty that envisions ideas that evolve into art in the way God envisioned and then created the world. Without imagination there can be judgment and justice but no liveliness. Historically, *lively* is in common use in late sixteenth- and early seventeenth-century England, but it is seldom used as a critical term.[29] Renaissance writers use other words, such as Henry Peacham's *quick*:

> In his satyres, [Horace] is quick, round and pleasant; and as nothing so bitter, so not so good as Iuvenal: his Epistles are neate; for while he teacheth the art, he goeth unartificially to worke, even in the very beginning.[30]

Quick when naturally associated with the biblical phrase "the quick and the dead" means vital, full of life, energetic, animated, spirited; here it is associated with naturalness and lack of artificiality (lack of contrivance). An important synonym is *animated*. By the Restoration, *lively* takes over the concepts embodied in Peacham's term *quickness* and adds others of its own.[31] The connection between *quick* and *lively* is clear if we look at two separate translations of the anonymous *Les Instructions pour l'histoire*.[32] In *The Modest Critick* (published in 1688), Robert Midgley uses *quickness* and *quick* to describe Sallust's style; whereas Caesar is not "quick enough."[33] John Davies of Kidwelly, in *Instructions for History* (published in 1680), says about Sallust: "The swiftness and rapidity of his discourses, 'tis that which animates it and makes it so lively." Caesar, to Davies, is "not lively enough."[34] Even though Dryden himself uses *quickness* with this connotation in "To the Memory of Mr. Oldham" (l. 20), Midgley is the exception.[35] There is more to say than this, however. The French critical words for which *lively* is substituted (*vif, vivant, vive,* and *animé*) are related to the Greek *psyche* (not so important to the Restoration) and to such Latin words as *vita, animare,* and *animus* (which are important to the Restoration) and are associated with organic or spiritual life. All of these spiritual and organic connotations are behind Restoration usages of *lively* as an aesthetic term connoting that there is a living force in a work of art and that the work is a living projection of the artist who created it (the notion of the artist as a creator or God).[36]

In Restoration England, *lively* (or *lifelike*) thus has two primary critical connotations. First, a lively or lifelike work can appear verisimilar, or probable, by means of the rules: for example, the length of a play's performance may correspond closely to the time the action would take in actual life. This is a French meaning. Second, a work is lively when its motion or energy and spirit or life is felt. The first quality, probability, which is seen or heard, is a product of, and appeals to, the judgment, reason, and understanding; the second, energy or motion, which is felt, is primarily a product of invention and imagination or fancy and appeals to the emotions or the imagination. Dryden in his definition contrasts *lively* to *just*, which embodies the more static virtues of judgment.[37] Other writers make the same dichotomy: Sir William

Temple (in 1699): "Besides the heat of invention and liveliness of wit, there must be the coldness of good sense and soundness of judgment."[38] In 1685, Robert Wolseley: "Poetical wit [is] . . . a true and lively expression of nature. . . . This expression of nature must be true that it may gain our reason, and lively that it may affect our passions."[39]

In his "Essay of Dramatic Poesy" (1668), we can see Dryden very much aware of how important a conception of *liveliness* as embodying a life spirit, an *animus*, and as exuding motion was to great art, despite his respect for those qualities the French admired as correct, just, and instructive. The argument for the importance of the imagination over judgment as a definition of *liveliness* is crucial in the discussion between Lisideius and Neander (I, pp. 44–77). Lisideius, arguing for the superiority of French drama, scorns English tragicomedy (I, p. 45), criticizes English negligence of the rules (I, p. 47), and praises French adherence to truth as associated with reason and probability (ibid.). His idea of literary beauties (and liveliness) is primarily intellectual and rhetorical. In one striking instance it is statically visual:

> The words of a good writer, which describe it lively, will make a deeper impression of belief in us than all the actor can persuade to us when he seems to fall dead before us; as a poet in a description of a beautiful garden, or a meadow, will please our imagination more than the place itself can please our sight. [I, p. 51]

While praising the judgment of the French, Lisideius also conducts a rearguard action against the arguments he knows Neander will use to substantiate English greatness, arguments about motion and about Shakespeare's spirit. In one place, he says that French plays have variety and motion. This passage is interesting for two reasons: it connects physical motion with imagination and it shows how motion can be conveyed by relation or narration (in the French manner) rather than by dialogue and action (as on the English stage). Lisideius says:

> They therefore who imagine these relations would make no concernment [passion] in the audience, are deceived. . . . What

> the philosophers say of motion, that when it is once begun, it
> continues of itself, and will do so to eternity, without some
> stop put to it, is clearly true on this occasion: the soul being
> already moved with the characters and fortunes of those imag-
> inary persons, continues going of its own accord; and we are
> not more weary to hear what becomes of them when they are
> not on the stage, than we are to listen to the news of an absent
> mistress. [I, p. 52]

Neander (who ordinarily speaks for Dryden) replies, affirm-
ing the second definition of *liveliness*:

> For the lively imitation of nature being in the definition of
> the play, those which best fulfil that law ought to be es-
> teemed superior to the others. 'Tis true, those beauties of the
> French poesy are such as will raise perfection higher where it
> is, but are not sufficient to give it where it is not: they are in-
> deed the beauties of a statue, but not of a man, because not
> animated with the soul of poesy, which is imitation of hu-
> mour and passions. [In Watson, I, p. 56]

In this passage, Neander says two things of importance: first, that
lively is associated with the beauties of a man (a living man) and
opposed to the beauties of a statue (since statues are motionless
however lifelike they may appear); and second, that the soul of
poesy (the essence of poesy) is in the "imitation of humours and
passion," all of which when seen as a part of motion and when
expressed in a moving manner exude liveliness. Neander uses the
word *animate*, with its Latin connotations, in connection with
poesy's soul, a soul that is felt (or moved) in the souls of the
audience.

When Neander elevates English plays, he concentrates on
their variety, copiousness, and motion (all of which terms we as-
sociate with the fullness of life itself). The concept of motion is
important as a part of the conceptions of liveliness and passion.
The *Oxford English Dictionary* has some appropriate informa-
tion. In an unusual English conception for its date (1598), Hay-
docke, in his translation of Lomazzo, says, "By motion, the painters
mean that comeliness and grace in proportion and disposition of
a picture, which is also called the spirit and life of a picture"

(meaning 2b). Shakespeare uses a more ordinary meaning when he says, "to keep his anger still in motion" (I Henry IV: I, iii, 226; *OED* meaning 6b). Bacon refers to "mocions of envye" (meaning 9a). Grimeston, in his translation of Coeffeteau's *A Table of Humane Passions With Their Causes and Effects* (1621), uses *motion* as a synonym for *emotion* or *passion*, explaining how passion overcomes reason.[40] It is perhaps worthwhile to quote from Grimeston's translation to show his unflattering conception of the passions and motion in relation to the understanding:

> Whereby it appears, that passions, to speak properly, reside only in the sensitive appetite, and that they are not fashioned but in the irrational part of the soul: so as if we should give the name of passions to the motions of the understanding, or of the will; it is by a kind of improper and figurative speech, alluding to the passions of the senses, with which they have some resemblance. [P. 2]

To indicate how Coeffeteau's idea of "no motion in the understanding" changed, Addison, in *The Spectator* (No. 413, 24 June 1712), for example, speaks of "admiration" as a "motion of the mind." Motion, although connected to rhetoric in the movement of figures, is an aesthetic term and becomes more so as the eighteenth century draws nearer. Even Coeffeteau, although he says passion is a sickness, equates movement and motion with transport. A work of art moves or transports us (pp. 18, 83, 84), and if there is no passion, there is no humanity. Man becomes either a stone or a God (p. 67). In John Evelyn's translation of Roland Fréart, *An Idea of the Perfection of Painting* (1668, the same year as the "Essay of Dramatic Poesy"), motion, one of the five parts of painting, includes in its conception both actions and passion, just as it does in Lomazzo's book on "Motion" (Lomazzo, however, has seven, rather than five, parts of painting, of which motion is one).[41] This conception of motion although also related to the visual expression of the passions in a painting and to a rhetorical view of painting is relevant to an analysis of English Renaissance drama. Motion in English drama is in the movement of its plots and subplots and in the expression of the passions.

Passion as a result of, and as an equivalent to, motion is communicated by the energy in the writing or speaking that the audience or spectators feel. The passions when expressed forcibly immediately affect the audience's emotion, causing motions (feelings) in its members, as we have seen in Chapter I. But the final effect of a tragedy, for example, is different from Aristotle's idea of catharsis as purgation, although Dryden refers twice to Aristotle's analogy of the purge (1679; I, p. 245; and 1697; II, p. 228), because motion and emotion, in Dryden, refer to all the passions that may be raised by a work of art, whether superficially sentimental or profound. If a play is lively, it exudes the qualities embodied in the aesthetic concepts of motion and liveliness. Dryden, in 1695, further connects liveliness and motion with passion and delight:

> Since a true knowledge of nature gives us pleasure, a lively imitation of it, either in poetry or painting, must of necessity produce a much greater. . . . Both these arts . . . are imitations of the passions which always move, and therefore consequently please; for without motion there can be no delight, which cannot be considered but as an active passion. [II, p. 194]

It is here we see clearly the instruction-pleasure dichotomy. Liveliness, emotion, and motion have to do with pleasure rather than with the understanding because they appeal to the sensible rather than the reasonable part of the soul. The kind of nature, variety, scope, copiousness, and energy that Neander feels (not necessarily sees) in English poesy, that which makes it superior to the French, is unmistakably pointed out by the imagery and the sense of the following passage:

> [Why should] Lisideius and many others . . . cry up the barrenness of the French plots above the variety and copiousness of the English. Their plots are single, they carry on one design which is pushed forward by all the actors, every scene in the play contributing and moving towards it. Ours, besides the main design have under-plots or by-concernments of less considerable persons and intrigues, which are carried on with the motion of the main plot; just as they say the orb of the

fixed stars, and those of the planets, though they have mo-
tions of their own, are whirled about by the motion of the
primum mobile, in which they are contained. That similitude
expresses much the English state; for if contrary motions may
be found in nature to agree, if a planet can go east and west at
the same time, one way by virtue of his own motion, the other
by the force of the first mover, it will not be difficult to imag-
ine how the under-plot, which is only different, not contrary
to the great design, may naturally be conducted along with it.
[I, p. 59]

Dryden makes the analogy here between the poet as creator and
God as creator, implying that an artist creates motions in his work
as God did in the world and that a work of art should be in har-
mony with itself. Copious English plays are better than the more
austere French plays to the extent that God's harmony of variety
in the universe is superior to the lack of variety in manmade con-
trivances. To go even further, in Neoplatonic astrological-aes-
thetic terms, the motions of the planets control the motions of the
soul. For instance, Lomazzo in Book II has a chapter entitled "Of
the Motions Procured by the Seven Planets." The connection to
music is apparent since plays, like music, imitate the cosmos. As
Finney says, astrologically powerful music was supposed to trans-
mit stellar influence and "cosmic spirit" to the spirit of man, to
alter his temperament, and to govern his emotions (p. 108). This
idea is expressed in innumerable places.[42]

In physical terms, the motions that Dryden talks of so bril-
liantly impinge on our senses, causing motions within us and ex-
citing the motions of our imaginations. Hobbes (the philosopher
of motion) helps us understand this process:

> In a sense, that which is really within us, is as I have said be-
> fore, only motion, caused by the action of external objects, but
> in appearance to the sight light and color, to the ear sound, to
> the nostril odor, etc., so when the action of the same object is
> continued from the eyes, ears, and other organs to the heart,
> the real effect there is nothing but motion or endeavor, which
> consists in appetite or aversion to or from the object moving.
> But the appearance or sense of that motion is that we either
> call "delight" or "trouble of mind."[43]

An active imagination, according to Hobbes, is intelligent and sensitive:

> On the contrary, a slow imagination, maketh that defect, or fault of the mind, which is commonly called dullness, stupidity, and sometimes by other names that signify slowness of motion, or difficulty to be moved.[44]

Neander's motion is similar. A good play is quick and lively (in character and plot).

A problem to which I have already alluded is that some of what I have said can be interpreted as rhetorical in nature; this difficulty arises especially with Hobbes because he is talking about motion in a local sense. Since poets use specific devices to achieve specific effects, the whole notion of arousing passion can be interpreted as rhetorical. Rymer, for example, refers to Aristotle's *Rhetoric*, Book II, in a discussion of manners.[45] Elsewhere he says:

> Nothing can be delightful but that which moves the affections, and which makes impression on the soul; little known is that rhetorick which can lay open the passions by all the natural degrees of their birth, and of their progress.[46]

But more than we might expect Dryden and most other Restoration critics are oriented to thought other than that based on rhetoric, and their aesthetic connotations of *lively* and *motion* lead us to this conclusion. Cudworth, arguing against Hobbes's purely mechanistic idea of motion, says:

> It is plain that there comes nothing to us from bodies without us but only local motion and pressure. Neither is sense itself the mere passion of those motions, but the perception of their passions in a way of fancy. But sensible things themselves (as for example light and colors) are not known or understood either by the passion or the fancy or sense, not by anything merely foreign and adventitious, but by intelligible ideas exerted from the mind itself, that is, by something native and domestic to it; nothing being more true than this of Boethius, that "whatsoever is known, is not known by its own force and power, but by the force and power, the vigor and activity of

that thing itself, which knows or comprehends it." [Cudworth
goes on to argue that local motions cannot impress us with
universal truths.][47]

Here we see explained the idea of how innate powers of the mind
(as part of an essentially harmonious universe) lead inward for
understanding and outward to an organic motion, an *élan vital*,
that is present in the greatest works of art. This side of English
thought leads to an aesthetic that transcends rhetorical considera-
tions, an aesthetic that agrees with the implications in Neander's
speeches and that elevates the imagination (as faculty) of both
poet and audience.

III

What Neander has said about the importance of *lively* to the
definition of a play as a "just and lively image of human nature"
clearly applies to Shakespeare, besides other authors of English
tragicomedies and Homer. Model poets (the best poets) were
thought those nearest nature, and to Dryden, despite his occa-
sional criticism, Shakespeare is the most important model, in all
of Dryden's criticism the only poet who is nature itself: "[Shake-
speare] is that nature which other poets paint and draw" (I, p.
136). And he likes Shakespeare best. In the "Essay of Dramatic
Poesy" (1668) he says:

> Shakespeare was the Homer, or father of dramatic poets; Jon-
> son was the Virgil, the pattern of elaborate writing; I admire
> him, but I love Shakespeare. [I, p. 70]

The intellectuality of Neander's admiration for Jonson (and Vir-
gil) as a model of rhetorical excellence ("elaborate writing") is
surpassed by the warmth with which he loves Shakespeare, who
is often linked to Homer.[48] Dryden had to ask himself this ques-
tion: if Shakespeare is the best loved of all playwrights, how im-
portant and necessary are the rules and the judgment? And the
common characteristic of the greatest poets, Homer and Shake-
speare, is that their works move the audience or the reader not by
means of rules and judgment but by their liveliness. Thus, to
Dryden, correctness and elocution, although necessary, become of

secondary importance.[49] Such a consideration points to the question of individual genius. Emphasis on judgment leads to corporate ventures, but the imagination needs flashes of individual insight to impose unity on chaotic materials or ideas.[50] Clarity and force of imagination thus became more important to Dryden, and others, in the recognition and appreciation of great art than the nice distinctions of the judgment. Such art has existed when Neoplatonic notions or notions similar to them have been predominant.

Shakespeare's contributions to the Restoration definition of great art also are evident in the ways his imaginative mind and his forceful plays are appreciated. To Milton, he is "fancy's child."[51] To Edward Philips, he is a writer with "unfiled expressions" and "rambling and undigested fancies" whose excellence comes from his "life," "spirit," and "poetical energy."[52] In a letter to the earl of Dorset, Dryden says, "Your . . . happy, abundant, and native genius . . . are as inborn to you as they were to Shakespeare; and for aught I know, to Homer; in either of whom we find all arts and sciences, all moral and natural philosophy, without knowing that they ever studied them" (1693; II, p. 74). Neander says, "[Shakespeare] was the man who of all modern, and perhaps ancient poets, had the largest and most comprehensive soul. All the images of nature were still [always] present to him, and he drew them not laboriously, but luckily; when he describes anything you more than see it, you feel it too" (1668; I, p. 67). Shakespeare's plays exhibit liveliness defined as the essence of poetry, the poetic soul, a quality of life that is found less in the visual or static "beauties of a statue" than it is in the energy that moves us, the life we feel transmitted to us when we regard great art. Shakespeare's energy is not like nature; it is, as Dryden says, nature itself. And it is the perception of an *élan vital* in Shakespeare's works that probably as much as anything else accounts for the difference between French and English theory, appreciation, and practice of poesy in the Restoration and later in the eighteenth century.[53] As Addison says in *The Spectator*, "[Shakespeare is] a stumbling block . . . to the whole tribe of these rigid critics" (No. 592, 10 September 1714).

The difference between a French and an English aesthetic carries over to painting. It is not surprising to find Roland Fréart

de Chambray disliking Michelangelo while extravagantly prais-
ing the more regular Raphael. The reluctant Evelyn translates
Fréart this way:

> There is none but easily perceives by paralleling the composi-
> tions and figures of Raphael, with those of Michel Angelo;
> that the first was the very sweetness of grace itself; whereas
> on the contrary, Mic. Angelo was so rude and unpleasing,
> that he retain'd not so much as any regard to good-manners.
> This is evident in that great work of his in the chappel of the
> Vaticane; where being to represent the Final Judgment over
> the very altar itself, he introduces certain figures in actions
> extreamly undecent; whereas Raphael observes a modesty,
> even in the most licentious subjects. From hence it is, we may
> conjecture how highly important this talent of expression is in
> a painter; 'tis really his greatest excellency, and should ac-
> cordingly be accompanied with a peculiar judgment and cir-
> cumspection; since by that alone, one may conjecture at the
> force of his understanding. [Pp. 14–15; Fréart de Chambray
> goes on in a like vein and in his Preface says that only the
> vulgar like Michelangelo.]

John Evelyn, the Englishman, has a much different attitude,
saying (in his "To the Reader"):

> Yet I conceive he might have omitted some of those imbit-
> tered reproaches he has revil'd him [Michelangelo] with, who
> doubtless was one of the greatest masters of his time: and
> (however he might succeed as to the decorum) was hardly
> exceeded for what he performed in sculpture and the statuary
> art by many even of the antients themselves, and happily by
> none of the moderns.

The works of Raphael and Michelangelo illustrate well the
difference between rules-oriented and imagination-oriented art.
The difference between Fréart's and Evelyn's reactions to these
artists illustrates the tendencies of the English and the French to
admire different kinds of art. Evelyn places much less emphasis
on decorum than does Fréart and more emphasis on liveliness or
imaginative force. We find the same disapproval of Michelangelo
in the Frenchman Claude-Henri Watelet's eighteenth-century

translation of the Abbé Marsy's *Pictura carmen* (Amsterdam, 1761):

Never make a monstrous mixture of the sacred and profane, of history and fable, of the serious and the grotesque. Michelangelo could never win approval for the bold and bizarre combination in his "Picture of the Last Judgment," where, in order to depict the end of the world and the circumstances of that terrible day, he introduced ghosts, monstrous and fantastical figures, even obscene objects and nudity, the Furies and old Charon, who has collected the ghosts in his boat and is floating down the River of Hell. At the sight of such a melange, pity was seized with horror, religion fled indignantly, truth turned its eyes aside and modesty covered its face. Always put wit, grace, and delicacy into your pictures; it was primarily for that reason that the masterpieces of Greece were the delight of their age.

[Ne faites point un mêlange monstrueux du prophane et du sacré, de l'histoire et de la fable, du serieux et du grotesque. On n'a point passé à Michel-Ange l'assortiment bizarre et hardi de son "Tableau du Jugement Dernier," où pour représenter la fin du monde et les circonstances de ce terrible jour, il a introduit des species, des figures monstrueuoos et de fantaisie, jusqu'à des objets obscenes et des nudités avec les furies et le vieux Caron qui rassemble les ombres dans sa barque, et qui vogue sur la fleuve des enfers. A la vue d'un pareil mêlange la piété fut saisie d'horreur, la religion indignée s'enfuit, la verité détourna les yeux, et la pudeur se couvrit le visage. Mettez toujours dans vos tableaux de l'esprit, de la grace et de la finesse: c'est par-la principalement que les chef-d'oevres de la Grece firent les délices de leurs siècles.] [Pp. 261–63]

Poussin is Marsy's painter with "l'esprit" (p. 295), and the difference between Poussin, the French Raphael, and Michelangelo is very similar to the difference between Racine and Shakespeare.[54] Watelet is not the only writer to say that Poussin has *l'esprit*. Louis Moréri's vastly influential *Grand Dictionnaire historique* (1681) as translated by Jeremy Collier (1701) expresses the same view. Collier's translated supplement, *Supplement to the Grand Historical Dictionary* (London, 1701), also calls Pous-

sin the French Raphael, saying that he is especially good in deco-
rum and the passions and affections, "with such incomparable
skill, that all his pieces seem'd to have the very spirit of the action,
and the life and soul of the persons whom they represent." A com-
parable painter, Le Brun, becomes a "vaste and universal genius"
(in Collier's *Supplement*, listed under Brun). Everywhere he is
treated by Frenchmen, Raphael is the greatest painter of all:
"sweet natured," "civil," "obliging," "amiable," "decorous." Du
Fresnoy says that Raphael is the best: his design is purer, he excels
at decorum, he surpasses everyone at "disposition." And Roger
Des Piles in his *Principles* (1709) calls Raphael the most elegant
painter (p. 100).[55] It is easy to see the qualities the French ad-
mire. They are the beauties of the rules, the products of judgment,
of discerning rationality.

French criticism of Michelangelo and his "follower" Rubens
is predictable. In Moréri's dictionary, Michelangelo has "extrava-
gant and fantastical fancies"; he flouts the rules and has "other
faults." Yet some like him because he is a great drawer and under-
stands architecture. To Du Fresnoy he lacks design; his outlines
lack elegancy; his draperies and habits are neither noble nor ele-
gant; he is bold to the point of being rash; he flouts the rules; his
coloring is deficient; and "he knows not the artifice of lights and
shadows" (p. 224). Rubens's faults are similarly identified. Roger
Des Piles, using a scale of twenty, rates the five painters we have
mentioned thus (pp. 297–300):

Painter	Compo-sition	Design	Coloring	Expres-sion
Raphael	17	18	12	18
Rubens	18	13	17	17
Poussin	15	17	6	15
Le Brun	10	16	10	16
Michel-angelo	8	17	8	8

The most consistent feature of Des Piles's scale is his low estima-
tion of Michelangelo; only in design (which Du Fresnoy thinks
Michelangelo lacks) does he receive a good rating.

The English attitude was consistently different, even through the eighteenth century. Watelet's notes include comments by the English painter Richardson (in his *Discourse on the Science of a Connoisseur*), who is much more partial to Michelangelo and compares *The Last Judgment* to Milton's *Paradise Lost* (p. 261).[56] In the English edition of Du Fresnoy (*The Art of Painting* [London, 1716], Richard Graham answers Du Fresnoy's criticism of Michelangelo's designs (p. 224) by saying simply that Michelangelo is "the greatest designer who ever lived" (p. 283). Sir Joshua Reynolds marks the difference between Michelangelo and Raphael as well as anyone else (1772):

> Raffaelle had more taste and fancy, Michaelangelo more genius and imagination. The one [Raphael] excelled in beauty, the other in energy. Michaelangelo had more of the poetical inspiration [like Milton, Homer, and Shakespeare]; his ideas are vast and sublime. . . . Raffaelle's imagination is not so elevated. . . .[57]

Reynolds goes on in the same vein, ending his last discourse with the highest veneration for Michelangelo, who, like Plotinus's ideal artist, created a world in his own mind, who "never needed, or seemed to disdain, to look abroad for foreign help" (p. 64). Michelangelo's energy is the *élan vital* Dryden and others in the seventeenth century feel in Shakespeare, that order in disorder, that *concordia discors*, which transcends the harmony of terrestrial nature exemplified by rules critics. The French *esprit* and other terms that describe lively art, or art of genius, meant something entirely different to Frenchmen and Englishmen and influenced the kind of art both produced in that the imagery and emotions they employ in one kind of art were drawn from other arts that were congenial to them. In other words, when an English poet and a French poet try to conjure up a sublime scene, they probably had in mind entirely different images. In comparing the arts, we must keep this idea before us, both in an individual and in a national sense.

The implications of seventeenth-century aesthetic conceptions of an *élan vital*, at least equal in importance to rhetorical conceptions of vividness, clarity, and regularity, are necessary to our un-

derstanding of English creation, literary history, and taste. The traditional English genres that had the most influence over these aesthetic theories were the English Renaissance drama and the epic, as exemplified by the works of Shakespeare and Milton and, to a lesser extent, Spenser, and the ideas that were of most importance were those of Plato and Plotinus, as they were discussed and refined by the Renaissance Italians and the Cambridge Neoplatonists. Milton, Pindar, and the Bible became, along with Shakespeare, linked to sublimity, emotion, and passion as they never could have, or did, to French critics, and the main course of English literature, aesthetics, and critical theory evolved naturally to considerations of imagination and genius as core issues.[58] In English poesy of the late seventeenth century, the central genre developed with these issues in mind is the great ode, the main English practitioner of which is of course John Dryden. We should not, however, underestimate the importance and prevalence of a Continental, mostly French, rules-oriented position for the arts in England. But a knowledge of the aesthetic movement that counteracted rules criticism makes much clearer what kind of art an English or a French creator might be alluding to in particular contexts.

SEVEN

Social Correctness
and Taste

Continental standards of social correctness greatly influenced Restoration English behavior, taste, and thought. The evidence indicates that English predilections for Continental works of art and ideas, both French and Italian, sometimes reached ridiculous proportions even if we allow for the exaggeration in English Restoration verse and dramatic satire. These predilections for French and Italian art can be explained by two primary reasons: the first is social—the urbane, sophisticated, genteel, rational qualities of French and Italian art, manners, and language were preferred to the relatively countrified boorishness and supposed intellectual inadequacy of the English; the second is aesthetic—it derives from English conceptions of the mind and theories of composition. The first reason led to the encouragement and imitation of correct, genteel, Continental art of the period. The second, despite appearances, led to a struggle between the new French Rationalism and the older English view of the universe, which although derived from the Continent was *passé*. Predilections for Continental art and ideas caused traditional English music to pass into disfavor, while English drama and critical thought resisted outside influences.

I

Given man's natural propensities, the kind of art that elicits the most admiration and respect and that is liked by those thought to possess the most refined sensibilities will be admired by those who want to do the right thing yet are unsure of their own judgment—whether they prefer that art and whether that art is worth liking. A rising, ambitious, but insecure middle class will seize and hold fast to art that its members think they are supposed to like, and the Restoration is noted for the rapid expansion of the middle class, its technology, business practices, and tastes becoming more and more important.[1] People aspiring to a higher social level on a national scale, especially if artists and performers are patronized by them, will cause the development of that art they think they should cultivate, while perfectly good, vigorous forms may at the same time be totally or partially destroyed in the name of proper judgment or taste. The simplest and clearest example reflecting the sociological forces in the Restoration that most influenced middle-class taste in the fine arts is Molière's *Le Bourgeois Gentilhomme* (1670).

Urbane, Continental correctness was a civilizing influence. In England, it led to the centralization of culture in London, a change from a rural to an urban culture. There developed a greater gentility in manners and language and a preference for less countrified, more refined works of art. Thomas Sprat says (1667):

> Their [Continental] nobility live commonly close together in their cities, and ours for the most part scattered in their Country Houses. For the same reason, why our streets are not so well built as theirs will hold also for their exceeding us in the Arts of Speech. They prefer the Pleasures of the Town [refined, witty, verbal], we, those of the field [hunting, fishing, non-verbal]; whereas it is from the frequent conversations in cities that the Humour and Wit and Variety and Elegance of language are chiefly to be fetch'd.[2]

Sprat's consciousness of a difference between England and the Continent was a common feeling, and the situation was one that most felt needed improvement. Restoration writers keep repeating that they are part of a new era, that they are more cultivated and

proper in language, conversation, and behavior, as well as in their taste for the arts; they define themselves as a part of an aristocratic community that includes all of Europe, at the same time excluding many English traditions. We see this identification in references to the introduction of French words, dress, and ideas; in the so-called Continental tours to "round out" the educations of rich young Englishmen; in the translations of Italian treatises on painting; and in a general invasion by Continental literary styles and modes of expression, seen in letter writing, literary salons, theater, rules of art, and reactions to different kinds of art. The Restoration English feel that the main advantages they have over the Elizabethans is the advancement of science, correctness in language, and correctness in art and manners.[3]

People most under the French influence thought the best, most useful, most correct art improved social behavior by appealing to the highest, reasonable part of the soul overtly, in the form of moral tags and poetic justice. They usually were part of the highest society and looked to the authority of correct French writers and correct French behavior for guidance and help in both social and critical matters.[4] Thomas Rymer is extreme in rejecting his national art on the ground that it lacks the judgment and order that appeal to the highest soul or faculties, but almost all other English writers are affected to a greater or lesser extent by Continental ideas.[5] The influence of Continental correctness and rules criticism was furthered by great French art produced inside the bounds of the rules (for example, the dramas of Corneille, Racine, and Molière). These works, as well as social pressure, the acceptance of rather stoical tendencies in the faculty psychology, and English dependence on French criticism for the development of their own, made many Englishmen susceptible to French influences. Ultimately, the English absorbed what they wanted to absorb. (This same sort of phenomenon had occurred earlier in France when the French borrowed and assimilated the vocabulary, ideas, and art of the fifteenth-, sixteenth-, and seventeenth-century Italians.)[6]

In the Restoration, changing tastes based on Continental examples destroyed English music as a serious, elevated form of art. Middle-class Puritanism may have played a part, but the strongest

influence on upper middle-class Londoners was social, for tradi-
tional English music despite Italian influences did not meet the
standards of Continental correctness and sophistication. The same
criteria also downgraded English architecture. Christopher Wren,
for example, is not mentioned in Jeremy Collier's *Dictionary* al-
though Matthew Wren is, and Christopher Wren himself in 1665
notes in a letter the following great artists and architects: Le Brun,
Poussin, Bernini, Mansart, and Vaux, all of them from the Con-
tinent.[7] Painting as an important English art did not really exist
until the eighteenth century, when it based its principles on Ital-
ian modes and rules, as it probably should have done. English
painting was not influential: there are no English painters, for
example, on Roger Des Piles's list,[8] and Oliver Millar reasonably
opines, "The English-born artist [was] inevitably rather stifled in
the cosmopolitan atmosphere of the late Stuart court."[9] Dramatic
literature of the English Renaissance, however, survived to be-
come a moving force in European thought, culture, and art.

II

As English men and women came to like and to admire more
correct, Continental art and manners, eschewing the more rough-
hewn, bawdy, and boisterous art and behavior of England, their
esteem for English music accordingly declined, both as a practice
and as a tradition. The aristocratic and would-be aristocratic classes
of society, the patrons of the arts, entirely repudiated English
music as a serious art form, desiring and encouraging the kind of
music that came mainly from Italy and France, although Italy was
the primary source of English ideas about the composition and
appreciation of music. Italian music, especially, had been influ-
encing English musical forms for some time, as we can see in the
Elizabethan lute songs and madrigals of Dowland, Campion, Mor-
ley, Byrd, and many others. But in those days, traditional English
songs and dances formed the backbone of much of their art mu-
sic, and despite the invasion of Italian madrigals, English com-
posers were prominent.[10] In the latter part of the century, how-
ever, the Italian influence grew stronger. Henry Purcell's concerti
and most of his songs are written in the Italian mode. Dryden's
numerous songs in his plays and operas are with two exceptions

cast in the new mode, expressing only delicate attitudes toward love and delineating correctness in characterization.[11] In the next century, musicians such as Handel, Buononcini, and Geminiani and the singers Nicholini and Valentini (to name only a few) dominated the English musical scene, and Addison's attempt, the opera *Rosamond* (1707; music by Thomas Clayton), to drive the Italians off the stage is a dismal failure. Addison also points out, rather ruefully, that the popular French composer Lully (a Florentine by birth) did not pretend to extirpate French music and plant Italian music in its stead, unlike musicians and composers in England.[12]

The English musical tradition ought to have been entrenched in the culture, but despite the excellence of John Blow and the genius of Henry Purcell there were not enough composers of stature—not of the stature of a Shakespeare or a Milton but composers of general excellence—who by their collective genius might have constructed a strong musical tradition, sturdy enough to resist the flood of Continental works and musicians.[13] John Dryden, for instance, employed the second-rate French composer Louis Grabu (who had been imported by Charles II) in his first opera, *Albion and Albanius* (1685), because he thought no one else available. He praises Grabu highly but says, "When any of our countrymen excel him, I shall be glad, for the sake of old England, to be shown my error."[14] Admiration for Grabu could only come from social considerations.[15] When Dryden discovers Henry Purcell, he is overjoyed. But Purcell also catered to the Continental tastes of his affluent audience.[16] During the seventeenth century, traditional English music lost its artistic stature. It did not disappear altogether but became popular mostly on broadsides, in taverns, and at lower-class rural entertainments.[17] Continental composers and even Continental performers found more lucrative employment than did native artists. John Playford says about English musicians in the Preface to *Musick's Delight on the Cithern* (1666): "Nor is any music rendered acceptable, or esteemed by many, but what is presented by foreigners."[18]

Restoration comedy documents factually the Continental influence on English art and manners, from the beribboned fops who ridiculously ape their French counterparts to the fashionable

turns of phrase and the proper, genteel behavior and speech of characters who represent the upper classes. The playwright who most fully expresses attitudes toward music is Thomas Shadwell, who wrote social criticism in the realistic tradition of Ben Jonson.[19] Shadwell, a musician, voices the latest musical opinions; his well-bred ladies and gentlemen reflect the tastes of the most sophisticated patrons of the arts, models against whom his audience was supposed to judge itself. Shadwell's audience was composed of the highest and most cultivated part of society. The court was the center. Many of Charles II's courtiers had been educated in France, for Charles spent his exile largely in Paris, and it is recorded that the dukes of York and Buckingham even appeared as dancers in the *Ballet de la nuit* on 23 February 1653.[20] Charles II, in imitation of the glorious French ruler Louis XIV, had his twenty-four violins.[21] It was this courtly society and the middle class who imitated it that was most responsible for the end of a strong cultural tradition of English music and musicians. They fostered the radical split between the old, popular English musical tradition and the kind of music composed and performed by people trained on the Continent. Shadwell's well-bred characters are intolerant of English songs and dances, while his low-bred characters dote on them. Jeremy Collier supports Shadwell's ideas, saying that the proper kinds of music are "the entertainment of people of quality."[22] The closer we look at Shadwell's plays, the more consistent we see he is.

Unlike other playwrights who merely exclude English music, except for comic effects, Shadwell has his sophisticated characters frequently discuss the virtues of Italian and the faults of English songs and music, praising Italian music in the most judicious, decorous, and correct manner, in the way persons of judgment are supposed to speak and to conduct themselves. Such persons always have the most refined entertainment. In *Bury Fair*, the sophisticated Bellamy directs his musicians to perform a two-part Italian song to entertain his guests,[23] and in a scene in which Philadelphia (in disguise) sings two Italian songs, the well-bred Gertrude says only, " 'Tis admirable! The court has not better" (IV, p. 328). There is no gushing, no expression of extravagant, passionate emotion. In *The Woman Captain* (IV, p. 31), Sir Humphrey Scat-

tergood, a man of exquisite taste in the pleasures of the senses, affirms that Italian music and musicians are the very best. In *The Lancashire Witches* (IV, p. 137) Belfort and Doubty, gentlemen of wit and understanding, comment both on well-bred people and on Italian songs to their host, Edward Hartfort, an outspoken patriot who is nonetheless judicious, has excellent taste, and dislikes English music and songs. After Hartfort's musicians have performed an Italian song, his refined guests give Hartfort and his music the highest possible praise, decorously and rationally:

> BELFORT. Finely composed and excellently performed.
> DOUBTY. I see, Sir, you are well served in everything.

Shadwell's characters who like English songs are either illbred or stupid, or both. The witless Prig in *A True Widow* writes and sings ridiculous English hunting and roaring songs. The uncouth Bernardo in *The Amorous Bigotte* hates Italian music and "loves" trumpets, cannons, drums, and the groans of wounded and dying men. His lack of breeding is even more evident when he sings a song tastelessly accompanied by a drum (V, p. 52). Oldwit, a country bumpkin in *Bury Fair* (IV, p. 343), staggers on stage drunk (something a gentleman would never do), roaring the old English song "There Were Three Men Came out of the West." In *The Virtuoso* (III, p. 121), after the foolish Sir Samuel Hearty sings an old English song, his well-bred audience says he sings worse than an old woman spinning. Our romanticized image of an old woman spinning and singing a lullaby apparently was regarded in a different light in the seventeenth century. In *The Lancashire Witches*, Edward Hartfort's doltish son's stupidity becomes even more apparent when he sings two old English songs, the second of which is the old favorite "Roger à Coverly."

The difference between urban sophistication and rural boorishness is made explicit in a scene in *Bury Fair* (IV, p. 329). In the following quotation, Bellamy and Wildish are sophisticated, knowledgeable men of London; whereas Sir Humphrey Noddy and Oldwit are ignorant country bumpkins. Bellamy and Wildish show us correct attitudes toward music and behavior. They do not like Oldwit and Sir Humphrey, and they do not know, or pretend

not to know, the popular "Thetford music." Notice also the strength with which they scorn their rustic acquaintances and how they cannot bear the way Sir Humphrey turns the conversation to the topics of the traditional English instruments the shawm and the bandore and the well-known English musicians Singleton and Clayton:

> BELLAMY. We will Wait upon you soon; but I have promised the ladies an entertainment, with a little concert of music by my own servants [Bellamy's servants play Italian music], who are ready now: and I desire you will call the ladies, Sir.
> OLDWIT. If your Lordship please: but faith, we had better be a topping [drinking].
> SIR HUMPHREY. Did you ever hear the Thetford music?
> BELLAMY. Not I, Sir.
> SIR HUMPHREY. 'Sbud [this country oath is just as ill-bred as Sir Humphrey's manners and his taste in music], they are the best music in England; there's the best shawm and bandore,[24] and a fellow that acts Tom of Bet'lem to a miracle! And they sing "Charon, Oh Gentle Charon," and "Come my Daphne," better than Singleton and Clayton did.
> WILDISH. Here's the pleasure of your country conversation, Bellamy: had not a man better be condemn'd to the galleys, than endure it?
> BELLAMY. I am of your opinion, Ned; and for that reason, never have such company at my house.

Epson Wells, too, is filled with fine old English songs, all sung by the clowns, Bisket, Fribble, and Clodpate. In *The Miser*, *The Woman Captain*, *The Squire of Alsatia*, and *The Scowrers*, the rogues, bullies, corrupt gentlemen, and fools, the ones who rant, roar, scour, and break windows, all sing and dance to well-known old English tunes.

In Shadwell's plays, people of good breeding approve of English music only twice. Major General Blunt, in *The Volunteers* (1692), is an admirable old Cavalier officer and is described as being of "good understanding." Yet he says, "Pox o' these entires, give me your jolly country dance, it puts good humour into us,

warms the ladies, and makes 'em kind and coming" (V, p. 219). The likable general is sentimentally conceived, of pre-Restoration vintage, reinforcing the idea that the polite society of the times provides a new standard that corrects the rudeness of previous generations. In *The Lancashire Witches* (IV, pp. 185–86), Sir Edward Hartfort, of "good understanding and honest principles," tolerates only Italian music but allows his servant Clodpate to express joy in an English dance. After the dance, Sir Edward says of his stout English retainers: "These honest men are the strength and sinews of our country; such men as these are uncorrupted, and while they stand to us we fear no Papists or French invasions; this day we will be merry together" (another dance follows). Here, Shadwell's transgression of his otherwise consistent principles of who should allow what music to be played was caused by his political and religious biases. The play was first performed in 1681, when feeling against the French and Catholics was very strong. Shadwell was a Whig who was playing up to fear of the "Popish Plot."

Fops, standard characters in Restoration comedy, always are amusing and ridiculous to cultivated people because they have only pretensions to good taste. In Shadwell's plays, the fops know what kind of music they are supposed to like, but they know neither how to produce it nor how to react to it. They are inept, act overly enthusiastic, misuse terminology, and in general like and do to excess the right things for the wrong reasons. The songs they sing and like characterize people who try to show understanding and good breeding but who are neither intelligent nor well-bred. In *The Humourists*, the fop Drybob attempts to write and perform what he foolishly thinks is an Italian song (I, p. 214):

> I hope it is your pleasure
> To accept of this dog for a treasure,
> From him that loves you beyond all measure;
> Which may mystically shew
> What to your eies I owe.
> That of your affection I have put on the clog,
> And am your most humble servant and dog.
> With a bow, wow, wow, etc.

In a scene from *The Volunteers* (V, p. 191), two fops discuss Italian music:

> SIR N. DAINTY. Ah, that's fine, that's chromatick. I love chromatick music mightily.
> SIR T. KASTRIL. Ah, that fuge! that fuge's finely taken.
> SIR N. DAINTY. And bacely carried on.
> SIR T. KASTRIL. All Italian, Sir, all Italian.

Sir Positive-At-All, a fop in *The Sullen Lovers*, also comically appreciates music merely because it is Italian. In *Bury Fair* (IV, p. 329), after Gertrude's well-bred succinct appreciation of an Italian song, a female fop, Lady Fantast (too much fancy, not enough judgment) says overenthusiastically: "You must be putting in with your ill-breeding! If any traveler should affirm that Italy afforded better, I should humbly demand his pardon."

Sophisticated Londoners consistently poke fun at the countryside for its old-fashioned manners and old-fashioned, boring entertainments, one of which is English music. In *The Sullen Lovers* (II, p. 29), the witty Caroline teases the sophisticated Lovel: "Why you look more comically than an old-fashioned fellow singing 'Robin Hood' or 'Chevy Chase.' "[25] In *Epsom Wells* (II, p. 38), Mistress Jilt says ironically: "Breeding yes; could I not play 'I am the Duke of Norfolk,' 'Greensleeves,' and 'The Fourth Psalm' upon the virginals; and did I not learn, and could play six lessons on the viol de gambo, before I went to that nasty, stinking, wicked town London." In *The Miser* (II, pp. 44–45), the sophisticated gentleman Theodore disapproves of Cheatley's "Country Song," a popular English song about a young girl gnawing her sheets for want of a man, because it lacks wit—here synonymous with gentility and good taste. In *The Scowrers* (V, p. 98), Eugenia and Clara speak of country boredom in terms of the music they had to play and hear:

> CLARA. And for musick an old hoarse singing man riding ten miles from his cathedral to quaver out the glories of our birth and state, or it may be a Scotch song more hideous and barbarous than an Irish cronan.
> EUGENIA. And another musick master from the next

town to teach one to twinckle out "Lilli burlero" upon an old pair of virginals, that sound worse than a tinker's kettle that he cries his work upon.

In *Bury Fair* (IV, p. 329), when the oaf Sir Humphrey Noddy wants the cultivated Bellamy's musicians to play "Lilli Burlero," Bellamy scornfully replies: "My servants are no fiddlers." This song is a country song to be played on old-fashioned fiddles, not on the refined violins that Charles II imported from France. The Whig Shadwell is not expressing any personal dislike for "Lilli Burlero." The words of this popular song helped drive James II off the throne, as a result of which Shadwell became poet laureate of England.

It may be puzzling that Shadwell includes so much English music in his plays. Judging from the number of songbooks printed at the time, we can conclude only that interest in music of all kinds was very high,[26] and Shadwell, probably from personal experience, realized that people liked English songs even though they intellectually disapproved of them.[27] A comment by John Dryden indicates the prevailing general attitude:

> I confess [Chaucer's poetry] is not harmonious to us; but it is like the eloquence of one whom Tacitus commends. . . . There is the rude, sweetness of a Scotch tune in it, which is natural and pleasing, though not perfect.[28]

Dryden is saying that despite their naturalness and pleasing quality Scotch tunes are rude and therefore lack artistic (and rhetorical) sophistication and perfection. Although he thinks Scotch tunes imperfect, he likes them in the same way he likes Chaucer's poetry.[29] Gossip recorded in Samuel Pepys's diary indicates that the liking for spirited English songs holds true for others. Pepys has heard "how the King and these gentlemen Buckhurst and Sedley did make the fiddlers of Thetford, this last progress, to sing them all the bawdy songs they could think of."[30] In another passage on the court, Pepys says: "The King did put a great affront upon Singleton's musique, he bidding them stop and bade the French musique play, which, my lord says, do much outdo ours."[31] The embarrassment and shame of the English performers must

have been deeply felt. The second scene takes place in a self-con-
ciously sophisticated court; the first, in the country. King Charles,
Buckhurst, and Sedley, models of courtly sophistication, could
enjoy English songs, but they did not consider them an elevated
form of art, fit for what they thought of as an elegant setting. The
same idea holds true for Sir Philip Sidney's and Addison's pen-
chants for the ballad "Chevy Chase." And Addison's Sir Roger
de Coverly, a character in *The Spectator Papers*, plays on the
reader's knowledge of that venerable dance tune of a similar name,
his charming, hearty, eccentric, and slightly bumpkinish charac-
ter a good index of attitudes toward the tune itself.[32] By the eigh-
teenth century, English tastes were more positive, and apparently
the English felt more self-confident socially. In the Restoration,
judging from the evidence, such was not the case.

Although good taste is generally thought to consist of a proper
response to correct and decorous art, it does not follow that art in
the seventeenth century was judged as good or bad by what a per-
son liked or disliked. Critics as a general rule rarely mention their
emotional preferences and rarely without intellectual justification.
Only the most self-confident, that is, only the most sophisticated
and the most naive, openly indicate their emotional preferences
for oddities they like rather than for what they were supposed to
like. Dryden's liking of Chaucer and Scottish tunes and Sir Philip
Sidney's penchant for "Chevy Chase" both show us what sophis-
ticated critics dare to say, just as the naive country bumpkins in
Restoration comedy who like unsophisticated amusements show
us what was regarded as bad taste.[33] Dryden recognizes the force
of imagination or passion in Chaucer and folk ballads. He mis-
takenly thinks Chaucer's versification (elocution) is deficient,
and he likes, although he does not admire, Scottish tunes. Sir
Philip Sidney bases his praise of "Chevy Chase" on his own emo-
tional response to the energy of the creative impulse, comparing
the ballad to the passionate sound of a trumpet and to the imagi-
native force of Pindar:

> I never heard the old song of Percy and Douglas that I found
> not my heart moved more than with a trumpet; and yet it is
> sung but by some blind crowder, with no rougher voice than

rude style; which being so evil apparelled in the dust and cob-
webs of that uncivil age, what would it work, trimmed in the
gorgeous eloquence of Pindar? [Sidney, "Apology for Poetry,"
p. 94]

The heroic idea arouses a noble passion in Sidney's heart.
Heightened feeling effected though the force of invention
appeals to Sidney's emotions about the glories of war and his En-
glish heritage, although the words (the eloquence or rhetoric)
are neither correct nor courtly. To Sidney, the poem is like a
trumpet. The comparison is apt, for the kind of trumpet Sidney
refers to is a crude, loud, martial, coarse instrument.[34] Its crude-
ness and strength are comparable to the poem's very qualities and
are reminiscent of real and literary trumpets from Joshua to Virgil
to Sidney's own time. Even rough words and the performance are
considered a part of rhetoric, and therefore Sidney asks, "what
would the poem work," or what passions would it raise, if it were
"trimmed in the gorgeous eloquence of Pindar?" He thinks that
the delight and movement of the poem would be reinforced or
strengthened by more correct rhetoric, and if the poem could be
more artfully made, it would be more ravishing to the sensible
soul of the hearer or reader. To Sidney, as well as to Dryden, rhe-
torical devices are conscious, secondary to instruction. If the maker
of the ballad were more skillful, the elocution would be more art-
ful and manipulative, more persuasive, and more correct.

III
Despite the pressure of French manners, the Restoration En-
glish in some ways were stubbornly chauvinistic and resisted the
encroachments of French theory and art in the name of natural
English superiority of individual powers of mind, powers that are
opposed to the bases of rules criticism. Dryden says, in one of his
less subtle statements (1693), "Our [English] authors as far sur-
pass theirs [French] in genius, as our soldiers excel theirs in cour-
age."[35] He also recognizes Thomas Rymer's role in the dissemina-
tion of French ideas, calling him one of those "who manifestly
aim at the destruction of our poetical church and state."[36] There
is no doubt that English chauvinism was a real, important force in

all parts of English life and thought and that resistance to Continental influences was based on a recognition of manifest cultural differences. French and English literary criticism is similar when the subject is a classical writer like Horace or Virgil, but on a contemporary subject or in a more abstract discussion there is less common ground than appears on the surface.

Thomas Rymer himself is mentioned approvingly most often by those who refer to his lines at the end of his *Short View* (1693), in which he says that English comedy is better than any other,[37] and although his theories were respected, Rymer's plainspoken, French-oriented criticism of Shakespeare was disagreeable to many of his contemporaries. Rymer criticizes Shakespeare from a position entirely outside the boundaries of Shakespeare's art. He picks on illogical details, wonders where the moral is, worries about poetic justice, and cavils over decorum of character types. He wants to see a particular kind of play Shakespeare does not offer, one that is an abstract of moral truth dressed up in the correctness of improbable probabilities. He is not interested in the truth of life existing in, and expressed by, a world created by the artist, but in another kind of truth existing in a world of previously defined absolutes, previously defined by other people and drawn from a world consisting of previously made works of art. Shakespeare does not fit Rymer's French model because Shakespeare was obviously not as much interested in the truth of theoretical probability as he was in absolute truth dramatically presented according to the exigencies of the play. He was not interested in poetic justice as much as in exciting passions through interesting characters and appropriate, exciting acts by those characters. The heroism and degradation of the Moor, Othello, the fragile, unreal delicacy of Desdemona, and the vile, worm-tonguish evil of Iago all are rhetorical in intention, in the sense that they induce in us certain passions, but they come from a tradition different from Rymer's pseudoscientific classification of decorous types. Rymer thinks in terms of parts of a play, how each incident and each character ought to be, given the rules as standards; whereas *Othello*, as an inspired work of art, is greater than the sum of its rhetorical parts.

Rymer fails to see that Shakespeare's plays are forceful and

lively, appealing simultaneously to the imagination and the understanding. Rymer is not overcome by the force of Shakespeare's imaginative vision, his idea, and the passion or movement that are intended to reinforce a view of life and character universal in its comprehension and significance, appealing to both the imagination and the understanding. The reasons why Rymer is unmoved are clear. Shakespeare leaves out the explicit, immediate kind of moral abstraction, or poetic justice (which Rymer thinks ought to be in every play), for poetic justice is not life. Life itself is not full of decorous characters or poetic justice; it is full of good and bad people, neither all good nor all bad, who are neither necessarily rewarded for their good deeds or intentions nor necessarily punished for their bad (although some people then as now liked to think that is what should happen and would happen in the world as it is supposed to exist). To Rymer, characterization should be based on types; actions should correspond to an artificial probability, that is, to how a typical soldier, lawyer, or courtier is supposed to act. Rymer misses the point that generalizations exist to help us understand specifics, whether positively or negatively. Iago, for example, is real and influential to a great extent because he is an anti-type—the opposite of the type of soldier Rymer criticizes Shakespeare for not using and the type of soldier people like Rymer mistakenly classify as honest. Shakespeare emphasizes character or the interplay of characters over plot, each person as uniquely and as fully realized in a dramatic situation as any artist has ever achieved. And we feel as well as understand Shakespeare's own feeling and understanding of truth and life through understanding his language because we feel we know the worlds of his plays and the characters who inhabit them.

Dryden, unlike Rymer, understands at least partially Shakespeare's emphasis on the relationships of characters rather than plot, but his ambivalence was shared by many seventeenth-century Englishmen. Although he respects the rules as reasonable, fundamentally he feels the superiority of an irregular, great English art, and although he poses a dilemma for us by conflicting statements about character and plot, we can sort out his ideas, showing that he emphasizes the importance of characterization. First, in "The Grounds of Criticism in Tragedy" (1679),[38] Dry-

den says in the mode of French rules criticism that the plot "is the
foundation of the play" and with the moral it comes before the
creation of the characters (in Watson, I, p. 248). He says also
that Shakespeare (and Fletcher) is deficient in his plots (I, p.
246). Yet, Dryden thinks Shakespeare the greatest playwright,
and his excellence, as it turns out, is his characterization: "[Shake-
speare] had an universal mind which comprehended all characters
and passions" (I, p. 260). It is also moving characterizations and
passions that make a play lively, as opposed to merely just, and to
Dryden liveliness becomes the most important quality of great art.

The extent to which Dryden appreciates Shakespeare depends
on how well he comprehended his world view, a view that is Neo-
platonic in its comprehension of the universe. The godlike imagi-
nation a Renaissance playwright assumed he had was more to
English taste than French, and Shakespeare's lively characters
obviously appealed to Dryden more than they did to French critics
or to English critics committed to French Rationalism. The fact
that Shakespeare was appreciated so much shows that Restoration
audiences were at least somewhat oriented toward the older Neo-
platonic view of the universe, but the extent to which Neopla-
tonism was a part of intellectual, as well as everyday, thought in
seventeenth-century England is difficult to assess. Its relation to
music, mathematics, magic, religion, astrology, poetry, drama,
medicine, painting, architecture, and superstition is so manifest
everywhere it is incalculable. At the same time, it is so mixed in
with other forms of philosophical, religious, and scientific thought
that it is impossible to document with exactitude how much mod-
ification Neoplatonic thought underwent and to exactly what ex-
tent the cultural drift away from it took place, especially in the
relationship of Neoplatonic thought to both the new science and
rules criticism. That there was a change, we can see in the literal
and figurative distance between the kind of art produced by the
early Michelangelo, in the Sistine chapel, which embodies uni-
versalized, idealized figures, and Rubens's *Life of Marie de' Me-
dici*, which embodies the circumscribed life of the French court.
This change is echoed by the distance between Shakespeare's
Cleopatra as a universalized conception of an extremely complex,
fascinating woman and Dryden's more circumscribed Cleopatra

as a lady of the English Restoration court.[39] All anyone can really
do is note that there is a change, explain how it is manifested in
individual instances, and expound generally on its extent. There
is also disagreement. Arnold Hauser, for example, does not see
signs of a new sensualism in France until the end of the century.[40]
But in a more balanced assessment that denotes the gradual change
of attitudes and beliefs, Gretchen Finney points out that because
of the new science music by the end of the century had lost much
of its mystique, becoming "nothing, literally, but a motion of the
air."[41] She also says, quite correctly, that those who were scien-
tifically oriented found it hard to shake off old occult ideas (p.
151). The older Neoplatonism was a powerful, moving force, and
the pervasiveness of Neoplatonic beliefs and thought is probably
little appreciated by us. Douglas Bush says, for example, "We
cannot overestimate the importance of the Platonic strain in En-
glish humanism."[42]

In the Restoration the influence of the new science was tre-
mendous, but not everyone was influenced in the same way or to
the same extent. It is easier for us to study the newer movements
of the Baroque age just because they were beginning to be ac-
cepted, for that also means they would be articulated, attacked,
explained, and defended.[43] Ideas have a habit of hanging around
for a long time anyway, and many Neoplatonic ideas are still with
us today, however diluted, distorted, or modified. The older, es-
tablished ideas that everyone takes for granted, that no one thinks
need explaining, often are hardest to identify and discuss. English
attitudes toward newer kinds of music, for example, are easy to
document. Although Neoplatonism had been more fashionable
in the beginning of the seventeenth century, it was so much a
part of human belief that there are still allusions to it almost every-
where at the century's end. In the Restoration, Neoplatonic ideas
were especially prevalent in traditional musical theory. For exam-
ple, Jeremy Collier, although skeptical of idealism and capable of
firm belief in his senses (which even Descartes and Antoine Ar-
nauld find difficult), talks about music in the old way, taking his
theory from Boethius, Glarean, and Galtruchius.[44] And Newton,
the great scientist, was fascinated by hermeticism.

The results of the conflict between Neoplatonism and rules

criticism are confusing. Sometimes Continental theory seems dominant, and sometimes the English absorbed what the Continent offered, obviously keeping their own national, artistic, and critical identities.[45] A part of every critic or person who had not espoused the French rules wholeheartedly wanted to see art that was more than an explanation of reality, art that presented a reality perceived and created by artists' imaginations, stimulating the receptors' own imaginations to a high degree. Rymer's criticism, as well as that of the French rules critics themselves, was fundamentally inimicable to the English experience, even though many paid lip service to it, because the English had found models in their own cultural tradition, poets like Shakespeare and Milton, and these artists or makers had taught the English what great art is all about. The English experience helped shape taste, art, and critical thought through an anti-Rationalistic, Neoplatonic mode of thinking about the arts that explained the power of English Renaissance art, as well as that of Homer, Michelangelo, Pindar, and the Bible, works whose excellence lies largely outside the bounds of the rules. Rules criticism and its attendant standards of taste became influential in England at a relatively late date. A. F. B. Clark notes, "No French critic of a generation preceding Boileau had any influence in England."[46] English provinciality, or the cultural lag between England and the Continent, proved to be a blessing.

EIGHT

Continental Pressures and the English National Culture

The power and subsequent influence of English art and ideas is grounded in the English national culture. A strong national tradition makes a great difference as to what kinds of art grow from it, what kinds of art are liked, the ideas embodied in the art itself, and the language used to express admiration, displeasure, appreciation, and so forth, for certain works of art. Despite the international character of Renaissance humanism, the new science, canons of sophisticated art and behavior, general ideas about education, and the whole conception of great painting, poetry, music, and the other arts always differ to some extent from one nation to another.[1] Artists and critics from different countries use different kinds of imagery and allude to different artistic models. A French critical work becomes peculiarly English in translation or when considered from an English point of view because words that are supposedly equivalent have different connotations. Artistic freedom, for example, means something different to each culture, although it may be stated by each in the same way, and a seventeenth-century Englishman saw things in Homer and Michelangelo beyond the ken of an ordinary contemporary French-

man, recalling from his own cultural experience different succes-
sions of feelings and impressions. Likewise, as Pierre Legouis
accurately points out, critics and historians do not fully realize
how opaque higher French art was to the Restoration English,
even in that age of French influence.[2] An understanding of na-
tional cultural history as well as European cultural (or sociological
or economic) history thus becomes crucial to an understanding of
specific works of art.

I

Seventeenth-century French critics gave the English a vocab-
ulary with which to talk about art. French treatises in England,
translations of French and Italian works on all the arts (which
inundated England during the Restoration), the creation of a
critical vocabulary derived from French, and native rules critics
like the highly respected Thomas Rymer influenced the English
to accept Continental rules and correctness. A survey of Donald
Wing's *Short Title Catalogue* and *A Gallery of Ghosts* shows the
dissemination of Continental works. Wing lists about seventeen
editions on architecture,[3] six editions on painting,[4] and only one
translation into English of musical theory (by Descartes) although
there are a number of songbooks by Pietro Reggio and others. The
lack of translations of musical theory does not negate Italian in-
fluence, considering the international character of musical com-
position and the fact that English music at the time was composed
in the Italian mode. The interest in French literature, criticism,
history, logic, rhetoric, and religious works was immense—there
are something like 228 translated editions.[5] The number of trans-
lations of French and Italian works, the popularity of the French
language itself (as recorded in drama and elsewhere), and the
many references to both original and translated works in English
writings give an indication that many Continental works were
also read in their original tongues. Dryden, to point out a few ex-
amples, uses Corneille (in the "Essay of Dramatic Poesy," 1668),
Boileau (in "The Author's Apology for Heroic Poetry and Poetic
Licence," 1667), and Bouhours (in the Dedication to *Amphyit-
ryon*, 1690) before their works were translated into English. With
the immense number of French works available, translated and

untranslated, it is no wonder that the French influence can be seen everywhere, at least on the surface.[6] English critical thought was not annihilated but augmented and improved. The improvement occurs primarily in vocabulary, in the new, sophisticated way the English express themselves, and comes from the introduction of French words into English, the use of English words with the meanings of their French equivalents, the cultivation of the French critical style, and the discussion of questions raised by French criticism.

The creation of an English critical vocabulary was mainly the work of John Dryden. Earlier English critics show the clumsiness of English critical language, which points up the importance of Dryden's achievement and the Continental influence. The inadequacy of the English vocabulary is everywhere apparent. Henry Peacham, for example, says:

> Of Latine Poets of our times, in the iudgment of Beza and the best learned, Buchanan is esteemed the chiefe; who albeit in his person, behauior, and fashion he was rough hewen, slouenly, and rude, seldome caring for a better outside than a Rugge-gowne girt close about him, yet his inside and conceipt in Poesie was most rich, and his sweetnesse and facilitie in a verse unimitably excellent.[7]

Inside apparently refers to Buchanan's soul; *conceipt* refers to the invention of ideas or images. And we might say Peacham means Buchanan has a "most rich soul" and a "most rich invention," phrases that are part of a Drydenian vocabulary although Dryden probably would not have used the vague "most rich." Peacham's "sweetnesse and facilitie" refer to the smoothness and easiness of Buchanan's Latin verse; "unimitably excellent" is obvious. Peacham lacked a critical vocabulary as such and was forced to use imprecise, ordinary language in a way for which it was not meant. No writer from the latter part of the century could have written such a passage.

It is not until the writings of Hobbes and Davenant, after their stays in France, that a new critical spirit emerges, although their work also is limited in scope and vocabulary. Davenant, for example, takes three pages to say the same things about wit that

Dryden expresses more exactly in a paragraph. The comparison between a good writer and a great one is somewhat unfair, but still it is impossible to say things as incisively without a precise, critical vocabulary. Davenant says this about wit:

> A wit is the laborious and the lucky resultances of thought, having towards its excellence, as we may say of the strokes of a painting, as well a happinesse as care. It is a webb consisting of the subt'lest threads; and like that of the spider is considerably woven out of ourselves; for a spider may be said to consider, not only respecting his solemnesse and tacit posture (like a grave scout in ambush for his enemy), but because all things done are either from consideration or chance, and the works of chance are accomplishments of an instant, having commonly a disimilitude, but hers are the works of time, and have their contextures alike.[8]
>
> Wit is not only the luck and labor, but also the dexterity of thought, rounding the world, like the sun, with unimaginable motion, and bringing swiftly home to the memory universall surveys [Neoplatonic image]. It is the soul's powder, which when supprest, as forbidden from flying upward, blows up the restraint, and loseth all force in a farther ascension to Heaven (the region of God), and yet by nature is much less able to make any inquisition downward towards Hell, the Cell of the Devill; But breaks through all about it as farr as the utmost it can reach, removes, uncovers, makes way for light where darkness was inclos'd, till great bodies are more examinable by being scattered into parcels, and till all that find its strength (but most of mankind are strangers to Wit, as Indians are to powder) worship it for the effects as deriv'd from the Deity.[9]

Davenant is explicit about the mystery and the force of imagination but he has to use metaphors and similes for everything.

Dryden, with an improved critical vocabulary, can make nuances of thought much clearer (1667):

> But to proceed from Wit, in the general notion of it, to the proper wit of an heroic or historical poem, I judge it chiefly to consist in the delightful imaging [a word not really available to Davenant] of persons, actions, passions, or things. 'Tis not the jerk or sting of an epigram, nor the seeming contradiction

of a poor antithesis (the delight of an ill-judging audience in
a play or rhyme), nor the jingle of a more poor paranomasia;
neither is it so much the morality of a grave sentence affected
by Lucan, but more sparingly used by Virgil; but it is some
lively [alive, animated, having the breath of life in it, derived
from the imagination; see Chapter V for a discussion of this
important word.] and apt description [derived from the judg-
ment], dressed in such colors of speech that it sets before your
eyes the absent object as perfectly and more delightfully than
nature.[10]

Dryden's criticism is obviously superior in vocabulary and sophis-
tication, and here, early in his career, he defines wit as encom-
passing both judgment and imagination; whereas Davenant in
the older, Renaissance tradition says wit comes primarily from
imagination. Dryden shows his awareness of increased English
urbanity and correctness when he says (1672):

> Wit's now arrived to a more high degree;
> Our Native language more refin'd and free.
> Our ladies and our men now speak more wit
> In conversation than those poets [Fletcher and Shakespeare,
> among others] writ.[11]

By expanding the meanings of current English words and
words from languages other than French and, more important,
by using French meanings for English words with French equiva-
lents (when the previous English meanings are sometimes quite
different) and by introducing French critical words and their
connotations into English, Dryden developed a critical vocabulary
that the English language lacked. He could not have done so un-
less his readers were attuned to French, and the *Dictionnaire de
l'Académie Française* (Paris, 1694) as well as historical French
dictionaries such as Émile Littré's *Dictionnaire de la langue fran-
çaise* (1956) often are more likely to produce meanings for Dry-
den's critical terms than is the *OED*.[12] *Sweetness*, as one example
among many, is usually the critical equivalent of the French
douceur, and we can see this association not only through defini-
tions but also in translations. In Nicholas Boileau's *Traité du
sublime* (Paris, 1674), there are two phrases we might consider:

"une certaine douceur agréable et fleurie" and "les douceurs et les grâces."[13] The first is construed as "a certain agreeable and blooming sweetness" by Boileau's translator J. Pulteney (*A Treatise of the Loftiness or Elegancy of Speech* [London, 1680]); the second, as "sweetness and grace" by F. Langbaine (*An Essay Upon Sublime . . . Composed With the French of the Sieur Dépreaux Boileau* [London, 1698]). As another example, the seventeenth-century French concept of *génie* is closer to the eighteenth-century English meaning of *genius* than it is to the normal seventeenth-century English usage. Boileau says, "Je sens que mon esprit travaille de génie" (Boileau, "Satire VII," in *Oeuvres* [Paris: Garnier Frères, 1961], p. 47, l. 41). According to Cayrou, "Il [génie] prend déjà, à la fin du siècle, son sens fort actuel et se dit surtout des aptitudes supérieures de l'esprit."[14]

To indicate more clearly the kind of stylistic change in vocabulary that takes place during the Restoration we can look at a passage from the beginning of Chapter VI of Boileau's *Traité du sublime* (1674) and the same passage in Pulteney's translation, *A Treatise of the Loftiness or Elegancy of Speech* (London, 1680), and in the 1712 English edition of Boileau's *Works*, Translated by Several Hands (London, 1712).

Traité du sublime (1674)

> Il y a, pour ainsi dire, cinq sources principales du sublime; mais ces cinq sources présupposent comme pour fondement commun une faculté de bien parler, sans quoi tout le reste n'est rien.
>
> Cela posé la, la première et la plus considerable est "une certaine élévation d'esprit qui nous fait penser heureusement les chose," comme nous l'avons déjà montré dans nos commentaires sur Xénophon.
>
> Le seconde consiste dans le pathétique; j'entends par pathétique cet enthousiasme et cette véhémence naturelle qui touche et qui émeut. Au reste, à l'égard de ces deux premières, elles doivent presque tout à la nature, et il faut qu'elles naissent en nous; au lieu que les autre dépendent de l'art en partie.
>
> La troisième n'est autre chose que les "figures tournées d'une certaine manière." Ou les figures sont de deux sortes: les figures de pensée, et les figures de diction.

Nous mettons pour la quatrième "la noblesse de l'expression," qui a deux parties: la choix des mots, et la diction élégante et figurée.

Pour le cinquième, qui est celle, à proprement parler, qui produit le grand et qui renferme en soi toutes les autres, c'est "la composition et l'arrangement des paroles dans toute leur magnificence et leur dignité."

A Treatise of the Loftiness or Elegancy of Speech (1680)

There are five principal heads of loftiness, but they all presuppose a good faculty of speaking, as a common foundation, without which they cannot stand. That therefore being supposed the first and most considerable is, "a regular elevation of thought." As is already shown in our remarks upon Xenophon. The second consists in being pathetical; by which is meant that Enthusiasm and Natural vehemency which touches and affects us. These two first we owe chiefly to Nature, and have from our cradles; whereas the two latter do partly depend upon Art. The third is nothing but "figures diversely fashioned." And those are of two sorts, figures in thoughts, and figures in words. The fourth Shall be "a stateliness of Expression." Which may be subdivided into two parts (viz.) the choice of words and elegant figurative phrases. The fifth and last (whence, properly speaking, all greatness is derived, and which includes the other four) "is the ordering and well placing of sentences according to their magnificence and dignity."

A Treatise of the Sublime (1712)

We may affirm that there are five original or principal causes of the sublime; but these five causes presuppose a common foundation to all, "a faculty of speaking well, without which all the rest is worth nothing."

The first and chiefest of those causes "is that elevation of mind, by which we think happily on everything," as we have already shewn in our commentaries upon Xenophon.

The second consists in the pathetick. By pathetick I mean that enthusiasm and natural vehemence which touch and move. These two causes are almost entirely the gift of na-

ture, and must be born with us; whereas the other three depend in some measure upon art.

The third is nothing but a happy turn of figures. Now figures are of two sorts; figures of thought, and figures of diction.

For the fourth we put nobleness of expression, which has two parts; choice of words, and an elegant and figurative diction.

The fifth is that which properly speaking, produces the sublime, and contains all the others in itself; being the composition and disposition of words with all the magnificence and dignity they are capable of.

A comparison of Boileau's *Traité* with the two translations indicates the trend in English vocabulary. The relative sophistication of the 1712 translation comes from the French influence. The English word *sublime* owes the origin of its acceptance to Boileau. *Loftiness* is the usual English equivalent to *sublime* until Dryden, who uses the term for the first time in "The Author's Apology for Heroic Poetry and Poetic Licence," prefixed to *The State of Innocence* (1677), applies it to Milton's *Paradise Lost*. The general English use of *sublime* dates from that time.[15] Dryden also uses *diction* for the first time in 1685, although the OED records its first use in 1700.[16] There are other characteristics of the 1712 translation that show its greater sophistication: the use of "elevation of mind" instead of "elevation of thought" for "élévation d'esprit"; "composition and disposition of words" instead of "the ordering and well placing of sentences" for "la composition et l'arrangement des paroles"; and "touch and move" instead of "touches and affects" for "touche et . . . émeut." The increased sophistication of the English critical vocabulary allows the second translation to be much closer to the French, word for word, while at the same time the style remains more elegant.

The influence of French attitudes toward art both from translations and from French treatises finds its purest English expression in the works of the English rules critic Thomas Rymer. Dryden disagrees with much of what Rymer says and speaks about him rather derogatorily, calling Rymer a venomous insect (1693),[17] and "arrogant" and "ill-natured" (1694).[18] But he always respects Rymer's learning, and the part of Dryden that likes "justness,"

regularity, and balance agrees with Rymer. He says, "Mr. Rymer sent me his book [*Tragedies of the Last Age*], which has been my best entertainment hitherto: 'Tis certainly very learned, and the best piece of criticism in the English tongue; perhaps in any other of the modern."[19] Dryden later mentions Rymer's wit and asserts that no man can answer him.[20] John Dennis also has mixed feelings about Rymer,[21] but Blackmore calls him "our best English critic" (however, Blackmore is Rymer's disciple).[22] Spence in 1736 quotes Pope:

> Rymer, a learned and strict critic? Aye, that's exactly his character. He is generally right, though rather too severe in his opinion of the particular play he speaks of, and is on the whole one of the best critics we ever had.[23]

It is apparent that the English were put off by Rymer. Dryden was much more widely published,[24] and even Thomas Pope Blount's *De re poetica* (London, 1694), oriented toward Continental critics, being a compendium of critical opinions drawn mostly from Adrien Baillet's *Jugemens des savans* (1685–86),[25] quotes Dryden more frequently than anyone else except René Rapin, although some of Dryden's best criticism had not yet been written.[26] Almost all that Blount quotes from Rymer comes from the Preface to his translation of Rapin's *Réflexions sur la poétique d'Aristote* (1674), and all of Blount's uses of Rapin come from Rymer's translation. Despite his *Tragedies of the Last Age* (1674) and *A Short View of Tragedy* (1693), Rymer does not loom very large in the total scope of English criticism, at least according to Blount.

The differences between French and English ideas are not found in the critical vocabulary itself, however, but in the artistic allusions called up by that vocabulary, allusions that affect the kind of images Baroque artists use in their work, or the kind of works upon which critics founded their theories. The term *sublime*, for instance, meant something different to an English as opposed to a French audience because of differing cultural traditions. A visual image in Dryden's poetry often alludes to an artistic vision clearly different from one alluded to by Boileau in a similar context. Writers use images from painters they like and admire

most, and someone who believes more in imagination is more likely to see images created by other imaginative artists. An English writer unless he is almost totally under Continental dominance is more likely to be influenced by Shakespeare than he is by Racine. As it turns out, a visual image like Rubens's might easily enter an Englishman's mind when induced to do so by an allusion; whereas a Frenchman would more likely envisage a painting by Poussin.

II

The odd double vision about Baroque English translations of French literature and French terminology is caused by a literary history or tradition unknown to French writers. What was felt to be profound and moving to many seventeenth-century Englishmen would have seemed ill-conceived, rough, and disjointed to Frenchmen of the same time. A play like William Wycherley's *Plain Dealer*, an English adaptation of Molière's *Le Misanthrope*, is typically much more irregular and full of violent emotions. Because of the powerful influence exerted by French art and criticism, the tension between the two cultures produces what can be called an English dilemma.

The English dilemma about what kind of art to regard as great is apparent in Sir William Soames's translation of Boileau's "L'Art poétique." He reveals a blind-sided rules bias toward art, omitting the most important English writers and trying to twist English literary history and achievement into a paradigm of the French. The only English writers praised are those known for their correctness:

> Fairfax [translator of Tasso's *Gerusalemme liberata*] was he,
> who in that darker age [Elizabethan],
> By his just rules restrain'd poetic rage.
> Spenser next in pastorals did excel,
> And taught the art of writing well;
> To strickter rules the stanza did restrain,
> And found for poetry a richer vein. . . .
> Waller came last, but was the first whose art
> Just weight and measure did to verse impart. . . .
> Thus 'twas great Jonson purchased his renown,

And in his art had born away the crown,
If less desirous of the people's praise,
He had not with low farce debas'd his plays. . . .[27]

The other Englishmen mentioned honorifically are John Dryden
(only as a critic), Abraham Cowley, John Denham, and Samuel
Butler (in burlesque). All the rest are criticized as low or mis-
taken: William Davenant, Thomas Shadwell, George Chapman,
John Milton (by implication only, in connection with Du Bartas),
and Elkannah Settle. With few exceptions, the English writers
who are praised for correctness would not ordinarily be mentioned
among the greatest English authors. Shakespeare, Fletcher, and
Milton are conspicuously absent by name, their virtues falling
outside the categories postulated by the French rules critics, of
whom Boileau was one. Even Ben Jonson is criticized for his lack
of decorum, his use of farce. There are other problems as well.
Fairfax and Spenser do not correspond well with Villon and Mo-
rot, nor is Davenant a close parallel to Ronsard. Malherbe was
more clearly a moving force for French letters than his supposed
equivalent Edmund Waller. The parallel that is most apt is that
of Ben Jonson with Molière, but even here we see a great deal of
difference between the tones of the two playwrights. The greatest
heroes of Boileau's own time and country are, as we might expect,
Corneille and Racine, while Benserade will "amuse les ruelles"
and Segrais is best in the eclogue. The English translator can
scratch up as literary heroes only Spenser (in pastorals), Cowley,
Denham, and Waller. It becomes evident that the similarities be-
tween the French and English attitudes toward art are found only
in common classical backgrounds and in Soames's yearning for
English literature to be like the French. He indicates less interest
in literature than in literary prestige judged against the rules.

The English dilemma about the arts also is reflected in politi-
cal and religious controversies. Those who were more generous
toward religious enthusiasm were more likely to favor imagination
in the arts and more likely to be against increasing the king's au-
thority (which is analogous to the rule of judgment in the human
soul.) It is not surprising that the Cambridge Neoplatonists, liber-
tarian philosophers, came from a dissenting background. Gerald

Cragg in several places is even more specific, saying that they came from Puritan backgrounds and were reacting to the dogmatism and rules of Puritanism itself.[28] John Dennis's enthusiastic religious analysis of the sublime in the late seventeenth and early eighteenth centuries emanates from Neoplatonic thought (as well as from Boileau's *Traité du sublime*) and is essentially low church.[29] Religious enthusiasm and imagination was suspect to those who thought possession of the inner light blasphemous,[30] to people who remembered the excesses of Cromwell's parliamentary forces, and to those who supported the Stuarts, who were in turn partially supported (even financially) by the French themselves. There are variations in thought, however, since the English were divided both within and among themselves. A leading critic like Dryden, a Tory, a Catholic, distrusted both the imagination and the rules, the imagination because of his belief in decorum and reason, the rules because of his appreciation of irregular great art. Yet he also felt drawn toward each, and that is where the problem lies.

Saint-Évremond, the elegant French critic exiled in London, makes some interesting observations in his comparisons between, and judgments about, French and English art. He thinks English comedy, for instance, the best in the seventeenth century because it represents "human life in common, according to the diversity of humours, and several characters of men."[31] Saint-Évremond seems to allude to Jonsonian comedies of humours in his phrase "several characters," implying the classification of people into types, perhaps types classified by humours. The French, he thinks, "content themselves with the first image received from objects: and to stop at the mere outsides of things, an appearance almost always serves instead of truth; and what is easy, for that which is natural" (pp. 33–34). In other words, English characters are more like actual people, less like types or abstractions. The English themselves also thought their comedy went beyond French understanding of the genre.[32] Sir William Temple sets off English comedies of humours from the French, saying that "humour [is a] word peculiar to our language,"[33] and he also ascribes the superiority of English comedy to its use of humours in characterization.[34] Saint-Évremond and Sir William Temple both are probably

referring to Ben Jonson's comedies as well as other regular plays of the Restoration. Saint-Évremond's statements seem perceptive, but he undoubtedly leaves out a whole range of plays that are more irregular than he likes.

In his statements on tragedy, Saint-Évremond clears up for us the conceptual differences between French and English ideas of freedom and imagination. He often shows a seeming reasonableness about the rules of tragedy:

> To avoid confusion, we ought to observe rules and directions, and to follow true judgment and good sense, which may allay the heat of an inflamed imagination: yet we are to undress those rules of all tormenting restraint, and to banish a scrupulous reason, which through too close embracing of justness, leaves nothing free and natural behind it.[35]

It is statements like these that made some Restoration Englishmen think they agreed with French theorists. As Joel Spingarn says, after quoting a passage in which Rapin criticizes the strictness of the rules, "It is these occasional elements of freedom in Rapin's theory that made his book popular in England."[36] The issue is not simply freedom versus rules, however; it concerns more exactly the emphasis on either the rationalities of plot or the emotional qualities involved in characterization. The English were certainly less concerned with plot. Although he exhibits much more knowledge about English dramatic works than other Frenchmen, Saint-Évremond's idea even of reasonable freedom falls outside the English tradition.[37] His statements about Jonson corroborate his distaste for irregular, indecorous writing; he cannot bear English music (p. 54); and after stating that French tragedies are most excellent, he criticizes English tragedies, tastes, and behavior:

> There are four or five English tragedies where in good truth, many things ought to be retrench'd; and with this curtailing they wou'd be render'd altogether exact and compleat. In any of the rest you can see nothing but matter without form and digestion, an heap of confused events: and without consideration of places or times, without any regard to decency; their cruel eyes delight to see blood and wounds and most direful murders. . . . Men of sense do disallow of this custom, estab-

> lisht perchance on no very civil and humane sense in the
> minds of men: but it is an ancient habit and way, wherein the
> nation's taste in general takes place over the delicacy of par-
> ticular persons. [P. 9]

Saint-Évremond is stating that the English on the whole are sav-
ages by comparison to the French, a prevailing view among
Frenchmen of the time. (The English, in turn, thought the
French effeminate.) The whole experience of Elizabethan trag-
edy is foreign to Saint-Évremond's nature, as is English music (not
to mention painting). Saint-Évremond's view is unique only be-
cause he (unlike other French writers) actually talks about En-
glish art. His statements are all the more striking when we realize
that except for a stay in the Netherlands from 1665 to 1670 he
lived in England from 1661 until his death in 1703. Dryden's
classic expression sums up the common English answer to the
kind of criticism voiced by Saint-Évremond. He thinks that the
concentration on plot devices limits too much the liveliness that
is the result of imaginative invention:

> By their [the French] servile observations of the unities of
> time and place, and integrity of scenes [liaison des scènes],
> they have brought on themselves that dearth of plot, and
> narrowness of imagination which may be observed in all their
> plays.[38]

Usually the Restoration English *thought* they should accept
the seeming rationality of the rules but *felt* they should not. The
seeming paradoxes candidly expressed by Saint-Évremond give
reasons why much French criticism impressed the English and
suggest the way in which it did:

> There is no country, where reason is more rare, than it is
> in France; when it is found there, there is not a purer in the
> world.
> For the most part all is fancy, but a fancy so fine, and a
> capricio so noble, in what regards the outside, that strangers
> ashamed of their judgment, as of a gross quality, seek to make
> themselves esteemed among them, by the imitation of our
> [French] modes, and renounce essential qualities, to affect an

air, and ways, which is hardly possible for them to invent.
Thus that continual alteration in our habits, which they re-
proach us with, and is always followed, becomes insensibly a
very great piece of wisdom; for besides, infinite sums of money
which we [the French] draw from thence, 'tis an interest more
solid than is imagined, to have Frenchmen dispersed through-
out, who form the outside of all people by our own; who begin
by enslaving the eyes, when the heart is still opposed to our
laws; who gain the senses in favor of our government, when
the opinions still hold for liberty. [*Miscellaneous Essays*, I, pp.
192–93]

Saint-Évremond's observation is shrewd. The English were won
over by appearances, by French manners, rather than by the sub-
stance of French culture. English taste still embraced the liberty
inherent in the English cultural tradition, even when it appears
not to do so. A knowledge of the differences between the two na-
tional cultures leads to a clearer understanding of both criticism
and art.

Comparisons of the Arts

There are three ways to approach comparisons of the arts. The first is historical and consists of investigating the processes, thoughts, and movements that lie behind the arts, as we did in the earliest chapters on ideas and theories current in the Baroque era. The second approach analyzes similarities of effects in the different arts. Such an approach derives its impetus from concepts such as *ut pictura poesis* and *ut musica poesis*, both of which tend actually to parallel rather than compare the arts and which rely for their justification on the process of creation as discussed in the chapters on rhetoric. The third approach compares the ways each art uses imagery from the others and explains what a work of art says through its reliance on the other arts. This last approach depends not only on ideas, theories, and practice but also on taste, both general and personal, as discussed in the last chapters.

I

Ut pictura poesis often has been defined and explained.[1] This notion came from Horace's *Ars poetica* (l. 361) and means "as a painting, so also a poem"; that is, a poet in his poetry supposedly paints a picture. Poets often describe in their poems a painting or even the process of painting. Sometimes they hang, figuratively, a series of poetic pictures or portraits in an imaginary gallery. As Jean Hagstrum points out in *The Sister Arts*, Giovan Battista Marino uses the technique in his poem *La Galleria* (1620) as does Pope in his "Moral Epistle II" (1735). Another technique is

to describe a painting in poetry. A poet could describe a real or an imaginary painting as he wrote, and readers should envision it when they read. Andrew Marvell's "Last Instructions to the Painter" (1667) is in parts quite successful in conjuring up period paintings; Pope's second "Moral Epistle" (1735) has excellent portraits; and Denham in "Cooper's Hill" describes recognizable landscapes. But Waller, for example, in his "Instructions to a Painter," states the obvious, recognizing that the device is not really functional:[2]

> Painter, forgive me, if I have awhile
> Forgot thy art, and used another style;
> For, though you draw arm'd heroes as they sit,
> The task in battle does the muses fit;
> They, in the dark confusion of a fight,
> Discover all, instruct us how to write. [Ll. 286–87]

Lessing says, with Shaftesbury, that those who call a painting mute poetry and a poem a speaking picture are indulging in spurious criticism: "Despite the complete similarity of effect, the two arts differ both in the objects imitated as well as in the manner of imitation."[3] He says, more explicitly, "Objects or parts of objects which exist in space are called bodies. Accordingly, bodies with their visible properties are the true subjects of painting. Objects or parts of objects which follow one another [in time] are actions. Accordingly, actions are the true subjects of poetry."[4] He adds, however, that "nothing is more deceptive than the laying down of laws for our emotions" and affirms that the effects of each art are similar.[5] Lessing therefore does not categorically deny that painting can imply action and poetry suggest objects. The arts are comparable but not parallel; their effects are communicated through the rhetorical devices proper to the means of each art. The same observations hold true for music and painting.

The differences between poetry and music are less striking than those between poetry and painting because the former arts move through time. But the piece of music that can be explained as a poem really becomes words in the explanation. The process of explaining is like the process of translating a lyric poem such as Wordsworth's "Intimations of Immortality" from English into

German. The poem is not the same poem but another work of art, more or less successful. The same result occurs when a poem is translated into music; in this case a different medium replaces the different language. Each art is separate, just as each work of art is separate from every other work of art, whether from poem to poem, or poem to sonata, or sonata to landscape, or landscape to poem. But the arts are similar because each poem, for example, differs no more in effect from every other poem on a similar subject, given the same intentions by the artist, than it does from a piece of music or a painting. Although the kind of art dictates to a great extent the kinds of approaches used and although there are different advantages and limitations for each art dependent on the devices available, intention and effect remain comparable. The deeds of Louis XIV are treated alike in painting, poetry, music, dance, and sculpture because they are similarly regarded by contemporary artists.

Effects that are the result of authorial intention are comparable. Effects that are not, are merely personal. Paula Johnson, in *Form and Transformation*, notes that Lessing's distinction between arts, those that are spatial and those that operate through time, is now starting to break down, but she also says that there is a difference between those arts that in themselves do and those that do not determine the order of what can be perceived, that "no matter how open a musical work of Stockhausen or of Cage may be, the listener cannot choose to have its sounds presented to him in any other order than that in which they are in fact presented."[6] And the author or composer or performer (if the composer refuses to accept the responsibility) places the elements of a composition in a certain order because he has a particular idea either of how the piece should sound or of what he wants to happen or to say. Again, we are in the realm of rhetoric, in which intentions and effects of different kinds of art can be compared.

If we can temporarily ignore differences among creators and recognize that through diverse media artists try to achieve similar effects, then we can compare colors and tropes and sounds without paralleling them, using the rhetorical conventions the audiences or spectators associate with each art. Gerard LeCoat says,

Cicero's *Rhetoric* and Quintilian's *De institutione oratoria*, the basic texts used in universities of the time, helped the theorists of "Musica poetica" to devise tropes and figures related to metaphor, synecdoche, apocope, ellipsis, etc. Here the link between music and poetry is clearly defined. But so is the link between music and painting, because in the last analysis, the composer, like the poet, becomes a painter of the passions, the emphasis being on descriptiveness. . . . All the arts pool their resources.[7]

The idea that the arts pool their resources is useful and important. But painters, poets, and composers use rhetorical devices to represent, describe, and express the passions (thus homeopathically raising these passions in their audiences and spectators) rather than to paint them. Theorists from Plato on have frowned on the idea that a poet "paints the passions," for that is to cross over into the fallacious realm of paralleling media in themselves through the use of metaphor. This point is not a useless cavil: abuse of this idea leads to fallacious considerations of parallelism between artistic media; it gives rise to all sorts of misleading parallels between the arts.[8] Every Baroque poet thought he expressed himself like an architect, a painter, or a musician because the arts are comparable not parallel. The skill involved in each art is a part of that art, but it is less important than the whole movement of the mind or the force of the imagination in producing an artistic creation, not merely a piece of handiwork. An awareness of the rhetorical bases of art, combined with the analysis of the soul, and the knowledge of taste and preferences of individual artists for particular kinds of art, whether socially or philosophically induced, enable us to compare art of all kinds. We can compare intention, imagery (as part of invention), and effect in each art, showing how imagery from each art enhances the other arts; how creators intend certain effects; and how those effects reach and impress us. We can do so in general theory and in specific works.

In a third kind of comparison, we see that poetry, painting, and music use and enrich each other for pleasure and instruction by means of allusions and references within one work of art to other media. In the Baroque era, the ways one kind of art rein-

force another is most obvious when similar topics or subjects or genres are used.[9] Everyone took imagery from a common source or supply. Artists worked with specific topics, each of which has prominent characteristics and associations that stay with it, no matter in what medium it is presented and interpreted.

An artist can present a subject or topic in a straightforward manner or he may use variations and even inversions. Satire quite often shows the strength of a conventional topic by inverting it or breaking it down, and the seventeenth century is full of such inversions, reversals, or breakdowns of topics: Dryden's mock-heroic "Mac Flecknoe" (1682), John Wilmot's rather vulgar, mock-pastoral "Fair Chloris in a Pigstye Lay" (ca. 1680), and the Frenchman Paul Scarron's complex burlesque *Virgile travestie* (1648). At the end of Dryden's "Mac Flecknoe," Flecknoe, the king of dullness, falls through a trap door (conveniently a parody of Shadwell's *The Virtuoso* [1676]) in an inversion of apotheosis. Dryden expected his audience to have in mind the conventional scenes of apotheosis in other poems and in paintings. Indeed, there are innumerable such scenes and they all are similar; their characteristics speak for themselves: Simon Vouet's *Apothéose de Saint Guillaume* (ca. 1621–22) and *Apothéose de Saint Louis* (ca. 1640);[10] Andrea Pozzo's *The Apotheosis of St. Ignatius Loyola* (see Plate 5); Rubens's *Apotheosis of the Duke of Buckingham* (1635; see Plate 8)[11] and *The Apotheosis of James I*, the central oval in the banqueting hall of Whitehall;[12] and Dryden's "Eleonora" (1691):

> And, that she died, we only have to show
> The mortal part of her she left below:
> The rest (so smooth, so suddenly she went)
> Look'd like translation thro' the firmament,
> Or like the fiery car on the third errand sent. [Ll. 335–59]

II

Rhetorical conventions aid in communication, and a composer, painter, or poet expresses personal views with a generally accepted rhetorical tradition. The selection or discovery of a topic is part of invention. The artist first chose his subject from a group

of subjects or topics (note Aristotle's use of *topoi* in his *Rhetoric*), and his treatment of the subject depends on the view of reality he took—does he see people as better or as worse than they are. A subject like Venus and Adonis, for example, may be treated comically or seriously (nobly) no matter what topic from it is being used: Venus's lament for Adonis, the advent of the hunt, or Venus's expression of love. The creator then tried to achieve a certain effect through arrangement or design and the means of his art: color, lines, proportion, meter, words, rhyme, word order, sounds, instrumentation, and so forth. These means are the artist's primary ways of expressing himself, his rhetorical tools, his means of affecting the senses. It is through examining the ways in which individual creators use the premises of invention and design or arrangement, and the means of a particular media, that we come to understand works of art, not by considering works as documents in an artificially imposed, anachronistic sequence of ideas. Communication was (and still is) accomplished through conventions, which we have to understand as much as possible in seventeenth-century terms if we are to understand art of that period. Since the number of genres and topics is so large, an analysis of some examples should demonstrate the kind of conventions generally existing; our analysis seeks to elucidate Baroque art and by extension all art.

An example of a topic that was supposed to achieve a specific effect is the lament, whether that lament is in poetry, painting, or music. When you hear a poetical or musical description or expression of lamenting despair, your memory and imagination should conjure up an image of appropriate paintings, and when you see a painting you should hear the kinds of expressions used in words and music. It is easier to understand Baroque attitudes toward this idea, if we view it as part of an established, historical assumption. There are various grades of laments such as that of an aspiring lover, of an abandoned wife or mistress, and of a Christian mourning the crucified Christ. The lover's lament is not particularly serious, nor is it expressed as violently as the second or third kind because the lover is usually hopeful and somewhat comic. The effect of a lament by an abandoned wife or mistress is more serious. In *A Tracte Containing the Artes of Curious Paintinge*,

Carvinge, and Building (trans. Richard Haydocke [London, 1598]), Lomazzo says:

> Despaire hath actions betokening a privation of hope and contentment; as to beate with the hands, teare the lims and garmentes about a dead body, of whose recovery they have no hope: as Thisbe uppon Pyramus, when being out of love for herselfe, she cast her bodie uppon the pointe of the sword and so died; or for some notable disgrace taken in warre [Saul] . . . ; or for the loss of some pleasure or contentment, as Cleopatra for M. Antonius . . . ; and Dido for Aeneas, when (according to Virgill's description) first stabbing herself with a dagger, she threwe herself with all her jewels and treasure, from an high rock into the sea; or as Cato . . . ; or Nero . . . ; and Lucretia, that she might not live after she was defiled; or Achitophel, and Judas Iscariot. . . . Or finally for feare as well speaketh the poet:
>
>> The troupe of ladies runnes about and flies,
>> A scar'd with feare to him for succour cries:
>> They weep, they rore, they beate, they
>> catch, they rase,
>> Their breast, their necke, their hayre,
>> their eies, their face.
>
> And for diverse other mishaps, from whence does arise great variety of desperate motions; as strangling, falling down headlong from a steepe hill or rock etc. All which actions would be resembled deliberate, and such as may terrifie the desperate person from executing his purpose. [Book II, pp. 71–72]

All of the subjects that Lomazzo mentions (Dido and Lucretia, among them), as well as many others, are treated in the same way in all the arts, and all are supposed to have the morally useful purpose of dissuading the viewer from inflicting violence on himself. The person lamenting is mentally deranged, meaning that passion has overwhelmed his understanding. Words in poetry, gestures in painting, and intervals and keys and phrases in music all point this aberration out. At the same time, it is evident that the pressures that drove the unfortunate example to such a state are so great and so out of his or her own control that we are supposed to feel pity. Boileau in "L'Art poétique" describes authorial

intention and supposed audience reaction to a properly executed depiction of Dido's lament:[13]

> The least honorable love, chastely expressed,
> Does not excite in us a shameful emotion.
> Dido cries and in vain shows her charms;
> I condemn her fault while sharing her tears.
> A virtuous author, in his innocent verse,
> Does not corrupt the heart even while he affects the senses;
> His fire does not ignite unworthy or criminal emotions.

> [L'amour le moins honnête, exprimé chastement,
> N'excite point en nous de honteux mouvement.
> Didon a beau gémir, et étaler ses charmes;
> Je condamne sa faute en partageant ses larmes.
> Un auteur verteux, dans ses vers innocens,
> Ne corrompt point le coeur en chantouillant les sens;
> Son feu n'allume point de criminelle flamme.]

The laments in all art follow a standard pattern and exhibit and express the same passions in the same conventional ways. Unlike tragedy, which is a natural genre based on the effect of what we say Aristotle calls pity and fear, lament has the effect of a pity mixed with a half-objective, half-felt horror at what happens when passions overcome the understanding. The victims of their passions become object lessons to the spectators or listeners. The victims all describe the state they are in but say they cannot help themselves. The pressures of events stimulate the uncontrollable animal nature of the passions in the second soul to overcome the understanding. This idea is true in the Renaissance and carries through into the eighteenth century. Shakespeare's Cleopatra expresses the situation succinctly: "Patience is sottish, and impatience does / Become a dog that's mad" (IV, xv, 82–83).

There are many examples of laments. Shakespeare uses several that Lomazzo gives, and others as well. In "The Rape of Lucrece" (1594), he introduces Lucrece's lament by saying she is "frantic with grief" (l. 762).[14] And so she is. Her passions assail her until death (l. 1725). Venus laments Adonis in much the same way, albeit more briefly.[15] Shakespeare plays on the excesses of the well-known lament of Thisbe over Pyramus in *A Midsummer Night's Dream* (V, i, 315–40). As Theseus says, "Her pas-

sion ends the play" (V, i, 308). Juliet laments for Tybalt and
Romeo,[16] and Cleopatra superbly laments Antony.[17] One differ-
ence between English exuberance and French decorum becomes
apparent in Racine's *Phèdre* (1677) when Phèdre's lament takes
place offstage, the madness accompanying the lament deemed
unfit for the decorous French theater. Panope describes her
gestures:

> Now she clasps her children to her, covers them with kisses,
> And seems to find a moment's respite from her grief.
> Then suddenly her mother's love is gone.
> She lifts her hands in horror and drives her children away.
> Aimlessly she wanders back and forth.
> Her staring eyes watch us without recognition. . . .[18]

Other examples of laments of despair are the composer Nich-
olas Lanier's "Hero and Leander" (1683), the composer Claudio
Monteverdi's popular "Lamento d'Arianna" in *Arianna* (1614),
the composer Henry Lawes's "Ariadne Abandoned" (1653), the
painter Peter Paul Rubens's *Death of Leander* (1602–1605), the
painter Nicholas Poussin's *Landscape with Pyramus and Thisbe*
(1651), the composer John Blow's *Venus and Adonis* (ca. 1685;
see Act III), and Arcabonne's "Ah! tu me trahis, malheureuse"
in the composer Jean-Baptiste Lully's *Amadis tragédie* (III, iii).
Dido's lament in the *Aeneid* is one of Virgil's most touching, emo-
tional passages. We pity her although we know that it is bad for
passion to overcome the understanding. Virgil's *Aeneid* was, of
course, a favorite and much admired work in the Baroque age,
and many treatments of the passion of Dido, both contemporary
and earlier, were available. A classic visual presentation of the
lament is Simon Vouet's *Mort de Didon* (1643).[19] Dido, over-
come by passion, is a quite unattractive madwoman, especially
when compared to Vouet's usual, serene characters. Her distorted
face, indicative of the passion in her soul, is the center of the
painting; her limbs are indecorously disposed, her clothing in dis-
array. Purcell's *Dido and Aeneas* (1689) treats the same subject
in the passionate key of d and Antoine Coypel's *Death of Dido*
(1702–1704) depicts the subject in painting, with the same ef-
fect in mind.[20] Dryden's famous and excellent translation of *The
Aeneid* appeared in 1697 in an impressive volume. There are

also a number of Italian songs entitled "Didone Abandonata."[21]

The pastoral mode encompasses a wide area of genres, including laments. Laments often appear in pastoral elegies and even pastorals but are less violent in these kinds of art. The ethos of the one who laments would be undesirable and unsympathetic if that person were overcome by the madness of passion, for pastoral subjects conventionally are agreeable, pleasant, and delightful—their ruling effect is that of beauty realized in the proportion and harmony of a rural, golden world. Virgil's *Eclogues* had much influence on pastoral art; for example, Dryden's "Ode on the Death of Henry Purcell" (d. 1695), set to music by John Blow, and the songs written for the same occasion by Daniel Purcell (words by Nahum Tate) and by H. P. Talbot. Other pastoral elegies, such as Milton's "Lycidas" (1637), are well-known examples of pastoral laments, and so is Poussin's serene *Landscape with the Body of Phocion Carried out of Athens* (1648). Some other works and kinds of works of art related to the pastoral are Poussin's justifiably famous allegorical works *The Kingdom of Flora*, and *Dance to the Music of Time* and his four paintings of the seasons. The seasons as interpreted by Lully, Purcell, and Vivaldi also are related, as are the numerous paintings of the shepherds adoring Christ and of prelapsarian Adam and Eve. Triumphs and allegories that celebrate or villify certain manifestations of the second soul often are related to the pastoral through their rural settings. Poussin's triumphs of Bacchus (Plate 13), Flora, Pan, Neptune, and Silenus (Plate 12), as well as his bacchanalian scenes, all are kinds of pastorals, as are the poetical, musical, and visual triumphs of Bacchus by Purcell, Vouet, Rubens, Titian, John Wilmot, and Dryden.

In triumphs, as in laments, the passions are represented more violently when apart from the pastoral mode. The triumph, like the lament, is a kind of rhetorical topic. According to André Félibien, Bacchus invented the triumph, and Alexander the Great and the Romans used it (*Entretiens sur les vies et sur les ouvrages des plus excellens peintres anciens et modernes* [Paris, 1666], II, pp. 87 ff.):

Anyone making a triumphal entry was seated in a two-wheeled chariot; which we have observed in several medals and as can

still be seen in the Arch of Titus, where the chariot of the
emperor is drawn by four horses.

> [Ceux qui entroient en triomphe estoient assis sur un chariot
> à deux roües; ce que nous remarquâmes par plusieurs me-
> dailles, et comme on le peut voir encore dans l'arc de tite, où
> le chariot de cet empereur et tiré par quatre chevaux.]

Although he elaborates on the subject at length, the image is
clear, the conventions precise. Charles Le Brun's *Le Triomphe
d'Alexandre ou l'entrée d'Alexandre à Babylone* (ca. 1664; see
Plate 15) is an excellent example of a triumph. It uses elephants
instead of horses, but the trumpets, the spoils of war, and the spec-
tators all are appropriate. Likewise, the modes of architecture in
the painting are appropriate: the Doric, for the majesty of the
triumph and the power of Alexander; the Corinthian, for the fes-
tive quality of the event (the palm leaves used on occasions such
as Christ's triumphant entry into Jerusalem on Palm Sunday).[22]
Félibien is talking about paintings of triumphs, and Le Brun's is
a fine visual depiction, but the same description applies to music,
poetry, and staged productions. Louis XIV conducted his own tri-
umphs (and other ceremonies) in real life and employed numer-
ous musicians on these occasions (among Louis's musicians the
position of honor was occupied by twelve trumpeters).[23] On 26
August 1660, he staged a triumph:

> Solemn entry of Louis XIV and Marie-Theresa into Paris. . . .
> In the vast program of decorations ordered by the city, Le
> Brun was entrusted with the responsibility for the Arch of
> Triumph erected on the Place Dauphine; he put up a large
> monument in the form of an arch surmounted by an obelisk
> and decorated with complex and subtle allegories.
>
> [Entrée solonnelle à Paris de Louis XIV et de Marie-Thérèse.
> . . . Dans le vaste programme de decorations ordonné par la
> ville, Le Brun est chargé de l'Arc de triomphe élevé place
> Dauphine; il dress un ample monument, en forme d'arc sur-
> monté d'un obélisque et decoré d'allegories complexes et raf-
> finées. . . .] [*Charles Le Brun*, p. lv]

Nicholas Poussin also painted a number of triumphs; some vary
from Félibien's description on account of their subject matter.

One is the pastoral allegory Le Triomphe de Flore (1631), in which there are no trumpets (as might be expected considering the subject matter) and in which the chariot is drawn by putti.[24] Others, more standard, are The Triumph of Neptune (ca. 1637), The Triumph of David (ca. 1626),[25] and The Triumph of Pan (1635–36). Triumphs by other painters are similar. Rubens, after Mantegna, for example, has a Triumph of Caesar.[26]

The triumph is mostly spectacular, and thus visual, but the sounds of the musical instruments, mostly trumpets, and the attendant dramatic possibilities allow it to be used in other kinds of art as well, although mostly in highly visualized art. The visual and aural conventional images are represented by the music and dances in Lully's Le Triomphe de l'amour (1681). There is a triumph in John Dryden and Sir Robert Howard's The Indian Queen (1663–64).[27] In Betterton's The Prophetess or Dioclesian (1690; music by Henry Purcell), the trumpets echo the sense of the triumph in "Sound Fame thy Brazen Trumpet sound." Another of Henry Purcell's triumphs is the prince of Gloucester's fifth birthday song, in which Purcell indicates the use of a trumpet: "Sound the trumpet, and beat the war-like drums; / The Prince will be with laurels crown'd." A satirical use of a triumph is in George Villiers's Rehearsal (1671), an amusing, mock-heroic reversal of the convention. Prince Pretty-man says in Act V, scene i:[28]

> Behold, with wonder! yonder comes from far,
> A god like cloud and a triumphant car;
> In which our two right kings sit one by one,
> With virgin vests, and laurel garlands on.

Bacchus's triumph is a separate topic or genre, especially since Bacchus is supposed to have invented the triumph. Dryden's triumph of Bacchus in "Alexander's Feast" (1697) calls up both aural and visual images:

> The jolly god in triumph comes;
> Sound the trumpets; beat the drums;
> Flush'd with a purple grace
> He shews his honest face:
> Now give the hautboys breath; he comes, he comes.
> [Ll. 49–53]

Dryden, because of his martial subject (Alexander the Great) in "Drinking is the soldier's pleasure" (l. 57), then presents drinking as an activity important to soldiers, an idea that accords with the idealized conventions that soldiers drink and that truth resides in alcohol. Thus, Bacchus has an "honest face." Handel, in setting "Alexander's Feast" to music in 1736, used this line as part of a fine drinking song. The festive quality of the scene comes from Bacchus's jollity. The passions connected to drunkenness (the triumph of the second part of the soul over the understanding) are celebrated not only with trumpets and drums but also with hautboys (the ancestor of the oboe). There are thus two kinds of passions represented: martial and amorous. The bulk of Dryden's poem shows how Alexander in a destructive rage burned Persepolis because he succumbed to those two passions. When Handel sets Dryden's poetry of Bacchus's triumph to music, he uses horns and oboes primarily. The result is superb.

We can tell what kind of imagery Dryden had in mind by looking at seventeenth-century paintings and listening to seventeenth-century music. The copy after Poussin's *Triumph of Bacchus* (1635–36; Plate 13) gives us a good idea of the visual image we are supposed to imagine in Dryden's song. Poussin includes all of Bacchus's allegorical accoutrements: the centaurs, the snakes, the leopard skins, the thyrsii, and so on.[29] Bacchus becomes representative of the triumph of the second soul, of the passions and appetites as they derive strength from the vegetative soul and are at odds with the reason. The painting also contains myriad wind instruments all associated with the passions: primarily martial (trumpets and drums) and erotic (pipes and reeds). Dryden mentions both passions (and Handel follows the convention). In Poussin's painting, we see Apollo, the god of reason and light, in his chariot far above the bacchanalian rout, allegorically showing the superiority and nobility of the understanding. Dryden's poem also shows the superiority of the reason. Without getting into the history of ideas and works of art about St. Cecilia, but realizing that celestial harmony appeals to the understanding, we see that heaven-inspired music, with its relation to the highest parts of the soul, is superior to Timotheus's sway over the passions of the drunken Alexander. Both Poussin and Dryden impose a

moral idea on their art. Invention, disposition, and meaning are approximately the same although the means of expression differ. The arts are comparable not parallel, just as Dryden's poem and Poussin's painting are comparable in effect and meaning, and each work uses imagery from other kinds of art.

III

An extended analysis of several lines from the first and last stanzas of Dryden's "Song for St. Cecilia's Day" (1687) will demonstrate more clearly that Baroque artists with similar intentions, working through different media, use culturally shared imagery and topics to produce analogous effects. And the increased knowledge of how Dryden relies for effect on imagery from different artistic media will heighten our appreciation of his poem since the content and the effect of musical and visually artistic images he employs in his poetry are to a great extent both controlled and expanded by the way they are employed elsewhere. We can therefore relate or compare Dryden's intentions, effects, and imagery to those of other arts. As examples, Vivaldi's "Concerto for Two Trumpets in C" (ca. 1700), Rubens's *Le Coup de lance* (Plate 6), Fra Andrea Pozzo's ceiling *The Apotheosis of St. Ignatius Loyola* in the Church of Sant' Ignazio in Rome (1691–94; see Plate 5), Michelangelo's *Last Judgment* (Plate 1), and Rubens's large *Last Judgment* all add to our understanding and appreciation of Dryden's "Song for St. Cecilia's Day" (1687). These works depend on similar rhetorically oriented conventions and devices to signify elevated intentions and to produce in their audiences what their creators would have called the strong passions of admiration and astonishment (as well as others that are weaker).[30]

Dryden's ode, Andrea Pozzo's ceiling, and Vivaldi's concerto as Baroque works of art all contain stunning, artificial effects. As such, they appeal overwhelmingly to the passions rather than to the intellectual faculties. In other words, these works appeal rhetorically to our senses, stimulating our imaginations and passions to such an extent that our reasons are overwhelmed by their force. Their instruction is therefore not accomplished primarily through the understanding. Each work is designed to induce in us a sense of the truth through our emotions rather than to present the truth

in harmony or beauty in the work of art itself. We are to be per-
suaded into a feeling about truth, truth justified before the work
of art was made, truth terrestrially rather than mathematically or
divinely conceived. There is too much propaganda in Andrea
Pozzo's ceiling, too much effect for its own sake in Vivaldi's con-
certo, and too much in the last stanza of Dryden's poem that is
merely meant to awe people. Our belief in the power of music (at
least while we are caught up in Dryden's poem) and in the effi-
cacy and holiness of St. Ignatius Loyola (at least while we are
under the spell of Andrea Pozzo's ceiling) is the result of our emo-
tions rather than our understanding.[31]

The focus on the passions and the senses as the main targets
for artistic devices means that there is little emphasis on appeals
to the reasonable soul through mathematical proportions and alle-
gory. Although allegory still exists as personification by Dryden's
time and later,[32] the layered (historical, allegorical, and so on)
conception of biblical and literary meanings preached by St. Au-
gustine in *De doctrina Christiana* (ca. 427), practiced by him in
his *Confessions* (ca. 400), expressed by Dante in his *Convivio*
(ca. 1306), and practiced by Ariosto in *Orlando Furioso* (1532)
and by Spenser in *The Faerie Queene* (1596) is not used by John
Dryden[33] or Andrea Pozzo or Antonio Vivaldi. We do not have to
search out complex allegorical meanings of the kind used by Ren-
aissance artists. Any allegory in their works exists in a one-to-one
ratio. Dryden's allegory in "The Hind and the Panther" (1687)
is of this simple kind: one animal equals one religious sect. The
same sort of simple allegory exists in Andrea Pozzo's *Apotheosis
of St. Ignatius Loyola* (Plate 5), in which we see represented alle-
gorically incidents from Loyola's life. Vivaldi's music works in the
same way. All three works do not depend on the mysterious con-
nections among all created things but rather on strong appeals to
the passions that seek to persuade audiences, readers, and specta-
tors to accept emotionally and willingly the makers' versions of
reality, their prime meanings are their emotional effects. The rhe-
torical devices used and the allusions made to the other arts there-
fore become central to our understanding of all three works of art.

In Andrea Pozzo's ceiling in Sant' Ignazio, we are deceived in
the prospect of sublime elevation (elevation is synonymous with

sublimity in the seventeenth century) by the false arches and columns, the effect of a contrived perspective, and by the *trompe l'oeil*, which produces the illusion of height, the deception of great space.[34] The use of the genre or topic of apotheosis (with its potential need for space) predisposes spectators to the kind of presentation Andrea Pozzo envisioned and expresses. Within its height, from bottom to top, the painting in the dome moves metaphorically or allegorically from hell's fires to the heights of heaven. The senses of the viewer are supposed to be overcome by the space and by the motion provided by the upward thrust of the columns, the ray of light emanating from God, the upward flight of the characters, the wind that shows the movement through space, and the implied action, all of which produce strong motions (or emotions) in us. The instruction, the appeal to the reasonable soul, comes from the allegory, or history, of the Jesuits, but the first impression on the passions overwhelms the reason. The ceiling is splendid and sublime. We should be overcome, or stunned, by the deceit. The main effects emanate primarily from the vast, artistically enhanced space and the motion of the characters in and through that space, in short, from the vastness and sublimity of the spectacle.

In Vivaldi's "Concerto for Two Trumpets in C," the predominant effects again are space and motion.[35] The space is first of all literal since there is space between two trumpets no matter how close together they are. Furthermore, the answering trumpets probably would have been placed on opposite sides of wherever the work was performed, say, a relatively large cathedral. There probably also would have been reverberations enhancing that effect. The exact meanings of specific phrases that people of the time apparently identified in a work like Vivaldi's are largely lost to us. Modern commentators point out his penchant for what we might call program music, and theorists of the time talk of what music says. Walter Kolneder says there were no textbooks dealing with musical rhetoric in Italian musical practice but that musicians were "thoroughly acquainted with musical formulae for the interpretation of words." He says, "Vivaldi's instrumental music is rich in characteristic turns of phrase . . . which are used in such a specific sense in his programmic works that in them may be found keys to the interpretation of his complete oeuvre."[36] Mer-

senne (1636) says that musicians can talk with instruments so that others can understand the discourse,[37] and we know that many other theorists discuss the meanings of keys, modes, and instruments.[38] On the simplest level, a major key denotes gaiety rather than sadness. We have seen that the key of C is used for apotheoses, triumphs, and other works and events of like nature and that the trumpet is used for the same kinds of music. Vivaldi speaks a musical language, just as painters speak a visual language, and we can understand his more general meanings. He is trying to express something through artistic effects, specific effects sought by him. He differs from painters and poets in his employment of the medium of music.

The instrumentation, key, and meter all are part of Vivaldi's effort to produce a certain kind of effect, one that transcends admiration to induce astonishment or sublimity. The reasonable soul is overcome through conscious, musical manipulation, through rhetorical devices. We in the twentieth century will react in the same way if the performance is given under the proper conditions (even though there probably are more specific meanings to the music than we are able to recognize) not because we know about the manipulation but because the effects of space and motion are a part of our culture and are related to natural phenomena. Through the brilliant dialogue between the trumpets, along with the rapid movement through time of the music itself, Vivaldi intends and produces a heightened effect of motion. The whole work is splendidly energetic and buoyant, building up to a climax of great strength and effort, a stunning exchange of open intervals in fanfares and a series of repeated high G's (in a modern B-flat trumpet) between the instruments, after which comes the perfunctory ending. The sensory effect is at least as stunning, at least as sublime, as that of Pozzo's ceiling.

John Dryden's ode excites passions similar to those of Andrea Pozzo's ceiling and Antonio Vivaldi's concerto. The poem's story is about the history of the world, from the beginning to the end of time, in terms of music and its effects. The most stunning intellectual, pictorial, and sound effects are located in the first and last stanzas, and since we are dealing with poetry, the meanings come from the words (reinforced by sound).[39] In the first stanza,

diapason (in "the diapason closing full in man") needs to be explained if we are to understand the imagery Dryden associates with the term, consonant with his elevated intentions. Our explanation takes us immediately to the other arts. We have no real conception of "the diapason closing full in man" unless we know what a diapason is to Baroque musicians and unless we know the related kinds of visual images created for the period by painters and engravers. Musically, diapason means unity, the full range of notes, and John Milton in "At a Solemn music" uses this word with that technical meaning (plus the allegorical equation of harmonious unity with God and godlike power):

> That we on Earth with undiscording voice
> May rightly answer that melodious noise;
> As once we did, till disproportioned sin
> Jarred against Nature's chime, and with harsh din
> Broke the fair music that all creatures made
> To their great Lord, whose love their motion swayed
> In perfect diapason, whilst they stood
> In first obedience and their state of good.[40]

The passion involved in the first sin jarred the harmony of the universe. The part of Milton's image that we should see in pictorial terms is the unification of all prelapsarian creatures in a harmony, or diapason, of sounding praise. *Motion* is visual as well as passionate or emotional. The grandeur of Milton's image is overwhelming if we see, hear, and feel the image. Paintings that seem to correspond to Milton's visual image are Fra Angelico's (d. 1455) *Last Judgment* and the *Coronation of the Virgin* (which Milton must have seen in Florence). Milton's *creatures*, as the product of a later age, are less delicate and not as stiff as Fra Angelico's, but the general idea is the same since both use similar topics—universal adulation and praise. In Fra Angelico's balanced, regular painting, he wanted us to see, and in our imaginations hear, the music and the beings. Fra Angelico implies a vision larger than his own canvas, and Milton's idea also exceeds what could be visually represented, the human imagination being more expansive than an existentially limited space. Both works imply the sound of a massed choir of all creatures on earth, which we

realize through our experience with other artistic representations of varying quality and size. Each work of art through the conception of diapason represents the ideal harmony of the universe. Although a painting by Fra Angelico may not represent exactly in the same way the image that Milton uses (because of the time element or because of Fra Angelico's temperament), the idea expressed is similar.

Roger Des Piles, in his analysis of Raphael's *The School of Athens*, says that next to Pythagoras is a young man holding a tablet containing "diapente, diapason, diatessaron—terms well known to able musicians." From these, he says, Plato "formed the accords and harmonick proportions of the soul."[41] In other words, a diapason is diagrammable. Thomas Mace (1676) also uses visual connotations when he says that of "All things . . . in nature . . . some harmonize in diapason's deep, / Others again more lofty circles keep."[42] The visual imagery here is embodied in *deep* and *circles*, whether they be places or circles as part of a diagram or places or circles as meetings of souls (or even groups of people). Something like Mace's comment or Rubens's *Apotheosis of James I*, on the ceiling at Whitehall, may have suggested to Dryden the visual imagery of diapason, but Pozzo's ceiling or perhaps Rubens's large *Last Judgment*, even though he never saw them, are better examples for revealing Dryden's imagery and for explicating his poem.[43] A poet's imagination may very well transcend the works of art at his disposal if the works lead him to greater ideas; if he hears descriptions of similar, but superior, unseen works; if other poets or theorists give him the image; or if his own imagination can transcend the limitations of his surroundings. Painters' or musicians' imaginations may, and often do, exceed the limits of their own works especially when they are trying to achieve specific, great effects, as does Dryden (or Milton). Works like Pozzo's ceiling help us see, and thus feel, "the diapason closing full in man" much more vividly because of its own range, its own diapason. Dryden, too, relies on a visual diapason in "Song for St. Cecilia's Day" because of the connection between diapason and man (an object we can easily visualize). Dryden's harmony is aural, too. In stanza one, he uses resonant, nasal sounds to echo the organ, the instrument with which the term *diapason* is most

commonly associated. He was very conscious of the sounds of words, as he demonstrates in his poem and says in many places in his criticism.[44] "The diapason closing full in man" assumes added dimensions if the imagery is aural as well as visual, and the intention and the effect of Vivaldi's concerto, Pozzo's ceiling, and Dryden's first stanza are generally similar in terms of admiration and astonishment.

The last stanza of Dryden's poem tries to achieve even stronger effects than stanza one. Works of music, painting, and poetry that are similar in purpose can elevate us far enough to visualize, hear, and feel the astonishment and admiration that Dryden intends in his last lines:

> The TRUMPET shall be heard on high,
> The dead shall live, the living die.
> And MUSIC shall untune the sky.

By seeing and hearing Dryden's imagery as much as possible in Baroque terms, we should recognize that he envisioned Judgment Day as a vast space, a great panoramic scene filled with sublime sounds. Since the trumpet is a central image in Dryden's lines, the history of the trumpet and the art of using trumpets for sublime effects on the passions by composers of the period become worthy of consideration. We cannot understand the power of Vivaldi's trumpet concerto, or the imagery in Milton's "the wakeful trump of doom must thunder through the deep,"[45] or Dryden's ending in the "Song for St. Cecilia's Day" unless we have heard or imagined in some version the effects supposedly produced by trumpets in the works of composers of the time.

The significance and construction of the trumpet have changed since J. S. Bach, but there is no reason to think that the best trumpeters of earlier periods did not powerfully move audiences, whatever sound we may suppose trumpets to have had then. Bate says that army maneuvers were directed by trumpets with coarse sounds (p. 109) and that seventeenth-century writers point out how trumpets can rage and snarl (p. 126). But the English musician John Blow glorifies the trumpet, saying, "Our English trumpet. Nothing has surpast our English trumpet."[46] Smithers points out that trumpet works are widespread and nu-

merous in the Baroque period and notes that Henry Purcell extends the capabilities of the trumpet from "the normal principal register to the upper harmonics of the clarino tessitura" (p. 361). Since music was written according to the physical limitations of the players, Purcell must have had trumpeters of some ability.[47] Modern trumpet players are now developing the virtuosity and stamina to play Baroque trumpet pieces. The opinions offered about trumpets hardly suggest an instrument of a coarse, snarling sound. Mersenne speaks for everyone when he says that the trumpet is "marvelously grand when sounded to perfection, and when we consider the range of its tones, from the lowest to the highest, there are forty-two: so that it surpasses all claviers, some spinets, and some organs" [merveilleusement grande, lorsque l'on en sonne en perfection, et que l'on prend tous ses ton depuis le plus grâve jusques au plus aigu, car elle fait un trent-deuzième: de sorte qu'elle surpasse tous les claviers des épinettes et des orgues].[48] And Mersenne lived in France, where the highest kind of trumpet playing (clarino playing, in the fourth octave) was least developed.[49] In other words, Dryden's trumpet imagery and Vivaldi's concerto excite the passions by employing trumpets with impressive, powerful sounds; it does not matter that these instruments lacked the versatility of the modern valve trumpet.

From the Renaissance through the early eighteenth century, there are, generally considered, two kinds of trumpet playing: a high, associated with the courts of princes and with elevated events; a low, associated with warfare, hunting, and other like activities. Rubens employs trumpets in different paintings that express obviously an association with violence, chaos, or splendor. In *The Wolf and Fox Hunt* (Plate 7), a violent, red-haired hunter blows his horn; his face is red, his cheeks puffed out, his head thrust forward. The scene projects the relatively base emotions surrounding the murder of a boar, as does Rubens's *The Wild Boar Hunt*, in which not only does the horn player look the same but also is a depiction of the same person. In *The Capture of Juliers*, Rubens's trumpeter is symbolic of prowess in battle. He displays violence and appears, framed by darkness, on a cloud behind the angel of death and destruction.[50] In Rubens's large *Last Judgment*, we have a version, though less impressive, of Michelangelo's

The Last Judgment (see Plates 1 and 2). The trumpeters are impressively wild and energetic, cheeks puffed out, heads thrust forward. They are placed well below heaven's serenity, next to the abyss of light (as in Michelangelo's painting). The high style of trumpet playing and the low, violent style are united. We can see and hear (in our imaginations) what Rubens intended, just as we see and hear the images Dryden, in his poem, intended us to imagine.

Other painters and writers use the same kind of trumpet imagery as Rubens uses. We can see the low style connected to irrational or violent behavior, and the opposite as well. Claude Perrault says that there are "trompettes de guerre" as well as "cors de chasse" and "saquebouttes." These trumpets, he says, speak appropriately to their function.[51] Gerard Terborch has a *Military Scene, Trumpet and Drinkers,*" in which the trumpet is associated with low activities (for example, the trumpet player has puffed-out cheeks).[52] Lully, just as every other composer, uses trumpets to indicate combat in *Amadis tragédie* (I, iv).[53] Henry Purcell, when he wants to praise the eternal glory of a great ruler, uses trumpets.[54] Charles Le Brun uses semi-cacophonous trumpets in a grand way in several important paintings. They are connected to war and destruction in *Le Roi arme sur terre et sur mer* (1679) and in *Prise de la ville et citadelle de Gand en 6 jours 1678* (1679).[55] As they are connected to the actions of Louis XIV, trumpets are not low instruments, and they are God's instruments in *Le Trébuchement des anges,* also known as *La Chute des anges rebelles* (ca. 1685), in which the good angels pursue the bad. Trumpets also are sounded to God's glory in Le Brun's *Dieu dans sa gloire* (1672–76).

To show how creators similarly use a common store of imagery connected to a topic, we can briefly look at various images of trumpets used in several paintings of Judgment Day.[56] The history of the actual form, use, and technique of playing instruments does not necessarily coincide with the use of instruments in painting. The depiction of embouchures in trumpet playing is an example of this phenomenon. Philip Bate points out that tense embouchures are depicted as early as the "woodcuts of Virdung and the so-called 'Leckingfelde Proverbs' of c. 1500" (p. 109), and

Daniel Speer in 1687 insists on a tense embouchure for trumpet playing. Lomazzo, however, says that according to convention, players of wind instruments always are shown with puffed-out cheeks; for examples, he cites Michelangelo's *Last Judgment* (Plate 2) and scenes of tritons blowing trumpets (Book II, p. 53; we can see how Lomazzo tends to classify at least some trumpet playing by the fact that he talks at the same time about the puffed-out cheeks seen also in Mantegna's rather low bacchanals and bagpipers). In other words, artists depicted trumpeters with puffed-out cheeks even after proper trumpet techniques had evolved to tense embouchures. Painters use the sound of trumpets and their symbolism without making their trumpets necessarily naturalistic.[57] Puffed-out cheeks show more emotion. The passionate and overwhelming nature of much trumpet imagery, and imaginary trumpet blasts, is evident.

Artists of an age earlier than the Baroque were not so much interested in depicting human passions as they were in showing the fundamental harmony of creation, of which music is representative and which their paintings also supposedly reproduce. The earlier Fra Angelico (d. 1455), for example, in his balanced, serene paintings, shows gentle trumpeters, with little emphasis on the instruments or players except as a part of the harmonious design. The angle at which each of the rather long trumpets is tilted up is set off by its opposite number on the other side of the painting. He uses the same design in his *Last Judgment* in the Convent of San Marco in Florence as well as his *Last Judgment* in the Kaiser-Friedrich Museum in Berlin. Although in each work half the earth is in chaos, the gentle trumpeters are a serene part of a harmonious heaven. He depicts trumpeters in the same general way in his *Coronation of the Virgin* (in the Uffizi in Florence), except that the trumpeter in the upper right shows a slight change: he is less decorous; with cheeks puffed out and head thrust slightly forward, the angel displays an energy slightly out of keeping with the composure of the rest of the benign company. As time goes on, there is a change in the depiction of trumpeters. In Luca Signorelli's (d. 1523) *Choir of Angels* in the Orvieto Duomo, the trumpeters are positioned lower than the rest of the angels and are more indecorous, more energetic. Their clothes show motion, and their cheeks are puffed out.[58]

In Michelangelo's *Last Judgment* (Plate 1) for the first time we can "hear" the marvelous sound, that grand, loud, half-cacophonous noise of powerful trumpets. Both in Rubens's large *Last Judgment* and in Michelangelo's *Last Judgment*, the trumpets and imaginary sounds emanating from them are set off by an abyss of light in front of the trumpet players, who overlook the chasm that separates earth from heaven. Each artist places his trumpet players lower than the prophets and the other heavenly beings that display love, concord, and the equilibrium of divine judgment. Power and disharmony are reflected in the way the angels are blowing, cheeks puffed out, their red faces showing great effort; the heads of the blowers and the trumpeters are thrust forward (see Plate 2). Fréart says that in Michelangelo's *Last Judgment* the angels "grimace" in the "mouthing of their trumpets" (besides "the contortion of their bodies"). Fréart dislikes this vulgarity and "excess" and dislikes the violence in Michelangelo's work in general, preferring Raphael's sedate beauty.[59] Michelangelo connects his trumpeters with the chaos of earth through their violence, yet separates them from earth by an abyss of light, thereby communicating to us their affiliation both with earthly passions and with heavenly reason and harmony. The effects Rubens, Michelangelo, and Dryden produce are similar, and Dryden's trumpet imagery is visual as well as aural. The paintings, and Dryden's poem, thus give us a feeling of the passion, turmoil, and disharmony of Judgment Day, yet the unity and harmony that will result from that dread day are reflected by the placement on high of the judges themselves, who appeal to our reason. If we react as we should, these paintings and the poem in their totality excite our passions to the extent that we are engulfed in speechless admiration.

The kind of image Dryden calls up by the last three lines of the poem also is related to the effect of Michelangelo's and Rubens's paintings by means of the description of Judgment Day. Since all Baroque artists draw from a store of imagery common to all, we see Dryden's image even more clearly if we know that elsewhere he envisions God's "throne [as] darkness in th'abyss of light, / A blaze of glory that forbids the sight," just as Rubens and Michelangelo separate God's throne from the violence of the trumpeters and from earth by an abyss of light.[60] But other works

of art can also help us in our consideration of Dryden's imagery. The sublime paradox of the last line of the ode, "And MUSIC shall untune the sky," rests partly on the harmony-disharmony conjunctive one finds in discussions of music. Disharmony moves to harmony as a musical piece moves from a relatively dissonant chord to the tonic. The dissonance of Judgment Day moves to the harmony of eternity, an image that rests on God's sublime judgment and on harmony of thought and feeling, a unity talked about at length by sixteenth-, seventeenth-, and eighteenth-century musicians. The octave and the tonic represent God's unity, arousing in us the sense of harmony and peace we feel from the contemplation of an harmonious eternity and at the restful end of a piece of music. Peacham says that we relish concord more because of previous "jarres," which are "harsh and discordant."[61] Mace, connecting music and religious mystical thought, says that the octave unites and harmonizes like unity itself and that the Holy Trinity is reflected in the three harmonical concords, the unison, the third, and the fifth. He says that a separation from unity in music is "irksome and unpleasing to a well-tuned soul." To illustrate his point further, he includes a poem called "Great God":

> Mysterious center of all mysterie;
> All things originate themselves in Thee,
> And in their revolution, wholly tend
> To thee their octave, their most happy end.
> All things (what e're) in nature, are thus rounded,
> Thus mystically limited and grounded,
> Some harmonize in Diapason's deep,
> Others again, more lofty circles keep. [P. 269]

Mace goes on in the same vein, ending in unity, "In th'unconceived harmonious mystery."[62]

Dissonance, or lack of harmony, also produces certain effects in an audience. The lack of harmony in Rubens's so-called *Le Coup de lance* (Plate 6) is an example of how the technique may be used in another kind of art. The complexion of the soldier with the spear denotes discordant choler (following Lomazzo's description of what a soldier should be like). If we observe closely, the soldier appears to be pulling the spear out of Christ's side (note his balance, the kind of grip he is using, and the spurting blood).

The sky is streaked, dark, and wild, and the sun is going into eclipse. The writhing of the thieves augments the awful effect. These grisly and cacophonous motions produce uncomfortable, disharmonious emotions in us. Yet, we know that out of such discord, harmony will result. In Dryden's poem, which also draws its imagery and its effects from religion, the disharmonious connotations of *untunes* are resolved by the open vowel of *sky* and by our knowledge of, and feeling for, the subsequent eternal peace, harmony, and unity that will result after Judgment Day. Since the universe is essentially in harmony, disharmony is a temporary phenomenon, an aberration that runs its course. We can see the working out of this belief in any comedy or tragedy in the period, from Shakespeare's *King Lear* to Addison's *Cato*. The mind and its passions, of course, also were thought of as a microcosmic reflection of the macrocosm.

The sharing of imagery from different media can exist at any time. What varies is the individual artist's sensitivity to the other arts and his willingness to use them for effect. Since the arts in the Baroque era were thought of as comparable, capable of achieving similar rhetorical effects, Dryden, who shows sensitivity to all the arts and who discusses them all at one time or another, uses imagery as he needs it, depending on his estimation of his audience's knowledge and sensitivity. We cannot reach a full appreciation of Dryden's intent and achievement unless we realize or feel the effects of the different arts that he employs. Dryden's poem is sublime. When our rational souls or minds are temporarily overcome, or stunned into acquiescence, we have come under the spell of the sublime. When we see, hear, and feel the powerful complex of images Dryden uses to arouse our passions, our rational minds will be temporarily overcome by the splendor of the imagery, leaving us with feelings of astonishment and admiration. When we think about Dryden's accomplishment in his own terms, he teaches us a number of things not only about God and music but also about poetic technique, the manipulation of audiences, the act of making public statements through poetry, and the glories of the human spirit. The more completely we understand the aesthetics behind his and other Baroque art, the more it can say to us.

AFTERWORD

The justification for this work (besides my own pleasure) is that it fulfills an important scholarly endeavor: to contribute to our own culture through an understanding of the past. When we absorb ideas from earlier periods, we cannot shed them entirely when we react to our own art, ideas, and institutions. We become more circumspect, more experienced, more sophisticated, less prone to accept modern conventions and ideologies uncritically. We feel a sense of what we have gained as well as a sense of what we have lost. But most of all we learn that fundamental issues and conflicts, such as the struggle to define the human condition, to explain the workings of the human mind and passions, and to solve the problems inherent in getting along with other people, do not change although language, manners, and artistic and behavioral conventions do. We learn that people always have been noble, conniving, envious, brutal, backbiting, loving, lustful, ignorant, loyal, wise. We learn that although words do not change, their connotations do; that the kinds of emotion a cultivated person can with propriety show will vary; that the ethos a writer or painter assumes when expressing ideas will vary according to what an age thinks impressive (for example, detached cynicism, sincerity, or earnestness); and that a collective belief in chance or a transcendent power capable of controlling human destiny may break down, becoming splintered by various views or various levels of unbelief. Whatever the ideas encountered in the Baroque era, and in whatever forms they are couched, they still concern the condition of man in relation to the universe.

I have tried to move through the important issues of the Baroque era and through the works of art themselves to both intentional and unintentional effects. There are two areas at the root of understanding Baroque art: the faculty psychology and the rhetorical process. They are intertwined and each is of universal

importance. There is no reason to think that people now are more interested in how their minds work, both individually and collectively, than they ever were. Open any book of the Baroque era, peruse any musical score, look at any painting, and you will find references to, and uses of, the faculty psychology. The variations, the different stresses placed on the faculties or parts of the mind, indicate artistic purpose or intention. A Baroque artist also constructed his works of art according to certain rhetorical principles, each work containing assumptions by the artist about the psychology of the human mind and its place in the universe; each expressing an attitude or idea about the human condition; each assuming certain kinds of responses in receptors; and each, because of all the foregoing, projecting an effect consciously intended by the writer, composer, painter, or architect. If there were no intention, there could be no form of any kind because in rhetorical theory every mode of expression and nuance in that mode, whether in music, poetry, or color, means something.

Aesthetics, the study of cognition in relation to art, has much to do with man's relation to, and conception of, the universe, and in the Baroque era aesthetics is an extension of the faculty psychology and rhetoric. Ideas about thought and feeling are important historically because such ideas have much to do with the tone and contents of works of Baroque art. An optimistic view of man's potential will produce art different from one that places human beings closer to animals than to angels. The scope of an optimistic vision of human potential is larger. According to this vision, cognition occurs in ways that transcend the senses; the emotional responses to works of art and to natural phenomena are more fulfilling than works appealing to narrower conceptions of the soul because they assume a larger capacity in the human mind; and the breadth and power of understanding that is communicated through art enlarges the spirit of the receptor. We feel different after seeing Michelangelo's *Creation* and Shakespeare's *King Lear* than we do after seeing Le Brun's paintings of Louis XIV's battles or Otway's play *The Orphan*. The first two works are products of a cosmic view that embraces much more than the earthbound visions of Le Brun and Otway. The difference is not so much in technique as in idea.

The parts of the soul also are related to ethics. For example, the choice presented to Hercules is more than a choice between sensual vice and heroic virtue; it also is a choice between living by means of one group of faculties or by another. The materialism and indulgence associated with the lower faculties of the sensible soul and the nobility, idealism, and self-denial associated with the faculties of the reasonable soul lead to two different kinds of life. The sort of choice Hercules faces is found in diverse works of art and is presented by different rhetorical means: in painting, by the colors associated with one side of Hercules or the other, which in turn correspond to the parts of Hercules' soul (and those of the audience as well) they attract, as in Poussin's *The Choice of Hercules* (ca. 1637); in music, by the keys, the instrumentation, and the tempos—as in Purcell's *Dido and Aeneas* (1689; Aeneas's choice between Dido and duty); in drama, by characterization by means of gesture, sentiments, and language—as in a performance of Thomas Otway's *The Orphan* (1680); in poetry, by the length and the rhythm of lines and by images, diction, and sentiments— as in Dryden's "Alexander's Feast" (1697). The parts of the soul are depicted through rhetorical conventions. It is difficult to overestimate the importance of understanding the faculty psychology and the concepts of rhetoric in order to appreciate and to comprehend baroque art.

This book is written to increase the reader's appreciation of, and pleasure in, specific works of art through greater understanding of the complex historical ideas behind those works. The rhetorical process is inverted: whereas the general Baroque idea is that the artist pleases or delights to make his instruction or great end palatable, I have tried to instruct to enhance pleasure. Another way to say the same thing is that the judgment or understanding is exercised to provide the imagination with images and sensations that stimulate the senses. We have come full circle. The purpose of this book is not pleasure to give instruction but instruction to give pleasure. The end is therefore the beginning.

NOTES

ONE. Theories of Knowledge and Perception

1. Willard Farnham, *The Shakespearean Grotesque* (Oxford: Clarendon Press, 1971), p. 159; for a further consideration of the grotesque in Dryden's work, including *The Tempest*, see Jean Hagstrum's excellent article "Dryden's Grotesque: An Aspect of the Baroque in His Art and Criticism," in *John Dryden*, ed. Earl Miner (London: G. Bell and Sons, 1972), pp. 90–119. The grotesque in the seventeenth century, as it was in the Renaissance, is frequently an exaggeration of the qualities of the second and third souls, with an omission of the highest. The grotesque is also combined, for example, with forces of evil, unnatural unions, and monsters. Naturalistic man feeding on passions and appetites with no check by the highest soul is a monster. Since much of what Farnham discusses as grotesque has its origins in distorted conceptions or depictions of the human soul, the political implications connected to the low life of *The Tempest*, which Hagstrum discusses, are also associated with lack of control by the highest soul over the passions and appetites of the members of that debased kind of society. The figure of Satan in Guido's *St. Michael* also is depicted as the embodiment of such characteristics. The idea of the evilness of passion is embodied in the lines from Dryden and Davenant's *Tempest* (which Hagstrum quotes): "The Monsters Sycorax and Caliban more monstrous grow by passions learn'd from man" (IV, iii, 270–71).

2. Louis Martz, *The Poetry of Meditation* (New Haven: Yale University Press, 1954), p. 128.

3. F. N. Coeffeteau, *Table of Humane Passions With Their Causes and Effects*, trans. Edward Grimeston (London, 1621; first pub. 1615). The whole work is not readily available. The original is at the Houghton Library, Harvard University. The pages in the Preface are not numbered. The Preface alone, however, may be found in an out-of-print book, *Prose of the English Renaissance*, ed. J. Wm. Hebel, H. H. Hudson, R. R. Johnson, and A. W. Green (New York: Appleton-Century-Crofts, 1952), pp. 581–88. Coeffeteau, for example, agrees with Robert Burton, whose medical treatise *The Anatomy of Melancholy* (1621) develops the same ideas in some detail. Burton goes on at some length to describe and to ana-

lyze passions of all kinds (as does Coeffeteau) as causes of illness. See also Thomas Wright, who also agrees: *The Passions of the Minde in Generall* (London, 1620). Burton refers briefly to Wright's book; Robert Burton, *The Anatomy of Melancholy*, ed. F. Dell and P. Jordan Smith (New York: Tudor Publishing Co., 1948), p. 358. Coeffeteau (1574–1623) was an Aristotelian and a Thomist—as reflected in his *Tableau des passions humains, des leurs causes et de leurs effets* (1615)—and a celebrated theologian and preacher; for his numerous publications, see Alexandre Cioranescu, *Bibliographie de la littérature française du dix-septième siècle*, 3 vols. (Paris: Centre National de la Recherche Scientifique, 1966); for a *resumé* of his distinguished life and writings, see the *Nouvelle Biographie générale*, ed. De. M. Le Dr. Hoefer (Paris: Didot, 1856), pp. 31–33. His most famous works are *Tableau des passions, Histoire romain*, and *L'Épitomé de Florus*. The *Florus* is evaluated by several writers in Adrien Baillet, *Jugemens des savans* (edition of 1722), III, p. 121, as having a style that was good for its day but a diction that had since dropped out of fashion. Another work that mentions Coeffeteau's prose style is Abbé Ch. Urbain, N. *Coeffeteau, dominican, évêque de Marseille, un des fondateurs de la prose française* (1893). The notable Jean-Louis Guéz de Balzac says that Coeffeteau was his master (letter written August 1630); see *Letters, Translated and Collected by Several Hands* (London, 1655). He is also mentioned by La Bruyère, *Les Caractères* (1688). A favorable estimate of Coeffeteau appears in Jeremy Collier, *Great Historical, Geographical, Genealogical, and Poetical Dictionary* (London, 1701), largely a translation from Louis Moréri, *Le Grand Dictionnaire historique* (1681).

4. This explanation of learning leads directly to John Locke's ideas, as expressed in his well-known *An Essay Concerning Human Understanding*, ed. Alexander C. Fraser, 2 vols. (New York: Dover Publications, 1959; first pub. 1690), and correlates closely with any other Baroque theory of learning and the soul; see, for example, Walter Charleton, *A Brief Discourse Concerning the Different Wits of Men* (1664; pub. London, 1669).

5. Thomas Hobbes, *Leviathan*, Parts I and II, ed. Herbert Schneider (Indianapolis: Bobbs-Merrill, 1958; first pub. 1651), p. 36. The disagreement is of great importance. For the relation of statements of great weight on the subject by Richard Hooker and St. Thomas Aquinas, see Peter Munz, *The Place of Hooker in the History of Thought* (London: Routledge & Kegan Paul, 1952), pp. 182–86. For another important statement, specifically against Hobbes, see Antoine Arnauld, *The Art of Thinking*, trans. James Dickoff and Patricia James (Indianapolis: Bobbs-Merrill, 1964), pp. 29–43, 293–320; first published as *L'Art de pensée* (1662).

6. See, for example, Perry Black, *Physiological Correlates of Emotion* (New York: Academic Press, 1970). We can observe the phenomenon in ourselves (as did the ancients). When we become angry, our blood pressure rises. See also Burton, *The Anatomy of Melancholy*, p. 219.

7. G. P. Lomazzo, *A Tracte Containing the Artes of Curious Paintinge, Carvinge, and Building*, trans. Richard Haydocke (London, 1598), Book II, chap. VI, p. 15; first published in Italy as *Trattato dell'arte della pittura, scultura, et architettura* (1584). The idea that improper education, which encourages the exercise of the passions, alters the soul for the worse is important through the seventeenth century. The view is expressed by Shaftesbury (*Characteristicks* [1711]), who believes that human beings at birth are innately good, and by Jeremy Collier (*Essays Upon Several Moral Subjects* [London, 1697], Part I, p. 222), who says that the prejudices of education affect our reason.

8. See Collier, *Essays Upon Several Moral Subjects*, p. 19; the same idea is expressed in the song "Musick's the Cordial of a Troubled Breast," in John Blow, *Amphion Anglicus* (Ridgewood, N.J.: Gregg Press, 1965; facsimile of 1700 ed.), pp. 117–22; see also Pompeo Batoni's drawing *An Allegory of Music*, in Anthony Blunt and Hereward L. Cooke, *Roman Drawings at Windsor Castle* (London: Phaidon, 1960). Mars approaches the musical scene from the right with a gesture of humility, his spear left behind, his warlike passions extinguished. See also Erica Harth, "Exorcising the Beast: Attempts at Rationality in French Classicism," *PMLA* 88 (1973):21. There are some complicating ideas, however. In general, wind instruments were thought to raise passions, while strings, which were more elevated morally, were supposed to induce harmony within the soul; see Emanuel Winternitz, *Musical Instruments and Their Symbolism in Western Art* (New York: Norton, 1967), esp. chap. XIV, "Musical Archaeology of the Renaissance in Raphael's *Parnassus*."

9. Ernest Barker, ed., "Galen," *Greek Medicine* (New York: J. M. Dent and Sons, 1929), pp. 166–69; Plato, *The Republic*, trans. H. D. P. Lee (Baltimore: Penguin, 1955), pp. 383–86.

10. I do not have to trace the origins of ideas concerning the soul's harmony. Leo Spitzer does this in a thorough way in his *Classical and Christian Ideas of World Harmony* (Baltimore: The Johns Hopkins University Press, 1963); see also Burton, *The Anatomy of Melancholy* (1621), on humours, for a seventeenth-century explanation.

11. Dryden, for one example, in 1693 calls the epic "the greatest work of human nature" (in *Of Dramatic Poesy and Other Critical Essays*, ed. George Watson [New York: Everyman, 1962], II, p. 96; see also II, p. 223). In 1695, he also calls *The Aeneid* the most perfect poem, with the most perfect idea (in Watson, II, p. 186). Since the epic was supposed to

appeal to the understanding, "to form the mind to heroic virtue by example" (1697; in Watson, II, p. 224), tragedy becomes, despite Aristotle, a lesser genre. The purpose of tragedy is to raise and afterward to calm the passions (1697; in Watson, II, p. 227). A tragic hero became more imperfect than an epic hero. Oedipus himself was, of course, imperfect (1695; in Watson, II, p. 185). Although it was translated, adapted, and performed in the seventeenth century in both England and France, *Oedipus Rex* was not as highly regarded as *The Aeneid*. Dryden also associates Raphael with Virgil (1695; in Watson, II, p. 195), and Dryden always lists him before Titian (see for examples Watson, II, pp. 182, 192). Titian as he expresses passion was thought of as a colorist (1695; in Watson, II, p. 204). Evelyn criticizes Titian for lack of decorum in John Evelyn, trans., "To the Reader," *An Idea of the Perfection of Painting*, by Roland Fréart de Chambray (London, 1668).

12. For the history of ideas connecting the cosmos and the soul, see Spitzer, *Classical and Christian Ideas of World Harmony*.

13. Barker, pp. 233, 242.

14. See, for a single example among many, Henry Peacham, *Minerva Britanna* (1612; reprint ed., London: Scolar Press Ltd., 1966), pp. 96, 191.

15. Boethius, "The Second Edition of the Commentaries on the Iogoge of Porphyry," in *Selections from Medieval Philosophers*, Book I, ed. Richard McKeon (New York: Charles Scribner's Sons, 1929), pp. 70–71. The fact that his *De consolatione Philosophiae* was translated in 1593 by Queen Elizabeth herself emphasizes the importance of Boethius to the English Renaissance. See *Early English Text Society Publications*, O.S., no. 113.

16. Michael Montaigne, *Essays*, trans. Charles Cotton (London, 1685), II, 256. I use the Restoration translation rather than the earlier one by John Florio.

17. Ibid., I, p. 202.

18. Pierre Charron, *Of Wisdom*, trans. Sampson Lennard (London, 1651), I, p. 43. This book also was printed in England in 1608, 1630, 1658, and 1670; it was first published in France as *De la sagesse* (1603). Such an organization of the soul may have something to do with ideas of meditation. Simon Vouet, for instance, has a painting called *L'Intelligence, la memoire, et la volonté*; see Yves Picart, *La Vie et l'oeuvre de Simon Vouet* (Paris: Cahiers de Paris, 1958), Part I. Memory is not usually included in the highest soul, but Vouet seems to think it should be. Our understanding of the painting and of Charron may be helped by the knowledge that these are the three faculties Ignatius Loyola recommended in his famous *Ejercicios espirituales* (1548).

19. René Descartes, *Traité des passions (les passions de l'âme)*, ed. Françoise Mizrachi (Paris: Union Générale, 1965; first pub. 1650), art. 47, p. 64. For other important explanations of the soul, see Baldasar Castiglione, *Il Cortegiano* (Venice, 1528), Book III; Thomas Wright, *The Passions of the Minde in Generall* (London, 1620); the stoical Martin Le Roy, sieur de Gomberville, *La Doctrine des moeurs tirée de la philosophie des stoiques, representée en cent tableau et expliquée par M. de G. P.* (Paris, 1646); and Thomas Willis, *Two Discourses Concerning the Soul of Brutes*, trans. S. Pordage (London, 1683; first pub. as *De anima brutorum* in 1672). For a history of ancient psychology, see George S. Brett, *History of Psychology, Ancient and Patristic* (London; Macmillan, 1962; first pub. 1912). For an interesting explanation of Elizabethan faculty psychology, see John Bamborough, *The Little World of Man* (London: Longmans, Green, 1952).

20. Jean-Louis Guéz de Balzac, *Letters*, Translated and Collected by Several Hands (London, 1655). Balzac, according to his own testimony, was a "scholar in the French tongue under Master F. N. Coeffeteau" (letter written August 1630). Balzac was widely read and emulated in England as well as France. He influenced Shaftesbury, and La Bruyère praises him several times in *Les Caractères* (La Bruyère also praises Coeffeteau); see *The Characters and Manners of the Last Age*, Translated by Several Hands (London, 1699; first pub. in France, 1688), pp. 19, 20, 30; for another reference, see *The Spectator* (No. 408, 18 June 1712), which may be by Alexander Pope.

21. Hobbes, *Leviathan*, p. 25. Other references to Hobbes are to his "Answer to Davenant's Preface to Gondibert" and "Preface to Homer," in *Critical Essays of the Seventeenth Century*, ed. Joel Spingarn (Bloomington: Indiana University Press, 1963; first pub. 1908), II, pp. 54–76; see also Walter Charleton, *Physiologia* (London, 1654), and *A Brief Discourse Concerning the Different Wits of Men* (London, 1669; first pub. 1664).

22. See also Clarence D. Thorpe, *The Aesthetic Theory of Thomas Hobbes* (Ann Arbor: University of Michigan Press, 1940).

23. Thomas Mace, Preface, *Musick's Monument* (London, 1676), p. 38.

24. Locke, *Essay Concerning Human Understanding* (1690), I, pp. 203–204.

25. For Shaftesbury's scientific influences, which come mostly from the Restoration, see Ernest Tuveson, "Shaftesbury on the Not So Simple Plan of Human Nature," *Studies in English Literature* 5 (1965): 403–34.

26. Shaftesbury, "The Moralists," *Characteristicks* (1711), ed. J. M. Robertson (Indianapolis: Bobbs-Merrill, 1964), II, p. 133.

27. See R. G. Collingwood, "Plato's Philosophy of Art," in *Essays in the Philosophy of Art*, ed. Alan Donagan (Bloomington: Indiana University Press, 1964), pp. 155–83; first published in *Mind: A Quarterly Review of Psychology and Philosophy*, n.s. 34 (1925): 154–72.

28. Jeremy Collier, *Essays Upon Several Moral Subjects* (1697), pp. 215–22; see also idem, *A Short View of the Immorality and Prophaneness of the English Stage* (London, 1698). A sentimental view of art like Collier's easily melds with a materialistic view of human nature.

29. See Louis I. Bredvold, "The Gloom of the Tory Satirists," *Eighteenth Century Literature* (New York: Oxford University Press, 1959), pp. 3–20.

TWO. Instruction and Delight in Art

1. See Jean Hagstrum, *The Sister Arts* (Chicago: University of Chicago Press, 1958), pp. 190–95. Hagstrum makes clear the importance of the motif of Hercules choice, referring also to other scholarly works on the subject. Hagstrum is correct when he says that the motif permeates the period: there are many paintings of it, and much scholarship has been devoted to showing that the motif is important to understanding art of the period. The motif has been applied to Shakespeare's *Antony and Cleopatra*, Milton's *Samson Agonistes*, and Dryden's heroic plays (to name only a few instances). Hagstrum uses Dryden's *All for Love* as an example; see Eugene Waith, *The Herculean Hero* (New York: Columbia University Press, 1962); see also Erwin Panofsky, *Hercules am Scheidewege und andere antike Bildstoffe in der neueren Kunst* (Leipzig and Berlin: B. G. Teubner, 1930).

2. John Dryden, "Absolom and Achitophel" (1681), in *The Poetical Works of Dryden*, ed. George R. Noyes (Boston: Houghton Mifflin, 1909; reprint ed., Boston: Houghton Mifflin, 1950), p. 111, ll. 163–64.

3. For Dryden's literary portrait of the Duke of Buckingham, see ibid., p. 116, ll. 544–68; for the standard late seventeenth-century view of religious fantasies, see Meric Casaubon, *Treatise Concerning Enthusiasm* (London, 1655).

4. The seminal view is Plato's in Book X of his *Republic*. He says that unthinking entertainment arouses irrational elements in the human soul (anger, pity, fear), which lead toward madness and which should be suppressed rather than exercised. Galen, the medical authority, says the same thing. His theme in "On the Passions" is that we should sublimate or purge them, and he says that if we restrain the passions they will moderate (see Ernest Barker, ed., *Greek Medicine* [New York: J. M. Dent and Sons,

1929], pp. 165–69). Meric Casaubon's *Treatise Concerning Enthusiasm* (1655) further expresses later patterns for disapproval of enthusiasm (or the divine *afflatus*, or false inspiration); see also Jonathan Swift's satirical treatment of the subject in *A Tale of a Tub* (written ca. 1696, pub. 1704), sects. VIII, IX, in *Prose Works* of *Jonathan Swift*, ed. Herbert Davis (Oxford: Clarendon Press, 1939), I.

5. See A. D. Nuttall, *Two Concepts of Allegory* (New York: Barnes & Noble, 1967), p. 159.

6. See Simon Goulart, *A Learned Summary Upon the Famous Poem of William of Saluste, Lord of Bartas* . . . , trans. Thomas Lodge (London, 1621), p. 264; for a fascinating discussion of air and music, see Gretchen Finney, "Music and Air: Changing Definitions of Sounds," *Musical Backgrounds for English Literature: 1580–1650* (New Brunswick, N.J.: Rutgers University Press, n.d.; articles pub. 1940–1960), pp. 139–58. She says that Dr. Helkïah Crooke in *Body of Man* (London, 1615) describes the process of how music gets into the soul (p. 144). She also quotes the passage from Lodge, pointing out the history of the phrase "aeriall nature" as it comes from the Neoplatonist Marsilio Ficino. See studies by D. P. Walker "Musical Humanism in the Sixteenth and early Seventeenth Centuries," *The Music Review* 2 (1941), 1–13, "Ficino's 'Spiritus' and Music," *Annales Musicalogiques* 1 (1953), 131–32, and *Spiritual and Demonic Magic from Ficino to Campanella* (London, Warburg Institute, 1958).

7. See Michael Murrin, *The Veil of Allegory: Some Notes toward a Theory of Allegorical Rhetoric in the English Renaissance* (Chicago: University of Chicago Press, 1969), p. 3. Murrin agrees that Renaissance poetry did not even exist until it was read. He refers to Ficino's statements on the subject.

8. See Henry Purcell, *Orpheus Britannicus* (Ridgewood, N.J.: Gregg Press, 1965; facsimile of 1721 ed.; first pub. 1698), II, p. 43.

9. David G. O'Neill, "The Influence of Music in the Works of John Marston," *Music and Letters* 53 (1972); 400–410.

10. Jeremy Collier, "Of Music," *Essays Upon Several Moral Subjects* (London, 1697), p. 21.

11. Joseph Addison, *The Spectator* (No. 405, 14 June 1712); see also ibid. (No. 630, 8 December 1714), wherein only music "employed at the altar" is reasonable.

12. See Finney, *Musical Backgrounds for English Literature*, p. 24; there she argues that music from 1580 to 1640 delighted and instructed. She points out, however, that rationalist church reformers saw nothing in music but the purpose of raising the wrong kind of emotions, citing as evidence the words of William Perkins, *Works* (London, 1612), I, p. 38;

John Cotton, *Singing of Psalmes a Gospel Ordinance* (London, 1647), p. 6; and Ludovick Bryskitt, *A Discourse of Civill Life* (London, 1606), p. 147. For an argument that Platonic notions of musical instruction through harmony were dominant in France until the eighteenth century, see Robert Isherwood, *Music in the Service of the King* (Ithaca, N.Y.: Cornell University Press, 1973), p. 11. The harmony of the dance also is allied to that of music (p. 10), which could be didactically used (p. 4). For an English example, see John Milton, *Of Education* (London, 1644). Isherwood thinks that Marin Mersenne, who wrote *L'Harmonie universelle* (Paris, 1636), was the main link to seventeenth-century musical Neoplatonism in France (p. 33); see also Heinrich Glarean, "The Dodecachordon," trans. Clement A. Miller (Ph.D. diss., University of Michigan, 1950), p. 63, on mundane music. Glarean follows the Neoplatonist Boethius.

13. Robert Burton, *The Anatomy of Melancholy*, ed. F. Dell and P. Jordan Smith (New York: Tudor Publishing Co., 1948).

14. John Dryden, *Of Dramatic Poesy and Other Critical Essays*, ed. George Watson (New York: Everyman, 1962), I, p. 2.

15. See Samuel H. Monk, "A Grace beyond the Reach of Art," *Journal of the History of Ideas* 5 (1944); 131–50.

16. John Davies, trans., Preface to *The Extravagant Shepherd, Anti-Romance, or the History of the Shepherd Lysis*, by Charles Sorel (London, 1653).

17. See H. James Jensen, *A Glossary of John Dryden's Critical Terms* (Minneapolis: University of Minnesota Press, 1969), pp. 39, 66–67, 87–88;

18. See Joseph Wood Krutch, *Comedy and Conscience after the Restoration*, rev. ed. (New York: Columbia University Press, 1949; first pub. 1924); for corroborative arguments on Hobbes's influence on Restoration comedy, see Thomas Fujimura, *The Restoration Comedy of Wit* (Princeton: Princeton University Press, 1952), pp. 39–57; and Virginia A. Birdsall, *Wild Civility* (Bloomington: Indiana University Press, 1970).

19. Robert T. Petersson, *The Art of Ecstasy: Teresa, Bernini, Crashaw* (London: Routledge & Kegan Paul, 1970), p. 45.

20. Leon Baptista Alberti, the Renaissance Neoplatonist, for example, says in his *Architecture* (ca. 1485), "We can in our thoughts and imagination contrive perfect forms of buildings entirely separate from matter" (I, p. i); see Alberti, *Architecture*, trans. James Leoni (London, 1739).

21. See Anthony Blunt, *Artistic Theory in Italy: 1450–1600*, rev. ed. (New York: Oxford University Press, 1968; first pub. 1940), p. 136.

22. Louis Martz, *The Poetry of Meditation* (New Haven: Yale University Press), pp. 129–30; see also his comments on p. 83.

23. See Blunt, *Artistic Theory in Italy*.

24. Ibid; see also John Sheffield, earl of Mulgrave, marquis of Normanby, and duke of Buckinghamshire, "An Essay on Satire" (1680), in *The Poetical Works of Dryden*, ed. George R. Noyes, p. 914, ll. 1–30; and René Rapin, *Treatise de Carmine Pastorale*, trans. Thomas Creech (London, 1684), p. 48.

25. René R. Le Bossu, *Traité du poème épique*, 3 vols. (Paris, 1665) I, p. 37; Baxter Hathaway, in *The Age of Criticism* (Ithaca, N.Y.: Cornell University Press, 1962), says that Paolo Beni (1552–1625) makes the same point earlier in his "Comparazione di Omero, Virgilio, e Torquato," in Tasso, *Opere* (Pisa, 1828), XXII, p. 46; Joseph Addison, in *The Spectator* (Nos. 70 and 369), paraphrases Le Bossu and supports the same point.

26. John Dryden, "A Parallel Betwixt Poetry and Painting," in Watson, II, p. 186.

27. Roland Fréart de Chambray, *An Idea of the Perfection of Painting*, trans. John Evelyn (London, 1668), p. 4.

28. Ruth S. Magoun, *The Letters of Peter Paul Rubens* (Cambridge: Harvard University Press, 1955).

29. Thomas Mace, *Musick's Monument* (London, 1672), p. 234.

30. Marin Mersenne, *L'Harmonie universelle: contenant la théorie et la practique de la musique* (Paris, 1636).

31. Ibid., pp. 374–424.

32. Thomas Rymer, Preface, *Monsieur Rapin's Reflections on Aristotle's Treatise of Poesie* (London, 1694). Note that many of Dryden's wild, heroic dramas were set in a kind of fashionable, Arabic background.

33. Voltaire, "A Discourse on Tragedy" (prefixed to *Brutus* [1731]), trans. Barrett H. Clark, in *European Theories of the Drama*, ed. Barrett H. Clark and rev. Henry Popkin (New York: Crown, 1965), pp. 235–36.

34. For the extension of this idea in music and dance, see Isherwood, *Music in the Service of the King*.

35. Thomas Morley, *A Plaine and Easie Introduction to Practicall Musicke* (1597), Shakespeare Association Facsimile no. 14 (London, 1937).

36. Jacques Gohory, Preface to *A Brieffe and Plaine Instruction to set all musicke of eight divers tunes in tableture for the Lute*, by Adrien Le Roy, trans. unknown (London, 1574; first pub. in France, 1557).

37. Morley, *A Plaine and Easie Introduction*.

38. Sir Thomas Browne, *Religio Medici* (London, 1642), in *Works*,

ed. G. L. Keynes, rev. ed. (London: Faber & Faber, 1964; first pub. 1928-31); Christian Huygens, *The Celestial Worlds Discovered* (London, 1698), pp. 83-91; see also Leo Spitzer, *Classical and Christian Ideas of World Harmony* (Baltimore: The Johns Hopkins University Press, 1963), pp. 3-43, et passim; Hathaway, *The Age of Criticism*, pp. 434-35; Plutarch, "On Music," *Moralia*, trans. Benedict Einarson and Philip H. DeLacy (London: W. Heinemann, 1967), XIV, pp. 385-447; for thorough discussions of music and literature, see Finney, *Musical Backgrounds for English Literature.*

39. G. P. Lomazzo, *A Tracte Containing the Artes of Curious Paintinge, Carvinge, and Building*, trans. Richard Haydocke (London, 1598).

40. Mersenne, *L'Harmonie universelle* (1636).

41. Ferrand Spence, Preface, *Miscellanea* (London, 1686), pp. 65-66.

42. Aristotle, *Nichomachean Ethics*, trans. Martin Oswald (Indianapolis: Bobbs-Merrill, 1962), pp. 285-86. This view of pleasure is much different from the connotations associated with the phrase "man of pleasure." In *The Spectator* (No. 151, 23 August 1711), Sir Richard Steele says that the man of pleasure "has given up the delicacy of his passions [Steele thinks higher passions are innately good] to the cravings of his appetites [or baser urges or passions]."

43. Laurence Lipking, *The Ordering of the Arts in Eighteenth Century England* (Princeton: Princeton University Press, 1970), p. 31; the English translation of Franciscus Junius, *De pictura veterum* (Rotterdam, 1637), was *The Painting of the Ancients* (London, 1638).

THREE. Rhetorical Theory and Practice

1. See, for example, Vincent M. Bevilacqua, *"Ut Rhetorica Pictura*: Sir Joshua Reynolds' Rhetorical Conception of Art," *Huntington Library Quarterly* 34, no. 1 (1970): 59-78.

2. See Philip C. Ritterbush, "Organic Form: Aesthetics and Objectivity in the Study of Form in the Life Sciences," in *Organic Form*, ed. G. S. Rousseau (London: Routledge & Kegan Paul, 1972), pp. 25-59; Ritterbush refers to Nehemiah Grew, *The Anatomy of Plants* (London, 1682), as well as to a number of other works. Our frame of reference often has to be revised. We need to adjust ourselves constantly to images of growth, not only to scientific definitions of growth but also to the relationship of man's soul to plants and the part people thought God played in endowing all living things with innate capacities.

3. Charles Sorel, *The Extravagant Shepherd, Anti-Romance, or the History of the Shepherd Lysis*, Translated Out of the French by John

Davies (London, 1653; first pub. in France, 1627). For selected texts on rhetoric in education, see L. H. D. Buxton and S. Givson, *Oxford University Ceremonies* (Oxford: Oxford University Press, 1935); Donald L. Clark, *John Milton at St. Paul's School* (New York: Columbia University Press, 1948); Lillian Feder, "Dryden's Use of Classical Rhetoric," *PMLA* 69 (1954); 1258–78; Harris F. Fletcher, *The Intellectual Development of John Milton*, 2 vols. (Urbana: University of Illinois Press, 1956); Charles Hoole, *New Discovery of the Old Art of Teaching School*, ed. E. T. Compagnac (Liverpool and London: The University Press, 1913; first pub. 1660); Wilbur S. Howell, *Logic and Rhetoric in England: 1500–1700* (New York; Russell & Russell, 1961); Miriam Joseph, *Shakespeare's Use of the Arts of Language* (New York: Columbia University Press, 1947); John Mulder, *The Temple of the Mind: Education and Literary Taste in Seventeenth Century England* (New York: Pegasus, 1969); Walter J. Ong, *Ramus: Method and the Decay of Dialogue* (Cambridge: Harvard University Press, 1958); Foster Watson, "A Bibliographical Account of Education in England: 1500–1660," *Notices of Some Early English Writers on Education* (Washington, D.C.: Annual Reports of the U.S. Commissioner of Education, 1903).

4. Mulder, *The Temple of the Mind*, pp. 35–36; see also pp. 37–41. For further understanding of how rhetoric relates to allegory in the Renaissance, see Michael Murrin, *The Veil of Allegory: Some Notes toward a Theory of Allegorical Rhetoric in the English Renaissance* (Chicago: University of Chicago Press, 1969); and Louis Martz, *The Poetry of Meditation* (New Haven: Yale University Press, 1954); see also Paula Johnson, *Form and Transformation in Music and Poetry of the English Renaissance* (New Haven: Yale University Press, 1972), who briefly mentions that analogues between music and poetry are rhetorical (p. 38) and that rhetorical devices were used by madrigal composers (p. 40). John M. Steadman, in *Milton and the Renaissance Hero* (New York: Oxford University Press, 1967), says that seventeenth-century heroic poetry had to "instruct, delight, and move" and that "wonder was the characteristic effect" (p. 2). Jeffrey B. Spencer, in *Heroic Nature: Ideal Landscape in English Poetry from Marvell to Thomson* (Evanston: Northwestern University Press, 1973), mentions that painting genres are rhetorical in origin.

5. See Roger Des Piles, *The Principles of Painting*, Translated by "A Painter" (London, 1743); first published as *Cours de peinture par principes avec une balance des peintures* (Paris, 1708). Des Piles uses the categories of invention, disposition, and design. After design, Des Piles goes on to discuss *actio*, coloring, and shade. He points out that painting and poetry differ in practice and in performance only (p. 267). The only differences, therefore, among the arts are in the media themselves (see

also p. 269). He says further that poets, orators, and painters all proceed in the same way (p. 32) but use various styles.

6. See Marcus Fabius Quintilian, *Institutio oratoria*, trans. H. E. Butler, 4 vols. (Cambridge: Harvard University Press, 1958–60; see also these three books by Marcus Tullius Cicero, *Brutus and Orator*, trans. H. M. Hubbell (Cambridge: Harvard University Press, 1939), *De oratore*, trans. A. S. Wilkins (London: Oxford University Press, 1895), and *De inventione. De optimo genere oratorum. Topica*, trans. H. M. Hubbell (Cambridge: Harvard University Press, 1949); for a discussion of figures of speech in a work attributed to Cicero but now thought not to be written by him, see *Rhetorica ad C. Herrennium*, rev. and trans., with introduction and notes, by Henri Bornèque (Paris: Garnier Frères, 1932).

7. John Dryden, "An Account of the Ensuing Poem" (1667), in *Of Dramatic Poesy and Other Critical Essays*, ed. George Watson (New York: Everyman, 1962), I, p. 98. We have to keep in mind, however, that the imagination must be kept under control by the judgment. Dryden also says (1664): "For imagination in a poet is a faculty so wild and lawless that like a high ranging spaniel it must have clogs tied to it lest it outrun the judgment," (in Watson, I, p. 8). See Watson's history of the image of the spaniel (I, p. 8). The image was a commonplace. Watson sees the spaniel image in Juan Huarte (*Examen de ingenios: The Examination of Men's Wits*, trans. from the Spanish by Camillo Camilli, trans. into English by Richard Carewe [Gainesville: Scholar Facsimiles and Reprints, 1959; first English trans. 1594]) and in Thomas Hobbes (*Leviathan*, Parts I and II, ed. Herbert Schneider [Indianapolis: Bobbs-Merrill, 1958; first pub. 1651], p. 34). Note also this passage in Aristotle's *Rhetoric*, trans. Lane Cooper (New York: Appleton-Century-Crofts, 1960; first pub. 1932): "In these special regions the orator hunts for arguments as a hunter pursues game" (p. 155). See Robert Burton, *The Anatomy of Melancholy*, ed. F. Dell and P. Jordan Smith (New York: Tudor Publishing Co., 1948; first pub. 1621), p. 13 ("running wit," or imagination, is like a spaniel). Roger Des Piles (*Principles*) implies the gathering and the use of classical learning and experience in Dryden's terms when he talks about historical invention, his first category of invention. He says, "Invention simply historical . . . is more or less valuable according to the quality of its matter, the nature of its choice, and the genius with which it is managed" (p. 34). His three categories of invention are historical, allegorical, and mystical (p. 33).

8. See G. P. Lomazzo, *A Tracte Containing the Artes of Curious Paintinge, Carvinge, and Building*, trans. Richard Haydocke (London, 1598), Book II, chap. XXI, p. 86, wherein he talks about hair. See the

use of hair, for example, in Giovanni Lorenzo Bernini's *Moor* in the *Fontano de Moro* in the Piazza Navona in Rome (1653–55). Rudolf Wittkower, in *Giovanni Lorenzo Bernini* (London: Phaidon Press, 1966), says that the figures accessory to the Moor were "replaced by copies in the nineteenth century" (p. 226).

9. See Aristotle, *Rhetoric*, Book II, sects. 22–24, on *topoi* (or topics) or "commonplaces." *Topoi* means "place" or "commonplace" in the sense either of a literal place or of a commonly accepted belief, category, or saying. In invention you can go to a place where you find accepted divisions of an argument, for example, or for an idea. "Places" or "commonplaces" are important to Baroque conceptions of invention. Milton, for example, had a practice of keeping commonplace books to jot down ideas or topics for later use. Dryden used rhetorical "places" for the topics in his poems "Eleanora" (1692) and "Ode to the Pious Memory of . . . Mrs. Anne Killigrew . . ." (1685); see comments in *The Works of John Dryden*, ed. Earl Miner (Berkeley: University of California Press, 1969), III, pp. 317–19, 491–95. Dryden's rhetorical places of panegyric in the "Ode to . . . Mrs. Anne Killigrew" are (1) "Worthy origins or ancestry"; (2) "Superiority to one's fellows"; (3) "Striking achievements"; (4) "Comparison with great predecessors"; (5) "Manner of death"; and (6) "Apotheosis." All of course are found in paintings and/or musical settings. See also a discussion of Dryden's types in Steven N. Zwicker, *Dryden's Political Poetry* (Providence: Brown University Press, 1972).

10. Robert Isherwood, *Music in the Service of the King* (Ithaca, N.Y.: Cornell University Press, 1973), p. 169; there are other examples besides those in Isherwood: Charles Le Brun's *Alexandre et Porus* (1673) is often said to have received at least part of its inspiration from Jean Racine's *Alexandre le grande* (1665), and it is surmised that Le Brun in his *Les reines de Perse aux pieds d'Alexandre, ou la tente de Darius* (1660–61) imitated Nicholas Poussin's *Coriolanus* (1648).

11. See Kenneth Clark, *Landscape into Art* (Boston: Beacon Press, 1961; first pub. 1949), p. 30.

12. The piece was first published in 1725 but was played before that time; see Walter Kolneder, *Antonio Vivaldi*, trans. B. Hopkins (Berkeley: University of California Press, 1970; first pub. 1965), pp. 90–91.

13. John Dryden, "A Parallel Betwixt Painting and Poetry" (1695), in Watson, II, pp. 189–90; see also Dryden's "Preface to an *Evening's Love*," in Watson, I, p. 146.

14. See also Baxter Hathaway, *The Age of Criticism* (Ithaca, N.Y.: Cornell University Press, 1962), p. 27.

15. Ibid.

16. The number of the quartet is K 464; it is written in C; see Louis Biancolli, *The Mozart Handbook* (New York: World Publishing Co., 1954).

17. See John D. Boyd, *The Function of Mimesis and Its Decline* (Cambridge: Harvard University Press, 1969).

18. Plato's well-known example of the bed occurs in the first part of Book X of *The Republic*.

19. Plotinus, *The Enneads*, trans. Stephen MacKenna and B. S. Page (London: Faber & Faber, 1962), IV, p. 174 (Ennead V, viii, 1). See also Giovanni Pietro Bellori, *The Lives of Modern Painters, Sculptors, and Architects* (1672), in Elizabeth G. Holt, *A Documentary History of Art* (New York: Anchor, 1958), II, pp. 94–106. Bellori says the same thing about Phidias that Plotinus says and he quotes from Cicero's similar statement "that Phidias worked from an idea" (p. 97). Nicholas Poussin refers also to Phidias in the same way in his "Observations on Painting," in Holt, II, p. 144. Likewise, Frederigo Zuccaro's *desegno interno* is the idea existing in the mind. The work of art is the form the idea takes when it assumes a form visible to the senses. The *desegno interno* comes first; see F. Zuccaro, *The Idea of Sculptors, Painters, and Architects* (1607), in Holt, II, pp. 87–92. Roger Des Piles's comments show a different orientation, one that is more theologically dogmatic. He calls the second kind of invention allegorical (*Principles*, p. 34). He mentions personifications, the subject or motif (or topic) of Hercules' choice, and *The School of Athens*, the specific painting he also thinks of as mystical. To Des Piles, allegories, through the apparatus of conventions, *represent* what in fact they are not (pp. 34–36). The third kind of invention Des Piles calls mystical: mystical invention "instructs us in some mystery, grounded on scripture, incarnation . . . ecclesiastical history" (pp. 36–46).

20. H. James Jensen, *A Glossary of John Dryden's Critical Terms* (Minneapolis: University of Minnesota Press, 1969), p. 102.

21. See Jensen, "Last Perfection," *Glossary*, p. 72; see also Des Piles's rating of all the painters (*Principles*). Des Piles considers Raphael and Poussin among the best of all painters. He rates both very high in composition, design, and expression but considers neither very good in the least important part, coloring (which corresponds to *elocutio*). Poussin was thought of as the French Raphael, and Raphael was thought of as the greatest of all painters. See Jeremy Collier, *The Great Historical, Geographical, Genealogical, and Poetical Dictionary*, The Second Ed. Revis'd, Corrected, and Enlarg'd to the year 1688 (London, 1701). This work is translated from Louis Moréri, *Le Grand Dictionnaire historique* (first pub. Lyon, 1674). Moréri's book was published also in 1681, 1691, 1699, 1712, 1725, 1732, and 1759 and in languages other than French and

English. In the discussions of Raphael and Poussin Moréri expresses the same opinions that Des Piles does.

22. John Dryden, "The Life of Plutarch," in Watson, II, p. 10.

23. See Ong, *Ramus*.

24. Jean-Louis Guéz de Balzac, "Letter No. 12, August 3, 1624," *The Letters of Monsieur de Balzac*, trans. William Tirwhyt (?) (London, 1624), p. 116.

25. See Holt, II, pp. 143–44.

26. See Quintilian, Book XI, chap. iii, sect. 6.

27. The same thing is true, of course, for other painters; for corroboration, see Lomazzo, Book II, which is specifically on actions and gestures; for other theorists of art, see Charles Le Brun, *Méthode pour apprendre à dessiner les passions* (Amsterdam, 1698); and André Félibien, *Entretiens sur les vies et sur les ouvrages des plus excellens peintres anciens et modernes* (Paris, 1666), III. The other works covering rhetoric that I have previously footnoted explain in more detail what I am saying here. On gesture, see Des Piles, *Principles* (1708), pp. 162 ff. Addison, in *The Spectator* (No. 407, 17 June 1712), comments on gesture, saying that Englishmen (middle-class Englishmen, his audience) should learn more about them.

28. Roger Des Piles (1635–1709), *Principles*, pp. 103 ff. Des Piles is, and was considered, one of the most important theorists and historians of his time. See also Félibien, *Entretiens* (1666), III, pp. 215 ff.

29. See Lomazzo, Books II and III. Book II is "Of the Actions, Gestures, Situation, Decorum, Motion, Spirit, and Grace of Pictures"; Book III is about colors. Lomazzo goes into a great deal of detail, showing how the external, rhetorical devices express the parts, attitudes, and passions of the mind. See also Félibien, *Entretiens* (1666). In Volume IV, he describes the Marie de' Medici paintings. As to the *Education of Marie de' Medici*, he calls Mercury the god of eloquence (p. 100), and he says that "Ce tableau . . . [est] un des principaux de la gallérie." He covers Rubens on pp. 92–128.

30. Peter Paul Rubens, "To Francis Junius," in Holt, II, p. 197.

FOUR. Rhetorical Theory and the Arts

1. The discussion of the passions and how to raise them starts with Aristotle, *Rhetoric*, trans. Lane Cooper (New York: Appleton-Century-Crofts, 1960; first pub. 1932), Book II. Considerations of rhetoric and rhetorical considerations of art are everywhere in theory and practice. John Donne, for example, employed rhetoric; see Brian Vickers, "The 'Songs

and Sonnets' and the Rhetoric of Hyperbole," in *John Donne: Essays in Celebration*, ed. A. J. Smith (London: Methuen, 1972), pp. 132–74. Heinrich Glarean talks about grammar, rhetoric, and music; see "*The Dodecachordon*," trans. Clement A. Miller (Ph.D. diss., University of Michigan, 1950), pp. 126 ff. Roger Des Piles, *The Principles of Painting*, Translated by "A Painter" (London, 1743), points out that painting teaches both the ignorant and the learned (p. 271) through deception (p. 257). In other words, paintings instruct while they divert (p. 258). The rhetorical purpose of painting leads André Félibien to say that painters need not know the nature and the causes of color, they need know only their effects; see Félibien, *Entretiens sur les vies et sur les ouvrages des plus excellens peintres anciens et modernes* (Paris, 1666), III, p. 26.

2. Anthony Blunt, *Nicholas Poussin* (New York: Pantheon, 1967), I, p. 78.

3. See, for example, John Hollander, *The Untuning of the Sky* (Princeton: Princeton University Press, 1961). Hollander points out that as a result of affective theories early seventeenth-century theories of music were identified with rhetoric. The parallels between tropes and figures of music and poetry became common. In Germany there was almost complete identification, and in Italy, too. Each element of music was analyzed as a figure of rhetoric.

4. Claude Perrault, *Essais de physique* (Paris, 1680), II, Part 3, pp. 377 ff; see also Joseph Addison, *The Spectator* (No. 416, 27 June 1712).

5. Such similar effects lead to comparisons among the arts, some by sensitive, appreciative connoisseurs of the arts; see, for example, Roy Daniells, *Milton, Mannerism, and Baroque* (Toronto: University of Toronto Press, 1963).

6. See *The Spectator* (No. 633, 15 December 1714).

7. George Puttenham, *The Arte of English Poesie* (Kent, Oh.: Kent State University Press, 1970; facsimile ed. of 1906 reprint; first pub. 1598), Book I, chap. iii, p. 24.

8. Ibid., p. 22.

9. Cicero's *docere* (to teach), *conciliare* (to persuade), and *movere* (to move), the three aims of speaking well, apply clearly to rhetorically conceived art of all kinds; see by Marcus Tullius Cicero, *De oratore*, trans. A. S. Wilkins (London: Oxford University Press, 1895), and *Brutus and Orator*, trans. H. M. Hubbell (Cambridge: Harvard University Press, 1939). The concepts were used in almost all subsequent theories of rhetoric; see also St. Augustine, *On Christian Doctrine* (Indianapolis: Bobbs-Merrill, 1958; written ca. A.D. 396), p. 136; see also Gretchen Finney, *Musical Backgrounds for English Literature: 1580–1650* (New Brunswick, N.J.: Rutgers University Press, n.d.), p. 96.

10. René Le Bossu, *Monsieur Bossu's Treatise of the Epick Poem,* trans. W. J. (London, 1695; first pub. in France, 1675), p. 4. Elsewhere, Le Bossu tries to distinguish between a rhetorician and a poet. The distinction lies in elevation of purpose: the rhetorician seeks only to persuade; the poet also seeks to instruct or to improve his audience (p. :68).

11. René Rapin, *Reflections* (London, 1674), trans. Rymer, pp. 9–10.

12. Henry Peacham, *The Compleat Gentleman* (Oxford: Clarendon Press, 1906, first pub. 1622), p. 103.

13. See Richard A. Lanham, *A Handlist of Rhetorical Terms* (Berkeley: University of California Press, 1969).

14. Thomas Mace, *Musick's Monument* (London, 1676), p. 118; note Mace's reference to "the internal [sensible part of the soul], intellectual [the reasonable part], and incomprehensible [vegetable] faculties of the soul."

15. Ibid., p. 234.

16. G. P. Lomazzo, *A Tracte Containing the Arts of Curious Paintinge, Carvinge, and Building,* trans. Richard Haydocke (London, 1598), Book III, p. 95.

17. Marin Mersenne, *L'Harmonie universelle: Contenant la theorie et la practique de la musique* (Paris, 1636), p. 93.

18. Camus de Mézières, *Le Génie de l'architecture ou l'analogie de cet art avec nos sensations* (Paris, 1780), p. 31.

19. Longinus, *On the Sublime,* trans. A. O. Prickard (Oxford: Clarendon Press, 1961; first pub. 1906), pp. 45–47.

20. Jean-Philippe Rameau, *Treatise on Harmony,* trans. Philip Gossett (New York: Dover Publications, 1911; first pub. 1722), p. 154.

21. Dryden wrote "A Parallel Betwixt Poetry and Painting" (1695), in *Of Dramatic Poesy and Other Critical Essays,* ed. George Watson (New York: Everyman, 1962), II, pp. 181–208. John B. Bender, in *Spenser and Literary Pictorialism* (Princeton: Princeton University Press, 1972), says that "Dryden and du Fresnoy [whom Dryden translated] are only late examples of the pervasive Renaissance embellishment of illustrative comparisons made by ancient authorities" (p. 8). Dryden and Du Fresnoy's parallels are primarily rhetorical, equating the sequence of compositional acts. Invention, disposition, and elocution in writing become invention, disposition (arrangement), and coloring in painting. The third rhetorical element is what differs from one art to another. Roger Des Piles, in his *Principles,* notes the similarity among the arts that the rhetorical sequence of composition imposes; he says about painting, "Composition implies both invention and disposition; it is one thing to invent objects and another to place them rightly" (p. 31).

22. Lomazzo, Book III, p. 112.

23. The opposite tendency also occurred. Not only was music like spoken expression, but poetry was like music. Thus Puttenham says in *The Arte of English Poesie*: "Poetical proportion . . . holdeth of the musical, because as we said before Poesie is a skill to speak and write harmonically: and verses or rime be a kind of musical utterance, by reason of a certaine congruitie of sounds pleasing the eare, though not perchance so exquisitely as the harmonicall concents of the artificial Musicke, or that of melodious instruments, as Lutes, Harpes, Regals, Records, and such like" (p. 79). For the equation of music, poetry, and rhetoric, see also Joachim Burmeister, *Musica poetica* (Rostock, 1606); for comments also see C. S. Brown, "The Relation between Music and Literature as a Field of Study," *Comparative Literature* 22 (1970): 97–107.

24. For writings on the subject published over a range of years, see Thomas Morley, *A Plaine and Easie Introduction to Practicall Musicke* (1597), Shakespeare Association Facsimile no. 14 (London, 1937); Mersenne, *L'Harmonie universelle* (1636); Rameau, *Treatise on Harmony* (1722); and Camus de Mézières, *Le Génie de l'architecture* (1780).

25. Plato, *Republic*, trans. H. D. P. Lee (Baltimore: Penguin, 1971), Part III, p. 139.

26. Aristotle, *Politics*, trans. Benjamin Jowett, in *On Poetry and Music*, ed. Milton C. Nahm (Indianapolis: Bobbs-Merrill, 1956), Book VIII, p. 46.

27. Plutarch, "On Music," *Moralia*, trans. Benedict Einarson and Philip H. DeLacy (London: W. Heinemann, 1967), XIV, pp. 385–454.

28. Bertrand Bronson, "Some Aspects of Music and Literature," *Facets of the Enlightenment* (Berkeley: University of California Press, 1968; first pub. 1953), pp. 91–118.

29. Mézières, *Le Génie de l'architecture*, John Evelyn, trans. *A Parallel of Architecture Both Ancient and Modern*, by Roland Fréart de Chambray (London, 1680).

30. Roland Fréart de Chambray, *The Whole Body of Ancient and Modern Architecture*, trans. John Evelyn (London, 1680); first pub. 1650), p. 36; see H. James Jensen, *A Glossary of John Dryden's Critical Terms* (Minneapolis: University of Minnesota Press, 1969) for the definition of beauty.

31. Fréart, p. 63.

32. For later seventeenth-century English usages, see Jensen, *Glossary: agreeable, ballad, beautiful, expression, figure, harmony, numerous, numerousness, proportion, smooth, sound,* and *sounding;* these words have to do with verse.

33. See Plato, *Republic*, Part III, pp. 138–39.

34. Nicholas Poussin, *Lettres*, ed. Pierre Du Colombier (Paris: À la Cité des Livres, 1929), letter of 24 November 1647.

35. See Elizabeth G. Holt, *A Documentary History of Art* (New York: Anchor, 1958), II, p. 156.

36. See Holt, II, pp. 143–44; Jacques Gohory says the same things about music in his Preface to *A Brieffe and Plaine Instruction to set all musicke of eight divers tunes in tableture for the Lute*, by Adrien Le Roy, trans. unknown (London, 1574); see also Lomazzo.

37. In Blunt, *Nicholas Poussin*, p. 223; Blunt says the quotation is from *Correspondance de Nicholas Poussin*, ed. C. Jouanny (Paris, 1911), p. 21.

38. Blunt, *Nicholas Poussin*, p. 223; *Baptism* is in the National Gallery of Art, Washington, D.C. (Samuel H. Kress Collection).

39. See Jeremy Collier, *A Short View of the Immorality and Profaneness of the English Stage* (London, 1698). In rhetorical theories, thoughts and expressions are two elements of style. They usually are called the "colors" of rhetoric, or figures and tropes. Abraham Fraunce, in *The Arcadian Rhetoricke* (London, 1588), for example, considers figures of words (expression) as delighting and figures of thoughts as persuading.

40. For an excellent study of effect in the Cornaro chapel, see Robert T. Petersson, *The Art of Ecstasy: Teresa, Bernini, and Crashaw* (London: Routledge & Kegan Paul, 1970).

41. The important work in the consideration of the sublime for us is not Longinus's *Peri Hupsous* (see Longinus, *On the Sublime*, trans. A. O. Prickard [Oxford: Clarendon Press, 1906]) but Boileau's *Traité du sublime* (1674), in N. D. Boileau, *Oeuvres complètes*, ed. Charles-H. Boudhors, 7 vols. (Paris: Société la Belles Lettres, 1939–52). His translation influenced English thought from Dryden on; see Samuel H. Monk, *The Sublime* (Ann Arbor: University of Michigan Press, 1960; first pub. 1935); see also Jensen, *Glossary*, for the formal introduction in 1677 of *sublime* into English critical vocabulary.

42. N. D. Boileau, *A Treatise of the Loftiness or Elegancy of Speech*, trans. J. P. (London, 1680; first pub. 1674).

43. See Walter J. Ong, *Ramus: Method and the Decay in Dialogue* (Cambridge: Harvard University Press, 1958), pp. 92 ff. Alexandre Maurocordato, *La Critique classique en Angleterre* (Paris: Didier, 1964), pp. 72 ff. John D. Boyd, *The Function of Mimesis and Its Decline* (Cambridge: Harvard University Press, 1968), pp. 111 ff.; Miriam Joseph, *Shakespeare's Use of the Arts of Language* (New York: Columbia University Press, 1947); John Mulder, *The Temple of the Mind: Education and Literary Taste in Seventeenth Century England* (New York: Pega-

sus, 1969), pp. 32 ff. As Mulder says, "John Milton wrote *A Fuller Insti-tution of the Art of Logic arranged after the method of Peter Ramus*" (p. 33). Antoine Arnauld shows his affinity for Ramistic theory in his assertion that rhetoric contributes little to thought, expression, or embellishment. He thinks its practical use is to avoid bad style. Arnauld obviously conceives of thought and its arrangement as falling under logic, which is Ramus's primary idea. Antoine Arnauld, *The Art of Thinking*, trans. James Dickoff and Patricia James (Indianapolis: Bobbs-Merrill, 1964), p. 22.

44. John Dryden, Dedication to the *Indian Emperor*, in *Works of John Dryden*, ed. Sir Walter Scott and rev. George Saintsbury, 18 vols. (Edinburgh: William Patterson, 1882–93), II, p. 286.

45. See Lomazzo, Book III, p. 112.

46. Jensen, *Glossary*, p. 26.

47. For Le Brun, see Holt, II, pp. 161–63 and figure 7; for Dryden, see *Works*, ed. Scott–Saintsbury, V, p. 5.

48. Charles Le Brun, *Methode pour apprendre à dessiner les passions* . . . (1698), in Holt, II, p. 162.

49. Gotthold Lessing, *Laocoön*, trans. E. A. McCormick (Indianapolis: Bobbs-Merrill, 1962; first pub. 1766), p. 11.

50. See Jensen, *Glossary*, pp. 27–28.

51. Dr. Samuel Johnson, "Dryden," *The Lives of the English Poets*, ed. George Birkbeck Hill, 3 vols. (Oxford: Clarendon Press, 1705; first pub. 1779–81), I, p. 461.

52. Morse Peckham, *Man's Rage for Chaos* (New York: Schocken, 1969; first pub. 1967).

53. John Hughes, *The Spectator* (No. 541, 20 November 1712). What is interesting also about this passage is that it is adapted directly from Cicero's *De oratore*. The idea is not original with Hughes. We have seen in Chapter III what Poussin did with the idea; see also André Félibien, *Entretiens*, II, p. 366; see also Glarean's consideration of the modes, pp. 114 ff.

54. André Félibien says the same things as Le Brun in *Entretiens*, III, pp. 215 ff. His descriptions of emotions as they are supposed to be depicted corresponds almost exactly to Le Brun's; Lomazzo's Book II is full of descriptions of how to draw passions; see *Charles Le Brun: 1619–1690*, ed. Ministère d'État/Affaires Culturelles (Paris: Recherches et Réalizations Graphiques, 1963), pp. 70–73, 88–90, 302–307, in which we can see a passion in graphic form and its subsequent use in specific paintings.

55. Roger Des Piles, *Principles*, pp. 73 ff. Notice also how close his ideas are to those of John Dennis, except for the idea of religious enthusiasm, which Dennis makes the source of the sublime. Notice in Des Piles

the rhetorical nature of the sublime as opposed to the genuineness of enthusiasm. It is this kind of conception of enthusiasm that causes the trouble in eighteenth-century considerations of art as imitation of nature. See E. W. Hooker, ed., *The Critical Works of John Dennis* (Baltimore: The Johns Hopkins University Press, 1939–43).

56. For corroboration of this idea, see Lessing, *Laocoön*, chaps. IV–XXI.

57. Jeremy Collier, after he says that music rules reason (p. 21), describes what happens in Dryden's "Alexander's Feast" (p. 22); see Jeremy Collier, "Of Musick," *Essays Upon Several Moral Subjects* (London, 1697).

58. Puttenham, *The Arte of English Poesie*, pp. 199–202.

59. All are, of course, translating what Boileau says in his Chapter XVII, and Boileau is interpolating Longinus's *On the Sublime* section XX. In Longinus the figure named is *asyndeta*, or disorder. Boileau emphasizes the homeopathic effect of disorder more than does Longinus. The idea, however, still means that the disorder is a part of the author's intention. There is method in it. It is the kind of effect that Hamlet has on Polonius in Act II, scene ii, to which Polonius says, "Though this be madness, yet there is method in't" (II, ii, 204), see William Shakespeare, *The Complete Works* (Baltimore: Penguin, 1969), p. 946.

60. Robert Burton, *The Anatomy of Melancholy*, ed. F. Dell and P. Jordan Smith (New York: Tudor Publishing Co., 1948).

61. For an excellent, thorough discussion of Louis XIV's use of art, particularly music, see Robert Isherwood, *Music in the Service of the King* (Ithaca, N.Y.: Cornell University Press, 1973).

62. See Anthony Blunt, *Artistic Theory in Italy: 1450–1600*, rev. ed. (New York: Oxford University Press, 1968; first pub. 1940).

63. André Félibien, *Des Principes de l'architecture, de la sculpture, de la peinture, et des autres arts qui en dependent* (Paris, 1690), pp. 104–106. *Gothic* was a pejorative term. Lomazzo in Book II says that astonishment comes from hearing or seeing "some strange matter" (p. 15).

FIVE. Passions, Rhetoric, and Characterization

1. William Shakespeare, "The Rape of Lucrece," *Complete Works*, ed. Alfred Harbage (Baltimore: Penguin, 1969), p. 1424, ll. 485–501.

2. The carry-over is in the same way similar to that of references to the Ptolemaic universe. We still, for instance, say we watch the sun set or rise. In each case, the diagrammable images are dead for us. In our language, we do not see images of the mind in terms of imagination or judg-

ment, nor do we see a scheme of the Ptolemaic universe. They are practical observations, observable by the senses, that are so much a part of the language that learned scholars say that a modern novelist appeals to our imagination, that he constructs imaginative worlds (Neoplatonic) that express the ideas in his very soul. It would seem that the Freudian psychology is awkward for most people explaining art. I suggest that we consider the artist's idea of how he created or made art or analyzed character, that we avoid the old terms for writers who use modern concepts and eliminate the anachronisms that result from applying Freudian thought to older works.

3. See Leo van Puyvelde, *Van Dyck* (Brussels: Elsevier, 1959), p. 143 and plate 28. The painting is in the Brussels Musées Royaux des Beaux-Arts. There is a copy after Poussin of *The Triumph of Silenus* in the National Gallery, London. See Anthony Blunt, *Nicholas Poussin* (New York: Pantheon), II, plate 90. There are also two paintings by Rubens (1577–1640): *The Drunken Silenus* (The Hermitage, Leningrad) and *The Dreaming Silenus* (Akademie, Vienna). See by Hans E. Evers, *Peter Paul Rubens* (Munich: F. Bruckmann, 1942), p. 97, plates 44–45, and *Rubens und sein Werk* (Brussels: London, 1944), pp. 220, 256; and see R. A. M. Stevenson, *Rubens: Paintings and Drawings* (New York: Macmillan, 1931), plate 138. The van Dyck painting shows the body of Silenus, those by Poussin and Rubens show the body and the face; for both, see also the Baroque painter Pietro da Cortona, ceiling of the Palazzo Barberini, Rome. John Dryden, "Essay of Dramatic Poesy" (1668), in *Of Dramatic Poesy and Other Critical Essays*, ed. George Watson (New York: Everyman, 1962), I, pp. 70–71.

4. Thomas Otway, *Venice Preserved* (1682); references are to *British Dramatists from Dryden to Sheridan*, ed. G. Nettleton and A. Case and rev. G. W. Stone, Jr. (Boston: Houghton Mifflin, 1969), pp. 113–47: "*Venice Preserved* was enormously popular. . . . It was acted 337 times between 1703 and 1800. With the sole exception of the 1771–72 season, it was played in some theater in every year of the eighteenth century" (p. 114).

5. Sir William Davenant, "Preface to Gondibert" (1650), in *Critical Essays of the Seventeenth Century*, ed. Joel Spingarn (Bloomington: Indiana University Press, 1963), II, pp. 17–18; see also Thomas Rymer, *Critical Works*, ed. C. Zimansky (New Haven: Yale University Press, 1956), p. 61; Frank Warnke, *Versions of Baroque* (New Haven: Yale University Press, 1972), says that he can see no form in *Venice Preserved* (pp. 203–204); Derek W. Hughes sees a Hobbesian influence in the play, saying that its central motif is man's reverting to a "primitive and animal state as a result of the triumph of physical impulse over the ra-

tional faculties" ("A New Look at *Venice Preserved*," SEL 11 (1971): 437–38; the article is on pp. 437–57.

6. William Congreve, *The Mourning Bride* (I, i, 1). Purcell's song in praise of music's power to calm the passions is in what historically was called the tender and gay key of G.

7. For a highly allegorical depiction of the sense of smell, for example, see Jan Breughel's *The Sense of Smell* (Prado, Madrid).

8. Henry Peacham, *The Garden of Eloquence* (Oxford: Clarendon Press, 1906; first pub. completely 1634), p. 96.

9. Thomas Mace, *Musick's Monument* (London, 1676), p. 30. We find the same opinion stated in Castiglione's *The Book of the Courtier* (1516): "He who does not take pleasure in [music] . . . can be sure that his spirit lacks harmony among its parts." See Baldasar Castiglione, *The Book of the Courtier*, trans. Charles S. Singleton (New York: Anchor, 1959), p. 76.

10. Jean de La Bruyère, *The Characters and Manners of the Age*, translated by Several Hands (London, 1699), p. 17; first published as *Les Caractères* (Paris, 1688).

11. Thomas Shadwell, *The Complete Works of Thomas Shadwell*, ed. Montague Summers, 5 vols. (London: Fortune Press, 1927), IV, Act II.

12. Edward Dent, *The Foundations of English Opera* (Cambridge: Cambridge University Press, 1928), p. 8.

13. See Aristotle, *Politics*, in *On Poetry and Music*, ed. Milton C. Nahm (Indianapolis: Bobbs-Merrill, 1956), Book VIII, chap. 6; Plutarch, *"Life of Alcibiades," Moralia*, trans. Benedict Einarson and Philip H. DeLacy (London: W. Heinemann, 1967), XIV, chap. 2. In the Baroque era there are many paintings of ordinary people playing instruments; for example, Jacob Jordaens's *Three Wandering Musicians*, in which the flute player is depicted as a person of low birth. See also Philip D. Stanhope, fourth earl of Chesterfield, *Letters*, 6 vols. (New York: Viking Press, 1932), letter of 19 April 1749.

14. Rosamond Tuve, "Sacred Parody of Love Poetry, and Herbert," *Studies in the Renaissance* 8 (1961): 249–90.

15. Vincent Druckles and Franklin B. Zimmerman, *Words to Music* (Publication of the William Andrews Clark Memorial Library, University of California, Los Angeles, 1967), p. 20.

16. Ibid. Gretchen Finney, in *Musical Backgrounds for English Literature: 1580–1650* (New Brunswick, N.J.: Rutgers University Press, n.d.), points out that to the Florentine musicians, Neoplatonists all, words were most important (p. 128). Mellers says that the human voice was the

most important instrument. Thus, words and music became close. When music became divorced from words, he thinks, it became divorced from life. See Wilfrid Mellers, "Words and Music in Elizabethan England," in *The Age of Shakespeare*, ed. Boris Ford (Baltimore: Penguin, 1960), pp. 389–90. The human voice is most important because it expresses the word as thought by someone. This idea goes along very nicely with the idea of Neoplatonic "humanism." But Corneille in the Preface to *Andromède* (1650) says that nothing concerning the understanding should be put into songs in plays because the words are too hard to understand— only the emotions are important; see also E. W. White, *The Rise of the English Opera* (London: E. Lehmann, 1969), p. 35; Dryden says essentially the same thing in his Preface to *Albion and Albanius* (1685), in *Of Dramatic Poesy and Other Critical Essays*, ed. George Watson (New York: Everyman, 1962), II, p. 35; see also John H. Long, *Shakespeare's Use of Music* (Gainesville: University of Florida Press, 1955), p. 43; for examples of Dryden's use of conventions of music, see his *Secret Love or the Maiden Queen* (1668; IV, iii), *Cleomenes* (1692; II, ii), and *The Assignation or Love in a Nunnery* (1673; II, ii).

17. See Robert Isherwood, *Music in the Service of the King* (Ithaca, N.Y.: Cornell University Press, 1973), pp. 12–24, for a development of the idea of Ficino; see also Finney, chaps. I–VI.

18. See Robert Burton, *The Anatomy of Melancholy* (1621), ed. F. Dell and P. Jordan Smith (New York: Tudor Publishing Co., 1948), pp. 478 ff.

19. For a brief explanation of Boethius's three kinds of music, see Isherwood, pp. 13–14.

20. Dent throughout his book indicates the key of a particular piece of music. He does so often enough to make us suspect he thinks there is a reason for a specific key but does not know that reason (for examples, see pp. 182, 189, 197–200). Yet, a minor key, he says, indicates voluptuousness, which it often does.

21. See also Don Smithers, "Seventeenth Century English Trumpet Music," *Music and Letters* 48 (1967); 358–65. Smithers has much interesting information but says at one point that most of Purcell's trumpet music is in D. A glance at the *Orpheus Britannicus* would dispute this claim: there are only two or three songs, primarily for trumpets, written in D; there is one song in E-flat and another in G. Smithers is mostly correct, however, in saying that there is no difference between C and D thematically. Actually, C, at least to Purcell, is more versatile. To John Blow (1648–1708) there apparently is no difference between the two keys. See Henry Purcell, *Orpheus Britannicus*, 2 vols. (London, 1721); John Blow, *Amphion Anglicus* (London, 1700); and Emanuel Winter-

nitz, *Musical Instruments and Their Symbolism in Western Art* (New York: Norton, 1967). There are modern editions of Purcell and Blow that are facsimiles of the volumes cited in this note: Henry Purcell, *Orpheus Britannicus*, 2 vols. (Ridgewood, N.J.: Gregg Press, 1965; facsimile of 1721 ed.); John Blow, *Amphion Anglicus* (Ridgewood, N.J.: Gregg Press, 1965; facsimile of 1700 ed.).

22. Smithers says Purcell's trumpet parts compare most favorably, of any English composer's, with those of the northern Italians (p. 361); he points out that the usual scheme of English trumpet pieces is like that of the Bolognese (p. 364); see also Anthony Lewis, "Purcell and Blow's 'Venus and Adonis'," *Music and Letters* 44 (1963), pp. 266–69, who says, "The relationship between Blow and Purcell is one of the most important in English music" (p. 266).

23. See also Jean-Philippe Rameau, *Treatise on Harmony*, trans. Philip Gossett (New York: Dover Publications, 1911; first pub. 1722). The classifications are thus: C, mirth and rejoicing; D, mirth and rejoicing, grandeur and magnificence; E, tenderness and gaity, grandeur and magnificence; F, tempests and furies; G, tenderness and gaity; A, grandeur and magnificence, mirth and rejoicing; B, tempests and furies; c, tenderness and plaints; d, sweetness and tenderness; e, sweetness and tenderness; f, tenderness and plaints, mournful songs; g, sweetness and tenderness; a, none listed; b, sweetness and tenderness, mournful songs. The dividing line is largely between major and minor keys.

24. See Heinrich Glarean, "The Dodecachordon," trans. Clement A. Miller (Ph. D. diss., University of Michigan, 1950), for another version of the modes. The hypoionian mode, for example, is in G or C and includes morning songs, love songs, elegies, and frivolities. The trumpet, he says, is used here. Again, the classification is very general.

25. Roger Des Piles, *The Principles of Painting*, Translated by "A Painter" (London, 1743), pp. 102–106.

26. See, for example, the frontispiece of Jean-Baptiste Lully's *Amadis tragédie* (ca. 1709). The frontispiece shows everyone with the expression of *étonnement* (astonishment) at the thunder and lightning so graphically illustrated (and corresponding to the effects presented at the beginning of the first act).

27. See *Charles Le Brun: 1619–1690*, ed. Ministère d'État/Affaires Culturelles (Paris: Recherches et Réalizations Graphiques, 1963), pp. 308–15.

28. André Félibien, *Conférences de l'académie royale de peinture et de sculpture* (Amsterdam, 1706); see also his *Entretiens sur les vies et sur les ouvrages des plus excellens peintres anciens et moderne* (Paris, 1666).

29. Pan, of course, personifies the appetites of the second soul. For

examples, see Poussin's *The Triumph of Pan* (1635–36) and *Pan and Syrinx* (1637).

30. Such a portrait or type was made to be broken, and Shakespeare shows how a soldier can be like Iago. Everyone in *Othello* thinks of Iago as a typical soldier, but he is only partially so. He is full of arrogance, hatred, and anger but lacks the typical bluffness, honesty, and boldness. Rymer, in his criticisms, misses the point, arguing that Shakespeare should be condemned because he upset probable truth.

31. In the Musée de Nantes; see Yves Picart, *La Vie et l'oeuvre de Simon Vouet* (Paris: Cahiers de Paris, 1958), Part II, plate 8.

32. In the Musée National, Versailles; *Charles Le Brun: 1619–1690*, pp. 70–73.

33. In the Louvre, Paris; see Blunt, *Nicholas Poussin*, I, plate 225.

34. The idea of perceiving the painter's soul in his work is equivalent to the idea of the ethos of the orator, whose character is revealed by his speech. Aristotle, for example, maintains that "Character [ethos] is the most potent of all the means to persuasion." (*Rhetoric*, trans. Lane Cooper [New York: Appleton-Century-Crofts, 1960; first pub. 1932], pp. 1–2).

35. In Holt, II.

36. See the catalogue of the degrees of perfection in the several parts of painting in Roger Des Piles, *Principles* (1708); Des Piles gives Raphael the highest rating in expression.

37. Félibien, *Entretiens* (1666), V, p. 68, also thinks them vulgar; for a discussion of ideas of "decency" in painting as derived from the Council of Trent and the succeeding Counter-Reformation, see Anthony Blunt, *Artistic Theory in Italy: 1450–1600*, rev. ed. (New York: Oxford University Press, 1968), pp. 103–36.

38. Nicholas Poussin, "A Chantelou" (1647), *Lettres*, ed. Pierre de Colombier (Paris: À la Cité des Livres, 1929); Chantelou is Roland Fréart de Chambray's brother, Paul.

39. Sir Joshua Reynolds, "Discourse Nine" (1798), *Discourses on Art*, ed. Stephen O. Mitchell (Indianapolis: Bobbs-Merrill, 1965), pp. 142–44; first published as a single work in 1797.

SIX. Rules Criticism and Aesthetics

1. John Dryden, "Essay of Dramatic Poesy," in *Of Dramatic Poesy and Other Critical Essays*, ed. George Watson (New York: Everyman, 1962), I, p. 56.

2. For more detailed studies of French criticism, its precepts, terms, and influence, see for example, René Bray, *La Formation de la doctrine*

classique en France (Lausanne–Geneva: Librairie Payot, 1931); E. B. O. Borgerhoff, *The Freedom of French Classicism* (Princeton: Princeton University Press, 1950); Joel Spingarn, ed., Introduction, *Critical Essays of the Seventeenth Century* (Bloomington: Indiana University Press, 1963; first pub. 1908); Robert Hume, *Dryden's Criticism* (Ithaca, N.Y.: Cornell University Press, 1970); Hoyt Trowbridge, "The Place of the Rules in Dryden's Criticism," *MP* 44 (1946): 84–96; A. F. B. Clark, *Boileau and the French Classical Critics in England: 1660–1830* (Paris: E. Champion, 1925); Thomas Hanzo, *Latitude and Restoration Criticism,* Anglistica XII (Copenhagen, 1961); Alexandre Maurocordato, *Le Critique classique en Angleterre de la Restauration à la mord de Joseph Addison* (Paris: Didier, 1964); Louis Charlanne, *L'Influence française en Angleterre au XVIIᵉ siècle* (Paris: Société Française, 1906); H. T. Swedenberg, Jr., *The Theory of the Epic in England* (Berkeley and Los Angeles: University of California Press, 1944).

3. This posture is ironic because, of course, it is the scientific imagination that brings together disparate ideas to produce discoveries. In this way, scientific thought is like every other kind of inventive thought. As an example of the way in which imagination works in mathematic invention or discovery, see Henri Poincaré, "Mathematical Creation," in *The Creative Process,* ed. Brewster Ghiselin (Berkeley: University of California Press, 1952). Although it is true, however, that in many ways mathematics, unlike the other sciences, is naturally aligned with Neoplatonism, with the magic of numbers (see Frances Yates, *Theatre of the World* [Chicago: University of Chicago Press, 1969]), the use of imagination holds true for other fields as well, especially in theoretical work.

4. Abraham Bosse, *Traité des practiques geometrales et perspectives* (Paris, 1665), also calls perspective a rule (p. 11) and says that the rules governing geometry are absolutely necessary to painting and designing (p. 121), and accordingly he likes the orderly planes he sees in Poussin. Bosse commends Palladio, Leonardo, Raphael, Poussin, Domenichino, and Correggio, among others, but never mentions the Neoplatonist Michelangelo, whose exuberance did not rate high in seventeenth- and eighteenth-century French taste.

5. Emile Bréhier, *The Seventeenth Century,* trans. Wade Baskin (Chicago: University of Chicago Press, 1966), p. 10; first published in France, 1938.

6. See David M. Knight, *Natural Science Books in English: 1600–1900* (London: B. T. Batsford, 1972); Paul H. Kocher, *Science and Religion in Elizabethan England,* Huntington Library Publications (Los Angeles, 1953); Madeleine Alcover's excellent book *La Pensée philosophique et scientifique de Cyrano de Bergerac* (Paris: Librairie Droz, 1970); and

Sir George Clark, *The Seventeenth Century*, rev. ed. (New York: Oxford University Press, 1970; first pub. 1929). Clark's book covers most aspects of the seventeenth century.

7. See Robert Wienpahl, "Modality, Monality, and Tonality in the Sixteenth and Seventeenth Centuries," *Music and Letters* 52 (1971): 407–17; he charts the change from modality to monality—the change in favor of monality is steady from 1500 to 1700 as music becomes more affective. Michael Murrin, in *The Veil of Allegory: Some Notes toward a Theory of Allegorical Rhetoric in the English Renaissance* (Chicago: University of Chicago Press, 1969), sees the same kind of development in terms of the decline of Neoplatonic allegory.

8. See Herbert M. Scheuller, "The Quarrel of the Ancients and the Moderns," *Music and Letters* 41 (1960): 313.

9. See Gretchen Finney, *Musical Backgrounds for English Literature: 1580–1650* (New Brunswick, N.J.: Rutgers University Press, n.d.), chap. VII.

10. Clark, *The Seventeenth Century*, p. 246.

11. Ibid., pp. 219–21.

12. Robert Isherwood, *Music in the Service of the King* (Ithaca, N.Y.: Cornell University Press, 1973), pp. 40, 103; see also André Félibien, *Des Principes de l'architecture, de la sculpture, de la peinture, et des autres arts qui en dependent* (Paris, 1690). Félibien, unlike some litterateurs, was a great supporter of Le Brun, Lully, and Colbert, among others. This book, very much a manual on making and techniques, is dedicated to Colbert, as are his *Conférences de l'académie royale de peinture et de sculpture* (Amsterdam, 1706) and his great work, *Entretiens sur les vies et sur les ouvrages des plus excellens peintres anciens et modernes*, 5 vols. (Paris, 1666). Félibien knew from whence patronage comes: Colbert was the central figure for the arts and academies, at least for a while (Isherwood, p. 151). The first academy for a specific art was the Académie Royale de Danse (1661), then came others: Académie des Inscriptions, Medailles, et Belles-Lettres (1663), Académie de L'Architecture (1671), Académie de Peinture et Sculpture (1663), and Académie Royale de Musique (1669). Colbert was the protector; Cassagne, director; Charles Perrault, chief director. Charles Le Brun was an important figure. Arnold Hauser, for example, says Le Brun was art dictator of France for twenty years; see Hauser, *The Social History of Art: Renaissance, Mannerism, Baroque* (New York: Random House, n.d.; first pub. 1951), II, p. 197. Lully, because of his monopoly of opera and dance became the wealthiest composer in history and the most powerful, at least in modern times (Isherwood, pp. 157–59, 194). The rigidity of the French rules and ideas can be found everywhere. Fréart de Chambray, in Evelyn's translation of *An*

Idea of the Perfection of Painting (London, 1668), for example, admiringly points out that in Le Brun's *Les reines de Perse aux pieds d'Alexandre* (1660–61) every person is depicted and placed according to rank, age, and other such criteria (p. 73); see Plate 14.

13. See Knight, *Natural Science Books in English*, p. 40; Clark, *The Seventeenth Century*, p. 337.

14. Kerry Downes, *English Baroque Architecture* (London: Zwemmer, 1966), p. 1.

15. Victor Fuerst, *The Architecture of Sir Christopher Wren* (London: Lund Humphries, 1956), p. 177; see also Stephen Wren, *Parentalia: Or the Memoirs of the Family of Wrens* (London, 1750).

16. See Clark, *The Seventeenth Century*. The economic development of England is closely linked to that of the Netherlands. The Dutch were preeminent in finance and technology, both predominantly middle-class occupations (Clark, p. 91). The English, however, were more interested in spiritual matters than were the Dutch, and Clark points out the extensive ramifications of such an interest in economic matters, specifically in the settlement of colonies. He says that the settlement of New England was not economic but spiritual. More English than Dutch preferred to live in America with less physical comfort so long as they had spiritual freedom, the right to worship, for example (p. 205).

17. H. T. Swedenberg, Jr., "Rules and English Critics of the Epic: 1650–1800," *SP* 35 (1938): 566–87.

18. In the eighteenth century, there are generally three overlapping categories of English critical thought that evolve from ideas expressed in England in the seventeenth century. The first is through the sublime and what produces it, as in the critical writings of John Dennis and in Addison's more placid statements in "The Pleasures of the Imagination." The second is the unification of French taste, science, and English Neoplatonism, illustrated by the influential third earl of Shaftesbury. The third is the so-called commonsense school, which leads to Dr. Johnson and his pragmatic, individualistic style of criticism. John Dryden is really the precursor of all three English movements in one way or another, and he certainly made speculation possible through his creation of a critical vocabulary with an English perspective.

19. For general support of this idea, see Pierre Legouis, "Corneille and Dryden as Literary Critics," *Seventeenth Century Studies Presented to . . . Sir Herbert Grierson* (Oxford: Clarendon Press, 1938), pp. 269–91; Frank L. Huntley, *On Dryden's Essay of Dramatic Poesy*, University of Michigan Contributions to Modern Philology no. 16 (Ann Arbor: University of Michigan Press, March 1951), pp. 1–67; John M. Aden, "Dryden, Corneille, and the Essay of Dramatic Poesy," *RES* n.s. 6 (1955):

147–56; Baxter Hathaway, "John Dryden and the Function of Tragedy," *PMLA* 58 (1943): 665–73; R. V. Le Clerq, "Corneille and an Essay of Dramatic Poesy," *Comparative Literature* 22 (1970): 319–27; Robert D. Hume, *Dryden's Criticism* (Ithaca, N.Y.: Cornell University Press, 1970), and "Dryden on Creation: 'Imagination' in the Later Criticism," *Review of English Studies* 21 (1970): 295–314.

20. The Cambridge Neoplatonists, for example, are, as Douglas Bush says, "the descendents of Grocyn, Colet, More, Linacre, Latimer, Lily, and others" (Douglas Bush, *The Renaissance and English Humanism* [Toronto: University of Toronto Press, 1939], p. 71). They were also, of course, avid readers of the Florentine Platonists and of Plotinus. See also Gerald Cragg, ed., *The Cambridge Platonists* (New York: Oxford University Press, 1968); and C. A. Patrides, *The Cambridge Platonists* (London: E. Arnold, 1969).

21. The edition of Dryden cited is *Of Dramatic Poesy and Other Critical Essays*, ed. George Watson, unless otherwise indicated.

22. Ralph Cudworth, *The True Intellectual System of the Universe*, chap. V, in Cragg, *The Cambridge Platonists*, p. 208; see also Plotinus, *The Enneads*, trans. Stephen McKenna and B. S. Page (London: Faber & Faber, 1962), II, p. 31 (Ennead III, ii, 16).

23. John Smith, *The Excellency and Nobleness of True Religion*, chap. I, in Cragg, p. 96. The equating of the poet with God is an important concept in English literature. In "Myth and Symbol," Northrop Frye mentions it: "When Shelley quotes Tasso on the similarity of the creative work of the poet to the creative work of God, he carries the idea a great deal further than Tasso did. The fact of this change in the Romantic period is familiar, but the trends that made it possible are still not identified with assurance." (Northrop Frye, "Myth and Symbol," in *Myth and Symbol: Critical Approaches and Applications*, ed. Berenice Slote [Lincoln: University of Nebraska Press, 1970; first pub. 1963], pp. 16–17). The same kind of idea moves Clark, in *The Seventeenth Century*, to say, "Imaginative literature is nearer akin to religion than to science" (p. 341).

24. In France, according to Isherwood, affective theories of music took over at the end of the seventeenth century (p. 328). These theories led to the idea of Du Bos (1670–1742) that the main purpose of art is to combat *ennui*; see Jean-Baptiste Du Bos, *Critical Reflections on Poetry, Painting, and Music*, trans. Thomas Nugent (London, 1748); first published in 1719 as *Réflexions critiques sur la poésie et la peinture*. Isherwood maintains that until then Plato provided the "underpinning" for seventeenth-century French music (p. 170). Jeremy Collier's rather confused musical theories tell us about English dilemmas (see "Of Music," *Essays Upon Several Moral Subjects* [London, 1697]). He says he relies

on the Neoplatonist Glarean for theory (see Heinrich Glarean, *"The Do-decachordon,"* trans. Clement A. Miller [Ph.D. diss., University of Michigan, 1950]), yet he says that music "takes hold of the highest part of the affections" (p. 25). Collier pays lip service to Neoplatonic religious theories of music, yet intellectually he subscribes to affective theories of music.

25. See Baxter Hathaway, *The Age of Criticism* (Ithaca, N.Y.: Cornell University Press, 1962).

26. See Anthony Blunt, *Artistic Theory in Italy: 1450–1600*, rev. ed. (New York: Oxford University Press, 1968; first pub. 1940).

27. We have talked earlier of the general extent of Neoplatonism in England; see also Yates, *Theatre of the World*.

28. See Watson, I, p. 25.

29. See Spingarn, *Critical Essays of the Seventeenth Century*; Volume I covers the period 1605–50; *lively* never appears in this volume.

30. In Spingarn, I, p. 127 (1622).

31. The term *lively* is connected to a matrix of related concepts: fire, force, vehemence, passion, manners, humours, breath, affection, spirit, soul, animation, inspiration, imagination, fancy, movement, to move, to raise, agitation, motion, and wit in its most elevated sense. Fire, of course, is life to the Neoplatonist Paracelsus; *breath* is very much a Neoplatonic term also and is closely allied to the notion of spirit; Finney discusses these relationships at some length in Chapter V: "Music, the Breath of Life." Bush points out that while "Aristotle deals with the nature of things, he, Ficino [the great Florentine Neoplatonist, teacher of Michelangelo, deals] with the nature of men" (*The Renaissance and English Humanism*, p. 56). All the terms associated with *lively* concern human life.

32. *Les Instructions pour l'histoire* comes from Port Royal; its author is anonymous. Cioranescu says the author is René Rapin (1667); see Alexandre Cioranescu, *Bibliographie de la littérature française du dix-septième siècle*, 3 vols. (Paris: Centre National de la Recherche Scientifique, 1966).

33. Robert Midgley, trans., *The Modest Critick* (London, 1688), pp. 48, 49; the translator of *The Modest Critick* is unnamed; Robert Midgley is listed on the flyleaf as having registered the work on 9 October 1688.

34. John Davies of Kidwelly, trans., *Instructions for History* (London, 1680), p. 46.

35. Hobbes, for example, makes the connection between *quick* and *lively*; see Thomas Hobbes, *English Works*, ed. Sir William Molesworth (London, 1839), III, pp. 57, 61.

36. See also C. S. Lewis, "Life," *Studies in Words*, 2d ed. (Cambridge: Cambridge University Press, 1967), pp. 269–305.

37. See H. James Jensen, *A Glossary of John Dryden's Critical Terms*

(Minneapolis: University of Minnesota Press, 1969), pp. 70–71. I had originally toyed with the idea of associating *enargeia* with *justness* and *energia* with *lively*. *Enargeia*, however, really is a rhetorical term connected with oratory and is not opposed to *energia*, which is related to *lively*. For a discussion of the two terms as they are used in the English Renaissance, see John Bender, *Spenser and Literary Pictorialism* (Princeton: Princeton University Press, 1972), pp. 9 ff.

38. Sir William Temple, "Of Poetry," in *Spingarn*, II, p. 81.

39. In Spingarn, II, p. 21. For the primary connection of the word *truth* with reason, judgment, and understanding, see Jensen, p. 118. It is true that in some cases *lively* is associated primarily with *judgment*, as in Sir Richard Blackmore's Preface to *King Arthur* (1695), in which it is used to describe poetry (see Spingarn, III, p. 227) and later is equated with *delightful* (ibid., p. 238), which in Blackmore's usage is associated with *judgment*. Still, Charles Gildon uses *lively* in his "Vindication of Paradise Lost" (1694) in the same way that Dryden, Wolseley, and Temple use it (ibid., p. 199).

40. F. N. Coeffeteau, *A Table of Humane Passions With Their Causes and Effects*, trans. Edward Grimeston (London, 1621), p. 71.

41. Roland Fréart de Chambray, *An Idea of the Perfection of Painting*, trans. John Evelyn (London, 1668), pp. 10, 14–17; see also Bernard Le Bovier de Fontenelle, *Dialogues of the Dead*, trans. John Hughes (London, 1708), p. 32; first published in France, 1683: "Passions among men are the winds that are necessary to give all things motion, tho' at the same time they occasion many a hurricane."

42. Coeffeteau, in his *Table of Human Passions* (p. 7), also parallels the motions of the planets to the motions of passions in man; later he says that planets have power over motions of the body (p. 90). These are both Neoplatonic notions. G. P. Lomazzo says the same thing in *A Tracte Containing the Artes of Curious Paintinge, Carvinge, and Building*, trans. Richard Haydocke (London, 1598), Book II, pp. 17–18. All are a part of Hermetic philosophy, astrology, and so on. Finney talks about exactly the same idea (p. 108). Robert Burton, in *The Anatomy of Melancholy* (1621), ed. F. Dell and P. Jordan Smith (New York: Tudor Publishing Co., 1948), talks about Ficino and the idea of stellar influences on passions (p. 660) and notes that the planets, sun, and other bodies all dance to the music of the spheres (pp. 710–11). A play is thus similar to a dance in a Neoplatonic sense, and Dryden in the quoted passage is expressing this similarity. We can easily recognize the Neoplatonic notion of the microcosm as an image of the macrocosm, a work of art as an image of the cosmos. Ficino has been called the main channel for the entry of musical ideas from antiquity into the Renaissance, and his ideas on the

planets and dancing and artistic creation, as derived from Plotinus, are everywhere in the Renaissance. They are important to an understanding of Dryden and of the Baroque age as well. For Neoplatonic ideas in France, see Isherwood on Ronsard and Margaret of Navarre, for example (pp. 1 ff.); Isherwood relies to a certain extent on works by Frances Yates. See also Poussin's paintings; in his numerous paintings on the dance, he embodies Neoplatonic ideas of harmony (in good dances) or of sensual abandon (in low dances).

43. Hobbes, *Works*, III, pp. 41–42.

44. Ibid., p. 56.

45. Thomas Rymer, trans., *Reflections on Aristotle's Art of Poesie* (London, 1694), p. 41.

46. Ibid., p. 121. That semi-rhetorician, semi-Neoplatonist Bernini also relies to a great extent on rhetorical movement. Gaulli, who painted the ceiling at Il Gesu, says that the most valuable thing he learned under Bernini is that "every rendering of the human figure should, if possible, express movement." See Robert T. Petersson, *The Art of Ecstasy: Teresa, Bernini, and Crashaw* (London: Routledge & Kegan Paul, 1970), p. 75. The Neoplatonic side of Bernini is exemplified not only by his fascination with the mysticism of St. Teresa but also by his idea that he breathed life into a statue the way God breathed life into "substance" (Petersson, p. 50).

47. Cudworth, in Cragg, pp. 195–96. The materialistic idea that man is only an animal leads directly to rhetorical, affective theories of the arts because the senses take precedence over all the other faculties. Cudworth of course does not view man as either animal or machine. He tries, among other things, to reconcile atomism (like Hobbes's particles) with the belief that man has an immortal soul; see, for example, Knight, *Natural Science Books in English*, p. 37.

48. For examples of preferences for the liveliness of Shakespeare and Homer over the more pedestrian correctness of Virgil and of the French, see John Dryden, *Works*, ed. Sir Walter Scott and rev. George Saintsbury, 18 vols. (Edinburgh: William Patterson, 1882–93), XVII, p. 235; Watson, I, pp. 64, 70, 161–62, 171; ibid., II, pp. 167, 186, 275; and Spingarn, III, pp. 82–83.

49. Their secondary importance is borne out by Dryden's idea that the last perfection of art is elocution, last in time and last in importance; see Jensen, *Glossary*, p. 72. This idea is further substantiated in Dryden's criticism of Shakespeare (1679; in Watson, I, p. 257); Dryden says that Shakespeare's passions are good but that "he often obscures his meaning by his words."

50. It is true that imaginative flashes of insight can be developed by others, but the question of unity of perception also arises. An individual

mind imposes unity on chaotic materials in a way impossible for several people to do together. If the unity is there, others can further substantiate or bring other ideas under the umbrella of that unity. We do not usually see good poems as the result of team writing, but we do see the advantage of scientific research being done by teams. At the same time, a scientific breakthrough of immense proportions needs as much imagination as judgment and is akin to a poetic vision. There has to be a guiding mind, however. Both Descartes and Arnauld, among others, believe that the mind of one person can do more than the minds of many. This places them outside the mainstream of French thought. See René Descartes, *Discourse on Method*, trans. F. E. Sutcliffe (Baltimore: Penguin, 1968), p. 35; first published in France as *Discours de la méthode* (1637); and Antoine Arnauld, *The Art of Thinking*, trans. James Dickoff and Patricia James (Indianapolis: Bobbs-Merrill, 1964), p. 287; first published as *L'Art de pensée* (1662).

51. John Milton, *The Works of John Milton*, ed. F. A. Pattison, 20 vols. (New York: Columbia University Press, 1931–38), I, p. 29.

52. See Spingarn, II, p. 271.

53. Shakespeare himself was strongly influenced by Neoplatonism. The point is obvious but perhaps too much taken for granted. Sister Miriam Joseph, in *Rhetoric in Shakespeare's Time* (New York: Harcourt, Brace & World, 1968; first pub. 1947), shows how his early training probably came from rhetorical stylists versed in Ramistic theories of rhetoric. Ramus's division of elocution from the rest of rhetoric is Platonically inspired; see, for example, Peter Munz, *The Place of Hooker in the History of Thought* (London: Routledge & Kegan Paul, 1952), pp. 152–53. *The Tempest* is obviously Neoplatonic. *Love's Labour's Lost* is set in the court of Margaret of Navarre, one of the centers for the dissemination of Neoplatonic ideas. Shakespeare has fun ridiculing the Neoplatonic notions of Berowne and his friends in a tone similar to that of Gilbert and Sullivan in *Patience* but this posture hardly makes Shakespeare an anti-Neoplatonist: he often makes fun in one place of ideas that he uses seriously somewhere else. Wilfrid Mellers says, "Shakespeare's greatness cannot be separated from the mature and profound reconciliation he effected between ideas of order inherited from the Middle Ages and the humanists' intensifying concern with the individual consciousness." The Renaissance in a way is a product of Neoplatonic consciousness. See Wilfrid Mellers, "Words and Music in Elizabethan England," in *The Age of Shakespeare*, ed. Boris Ford, 2nd rev. ed. (Baltimore: Pelican, 1960; first pub. 1935), p. 386.

54. Raphael and Poussin concentrate more on clarity of passion; Michelangelo is more copious. Compare the different passions and kinds of

people in Shakespeare's *King Lear* with those in Racine's *Phèdre*. Bernard Weinberg says, for example, that the play, classically about perfect, is the augmentation of a single passion; see Bernard Weinberg, *The Art of Jean Racine* (Chicago: University of Chicago Press, 1963), pp. 266 ff.

55. C. A. Du Fresnoy, *The Art of Painting*, trans. J. Dryden (London, 1716), pp. 225–26; Dryden worked from the translation of Roger Des Piles (1668); see also Roger Des Piles, *The Principles of Painting, Translated by "A Painter"* (London, 1743).

56. For Richardson's appreciation of *Paradise Lost*, see Jonathan Richardson, father and son, *Explanatory Notes and Remarks on Milton's Paradise Lost* (London, 1734).

57. Sir Joshua Reynolds, "Discourse Five," *Discourses on Art*, ed. Stephen O. Mitchell (Indianapolis: Bobbs-Merrill, 1965), pp. 63–64; the whole work was first published in 1797.

58. See Joseph Addison, *The Spectator* (No. 160, 3 September 1711), in which he mentions by name the works of genius and the geniuses who are the opposite of "les bel-esprits" and who sometimes miss decorum but rise to the sublime: Homer, the Old Testament, Shakespeare, and Pindar. For a French critic who exceptionally defines the term *liveliness*, see Saint-Évremond, "Reflections Upon the French Translators," *Miscellaneous Essays* (London, 1692; first pub. 1663), pp. 174–88. Saint-Évremond dislikes Aeneas, thinking him too pious, unlike a soldier. He says of characterization, "I find those of Homer as enlivening, as those of Virgil are flat and insipid" (p. 187). These ideas are not new: Sperone Speroni compares Virgil to Titian, saying that both lack imagination; and Castelvetro, paralleling Speroni's ideas, compares Michelangelo and Homer, both of whom have greater genius; see Hathaway, *The Age of Criticism*, pp. 196–97.

SEVEN. Social Correctness and Taste

1. See Sir George Clark, *The Seventeenth Century* (New York: Oxford University Press, 1970).

2. In *Critical Essays of the Seventeenth Century*, ed. Joel Spingarn (Bloomington: Indiana University Press, 1963; first pub. 1908), II, p. 112.

3. See Dryden, "Defense of the Epilogue: Or an Essay on the Dramatic Poetry of the Last Age" (1673), in *Of Dramatic Poesy and Other Critical Essays*, ed. George Watson (New York: Everyman, 1962), I, pp. 169–83.

4. John Dryden, the most important critic and writer of the time,

probably has more in common with the Frenchman Nicholas Boileau than he does, for example, with John Bunyan. The close relationship with the French also is true for other important writers connected with the court, such as John Wilmot and Sir George Etherege.

5. Dryden gives us the arguments for French drama in the "Essay of Dramatic Poesy" (1668), in Watson, I.

6. It is interesting to note how rapidly the French critics grew away from the Italians and came to rely on a rationality they thought of as their own. A. F. B. Clark, in *Boileau and the French Classical Critics in England: 1660–1830* (Paris: E. Champion, 1925), points out the French anti-Italian tendency (p. 337) and says that Nicholas Boileau's (1636–1711) contempt for Italian literature has its source in utter ignorance (p. 338). Earlier attitudes are different: Jean-Louis Guéz de Balzac (1597–1654), from the preceding generation and one of the original forty of the French Academy, sounds like a member of the English Restoration court talking about Frenchmen: "I extreamly approve your stay in Italy [to Jean Frederich Gronovius], and the desire you had to understand and observe the deportment of the most rationall people of the world" (letter of 1 October 1640); see *Choise* [or *Choyce*] *Letters* (London, 1658), p. 219. For the importance and complexity of Italian thought, see Baxter Hathaway, *The Age of Criticism* (Ithaca, N.Y.: Cornell University Press, 1962); and *Marvels and Commonplaces* (New York: Random House, 1968); Joel Spingarn, *Literary Criticism in the Renaissance* (New York: Harcourt, Brace & World, 1963; first pub. 1899); and Bernard Weinberg, *A History of Literary Criticism in the Italian Renaissance* (Chicago: University of Chicago Press, 1961).

7. Stephen Wren, *Parentalia: Or the Memoirs of the Family of Wrens* (London, 1750), p. 202.

8. Roger Des Piles, *The Principles of Painting*, Translated by "A Painter" (London, 1743), pp. 297–300.

9. Oliver Millar, "Charles II and the Arts," *The Age of Charles II* (London: Royal Academy of Arts, 1960), p. ix. Millar comes to this conclusion after noting that "the magnificent exhibition at the Royal Academy last winter [on the tercentenary of May 1660] showed how eagerly Italian pictures were bought and commissioned by English collectors in the age of Charles II" (ibid.). Charles II even commissioned Benedetto Gennaro to paint portraits of his mistresses and bastards as the Madonna and Child or John the Baptist (p. v). The court was decidedly secular. See also Oliver Millar, "Painting and the Age of Charles II," *Connoisseur* 147 (1961): 3–7; he argues that painting in England during the reigns of Charles II and James II, although not at a very high level, is in a formative period (p. 7).

10. The treatment of the madrigal in England resulted in the nationalization of an Italian style; see Gustave Reese, *Music in the Renaissance* (New York: Norton, 1964), pp. 815 ff. E. D. Mackerness, in *A Social History of English Music* (London: Routledge & Kegan Paul, 1964), says that the musical interchange between England and France started in 1471. He thinks that "from this period the status of English minstrels declined" (p. 52), but he also says that the golden age of English music is 1570–1645 (p. 60). Rosamond Tuve also says the Renaissance English adapted Italian techniques to their own purposes; see R. Tuve, "Sacred Parody of Love Poetry and Herbert," *Studies in the Renaissance* 8 (1961): 249–90. See also Paula Johnson, *Form and Transformation in Music and Poetry of the English Renaissance* (New Haven: Yale University Press, 1972). After 1580, she says, Italian madrigals took England by storm (p. 132) and she points out that Yonge's *Musica transalpina* (1558) and Thomas Morley's adaptations of Italian ballets and canzonets from 1593 urged English composers to compose secular music (that is, music to raise the passions). Note, however, that even in Shakespeare there are social classifications as to who sings or likes what music. In *Twelfth Night*, Sir Toby Belch is not as sophisticated as Olivia or Duke Orsino. In *The Winter's Tale*, it is the country rogue and swindler Antolycus who shows us his lack of the highest discriminating powers and also his penchant for "country" music. See also Mackerness, *A Social History of English Music*. Gretchen Finney, *Musical Backgrounds for English Literature: 1580–1650* (New Brunswick, N.J.: Rutgers University Press, n.d.), says that the decline in English instrumental music from 1600 on in large part results from the importance of words (p. 136); but this explanation covers only a small part of that development.

11. The first exception occurs in the last act of *King Arthur* (1691), "Harvest Home," in which stout English yeomen are presented as a part of the panoply of English life. The other is the rather risqué song "As Alexis Lay Pres't" in *Marriage à la Mode* (1673): here the song is presented as Italian.

12. See Joseph Addison, *The Spectator* (No. 18, 21 March 1711; No. 19, 22 March 1711; No. 314, 29 February 1712). The ironic part about French taste in music and dance is that it was catered to, and further developed, mainly by Jean-Baptiste Lully, a Florentine. In other words, French music was not overcome by Italian, and the kind of music written by Lully determines to a great extent the style of Rameau (in the next century). Lully, who wrote for all classes of French people (see Robert Isherwood, *Music in the Service of the King* [Ithaca, N.Y.: Cornell University Press, 1973], p. 194), catered to the French preference for the dance and for simple melodic lines, which also corresponded to the tastes

of Louis XIV. In England, the distance between the court and the general population was too great, especially since the court's tastes had been molded on the Continent. Of all the countries in Europe, only France resisted Italian music. Mazarin's introduction of Italian opera in the 1640s failed miserably. The French had enough self-confidence in their own tastes to turn elsewhere. Isherwood (p. 134) gives us reasons. They disliked another language, and they found the recitative and the florid arias disorderly, unbalanced, and boring. They disliked the irrational absurdities of Italian opera, preferring ballet and uncontaminated classical drama. Their own operas, subsequently, are combinations of ballet and classical drama. Lully's *Ballet de la raillerie* (1659) is even a dialogue, a debate, between French and Italian music (see Isherwood, p. 131).

13. See Edward Dent, *The Foundations of English Opera* (Cambridge: Cambridge University Press, 1928). Dent states that Purcell and Blow really pave the way for English operatic composers, but no one is able to follow them; he says that Blow's *Venus and Adonis* (ca. 1685) is a real opera and a good work for the stage, albeit a chamber opera. Dent says further that Henry Purcell's *Dido and Aeneas* (1689–90), although it has strong Italian influences (pp. 180–88), is decidedly English and is the only real opera Purcell ever wrote (p. 188). It is difficult, however, to assess exactly what Dent means by *real opera* because later he says *King Arthur* (1691) is a classic example of an English opera (p. 215). Anthony Lewis echoes the importance of Purcell and Blow in "Purcell and Blow's 'Venus and Adonis'" *Music and Letters* 44 (1963): 266. Dent's idea is supported by Stoddard Lincoln, who says that opera sung all in Italian first came to England in 1705, that Thomas Clayton wrote the recitative in English for *Arsinoe* (1705), and that no Englishman wrote music for opera thereafter until John C. Smith did *The Fairies* (London, 1755); see Stoddard Lincoln, "The First Setting of Congreve's *Semele*," *Music and Letters* 44 (1963): 103.

14. John Dryden, Preface to *Albion and Albanius* (1685), in Watson, II, p. 39; Dent thinks the Preface an important contribution to the development of English opera (p. 161).

15. Dent has nothing good to say about Louis Grabu. He ascribes the failure of *Albion and Albanius* to him and then proves him incompetent by analyzing the text and by citing contemporary critics' opinions of his music. Purcell and Blow apparently have nothing good to say about him either (see pp. 161, 165 ff).

16. See Henry Purcell, *Sonnatas of III Parts* (London, 1683); the unsigned Preface even explains certain "Italian Terms of Art."

17. Only occasionally does traditional English music appear in sophisticated art, as in John Gay's *The Beggar's Opera*; but Gay is writing a

conscious parody of the prevailing musical art form, Italian opera. For a
survey of patronage and the arts, see Michael Foss, *The Age of Patronage*
(Ithaca, N.Y.: Cornell University Press, 1972).

18. See Mackerness, *A Social History of English Music*, p. 84. F. B.
Zimmerman also says that English music succumbs to the Italian invasion
and that English music dies; see Franklin B. Zimmerman, "Sound and
Sense in Purcell's Single Songs," *Words to Music* (Publication of the
William Andrews Clark Memorial Library, University of California, Los
Angeles, 1967), p. 78. Arthur Hutchings presents supporting evidence.
In his article "The Seventeenth-Century Music in the Durham Cathedral
Library," *Durham University Journal* 56 (1963–64): 23–30, he points
out that from 1630 to 1690, and later, the music in the Durham Cathe-
dral Library is represented only by the kind played by provincial amateurs
(p. 25).

19. George Etherege, in "Letter to Mr. Jepson (1687–88), *The Let-
terbook of Sir George Etherege*, ed. Sybil Rosenfeld (Oxford: Oxford
University Press, 1928), pp. 336–39, says: "Though I have given over
writing plays I should be glad to read a good one, wherefore let Will. Rich-
ards send me Mr. Shadwell's when it is printed [*The Squire of Alsatia*,
1668], that I may know what follies are in fashion. The fops I know are
grown stale, and he is likely to pick up the best collections of new ones."
For other seventeenth-century evidence of Shadwell's realism, see John
Wilmot, earl of Rochester, "Horace, The Tenth Satyr of the First Book,"
Poems, ed. Vivian de Sola Pinto (Cambridge: Harvard University Press,
1953), ll. 44–47:

> Shadwell's unfinished works, do yet impart,
> Great proofs of Nature [what life was really like],
> none of Art [artificiality]:
> With just bold strokes he dashes here, and there,
> Showing great mastery with little care.

See also Peter Motteaux, *The Gentleman's Journal or the Monthly Mis-
cellany*, November 1692, p. 21. For twentieth-century evidence, see Albert
S. Borgman, *Thomas Shadwell: His Life and His Comedies* (New York:
New York University Press, 1928); Russell J. Smith, "Shadwell's Impact
upon Dryden," *Review of English Studies* 200 (1944): 29–44; P. F.
Vernon, "Social Satire in Shadwell's *Timon*," *Studia Neophilologica* 35
(1963): 221–26; and Gunnar Sorelius, "Shadwell Deviating into Sense,"
Studia Neophilologica 36 (1964): 232–44. For Shadwell's explicit inter-
est in music, see John Dryden, "Mac Flecknoe," in *The Poetical Works of
John Dryden*, ed. George R. Noyes (Cambridge: Harvard University
Press, 1950), p. 137, ll. 209–10; see also Thomas Shadwell, "To Sir

Charles Sidney," in "The Tenth Satyr of Juvenal," in *The Complete Works of Thomas Shadwell*, ed. Montague Summers, 5 vols. (London: Fortune Press, 1927), pp. 291–94. Edward Dent in *The Foundations of English Opera* has much to say about Shadwell's ability. He is a musician and a composer who shows his knowledge of music in his *Psyche* (1673), an imitation of the French *Psyche* (1671) by Molière, Quinault, and Lully. Dent says that the first part is all Shadwell and that the play, machines, and music are all of a piece (p. 115). In typical Shadwellian fashion, however, the excellence starts to break down. Dent says that toward the end Shadwell borrows more from Molière, and the whole performance becomes "scrappy" (p. 115); for extensive general comments on Shadwell's musicianship, see Dent's listings in his Index.

20. See Isherwood, p. 138. French public dancing was modeled on Louis XIV's own practices; from his youth, until he lost his agility, he danced many performances (see Isherwood, pp. 136 ff.). Performing in public was not the sort of thing done in England.

21. The question of the violins is interesting. They were a new kind, like modern violins, complete with bridge. The older kind have a melodious sound but lack the potential virtuosity. They are what we correctly call fiddles, and in the following pages when fiddlers are mentioned they are using the older kind of violins. Versions of the older kind are still used in rural areas, for instance, in Norwegian folk music. Thomas Mace, the rather old-fashioned English musical theorist, disapproves in *Musick's Monument* (London, 1672) of the "new fangled" violins as well as of modern Italian music; see also Hutchings, "The Seventeenth-Century Music in Durham Cathedral Library," p. 26; see also Mackerness, *A Social History of English Music*, p. 85. Jean-Baptiste Lully ran Louis XIV's violinists with an iron hand, making them play with precision. Louis's violinists were important and innovative primarily because of their discipline; whereas Italian violinists usually improvised and embellished as they saw fit.

22. Jeremy Collier, "Of Music," *Essays Upon Several Moral Subjects* (London, 1697), p. 19.

23. Thomas Shadwell, *Complete Works*, ed. Montague Summers (London: Fortune Press, 1927), IV, p. 329.

24. A shawm, an obsolete instrument apparently like a primitive oboe, had a double reed and probably a similar, albeit cruder, sound; a bandore is an instrument similar to a lute but with only three strings.

25. See also Sir Philip Sidney's comments on "Chevy Chase" in his "Apology for Poetry" (1595), in *Criticism: The Major Texts*, ed. Walter J. Bate (New York: Harcourt Brace Jovanovich, 1972), p. 94; Joseph Addison, *The Spectator* (No. 70, 21 May 1711; No. 74, 25 May 1711).

26. See Donald Wing, *Short Title Catalogue of Books Published in England, Scotland, Ireland, Wales, and British America, and of English Books Printed in Other Countries: 1641–1700* (New York: Columbia University Press, 1945), and *A Gallery of Ghosts: Books Published between 1641–1700 Not Found in the Short Title Catalogue* (New York: Modern Language Assoc. of America, 1967); in these volumes he lists seventy-two editions of various books by John Playford alone, thirteen by Henry Purcell, and twenty-one by Henry Playford.

27. See John Dryden's portrait of Og (Shadwell) in "Absolom and Achitophel, Part II," in *The Poetical Works of Dryden*, ed. George R. Noyes (Boston: Houghton Mifflin, 1950), pp. 143–44, ll. 457–509.

28. Dryden, Preface to the *Fables* (1700), in Watson, II, p. 281.

29. Ibid., pp. 284 ff.; Dryden is very fond of Chaucer and rates him higher than Ovid; see below for the association of Scottish, Irish, and English country music.

30. Samuel Pepys, *Diary*, ed. Mynors Bright (London: Everyman, 1953), III, p. 293 (23 October 1668). Thetford is in Norfolk; its musicians apparently were well known in this period. Note Sir Humphrey Noddy's reference (Shadwell, *Complete Works*, IV, p. 329). The Thetford fiddlers were country musicians playing English fiddles and would have been unfamiliar, except indirectly, with London sophistication in music and instrumentation.

31. Pepys, *Diary*, I, p. 114 (20 November 1660). Singleton is a well-known English musician; note Sir Humphrey Noddy's reference to him (Shadwell, *Complete Works*, IV, p. 329).

32. Sidney, "Apology for Poetry" (1595), p. 94; Addison, *The Spectator* (Nos. 70, 74).

33. See Sir Wilful Witwoud's English drinking song in *The Way of the World* (IV, i, 435–97); see also Dryden's liking for Scottish tunes (which he parallels with his liking for Chaucer) in Preface to the *Fables* (1700), in Watson, II, p. 281. See also Sidney's and Addison's liking of "The Ballad of Chevy Chase": Sidney, "Apology for Poetry" (1595); Addison, *The Spectator* (Nos. 70, 74). Addison tries to justify the poem by equating it with the work of Virgil, the epitome of correctness and judgment.

34. See Philip Bate, *The Trumpet and Trombone* (New York: Norton, 1966), p. 109.

35. Watson, II, p. 161; the issues of imagination and judgment are laid out in Dryden's "Essay of Dramatic Poesy" (1668), in Watson, I, pp. 18–92.

36. Ibid., p. 160 (1693).

37. See, for example, Sir William Temple, "Of Poetry," in Spingarn,

III, pp. 103–104; John Dennis, "The Impartial Critic," in Spingarn, III, pp. 196–97.

38. Watson, I, pp. 243–61. Michael Murrin, in *The Veil of Allegory: Some Notes toward a Theory of Allegorical Rhetoric in the English Renaissance* (Chicago: University of Chicago Press, 1969), points out that you cannot expect poetry that is allegorical to be unified, whether the medium is drama or something else, in action (plot) the way Aristotle says it should be in his *Poetics* (p. 73); see Aristotle, *Poetics*, trans. Leon Golden (Englewood Cliffs, N.J.: Prentice-Hall, 1968), pp. 15–16.

39. The change from an expression of universal truths to the raising of local emotions in regard to depictions of Antony and Cleopatra leads fairly evenly to Giambattista Tiepolo's fashionable, elegant paintings and drawings of the two lovers; for the location of his paintings, see Everett Fahy, "Tiepolo's Meeting of Antony and Cleopatra," *Burlington Magazine* 113 (1971): 736–39; on music, see Robert Wienpahl, "Modality, Monality and Tonality in the Sixteenth and Seventeenth Centuries," *Music and Letters* 52, no. 4 (1971): 407–17.

40. Arnold Hauser, *The Social History of Art: Renaissance, Mannerism, Baroque* (New York: Random House, n.d.; first pub. 1951), II, p. 200.

41. Finney, p. 158. She quotes William Wotton's "Reflections Upon Ancient and Modern Learning" (1694; in Spingarn, III, pp. 329–33): "Music is a physico-natural science. . . . Its great end . . . is to please the audience" (p. 157). She also says that the change from harmony divorced science from everyday understanding of the universe and life (p. 46; see also p. 138). This is a profound statement about a shift in beliefs that affected poetry and painting as well and was reflected in all people in all walks of life. The shift to a reliance on the senses and away from a feeling of participation in the harmony of the cosmos is still going on.

42. Douglas Bush, *The Renaissance and English Humanism* (Toronto: University of Toronto Press, 1939), p. 72. The problem is not one of whether there is Neoplatonism in this period, it is rather where and to what extent. And when we speak of extent, we mean a great extent. Thomism, for example, is present both actively and latently. After all, Hooker is an important thinker. Yet we do not consider Thomistic philosophy one of the important movements of the period, and it comes as quite a shock to see a drawing such as the one by Giuseppe Passeri (1654–1714) entitled *The Triumph of St. Thomas Aquinas*, an allegorical depiction of St. Thomas vanquishing philosophical and theological opponents of himself and the church; see Anthony Blunt and Hereward Lester Cooke, *Roman Drawings at Windsor Castle* (London: Phaidon, 1960), plate 62; for information on several facets of Neoplatonism, see also Ar-

thur E. Waite, *The Secret Tradition in Alchemy* (London: Stuart and Watkins, 1969); *The Hermetic Museum* (twenty-two celebrated chemical tracts translated from the Latin of 1678) (London, 1893); and Murrin, *The Veil of Allegory*, especially his discussion of Henry Reynolds's "Mythomystes" (1632).

43. See, for example, Robert Burton's *Anatomy of Melancholy* (1621), ed. F. Dell and P. Jordan Smith (New York: Tudor Publishing Co., 1948), pp. 113, 620–24, 660, 710–11. For excellent studies of the extensiveness of seventeenth-century Neoplatonic thought, see Frances Yates, *Theatre of the World* (Chicago: University of Chicago Press, 1969). There is much in her book on Robert Fludd and Inigo Jones and on others. She also has other books: *Giordano Bruno and the Hermetic Tradition* (Chicago: University of Chicago Press, 1964) and *The Art of Memory* (London: Routledge & Kegan Paul, 1966). See also Finney, *Musical Backgrounds*, and Isherwood, *Music in the Service of the King*. Isherwood often uses the work of Frances Yates but also develops extensively Neoplatonic backgrounds for music in France in the first part of his book. See also Elumed Crawshaw, "Hermetic Elements in Donne's Poetic Vision," in *John Donne: Essays in Celebration*, ed. A. J. Smith (London: Methuen, 1972), pp. 324–48; and Murrin, *The Veil of Allegory*, in which he talks at some length about Henry Reynolds's "Mythomystes" (1632), which appears in Spingarn, I. It is interesting to note that Antoine Arnauld, in *The Art of Thinking* (1662), trans. James Dickoff and Patricia James (Indianapolis: Bobbs-Merrill, 1964), spends a comparatively larger amount of space disparaging Robert Fludd, Paracelsus, and van Helmont, among others (see, for example, pp. 25, 88), than he does Thomas Hobbes or Gassendi (see, for example, p. 256). One can conclude only that Neoplatonic thought seemed important enough to argue against. There are also translations of many, many books in the period, such as Giambattista della Porta's *Natural Magick*, into English in 1658 (first pub. Naples, 1558). For an interesting but partial account of Renaissance Neoplatonism, see Emanuel Winternitz, *Musical Instruments and Their Symbolism in Western Art* (New York: Norton, 1967). In his Chapter IX, "Quatrocento Science in the Gubbio Study," he discusses harmonic proportions and the great library of Federigo da Montefeltro. He notes the connections of Raphael and the great English Neoplatonist and mathematician John Dee to this center of learning. See also Winternitz's Chapter XIII: "Muses and Music in a Burial Chapel: An Interpretation of Filippino Lippi's Window Wall in the Capella Strozzi."

44. Collier, *Essays Upon Several Moral Subjects* (London, 1697), pp. 17, 19–25; see also Arnauld, *The Art of Thinking* (1662), pp. 293, 295, 296, 319; see also René Descartes, *Discourse on Method* (1637),

trans. F. E. Sutcliffe (Baltimore, Penguin, 1968), p. 58. Descartes, of course, does not believe like Hobbes that the soul of animals is like our own (p. 76), saying, "We perceive bodies only by the understanding that is in us, and not by the imagination, or the senses, . . . but only because we conceive them in thought" (p. 112). Yet, as the Cambridge Platonists finally perceive, the Cartesian separation of imagination from the perception of truth (imagination cannot conceive of truth, p. 106) reduces man to scientific contemplation of the phenomenal world, to a disbelief in absolutes of goodness, and so on, leading to the relativism we have inherited from seventeenth-century skeptical thought.

45. See Dryden's "Essay of Dramatic Poesy" (1668), in Watson, I, pp. 10–92, for the best marshaling of arguments and counterarguments about the relative excellence of English, French, and ancient drama.

46. Clark, *Boileau and the French Classical Critics in England*, p. 232.

EIGHT. Continental Pressures and the English National Culture

1. Douglas Bush in *The Renaissance and English Humanism* (Toronto: University of Toronto Press, 1939) affirms the international quality of ideas. We see this quality also in the international reliance on rhetoric and theories of the mind. Coeffeteau's ideas in *A Table of Humane Passions* (1614) are the same as Burton's in *The Anatomy of Melancholy* (1621), to name only two examples among many.

2. Pierre Legouis, "Corneille and Dryden as Literary Critics," *Seventeenth Century Studies Presented to . . . Sir Herbert Grierson* (Oxford: Clarendon Press, 1938), p. 287.

3. See Donald Wing, *Short Title Catalogue of Books Published in England, Scotland, Ireland, Wales, and British America, and of English Books Printed in Other Countries: 1641–1700* (New York: Columbia University Press, 1945), and *A Gallery of Ghosts: Books Published between 1641–1700 Not Found in the Short Title Catalogue* (New York: Modern Language Assoc. of America, 1967). Roland Fréart de Chambray, 2; Pierre Le Muet, 1; Vitruvius, 1; Sebastian Serlio, 1; Vincenzo Scamozzi, 4; Andrea Palladio, 6; and Giacom Barozzi, 2. William A. Gibson, "Literary Influences on the Early Architectural Theory of Robert Morris" (Paper delivered at the Midwest Modern Language Association Meeting, Detroit, 4–6 November 1971), lists other translations: Joannes Blum's *Quinque colummarum* (Zurich, 1550; also 1608, 1635, 1660, 1668, and 1677); Vignola's treatise on the five orders (1655, 1665, 1669, 1673,

1676, and 1694); Jean Barbet (1670); Julien Mauclerc's abridged Vitruvius (1669, 1676, and 1699); and other works by Englishmen based on Continental treatises. Gibson, in this informative essay, points out that "the publication of comparatively sophisticated books on architecture coincided quite closely with the beginnings of the Palladian revival around 1715."

4. See Wing, *Short Title Catalogue* and *A Gallery of Ghosts*. Roland Fréart de Chambray, 1; Charles Le Brun, 1; Andrea Pozzo, 1; an anonymous publication called "The Judgment of Hercules" (1641); and Charles Alphonse Du Fresnoy, 2.

5. See Wing, *Short Title Catalogue* and *A Gallery of Ghosts*. There are 4 editions of Charron's *De la sagesse*; 6 of Jean-Louis Guéz de Balzac's *Lettres* and *Aristippus*; 12 of various works by Descartes; 10 of Fontenelle; 10 of Gassendi; 13 of Paul Scarron; 18 of Madeleine de Scudéry; 7 of Charles Sorel; 9 of Saint-Évremond; and 23 of various works by René Rapin, only 2 of them religious. Besides, there are large numbers of other editions by writers such as Antoine Arnauld (9), d'Aubignac (1), René Le Bossu (1), Françoise Perrault (9), Jean Prechac (9), Nicholas Malebranche (7), Françoise duc de La Rochefoucauld (4), La Calprenède (21), Boileau (4), Bossuet (13), Bouhours (9), François Breval (16), Philippe de Comine (3), and many others on all subjects. See also Alexandre Maurocordato, *Le Critique classique en Angleterre de la Restauration à la mort de Joseph Addison* (Paris: Didier, 1964); A. F. B. Clark, *Boileau and the French Classical Critics in England: 1660–1830* (Paris: E. Champion, 1925); and Louis Charlanne, *L'Influence française en Angleterre au xviiᵉ siècle* (Paris: Société Française, 1906).

6. See by John M. Aden, "Dryden and Boileau: The Question of Critical Influence," *SP* 50 (1953): 491–509, and "Dryden, Corneille, and the Essay of Dramatic Poesy," *RES* n.s. 6 (1955): 147–56; Legouis, "Corneille and Dryden as Literary Critics," pp. 269–91; Arthur C. Kirsch, *Dryden's Heroic Drama* (Princeton: Princeton University Press, 1965); and H. James Jensen, "Sublime" and "Admiration," *A Glossary of John Dryden's Critical Terms* (Minneapolis: University of Minnesota Press, 1969), pp. 20–21, 111–12.

7. In *Critical Essays of the Seventeenth Century*, ed. Joel Spingarn (Bloomington: Indiana University Press, 1963; first pub. 1968), I, p. 139. A *Rugge-gowne* is an outer garment made of a sort of coarse frieze, a rough, woolen material in common use. Obviously, it is not smooth, elegant, or fashionable.

8. For an opposing view of the spider and wit, see Jonathan Swift, "A Full and True Account of the Battel Fought Last Friday Between the *Antient* and the *Modern* Books in St. James Library" (1710), in *A Tale*

of a Tub with Other Early Works: 1696–1707, ed. Herbert Davis (Oxford: Basil Blackwell, 1939), pp. 147–50. Swift introduces a spider who spins material out of himself, and his own poison, as a writer uses his own imagination. The whole passage denigrates the use of imagination instead of judgment and learning. Swift says, "Which is the nobler being of the two, that which by a lazy contemplation of four inches round, by an overweening pride, feeding and engendering on itself, turns all into excrement and venom, produces nothing at last, but flybane and cobweb; or that which, by an universal range, with long search, much study, true judgment, and distinction of things, brings home honey and wax" (pp. 149–50). The tendency to play down imagination and to elevate the understanding is very strong in Swift, as it is in many others.

9. Sir William Davenant, Preface to *Gondibert,* in Spingarn, II, pp. 20–21.

10. John Dryden, "An Account of the Ensuing Poem . . . : Prefixed to *Annus Mirabilis, The Year of Wonders, 1666,*" in *Of Dramatic Poesy and Other Critical Essays,* ed. George Watson (New York: Everyman, 1962), I, p. 98.

11. Ibid., p. 167.

12. For explanations of other problems concerning Dryden's critical vocabulary, see Jensen, Introduction and text of *Glossary.* See Émile Littré, *Dictionnaire de la langue française,* ed. Jean-Jacques Pauvert (Paris: Pauvert, 1956–58).

13. See Jensen, *Glossary,* pp. 5, 112–13; Nicholas Boileau, *Oeuvres complètes,* ed. A. Charles Gidel (Paris, 1873), IV, p. 141.

14. Gaston Cayrou, *Le Français classique* (Paris: Didier, 1924), p. 437; see also Jensen, *Glossary,* pp. 54–55, for a discussion of other words Dryden uses with French meanings, see Jensen, Introduction, *Glossary,* pp. 5–9, and words such as *spirit* (p. 110), *genius* (pp. 54–55), and *sublime* (pp. 111–12); for a discussion of other terms, see Barbara Strang, "Dryden's Innovations in Critical Vocabulary," *Durham University Journal* n.s. 3 (June 1959): 114–23; see also E. A. Horsman, "Dryden's French Borrowings," *RES* n.s. 1 (1950): 346–51; for a complete discussion of Dryden's criticism, see Robert D. Hume, *Dryden's Criticism* (Ithaca, N.Y.: Cornell University Press, 1970).

15. See Samuel H. Monk, *The Sublime* (Ann Arbor: University of Michigan Press, 1960; first pub. 1935), chap. I on history of usage. He says, "Boileau's translation was the turning point of Longinus' reputation in England and France" (p. 21). That is undoubtedly true. Yet, there are no English comments before Boileau such as this one by Jean-Louis Guéz de Balzac: "The first discourse that I sent you of eloquence, shall be sud-

dainly followed with a second, wherein I speak of the critick Longinus, and of his treatise *Peri Hupsous*, whereof the severall parts deserve consideration. 'Tis a subject wherewith I am much affected, and have great inclination to it in my fancy . . ." (*Familiar Letters* [London, 1654?]), Book VI, pp. 148–49 (letter of 12 March 1641). Balzac, as well as earlier Italian critics, knows the *Peri Hupsous* (*On the Sublime*) in a way unknown to the English of that time.

16. Sir Philip Sidney actually uses *diction* much earlier in his "apology for Poetry" (1595), in *Criticism: The Major Works*, ed. Walter J. Bate (New York: Harcourt Brace Jovanovich, 1972), but it never comes into common use; see Jensen, *Glossary*.

17. See Watson, II, p. 159 (1693).

18. Ibid., p. 178 (1694).

19. Ibid., I, pp. 209, 211, 218 (all 1677); ibid., II, pp. 48 (1690), 178 (1699), 272 (1700).

20. Charles Ward, ed. *The Letters of John Dryden* (Durham: University of North Carolina Press, 1942), pp. 13–14 (letter no. 6, "To Dorset"). Sometimes, we may conjecture that when Dryden addresses Dorset he expresses himself according to what he thinks Dorset wants to hear rather than tells the truth of what he thinks, whether in jest or otherwise; see, for example, "A Discourse Concerning Satire," in Watson, II, pp. 79–82, in which Dryden, addressing himself to Dorset, places him on a level with Shakespeare and the greatest writers of antiquity.

21. See Spingarn, III, pp. 149, 152, 161, 166, 167, 176, 179, 180, 181, 196–97.

22. Spingarn notes Blackmore echoes Rymer; ibid., III, pp. 227, 229, 333.

23. Joseph Spence, *Observations, Anecdotes, and Characters of Books and Men*, ed. James M. Osborn, 2 vols. (Oxford: Clarendon Press, 1966), I, p. 205.

24. Rymer has only twelve editions of his works listed in Wing's *Short Title Catalogue* and *A Gallery of Ghosts*, while Dryden has ten columns (three pages).

25. Adrien Baillet, *Jugemens des savans sur les principaux ouvrages des auteurs*, revised, corrected, and augmented by M. de La Monnoyne, 9 vols. (Paris, 1722; first pub. 1685–86).

26. In Thomas Blount, *De re poetica* (London, 1694), Rapin is cited 88 times, Dryden 83; then come Vossius (35), Julius Caesar Scaliger (34), Borrichius (31), Joseph Scaliger (26), and Rymer (24). After Rymer, Giraldus (18), Quintilian (17), Boileau (14), John Sheffield, earl of Mulgrave (14), Lipsius (13), Sir William Temple (12), Barthius

(11), Erasmus (9), Cowley (9), Cicero (8), and then too many to enumerate. One hundred twenty-two English critics are mentioned two times or more (besides Dryden and Rymer).

27. Sir William Soames, "The Art of Poetry," in *The Poetical Works of Dryden*, ed. George R. Noyes (Boston: Houghton Mifflin, 1950; first pub. 1909), pp. 916–25, ll. 115–20, 131–32, 822–26. Boileau's original was first published in 1674; Soames's translation (ca. 1680) was published in 1683. It does not matter to us whether Dryden revised Soames's work. The same kind of conflict exists among English architects. Viktor Fuerst comments that Christopher Wren had to reconcile his heart and reason (p. 176), that "Baroque splendor is anti-pathetic to the rationalism which underlies Wren's thought and age" (Viktor Fuerst, *The Architecture of Sir Christopher Wren* [London: Lund Humphries, 1956]). Wren, just as Dryden, was educated at Westminster by Dr. Busby (Wren: 1641–46; Dryden: 1644–49). Both indicated an interest in science. Wren was an astronomer, a mathematician; Dryden was an original member of the Royal Society. A parallel study of the work of such great English artists might possibly be interesting. See Kerry Downes, *Christopher Wren* (London: Allen Lane, 1971); Charles E. Ward, *The Life of John Dryden* (Chapel Hill, N.C.: University of North Carolina Press, 1961).

28. See Gerald Cragg, ed., *The Cambridge Platonists* (New York: Oxford University Press, 1968).

29. See John Dennis, *Critical Works*, ed. E. N. Hooker, 2 vols. (Baltimore: The Johns Hopkins University Press, 1939–43).

30. See Meric Casaubon, *Treatise Concerning Enthusiasm* (London, 1655).

31. Charles de Saint-Évremond, "Of the English Comedy," *Miscellanea*, trans. Ferrand Spence (London, 1686), p. 32.

32. But curiously enough, the English word *humour* changes to mean something more superficial than the inner reality of a human being. We can see this transformation in the changing meanings of the word. Dryden probably borrowed his meanings of *humour* from earlier English and French writers, and one can trace its development as a critical term through his use. Dryden starts by using *humour* to mean temperament, which agrees with the French usage (see Cayrou, *Le Français classique*, pp. 472–74; see also Jensen, *Glossary*, pp. 60–61) and then expands it to mean an overriding whim, a jest, a mood, or an extravagant habit. These are the common Restoration usages. In good satire, a *humour* and its depiction become more important than the character who displays it. A character thus literally displayed becomes a humour. It is an easy step to designate the kind of comedy that represents humours as "comedy of humours," sometimes called "mechanic comedy" (when a low class of people,

artisans or mechanics, is represented). Dryden's last meaning is the expanded English connotation, which is recognized as different from the French.

33. Sir William Temple, "Of Poetry," in Spingarn, III, p. 103.

34. Spingarn points out that the idea is repeated "by Congreve (1696) and many others from the 144th Guardian in 1713 to Blair's *Lectures on Rhetoric and Belles Lettres* in 1783" (III, p. 311).

35. Saint-Évremond, *Miscellanea* (London, 1686), p. 39; note his use of *justness*; see Dryden's definition of a play as "a just and lively image of human nature," in Watson, I, p. 25; *lively* is an important word, linked to the importance of the passions and the imagination.

36. Spingarn, III, p. 311; see also E. B. O. Borgerhoff, *The Freedom of French Classicism* (Princeton: Princeton University Press, 1950).

37. Charles de Saint-Évremond, "Taste and Judgment," *Miscellaneous Essays*, Translated by Several Hands, 2 vols. (London, 1692–94; first pub. 1686), I (1692), pp. 192–93.

38. Dryden, "Essay of Dramatic Poesy" (1668), in Watson, I, p. 64.

NINE. Comparisons of the Arts

1. For general works on *ut pictura poesis*, see Jean Hagstrum, *The Sister Arts* (Chicago: University of Chicago Press, 1958); Rensselaer Lee, "Ut Pictura Poesis: The Humanistic Theory of Painting," *Art Bulletin* 22 (December 1940): 197–269; and Luigi Salerno, "Seventeenth Century Literature on Painting," *Journal of the Warburg and Courtauld Institutes* 14 (1951): 234–58. For an excellent later treatment of the subject, see John Bender, *Spenser and Literary Pictorialism* (Princeton: Princeton University Press, 1972).

2. See Hagstrum, *The Sister Arts*, pp. 102, 236; Edmund Waller, "Instructions to a Painter," in *The Poetical Works of Edmund Waller and Sir John Denham* (Edinburgh: James Nichol, 1862), pp. 82–92.

3. G. H. Lessing, *Laocoön*, trans. E. A. McCormick (Indianapolis: Bobbs-Merrill, 1962; first pub. 1766), pp. 4, 5; Shaftesbury, "Notion of the Historical Draught or Tablature of the Judgment of Hercules" (1713), in *A Documentary History of Art*, ed. Elizabeth Holt (Garden City, N.Y.: Doubleday, 1958).

4. Lessing, p. 78.

5. Ibid., p. 28.

6. See Paula Johnson, *Form and Transformation in Music and Poetry of the English Renaissance* (New Haven: Yale University Press, 1972), p. 1; see also E. H. Gombrich, "Moment and Movement in Art," *Journal*

of the Warburg and Courtauld Institutes 27 (1964): 293-306; Victor Zuckerkandl, *Sound and Symbol: Music and the External World*, trans. W. R. Trask (New York: Pantheon Books, 1956); and Joseph Frank, "Spatial Form in Modern Literature," *The Widening Gyre* (New Brunswick, N.J.: Rutgers University Press, 1963), pp. 3-62.

7. Gerard LeCoat, "Comparative Aspects of the Theory of Expression in the Baroque Age," *Eighteenth Century Studies* 5, (Winter 1971): 223.

8. James Merriman, in "The Parallel of the Arts: Some Misgivings and a Faint Affirmation," *Journal of Aesthetics and Art Criticism* 31 (1972): 153-64, 310-21, says that rhetorical analysis is a real possibility (p. 312), although he is skeptical of parallels; he argues that there is too much subjective theorizing in parallels (p. 155).

9. Roger Des Piles, in *The Principles of Painting*, Translated by "A Painter" (London, 1743), p. 273, says that poesy and painting assist each other; Robert Petersson, in *The Art of Ecstasy: Teresa, Bernini, Crashaw* (London: Routledge & Kegan Paul, 1970) agrees. The use of pictorial allusions in the period has hardly been touched; see, for example, Laurel Brodsley, "Butler's Character of Hudibras and Contemporary Graphic Satire," *Journal of the Warburg and Courtauld Institutes* 35 (1972): 401-404.

10. *St. Guillaume* is in the Dresden Museum; *St. Louis*, in the Musée des Beaux-Arts, Rouen; see Yves Picart, *La Vie et l'oeuvre de Simon Vouet* (Paris: Cahiers de Paris, 1958), Part II, plates 14, 48.

11. Rubens's *Buckingham* is in Lord Jersey's Osterley Park with another with variations in the National Gallery, London; see *Loan Exhibition of Forty-three Paintings by Rubens and Twenty-five Paintings by Van Dyck* (Los Angeles: Los Angeles County Museum, 1946), plate 40; see also, for example, the *Apothéose de Henri IV*.

12. See John Charleton, *The Banqueting House* (London: Whitehall, 1964).

13. Aristotle defines part of what we are supposed to feel. Pity is "a sense of pain at what we take to be [what vividly strikes us as] an evil of a destructive or painful kind, which befalls one who does not deserve it, which we think ourselves or someone allied to us might likewise suffer, and when this possibility seems near at hand. In order to feel pity, one obviously must be the sort of man who will think that some evil may befall either himself or someone allied to him—an evil such as we have mentioned in our definition, either resembling it or equally momentous." Aristotle then elaborates. See Aristotle, *Rhetoric*, ed. Lane Cooper (New York: Appleton-Century-Crofts, 1960; first pub. 1932), pp. 120-23. Nicholas D. Boileau, "L'Art poétique," in *Oeuvres*, ed. Georges Mongrédien (Paris: Garnier Frères, 1961), p. 185, ll. 101-107 (Chant IV).

14. William Shakespeare, *Complete Works* (Baltimore: Penguin, 1969).

15. Ibid., *Venus and Adonis* (1593), ll. 1057–1168.

16. Ibid., *Romeo and Juliet* (1596), III, ii, 57–137.

17. Ibid., *Antony and Cleopatra* (1607), IV, xv, 63–94; there are other laments, of course, such as Desdemona's, but these will suffice.

18. Jean Racine, *Phèdre*, trans. Oreste F. Pucciani (New York: Appleton-Century-Crofts, n.d.), pp. 61–2, (V, v, 12–17).

19. In the Dole Museum; see Picart, *La Vie et l'oeuvre de Simon Vouet*, Part II.

20. See Henry Purcell, *Orpheus Britannicus*, 2 vols. (Ridgewood, N.J.: Gregg Press, 1965; facsimile of 1721 ed.), I, pp. 170–75; Coypel's painting is in the Musée Fabre, Montpellier.

21. See Vincent Druckles and Franklin B. Zimmerman, *Words to Music* (Publication of William Andrews Clark Memorial Library, University of California, Los Angeles, 1967), p. 10; Sigismondo d'India (ca. 1582–1627), for example, wrote "Infelice Didone," a "soliloquy of despair."

22. *Charles Le Brun*, ed. Ministère d'État/Affaires Culturelles (Paris: Recherches et Réalizations Graphiques, 1963), pp. 80–81.

23. Robert Isherwood, *Music in the Service of the King* (Ithaca, N.Y.: Cornell University Press, 1973), p. 284.

24. *Le Triomphe de Flora* is analyzed in detail by André Félibien, *Entretiens sur les vies et sur les ouvrages des plus excellens peintres anciens et modernes* (Paris, 1666), IV, pp. 327 ff; this painting is in the Louvre, Paris.

25. Le Brun also has a sketch *Le Triomphe de David* (1668), complete with chariot, trumpets, and so on.

26. See Jennifer Fletcher, *Peter Paul Rubens* (London: Phaidon, 1968).

27. At the beginning of Act III.

28. *Orpheus Britannicus*, II, pp. 129–31, 73–75; George Villiers, *The Rehearsal*, in *Plays of the Restoration and Eighteenth Century*, ed. Dougald MacMillan and Howard M. Jones (New York: Holt, Rinehart and Winston, 1959; first pub. 1931), p. 76.

29. See Euripides' *The Bacchae* for most of the information on the ancient cult of Bacchus; see William Arrowsmith, trans., *The Bacchae, Euripides*, vol. 4 of *The Complete Greek Tragedies* (Chicago: University of Chicago Press, 1959), pp. 542–610.

30. See Chapter II for definitions of *admiration* and *astonishment*.

31. If works of art try to make their receptors irrational, it is not surprising that both religious and political institutions try to regulate artistic

ends, to control art for the purposes of state and religion, to impose a seemingly rational, manmade order on the apparent chaos of nature. Such an attitude arose from materialistic thought, as the belief in an ultimately harmonious universe as parallel to an harmonious soul waned, and as the belief that art is to depict or to reflect that harmony declined. Louis XIV tried to regulate French art for his own political ends. The Catholic church of the Counter-Reformation also tried to do so when possible, but for religious ends: witness the trial of Paul Veronese before the Inquisition in 1573 for inserting unsuitable objects into his painting of *The Feast in the House of Simon* (which he altered to *The Feast in the House of Levi* to placate his accusers) and the painting of draperies over the nude figures in Michelangelo's *Last Judgment* (which alterations took a period of years). See Anthony Blunt, *Artistic Theory in Italy: 1450–1600*, rev. ed. (New York: Oxford University Press, 1968), chap. VIII. The change of attitude toward the affections had been occurring for some time. Claude Palisca, in *Baroque Music* (Englewood Cliffs, N.J.: Prentice-Hall, 1968), p. 4, says, "One of the masques of the carnival of 1574 in Florence was even called 'The Affections.'"

32. As Addison says in *The Spectator* (No. 183, 29 September 1711), "Pallas is only another name for reason."

33. See H. James Jensen, *A Glossary of John Dryden's Critical Terms* (Minneapolis: University of Minnesota Press, 1969), "Allegory."

34. See also Andrea Pozzo's study for the vault in Rome (in the Galleria Nazionale d'Arte Antica). There are vaults and ceilings for the Baroque period in which other artists have also tried to achieve a sublime scope and magnitude. Pietro da Cortona, for instance, painted the ceiling of the Palazzo Barberini in Rome; Gaulli, the vault of Il Gesu. In England, Antonio Verrio painted *Catherine of Braganza as Britannia* (ca. 1678) in the queen's audience chamber at Windsor; it is less impressive than the other examples we have mentioned but still Verrio has striven for the same scope and effect. Sir James Thornhill (1675–1734) tried to paint scenes from the book of Revelation. See Robert Wark, *Early British Drawings in the Huntington Collection: 1600–1750* (Huntington Library, Los Angeles, 1969). In France, Charles Le Brun, in *Dieu dans sa gloire* (1672–76), tries to achieve the same kind of effect that Andrea Pozzo does. We have already referred to works by Rubens such as his *Last Judgment* that achieve a similar effect. Jeffrey B. Spencer in *Heroic Nature* (Evanston: Northwestern University Press, 1973) says that Tiepolo also tries to show movement through limitless space (p. 19). Petersson in *The Art of Ecstasy* says that the vault of the Cornaro chapel, although smaller than that of Il Gesu or Sant' Ignazio, gives "the same sense of endless spiritual ascent" (p. 64).

"It is Teresa's apotheosis" (p. 65). Petersson then tries to show the same kind of mounting effect in Crashaw's poetry (p. 124).

35. I could also have used for comparison trumpet works by Dryden's friend and protégé Henry Purcell, such as his "Voluntary for Two Trumpets in C" (which is only tentatively attributed to Purcell). Purcell wrote much music for trumpets, and the same kind of analysis of imagery and intent would hold for his work, as it would for Handel's trumpet parts and numerous works by many other Baroque composers. The Vivaldi piece merely serves as a clear example, and there is no problem of attribution.

36. Walter Kolneder, *Antonio Vivaldi*, trans. B. Hopkins (Berkeley: University of California Press, 1970; first pub. 1965), pp. 85–87; see also Marc Pincherle, *Vivaldi*, trans. Christopher Hatch (New York: W. W. Norton, 1957; first pub. 1953).

37. Marin Mersenne, *L'Harmonie universelle: contenant la théorie et la practique de la musique* (Paris, 1636), Book II, p. 39.

38. For a brief discussion of expression in music, painting, and poetry, see LeCoat, pp. 221–23; see also Mersenne, chap. IX.

39. Earl Miner has explicated the sources and analogues of the poem in his book *Dryden's Poetry* (Bloomington: Indiana University Press, 1967), pp. 274–85; and Bertrand Bronson has analyzed Handel's setting of the ode in his essay "Some Aspects of Music and Literature," *Facets of the Enlightenment* (Berkeley: University of California Press, 1968), pp. 91–118; for the meanings of the instruments used in the poem (which show the history of the world through music), see Emanuel Winternitz, *Musical Instruments and Their Symbolism in Western Art* (New York: Norton, 1967).

40. John Milton, "At a Solemn Music," in *Poems*, ed. James Holly Hanford (New York: Ronald Press, 1936), p. 101; see also Thomas Mace, *Musick's Monument* (London, 1676), Book I, pp. 265–70, for a further explanation of the equation of harmony with God and his power.

41. Des Piles, *Principles*, p. 52.

42. Mace, *Musick's Monument*, Book I, pp. 265–70.

43. Dryden, of course, knows more of Rubens than the ceiling at Whitehall; he mentions him (and Michelangelo) as a history painter in his "Parallel Betwixt Poetry and Painting," in *Of Dramatic Poesy and Other Critical Essays*, ed. George Watson (New York: Everyman, 1962), II, 182. Jean Hagstrum mentions what he calls Dryden's "spiritual" affinities with Rubens in *The Sister Arts*, p. 207. I suggest that these affinities have to do with a similarity of vision or imagery and intent and that they help illuminate Dryden's poetry. Dryden also, no doubt, saw Roland Fréart, whose *An Idea of the Perfection of Painting*, trans. John Evelyn

(London, 1668), has a whole section written on Michelangelo's *Last Judgment* (pp. 74–80). For a good comparison of different artists whose works are not directly connected, see Petersson. There are no direct links among the three creative persons he discusses (Crashaw, Bernini, and St. Teresa) and their works. As Petersson says, "[The] resemblances . . . transcend differences of individual temperament, nationality, and artistic medium" (Introduction). Bernini, for example, uses literary themes, as Petersson points out; Crashaw uses allusions to visual art to enlarge the scope of his poetry.

44. See "Sound" in Jensen, *Glossary*, p. 109. Although the quality of organ making varied from country to country, Dryden's organ imagery could be based on the tones of the magnificent Baroque organ, an instrument which after a long period of neglect, craftsmen and musicians have recently started to construct along seventeenth- and eighteenth-century lines. From modern imitations, we may conclude that the image is indeed impressive; see E. Power Biggs, "The King of Instruments Returns," *Horizon* 2 (March 1960): 72–80.

45. John Milton, "On the Morning of Christ's Nativity," in *The Poems of John Milton*, ed. J. H. Hanford (New York: Ronald Press, 1936), p. 65.

46. Philip Bate, *The Trumpet and Trombone* (New York: Norton, 1966). Blow's reference is in "Welcome every guest, welcome to the muses' feast: Music is your only cheer" (John Blow, *Amphion Anglicus* [Ridgewood, N.J.: Gregg Press, 1965, facsimile of 1700 ed.], pp. 1–5); Blow goes through all the instruments, ending on the glorification of the trumpet.

47. See Don Smithers, "Seventeenth-Century English Trumpet Music," *Music and Letters* 48 (1967): 358–65, for comments on two English trumpet players, William Bull and Mathias Shaw (or Shore or Show or Shoar).

48. See Mersenne, *L'Harmonie universelle*, Book III, pp. 247–61, for further corroboration; see also Daniel Speer, *Grund-richtiger kurtz leicht unnothiger unterricht de musicalischen kunst* (Ulm, 1687); for perhaps the most complete work on the trumpet, see Bate, *The Trumpet and Trombone*; Smithers talks about English trumpets, trumpeters, and trumpet music in "Seventeenth-Century English Trumpet Music." See also Don Smithers, *The Music and History of the Baroque Trumpet before 1701* (London: J. M. Dent and Sons, 1973).

49. See Bate, *The Trumpet and Trombone*, p. 110.

50. See also Mersenne, *L'Harmonie universelle*, Book III, p. 261. Mersenne says what Dryden implies in his poem: "Trumpets prepare the hearts and spirits of soldiers for going to war, for mounting attacks, and for hand-to-hand fighting" [(Trumpets) preparoient le coeur et les esprits

des soldats pour aller à la guerre, pour aller à l'assaut, et pour donner les combats]. Later, Mersenne talks about Judgment Day. Rubens also uses trumpets as a spur to violence in his *Rape of the Sabines*.

51. See Claude Perrault, *Essais de physique*, 3 vols. (Paris, 1680), II, pp. 149 ff.; see also pp. 337, 343.

52. See Raymond Cogniat, *Seventeenth Century Painting* (New York: Viking, 1964), plate 92.

53. See Jean-Baptiste Lully, *Amadis tragédie* (Paris, 1709), p. 54.

54. See *Orpheus Britannicus*, II, pp. 129–31: "Sound Fame thy Brazen Trumpet sound."

55. *Charles Le Brun*, pp. 112–15.

56. The imagery available to painters, musicians, and poets, as we have seen, is located in a kind of pool of ideas, the use of which comes from invention (or discovery). In other words, images are a part of the *topoi* (equivalent to the rhetorical term; see Aristotle's *Rhetoric*, Book II). These images can come from other works as well as from nature. Thus, as late as 1769, Sir Joshua Reynolds, in "Discourse Two," *Discourses on Art*, ed. Stephen O. Mitchell (Indianapolis: Bobbs-Merrill, 1965), p. 16, can say, "The more extensive therefore your acquaintance is with the works of those who have excelled, the more extensive will be your powers of invention."

57. Winternitz, although he does not deal with trumpets in his valuable book *Musical Instruments and Their Symbolism in Western Art*, points out how to tell if an artist is presenting a musical instrument naturalistically and also says that in the Renaissance and in the Baroque "it was the painters, above all, who availed themselves of the symbolic character of musical instruments" (p. 18); poets certainly did, too, not to mention composers. Winternitz has a chapter on functional and nonfunctional instruments that are depicted in painting (chap. XVI).

58. See Winternitz, chap. XI, "On Angel Concerts in the Fifteenth Century: A Critical Approach to Realism and Symbolism in Sacred Painting"; see also Reinhold Hammerstein, *Die Musik der Engel, Untersuchungen zur Musikanshauung des Mittelalters* (Bern: Francke Verlag, 1962).

59. Fréart de Chambray, p. 77; John Evelyn, the English translator, in his "To the Reader" disagrees with Fréart's low appraisal of Michelangelo and rates him highest, higher even than Raphael; Bate answers most of the problems concerning the history of trumpet embouchures.

60. John Dryden, "The Hind and the Panther," Part I, in *The Poetical Works of Dryden*, ed. George R. Noyes (Boston: Houghton Mifflin, 1950), p. 219, ll. 66–67; this poem was published the same year as the "Song for St. Cecilia's Day"; see also Sanford Budick, *Dryden and the*

Abyss of Light (Ithaca, N.Y.: Cornell University Press, 1970). Dryden's description could not, of course, be reproduced in paintings of the time because his "blaze of glory . . . forbids the sight." But we are not comparing media. The image in the mind is in actuality the same, and the effects are supposed to be similar.

61. Henry Peacham, *Minerva Britanna* (London, 1612; reprint ed., Leeds, Eng.: Scolar Press, 1966), p. 204.

62. Mace, *Musick's Monument*, Book II, pp. 265–70.

INDEX